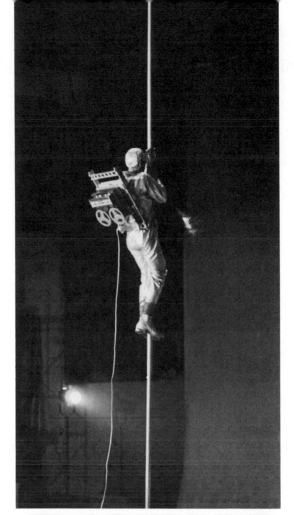

ART AND THE FUTURE

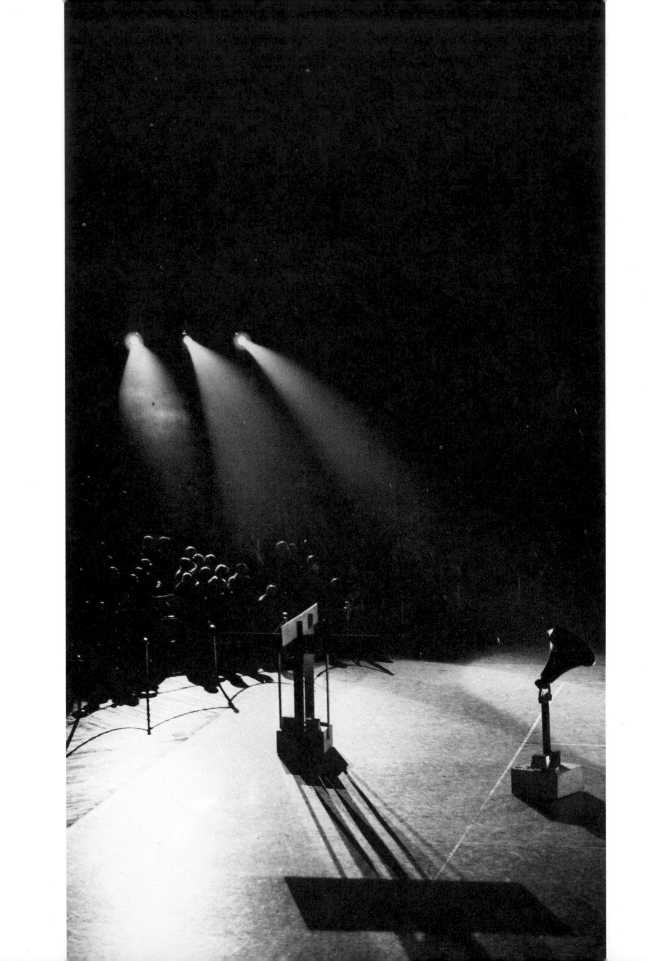

ART AND THE FUTURE

A HISTORY/PROPHECY
OF THE COLLABORATION BETWEEN
SCIENCE, TECHNOLOGY AND ART

DOUGLAS DAVIS

PRAEGER PUBLISHERS

NEW YORK · WASHINGTON

Frontispieces:
Alex Hay. *Leadville,* 1965. The First New York Theatre Rally Intermedia performance. Photo © 1965 by Peter Moore.

David Tudor. *Bandoneon! (A Combine),* 1966. Photo © 1966 by Peter Moore.

BOOKS THAT MATTER
Published in the United States of America in 1973
by Praeger Publishers, Inc.,
111 Fourth Avenue, New York, N.Y. 10003

© 1973 by Douglas Davis

Library of Congress Catalog Card Number: 76-119522

Printed in the United States of America

Book design by Gilda Kuhlman and Robert Fabian

To J.
for the first time

To M. B. and L. K.
for the second time

To none
for the last time.

CONTENTS

Introduction 11

I PROLOGUE 13

Technology as Landscape 15

The Beginnings 16
Leonardo The Industrial Revolution William Morris
Art Nouveau Henry van de Velde The Deutscher
Werkbund Walter Gropius

The New Esthetic in Theory: A Platform for the Future 17
Cubism Futurism Suprematism Dada and Duchamp
Kurt Schwitters Surrealism Tatlin and Constructivism
Gabo: *The Realist Manifesto* The Bauhaus De Stijl:
Mondrian and van Doesburg

The New Esthetic in Action: Between the Wars 27
The Machine in Painting Duchamp's *Precision Optics*;
the *Bicycle Wheel* Scriabin's "light keyboard" Len
Lye's *Kinetic Machine* Gabo's *Kinetic Sculpture:
Standing Wave* Alexander Calder Noise and Sound
The Theater Machine Moholy-Nagy's *Light Space
Modulator*

**The United States, 1937–65:
Process in Triumph** 33

From Moholy to Cage: The Beginnings in America 33
The "New Bauhaus" in Chicago The World War II
European Influx Thomas Wilfred John Cage Elec-
tronic Music Gyorgy Kepes and the New Landscape
Frank Malina: Engineer-Artist

**Two Decisive Figures:
David Smith and Robert Rauschenberg** 36

The Industrial/Environment Esthetic 38
Allan Kaprow Claes Oldenburg Andy Warhol Don-
ald Judd Robert Morris Frank Stella

New Materials in the Early 1960's 44
Dan Flavin Larry Bell Fletcher Benton Norman
Zammitt Others The New Music The New Theater

Europe After the War 52

The Post-Bauhaus Renaissance 52
Lucio Fontana Bruno Munari Max Bill Karlheinz
Stockhausen Yves Klein: The New Realism *Le
Mouvement* Jean Tinguely Takis Nicolas Schöffer
Editions M-A-T

The Early 1960's in Europe: Nouvelle Tendence 56
Group ZERO Groupe de Recherche d'Art Visuel
Dvizdjene Others

England: The Aftermath 59
Vorticism Herbert Read Richard Hamilton Eduardo
Paolozzi Reyner Banham Archigram Bridget Riley
Anthony Caro The Signals Gallery David Medalla
Centre for the Studies of Science in Art SPACE The
Artists Placement Group Gustav Metzger The Bomb
Culture *The Soft Machine*

The Radical Shift: Technology as Creative Force 67

The Late 1960's in the United States: The Movement Becomes Explicit 67
USCO Marshall McLuhan Buckminster Fuller *Nine Evenings: Theater and Engineering* Robert Rauschenberg: Electronic Tennis David Tudor: *Bandoneon!*
Billy Klüver: The Engineer as a Work of Art

The Radical Shift: The Artist–Engineer–Machine 71

The American Platform: Toward Fusion 72
Experiments in Art and Technology, Inc. Gyorgy
Kepes: The Center for Advanced Visual Studies

New Media/New Scale: Physical and Temporal 75
Tinguely's *Gigantoleum* *The Magic Theater* Cage's
HPSCHD *Art and Technology* at Los Angeles Air Art
Sky Ballet Laser Light Holography

The New Audience: Television and Videotape 84
Black Gate Cologne Nam June Paik Wolf Vostell
Bruce Nauman Les Levine The Television Gallery in
Düsseldorf Information Systems: The Raindance Corporation, Global Village, Videofreex Electronic Mixing:
Boston, San Francisco, and Beyond Stan Vanderbeek
Video Variations TV as Private Communication

Environmental Space and Time: The "Living" Work of Art 92
Intersystems Pulsa Robert Whitman Keith Sonnier
Ted Kraynik Hans Haacke Alan Sonfist

The Computer: Final Fusion 97
The Computer as Composer: Lejaren Hiller, John
Pierce, Max Mathews The Computer as Draftsman
and Film-maker: John Whitney, Ken Knowlton, Leon
Harmon, Stan Vanderbeek The Computer as Architect: Nicholas Negroponte The Computer Extended:
Charles Csuri, Ivan Sanderson The Computer as Alter
Ego: Michael Noll, Roger La Fosse, José Delgado,
David Rosenboom

The Single Spirit 106

Counter Currents:
Frankenstein; Reaction; Disillusionment 106
Electronic Zen Lewis Mumford The Frankenstein-
Robot Image The Perils of Collaboration The Com-
puter Unrealized

Hybrid Art/Engineering/Science: Dada Vindicated 111
The Artist-Engineer The Anti-Ego The Irresistible
Attraction

II PROCESS: CONVERSATIONS, MANIFESTOS, STATEMENTS 113

Introduction 114
Gyorgy Kepes: The New Landscape 115
Nicolas Schöffer: The Cybernetic Esthetic 120
Jean Tinguely: Be Movement! 123
Takis: The Force of Nature 127
Two Groups: ZERO and GRAV 131
Billy Klüver: The Engineer as a Work of Art 136
Robert Rauschenberg: Technology as Nature 141
Nam June Paik: The Cathode-Ray Canvas 146
James Seawright: The Electronic Style 153
Gerd Stern and USCO: The Experiential Flow 157
James Turrell/Robert Irwin/Edward Wortz:
The Invisible Project 161

III PROPHECY: THE ART OF THE FUTURE 167

Glossary 189
Notes 192
Bibliography 195
Index 204

Glass & crystal, salt shaker, T-square, radiator, alcohol burner, semaphore, or iron construction appeared in my paintings—instead of apples, lobsters, & pears.
—*László Moholy-Nagy*

Let us be transformed!
—*Jean Tinguely*

Technology doesn't mean. It is means.
—*Robert Rauschenberg*

It's like the old Zen story: Everything is still the same as it was, but it's different.
—*Edward Wortz*

Introduction

The complexity and catholicity of this book is more apparent than real. Once I had the illusion that I would write a many-sided book on this subject, innovative in form. But the more I worked and saw, the more single-minded I became. In every artist, in every period, and in every medium, old or new, I found the same issues and the same resolutions. The result is a tightly woven, embarrassingly linear book. As for its cross-media attack, I find even that a domestic matter now. The solid central concern is painting and sculpture, opening out to include arts beyond them—film, music, dance, happenings, theater, architecture—when they are organically related. It may well be an innovation within the standard practice of art history to tell so "total" a story, even about "total" art. But here I join the French critic Pierre Francastel, who acknowledged in the preface of *La Réalité figurative* (Paris, 1965) that although his book might "shock the specialists" it was essentially orthodox in purpose. Francastel sought no new synthesis or disciplines and neither do I, save as an afterthought.

Such innovation as is here lies in the conclusion, not the content and not the form. I am also conscious, upon rereading the book, that I have given way completely to the subject. Many works of art history are essentially products of connoisseurship. The choices made by the author are exercises in taste rather than necessity. I was driven in the opposite direction. I both wrote about and reproduced artists passionately involved with the issues I wanted to raise, and deemphasized others, regardless of reputation. The decision is most readily apparent in Part II, where I leave out several artists of the first rank (Calder, for example); but it shows up elsewhere as well. I regret these slights but I defend them, just as I defend the omission of work executed beyond the reach of my eyes or my research, particularly in Japan, Latin America, and the Soviet Union. I made a conscious effort to limit myself to what I had seen or personally investigated.

My debts to the friends and colleagues who helped me write, edit, and rewrite this book are heavy. Joan Allard, Terry Martin, Gwen Wright, and Marlene Nagorski all aided me in research. My early conversations with Gyorgy Kepes and Billy Klüver were of great practical importance. The manuscript was read at various stages by several keen-eyed colleagues, all of whom made important suggestions. Without the elegant editing and presence of my wife, Jane, the book simply would not exist. The encouragement of my editor, John Hochmann, has been important from the first. Furthermore, he has allowed me to participate in the design of the book, for once linking form and content in the author's hand.

As I write this, I am more than normally aware that the heady euphoria of the mid-1960's, when artists and engineers came together in significant numbers for the first time, has passed. The critic of the *New York Times* has lately pronounced the Russian Constructivists—who mixed art and technology in an earlier, equally euphoric time—nothing less than "totalitarian" in their ideology. Max Kozloff charges the artists who participated in the Los Angeles County Museum's *Art and Technology* exhibition with nothing less than moral blindness.

God knows, I sympathize with the emotions behind this reaction. The war has sickened us all, and we hear little at this hour about the creative potential of technology and much about its destructive capacity. Rather, we are told by a variety of sophisticated Luddites that we must retrench. This position cannot long endure, of course. Art can no more reject either technology or science than it can reject the world itself. The world can no more reject them than it can accept hunger, disease, ignorance, or the feudal structures that nourished them. We have sentimentalized too long a past that was in fact brutal and sordid. The totalitarianism that reared the pyramids and subjugated medieval Europe proceeded without the benefit of computers or the Los Angeles County Museum. The future, if not better, is at least uncharted and therefore malleable. It will fail us only if we surrender knowledge and technology to the utilitarians.

This book thus appears paradoxically at the best moment. If it succeeds, it will remind artists everywhere of what has been accomplished in this century through collaboration and why. Out of that awareness can come an art and a society at once saner and freer than any we have seen before.

November, 1972

I PROLOGUE

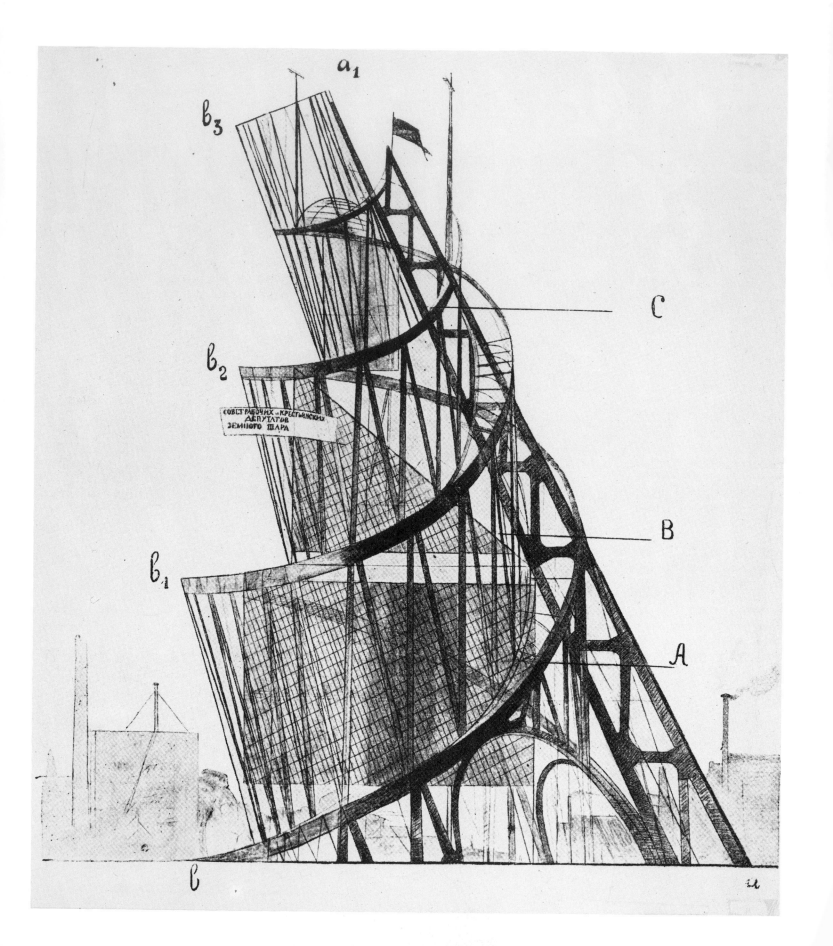

Technology as Landscape

Like society, art has courted technology in the twentieth century with conflicting emotions, with a mixture of passion and love, loathing and fear. The Futurists lusted after what they call "victorious science." In 1911, Marcel Duchamp painted his *Coffee Grinder*, tenderly exposing its inner workings: "I used the mechanism as a description of what happens," he said later. "You see the handle turning, the coffee after it is ground—all the possibilities of that machine." One decade later, the Russian Constructivist El Lissitsky, an early convert to the new technological art, complained: "We have had enough of perpetually hearing Machine Machine Machine Machine when it comes to modern art production." In 1952, the critic Lewis Mumford, speaking on behalf of a widespread and continuing body of literary and artistic belief in the United States, compared technology to "the walls of a prison." In a 1965 manifesto, the British artist Gustav Metzger charged that technology had built a "self-destroying society" demanding "auto-destructive" art in response. As these feelings have interacted with one another, they have formed a complex conceptual web obscuring the origins of a phenomenon that extends far back into the past. By the terms of Donald Schon's definition, artists have always been involved with "technology," with the use, that is, of relatively new tools, methods, and knowledge to extend their work—or "human capability," as Schon says—beyond the limits allowed by traditional means.[1]

To some extent, we are already aware of the fact. One of the clichés of art history concerns the effect of the camera. Students are told that the invention of this instrument in the nineteenth century deprived painters of their *raison d'être*—to reproduce and preserve reality, whether it be a sitter's face or a landscape—thus turning the focus of art inward, upon the self. The influence of Eadweard Muybridge's photographic studies of motion on artists who dealt with the figure in the last century is also well known; the American Thomas Eakins not only used Muybridge's work in teaching but made photographic studies himself, which he used as direct models for his own painting.

But the influence of technology is subtler —and tougher—than this. Even the nature of pigment betrays that influence, as do the means of its application. Before 1700 and the maturation of chemistry as a science, few synthetics were in use, most pigments being "natural," like carbon black, colored earth, and certain natural metallic compounds. Since then, a variety of colors, titanium white, Prussian blue, cobalt blue, and a wide number of yellows based on zinc, chromium, and cadmium, have been added by chemistry to the palette of the painter. The development of synthetic, quick-drying acrylic paints since World War II has changed the very application of color to canvas. The new water-soluble blends permit saturation by staining, a method exploited by the American painter Morris Louis, who began in 1953 to pour acrylics directly on canvas, sinking the color deep into the fibers.[2] Oil-based pigments, which must be applied over a primer, hardly suit this process. He was followed, in time, by many others, specifically including "Color Painters" like Kenneth Noland, Gene Davis, and Howard Mehring.

Acrylics lend themselves to other methods, too. Sam Gilliam, one of the American "post-Color" painters influenced by Louis, brushes and mops his paints upon the canvas, then folds the results into one another, creating an effect of great spontaneity within the original structure, thanks to the qualities inherent in the texture and the nature of acrylic—its tendency to flow and to dry quickly. Acrylics also lend themselves well to application by

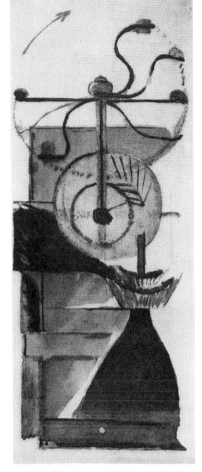

Marcel Duchamp. *Coffee Grinder,* 1911. Oil on wood. 12⅞" x 4¾". Collection Maria Martins, Rio de Janeiro.

Gustav Metzger standing behind an "auto-destructive" painting, 1961. Photo by Cyril Nelson, London.

James Rosenquist. *Circles of Confusion,* 1965. Charcoal and pencil on paper. 49″ x 21½″. Collection Mr. and Mrs. Richard L. Feigen, New York. Courtesy Richard Feigen Gallery, New York and Chicago. Photo by Geoffrey Clements.

Edward Kienholz. *The Friendly Gray Computer—Star Gauge Model #54,* 1965. Motorized construction; rocking chair. 40″ x 39⅛″ x 24½″. Collection The Museum of Modern Art, New York. Gift of Jean and Howard Lipman.

the spray gun. Dan Christensen, a New Yorker, and William Pettet, a Californian, mix them with varying degrees of air to create "wet" and "dry" surfaces of extraordinary complexity. Christensen adds a detergent that places a filmy screen between his forms and the eye of the viewer. Pettet's canvases in particular reveal a delicate, cloudlike lyricism, combined with brilliant color, that would have been technically impossible two or three decades before. After several years of experimentation, he learned how to spray alternating wet and dry clouds of acrylic color on top of each other, creating in the process a striated blend of contrasting hues, sometimes more than forty layers, producing together a highly complex color. A clean, smooth, "industrial" finish is possible in acrylic, of course, as countless artists seeking that look discovered during the 1950's and 1960's.

The way in which painting has been substantially modulated by technology is a prime example of what is normally overlooked in the histories. Technology's influence upon the way we paint, sculpt, dance, compose, and so on is indirect as well as direct, unseen as well as seen, unconscious as well as conscious. Neither Morris Louis nor William Pettet set out to use "technology" in their work. They merely reached for the tool or material at hand, like the anonymous architects who reared the pyramids of Egypt and cathedrals of Europe, with the materials, the tools, and the knowledge at hand. The ancient Greeks used one word—*techne*—to stand, roughly, for both "art" and "technics."

There is, all the same, a difference now, and it is one of degree. Man is creating in our time new tools and methods at a rate unmatched in the past. Their presence is—as we shall see throughout this book—a creative presence. As these new means have multiplied in the twentieth century, they have steadily altered not only our sensibilities but the form and purpose of art itself. What begins as a conscious attempt to fit new materials into old forms ends with new forms based on those materials. Technology, now, is our environment, our landscape. New tools and knowledge no longer hide from the artist: they surround him. He can no more escape them in his work than Constable could escape the fields and trees of England or Winslow Homer the seacoast of Maine. The story that must be told, then, has to do with that development and its consequences, for both art and life.

The Beginnings

Leonardo da Vinci lived in a different, less informing landscape. He was forced actively to seek new knowledge. He worked closely with the anatomist Marc Antonio della Torre to learn what he needed to complete his figure studies and drawings. The rediscovery in 1967 of notebooks previously hidden in Madrid's National Library revealed the extent of his studies in both mechanics and the science of bronze casting. If the technology of his time handicapped Leonardo, its attitude toward *techne* did not. Living in a preindustrial society, before the triumph of specialization, he felt no hesitancy about assuming the engineer's as well as the artist's role.[3] He planned and constructed field guns, flying machines, and kinetic theaters.[4] It is not accidental that our time, which is post-industrial in nature, thanks to the computer, is witnessing a rebirth of the artist-engineer.

This rebirth had to await the passing of certain well-founded anti-machine attitudes. The early excesses of the Industrial Revolution earned for the machine the almost unrelieved hatred of most artists and intellectuals throughout the nineteenth century. In England, both John Ruskin and William Morris insisted that the artist and the machine were essentially incompatible, that beauty was inevitably handmade and ugliness mass-produced. Ruskin believed in the virtues of ornamentation in architecture, not the simplicity that came later with industrial fabrication. Morris took a firm and significant stand against an aloof role for art when he established a craftsman's firm of artists in 1861 ("Morris, Marshall, and

Roy Lichtenstein. *Modern Painting with Sun Rays,* 1967. Oil and magna on canvas. 48″ x 68″. Collection Joseph H. Hirshhorn. Photo by Rudolph Burckhardt.

Faulkner, Fine Art Workmen in Painting, Caning, Furniture and the Metals"), but he demanded that its products distinguish themselves from the machine-made; he even avoided new and cheaper materials. "As a condition of life," he once said in a lecture, "production by machinery is evil." The flowery school of design known as Art Nouveau, which superseded Morris in England and swept the Continent around the turn of the century, was equally at odds with the new age. When even so enlightened an Art Nouveau architect as Hector Guimard employed cast iron in the entrances of the Paris Métro, he made it twist and bend to resemble carved wood.[5]

Morris had other heirs, though. First among them was the Belgian architect Henry van de Velde, directly influenced by Morris's esthetic socialism and his insistence that art should influence design on every level. But van de Velde—like Adolf Loos in Austria and Frank Lloyd Wright and Louis Sullivan in the United States—welcomed the benefits provided by machines. "The powerful play of their iron arms will create beauty," he declared in 1894, "as soon as beauty guides them." Hermann Muthesius, a German statesman and designer, was a shade more radical than van de Velde, whose belief in imposing "beauty" echoed Ruskin's love for useless ornamentation. In 1907, Muthesius helped to found the Deutscher Werkbund, an association of manufacturers, architects, artists, and writers determined to find new, streamlined, and functional design standards based in, not foisted upon, the machine. "There is no fixed boundary," announced a speaker at the Werkbund's first convention, "between tool and machine." This evolution was completed when another architect, the young Walter Gropius, succeeded van de Velde as head of the Weimar School of Arts and Crafts. Gropius had by then built and planned several severely simple factories and housing projects using new materials and mass-produced parts. Shortly after replacing van de Velde, he converted the Weimar School into the influential Bauhaus, which opened in 1919.

The New Esthetic in Theory: A Platform for the Future

The change in painting was less precipitous than in architecture and design, but equally radical. The predominant credit for the triumph of modernism in the West has been given to Cubism, after the transitional tri-

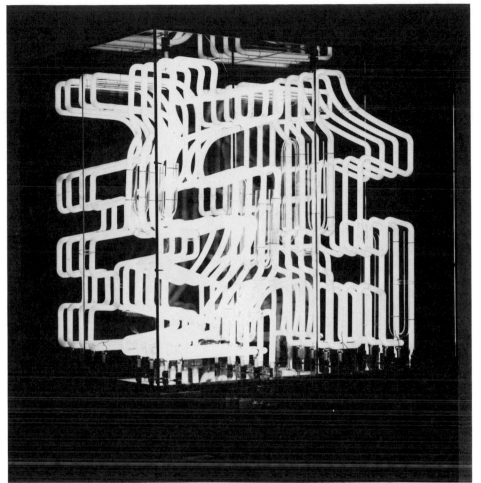

Chryssa. *Fragment for the Gates to Time Square, II,* 1966. Neon and plexiglass, 43" x 34¼₆" x 27¼₆". Courtesy The Pace Gallery, New York. Photo by Ferdinard Boesch.

umphs of Impressionism. There is much to be said for this attitude, though it neglects the conceptual revolution launched by the Italian Futurists and their colleagues in Russia. The Cubists clearly thought of themselves in any case as visionaries. Apollinaire said of Georges Braque, in fact, that he composed his pictures "in absolute devotion to newness . . . of the fast-moving, visually fragmented modern world." Another French artist, Fernand Léger, explained that the breakdown of form in the new painting was necessary because the locomotive insisted upon it: "The daily life of the artist is much more condensed and more complex than that of people in earlier centuries," he wrote. "The thing that is imagined does not stay as still; the object does not exhibit itself as it formerly did."

For the Futurists, Cubism did not go far

Umberto Boccioni. *Untitled,(Speeding Automobile),* 1901. Tempera. 29⅛″ x 50⅜″. Courtesy Automobile Club d'Italia, Rome.

enough: "[The Cubists] obstinately continue to paint objects motionless, frozen, and all the static aspects of Nature," claimed one of the Futurist manifestos. The term Futurism was invented by the dynamic poet-editor Filippo Tommaso Marinetti, who announced a set of modernist dogmas under its name in the front page of *Le Figaro* in Paris on February 20, 1909 (two years before the definitive spread of Cubism in Paris), claiming, among other things, that the speeding automobile was more beautiful than the *Victory of Samothrace.* Marinetti also mailed copies of his statement to friends and potential supporters throughout Italy. He was soon joined as polemicist by a circle of painters including Giacomo Balla, Umberto Boccioni, Aroldo Bonzagni, Carlo Carrà, Luigi Russolo, and Gino Severini. It was in the name of his colleagues that Boccioni demanded—from the stage of a theater in Turin in 1910—that art portray the moving world around us, the world trans-

Gino Severini. *Dynamic Hieroglyph of the Bal Tabarin,* 1912. Oil on canvas, with sequins. 63⅝″ x 61½″. Collection The Museum of Modern Art, New York. Acquired through the Lillie P. Bliss Bequest.

Umberto Boccioni. *States of Mind: The Farewells,* 1911. Oil on canvas. 27¾″ x 37⅞″. Private Collection, New York. Courtesy The Museum of Modern Art, New York.

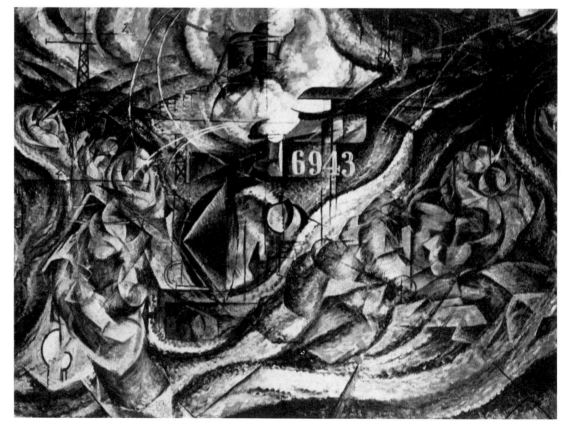

formed by "victorious science." Art must align itself, said the Futurists, with "the magnificent radiance of the future."

For Boccioni specifically, and for Balla and Severini, painting came to mean the depiction of speed itself. Their methods may have been essentially conservative and the net effect of their work more personal and romantic than "objective," but the premise behind it—a mystical, quasi-theatrical belief in positivist progress—remained firm, even during the darkest hours of World War I. Boccioni, among others, anticipated Futurism as early as 1901 in his painting *Untitled* (*Speeding Automobile*); despite its subject, the work was patently traditional and illustrational. Balla took on the same subject in his *Speed of an Automobile* series begun about 1912, but he altered his method accordingly. In painting after painting, he broke down the literal surface of nature into component parts in a manner related to Cubism, so that the *effect* of the car and its speed is communicated rather than its static, surface form. We see parts of the automobile, repeated over and over, interlaced with swirling, spiraling, thickly etched forms, the whole combining to present a picture of unrestrained energy. Boccioni, who had visited Paris and acquainted himself with the Cubists, began a series of his own, *States of Mind*, in 1911. These paintings were not overt celebrations of the mechanical age: they are expressive renderings of inner moods occasioned by it. In *The Farewells*, however, his admiration for the strength of the locomotive comes through the delicacy of the brushwork. His colleague Severini was less metaphoric. Works like *Autobus*, *Nord-Sud Métro*, *Dynamic Hieroglyphic of the Bal Tabarin*, and finally *War* (finished in 1914, just in time to carry out Marinetti's earlier admonition to "glorify War—the only health giver of the world") are paeans to their subjects.[6]

If the Futurist position on the machine was well defined, the same was not true for Suprematism and Dada. The Russian painter Kasimir Malevich, who gave birth to Suprematism, knew and admired the Futurists. In one of his first manifestos (*The New Realism in Painting*, 1916), he called for an art based on "weight, speed and the direction of movement." The earliest Suprematist paintings betray this persuasion: witness *Suprematist Composition* and *Airplane Flying*. But Malevich was never entirely at home with the world of objective phenomena, despite his

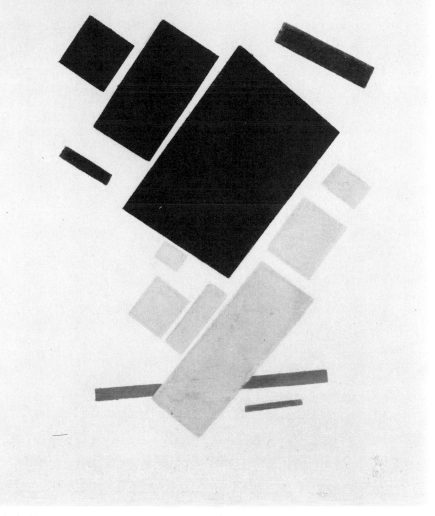

Kasimir Malevich. *Airplane Flying*, 1914. Oil on canvas. 22⅞" x 19". Collection The Museum of Modern Art, New York. Courtesy Leonard Hutton Galleries, New York.

Kasimir Malevich. *Suprematist Composition*, 1915. Gouache and pencil. 8⅝" x 7". Courtesy Leonard Hutton Galleries, New York.

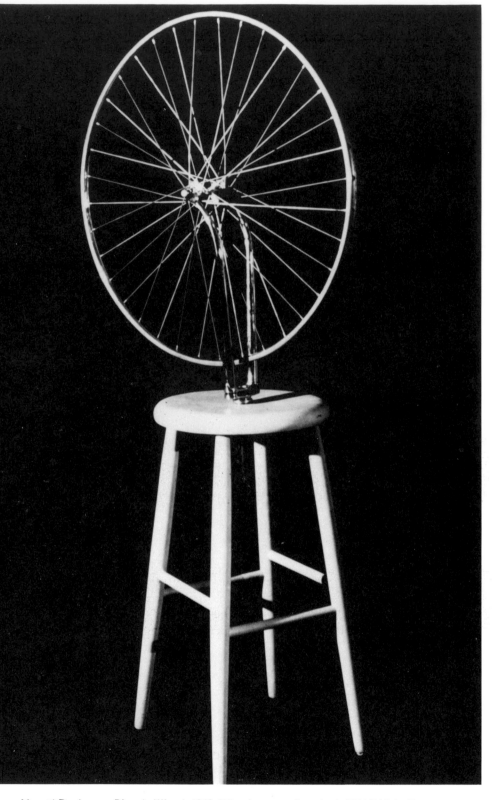

protestations. At base, Suprematist doctrine came to advocate the depiction of an ordered, ideal world, available through subjective contemplation. "To the Suprematist," Malevich wrote, "the visual phenomena of the objective world are, in themselves, meaningless; the significant thing is feeling." Although he declared an affection for "the new life of iron and the machine"—and despite his active support for the Russian revolution—Malevich remained in his work an exemplar of purist esthetics. In the search for a higher reality, his paintings grew simpler and simpler. When he finally reached the austere perfection of *White on White*, exhibited in Moscow in 1918, the Constructivist Rodchenko countered with *Black on Black*. In the end, Malevich stood in ironic opposition to Boccioni, aligning himself with the view that art is largely prompted by inner sources, not the outside world.

Dada's position on "the new life" was equally convoluted. On the one hand, the hardcore Dadaists, such as Tristan Tzara and Richard Hülsenbeck, who launched the movement in 1916 at the Café Voltaire in Zurich, were strongly opposed to the industrial age, with its emphasis on war and violence. Many

Marcel Duchamp. *The Bride Stripped Bare by Her Bachelors, Even (The Large Glass),* 1915–23. Oil, lead, lead wire, foil, dust, and varnish on glass. 9'3" x 5' . Replica based on original built in 1961 by Duchamp and Ulf Linde. Courtesy Philadelphia Museum of Art.

Marcel Duchamp. *Bicycle Wheel,* 1913. Wheel on wooden stool, 53⅛" high. Reconstructed 1960 by Per Olof Ultvedt and Ulf Linde for Moderna Museet, Stockholm. Courtesy Moderna Museet, Stockholm.

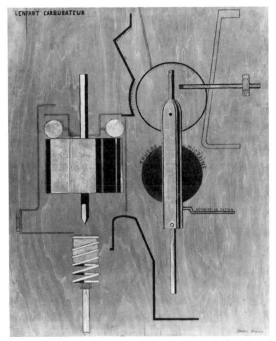

Francis Picabia. *Child Carburetor*, c. 1919. Mixed media on wood. 49¾" x 39⅞". Courtesy Solomon R. Guggenheim Museum, New York.

other Dadaists and proto-Dadaists found the machine an attractive anti-art ally. The machine was the antithesis of the romantic tradition, that reverence for the touch of the gifted, individualistic hand revered by William Morris. Marcel Duchamp, Francis Picabia, Max Ernst, and Man Ray all flirted with the machine as subject matter. Duchamp had been influenced as a painter first by Cézanne and then by Cubism; his *Nude Descending a Staircase* (1911) split the human figure into moving, fragmented parts almost as violently as the Futurists wished. But Duchamp quickly grew bored with the new esthetic. In 1913, prior to the advent of Dada, he exhibited machine-made products purchased in the shops as "readymade" works of art, beginning with a bottle-carrier and bicycle wheel, and ending, several years later, with a steel comb, a typewriter cover, and a urinal.[7]

Duchamp flitted in and out of the Dada movement during its golden years (roughly, 1918–22), with all its meetings, macabre "manifestations," parades, and manifestos, but he contributed most through his ideas and his work. In 1912, he made drawings that later evolved into a large "painting," *The Bride Stripped Bare by Her Bachelors, Even*, which used complex ironic imagery to describe human sexuality.[8] In 1915, he began

the work, which continued intermittently for eight years, never reaching completion. During the same period, Picabia initiated an extensive series of "machine" paintings on the same theme, beginning with *Voilà la Femme*. Max Ernst made a collage of pasted papers entitled *Demonstration Hydrométrique à Tuer par la Temperature* in which cylinders, funnels, pipes, and other mechanical parts were linked illogically and mysteriously together. These ironic machines anticipated the useless, comic constructions drawn later by the American cartoonist Rube Goldberg, and they share a similar irony of purpose. In 1922, Man Ray subverted photography, too, along with art, by discovering and exploiting the "rayograph." He laid objects (often bits of machinery) on photosensitive paper and exposed them to the sun; the objects blocked out the light while the adjoining areas were slowly darkened, thus creating subtly delineated silhouettes.[9]

There were many strains to the Dada culture. In Hannover, Germany, the lonely Kurt Schwitters, a sometime Dada figure with ties to most of the groups and movements of the day, constructed collages out of street refuse, though his compositional sense was purist and geometrical. He also drew plans for a "total theater," a stage using solid, liquid, and gaseous surfaces that expanded and contracted around the audience. Primarily, he evidenced a familiar distaste for the egocentric tradition in art. He called his work *Merz* to avoid the term "art" and installed major portions of it in his home; they grew into one composition, the *Merzbau*. He preferred cast-off junk in collage because it lacked what he called "personality poison." This distaste for the ego is near the heart of both Dada and Surrealism. Tristan Tzara, Jean Arp, and others experimented with chance methods in compositions; André Breton declared that Surrealists believed in the supremacy of "undirected thoughts."

Berlin Dada is a special, even more significant case. There the movement had a more serious cast than in Dada centers like Zurich, Cologne, or Paris (where Duchamp, Picabia, Ernst, and Man Ray tended to operate). In Germany, the defeat in war, widespread poverty, and slow disintegration of the imperial government turned artists like Raoul Hausmann, George Grosz, John Heartfield, and others into neo-revolutionaries: "Dada is political," read a sign carried in a typically antic rally. The photomontage—a collage of pictures taken from the daily press—flour-

Kurt Schwitters. *Merzzeichnung*, 1921. Merz-drawing. Collage. 7⅞" x 5⅞". Courtesy The Museum of Modern Art, New York. Bequest of Katherine S. Dreier.

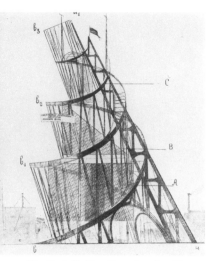

Vladimir Tatlin. Drawing for *Monument for the Third International*, 1920. Reproduced in Nikolai Punin's pamphlet on the tower. Courtesy Moderna Museet, Stockholm.

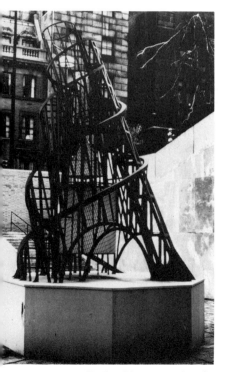

Vladimir Tatlin. *Monument for the Third International*, 1920. Wood and metal with motor, a model reconstructed in 1967–68. 15'5" h. The original model was destroyed and rebuilt for the Moderna Museet, Stockholm, by Arne Holm, Ulf Linde, Eskil Nandorf, Per Olof Ultvedt, and Henrik Ostberg. Courtesy Moderna Museet, Stockholm.

ished in Berlin, because it vividly communicated a sense of impending social crisis. In 1920, both Grosz and Heartfield demonstrated at the First International Dada Fair in behalf of the Russian artist-architect Vladimir Tatlin, who had constructed a model for a streamlined building dedicated to the Bolshevik revolution, the *Monument to the Third International*. "Art is dead," Grosz and Heartfield proclaimed with their placard. "Long live Tatlin's new machine art." Georges Hugnet, an early Dada historian, cautions us against interpreting this act as a conscious attempt to associate Berlin Dada with either Futurist or Russian Constructivist theories.[10] For Grosz and Heartfield, Tatlin's work was in part an anti-art banner to wave before the masses, as Hugnet says.

The incident nonetheless provides proof of a link—however subtle—between Dada's wry endorsement of the machine and the direct commitment evidenced elsewhere, at the Bauhaus, among the De Stijl group in Holland, and the Constructivists, who matured amid the violent drama of the Russian Revolution. Tatlin, one of their early leaders, was a dedicated revolutionary, determined to use art to remake the social and political order. He based his esthetic in new industrial materials, new techniques, and a fidelity in form to both. His development was quickened after a trip to Paris in 1913, when he caught the scent of radical artistic change through Picasso and Cubism, but Tatlin is by no means a product of Western art alone. The movement now known as Constructivism is an extraordinarily rich and complex phenomenon with roots in both Russian primitivism and its own native brand of futurism. Before Tatlin went to Paris, painters and poets like David Burliuk, Natalia Goncharova, Khlebnikov, Alexandra Exter, Mikhail Larionov, Liubov Popova, and others attacked the traditional artistic and literary order with an alogical vitality bordering on Dada (in one case they painted their faces and set to the streets to *epater la bourgéoisie*).[11] Larionov and others devised a *Rayonist and Futurist Manifesto* in 1913. Rayonist painting, of which Larionov was the principal prophet, based itself on the "intersection of reflected rays"; Larionov announced that it proceeded from a study of radioactivity.

But it is with the work of Tatlin and Gabo, and the 1917 revolution, that we properly date the triumph of Constructivist ideas. After the revolution the leftist avant-garde found itself appointed to places of power within the cultural and educational hierarchy. Suddenly

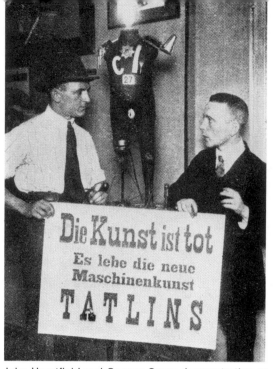

John Heartfield and George Grosz demonstrating at the International Dada Fair, Berlin, 1920. Courtesy Richard Hulsenbeck.

art and life came together. Tatlin, who had concentrated on radically extended wall reliefs, began to think in larger terms. He had function, form, and politics in mind when he designed his *Monument* in 1920, though it was never built by the new Russian Government. He wanted the structure to *function* as well as to honor the Bolshevik revolution. He designed rotating glass-walled chambers to house administrative offices and public buildings. He was determined to match form and material, though he was forced to construct his fifteen-foot model in wood rather than in the iron, glass, and concrete envisaged for the final structure (which would have stood higher than the Eiffel Tower). Tatlin wrote in 1920 that his experiments, along with those of his Russian colleagues, were "models which stimulate us to inventions in our work of creating a new world, and which call upon the producer to exercise control over the forms encountered in our new everyday life."

The model was saturated with esthetic as well as political implications. Its twisting, hard-edged shape had roots in Cubism and Russian Futurism, its resolute abstraction in Malevich. Tatlin's determination to combine art, architecture, and engineering in one person, himself, is related to the synthesis of old specialties everywhere in the wind. Basically, though, the *Monument* was a political act; the

renewal of Western interest in it during the late 1960's—a time of youth-led political unrest—is obviously significant. Large exhibitions devoted to Tatlin were staged in Sweden and Germany; the model for the *Monument*—long since destroyed—was reconstructed and displayed in Stockholm, London, and New York; in the United States, the sculptor Dan Flavin dedicated a series of works in fluorescent tubing to Tatlin.

Tatlin first referred to himself as a "Materialist Constructivist," though his group used the term "Productivists" in 1920. There were many creative talents working in Moscow in related ways, however, and all since have been subsumed under the broad label of Constructivism. Among them were Alexander Rodchenko, El Lissitsky, Naum Gabo, and Antoine Pevsner (all painters and sculptors in origin), the playwright-poet Mayakovsky, the filmmaker Vertov, the theatrical director Meyerhold, and architects like Leonidov, Vesnin and Melnikov. Rodchenko made drawings with a compass and ruler as early as 1914, defying traditional methods. He befriended

Alexander Rodchenko. *Composition,* 1919. Woodcut. 6½" x 4½". Courtesy Leonard Hutton Galleries, New York.

Tatlin one year later; while his friend was designing reliefs and architectural forms, Rodchenko assembled suspended metal *Constructions in Space* with a conspicuously fabricated appearance, inspired by the anti-esthetic tone of Tatlin's work. Ideologically, he was the antithesis of Malevich, whose Suprematist doctrines remained popular in Moscow despite their opposition to art as function. When Malevich painted *White on White*, as I mentioned before, Rodchenko answered with black circular and elliptical forms painted on a black background. In 1922, he discarded painting (an "anachronistic" activity) and occupied himself thereafter with photography, furniture, and graphics.

Other Constructivists turned to propaganda in the highest sense—posters, placards, signs, monuments, and street spectacles designed to inform and inspire. "Agit-trains" emblazoned with revolutionary art moved through the countryside, extending Léger's theory. "Let us make the street our brushes," said Mayakovsky, "the squares our palette." Vertov literally invented the swiftly moving montage newsreel—*Kino-Pravda*—to fulfill the same function. In his own manifesto, *We,* issued in 1922, Vertov saluted "dynamic geometry" and promised to make peace between man and the machine.

Lissitsky, first influenced by Matisse, the new architecture, and Malevich, turned in time to a more open, functional view of art. He designed what he called *Proun Rooms,*[17] visually integrated wall-floor-ceiling units, many for exhibitions of the new art; like countless others, he planned a complete technological theater, what he called—with typical irony—an "electromechanical peep show"; like the Bauhaus artists, he experimented with product design and especially with typography, designing books and posters notable for their bold color and sans-serif lettering. The typography was politically motivated. Like Tatlin and Vertov, he wanted most of all to turn the techniques of vanguard art into revolutionary weapons. He wanted his books and posters to speak and command, for the widest possible audience. Lissitsky and his colleagues raised Agit-prop to the highest level of art. In the end, however, their cause did not prevail. In the end, realism triumphed in Soviet painting and romantic orthodoxy in Soviet architecture, as Stalin rose to power in the 1920's. Constructivism could flourish only in a climate warmed by political sympathy. Its goals demanded immediate and practical

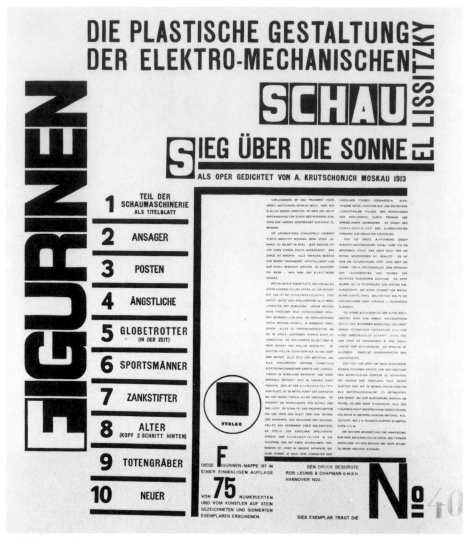

El Lissitsky. *Victory Over the Sun,* 1920–21. Frontispiece for a series of lithographs. 21″ x 17½″. Based on the Futurist opera by Kruchenykh and Matyushin premiered in St. Petersburg in 1913, with sets designed by Malevich. Courtesy Leonard Hutton Galleries, New York.

mations, too (the most important being the *Program of the Productivist Group,* written in 1920 largely by Tatlin himself). Moreover, Tatlin remained in the Soviet Union for the balance of his life; Gabo soon left for Europe and eventually the United States, escaping—finally—the heavy esthetic hand imposed by Stalin. Alexei Gans's statement, "Constructivism," published in 1922, is another signal document; like Tatlin's, it is explicitly political as well as artistic in its motives ("Masters of intellectual-material production in the field of artistic work," Gans declared, "will collectively stand in the road of communist enlightenment"). Malevich and his Suprematist allies were equally verbose and prolific, pursuing another decidedly less functional theme.

But Gabo's manifesto, which cuts ideologically between the two, gained greater currency outside of Russia, where it became in time an iconographical primer for the entire movement. Gabo is neither as insistent in his devotion to social goals as Tatlin and Gans nor as removed from them as Malevich. Like the Futurists, Gabo aligns himself with the new age, but on a more sophisticated level. He calls not for an uncritical celebration of the new technology in paint—a medium firmly anchored in the past; his call is to new methods, new materials, and a new conception of the artist's role. He encourages his colleagues to create in the manner of the engineer ("We construct our work," the manifesto begins, "as the engineer constructs his bridges"), to use all materials without prejudice, and finally, to resist introversion.

realization, beyond the gallery and the museum.

But Gabo had meanwhile articulated for succeeding generations in the West the esthetic that evolved from this heady mix of revolution, new media, and experimentation (he also created the first fully kinetic work of sculpture, as we shall see). In the same year that saw the appearance of the model for the *Monument,* Gabo issued what he called the *Realist Manifesto,* cosigned by his elder brother, Antoine Pevsner, also a sculptor. It was not the only esthetic manifesto posted and distributed in Moscow during those halcyon days, or even the most influential in its time. Tatlin and his allies issued procla-

El Lissitsky. *Proun Room,* 1923. 12′ square. Reconstructed in 1971. Courtesy Stedelijk van Abbe-Museum, Eindhoven, Holland.

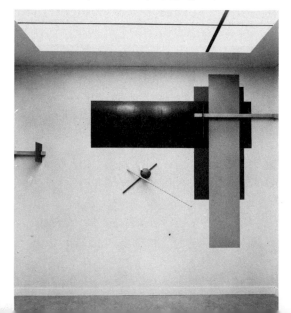

Gabo did not call himself a "Constructivist." Later, he wrote, "The word 'realism' was used by all of us because we were convinced that what we were doing represented a new reality." He nonetheless employed the term *postroyenia* ("construction," in Russian); like the Productivists, furthermore, he saturated his statement with phrases borrowed from engineering and industry. Tatlin had also spoken of "construction" ("Construction is organization. . . . Construction is formulating activity taken to the extreme"). In time, all of the Russian vanguard—and all the conflicting isms, from Cubo-Futurism to Suprematism—were merged into one oversimplified ideology, by commentators then and now. This is an abortion of history, of course, desperately in need of correction, but solid links do exist between many of the component sectors of the Constructivist "school." On the key issue of form, for example, Gabo is at one with Tatlin and the heart of the Russian vanguard, dating back to the alogical poems of Khlebnikov, which freed words to stand for themselves. Instead of the depiction of speed by the Futurists, or of light by the Rayonists, let us have the "forms of space and time themselves," says Gabo. The material, in brief, should be left to speak for itself:

> The realization of our perceptions of the world in the forms of space and time is the only aim of our pictorial art and plastic art. . . .
> The plumb-line in our hand, eyes as precise as a ruler, in a spirit as taut as a compass . . . we construct our work as the universe constructs his own, as the engineer constructs his bridges, as the mathematician his formula. . . .
> We know that everything has its own essential image; chair, table, lamp, telephone, book, house, man . . . they are all entire worlds with their own rhythm, their own orbits.[13]

As for Tatlin, he never varied from this ground. His program, he wrote in 1920, "accepts the contents of the matter itself, already formulated." More than a decade later, he specifically inveighed against imposing past forms on new materials; rather, the artist must present, he said, "a succession of new relationships." Stalin, alas, did not agree. Gabo continued to work unimpeded in the West, ultimately taking paths unmentioned in his manifesto; at home the official decree of 1932, chastising the more adventurous Russian artist for "alienation," brought the brief romance between art and power to an end. Mayakovsky, one of the boldest and most optimistic of the early Constructivists, committed suicide. Others survived, although quietly. There is much yet to learn about the fate of the Russian avant-garde after 1932.[14]

In retrospect, then, the 1920's represented an especially active decade, and not only in the Soviet Union. By 1920, the year when both Tatlin and Gabo issued their calls to arms, the Bauhaus was open and functioning in Germany. In its determination to put art at

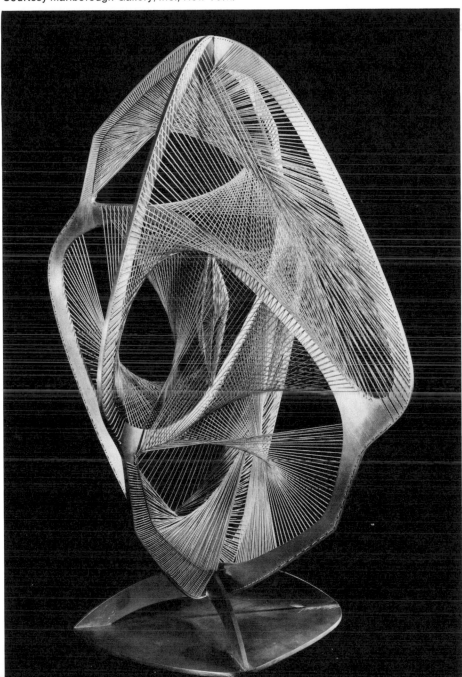

Naum Gabo. *Model for Linear Construction No. 4,* 1959–61. Bronze, 20½" x 10½" x 10½". Courtesy Marlborough Gallery, Inc., New York.

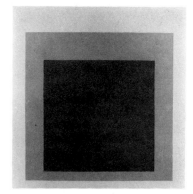

László Moholy-Nagy. *Mechanical Eccentric for a Rotating Cylindrical Space for Gymnastics and Display,* 1922. Drawing. One of Moholy's several plans for *Das Totaltheater,* part of which would perform by itself, through mechanical instruments. Courtesy Sibyl Moholy-Nagy.

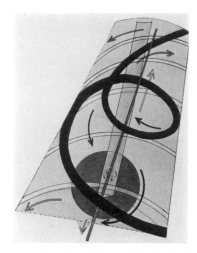

Josef Albers. *Deep Signal,* 1967. Oil on board. 48″ x 48″. Private collection. Courtesy Sidney Janis Gallery, New York.

Piet Mondrian. *Composition with Red, Blue, and Yellow,* 1921. Oil on canvas. 34¾″ x 28½″. Courtesy The Pace Gallery, New York. Photo by Ferdinand Boesch.

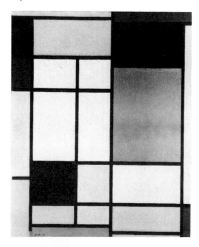

the service of society, the Bauhaus is allied with Constructivists like Tatlin and Lissitsky, although the two groups served widely different social systems. Gropius's early work as an architect was directed mainly at finding ways to mass produce habitable, humane, and esthetically pleasing homes for the middle and lower classes; he was the first architect fully to examine the possibilities of prefabricated housing. Like Tatlin, he tried to find forms based in the properties of the new materials and the dry assembly of parts themselves—mainly clean, rectilinear structures with glass walls that admitted streams of natural light, together with sweeping interiors. These forms were possible, he argued, because synthetic materials like steel permitted wide-spanned roofs with streamlined supports. He was equally interested in designing quality furniture and related objects that could be mass produced and cheaply sold. In this venture, he needed the artist. The Bauhaus's first proclamation, reminiscent of Morris, included this call: "Architects, sculptors, painters, we must all turn to the crafts."

In method, as Gropius later said, the Bauhaus was really a series of laboratory workshops aimed at "working out practical new designs for present-day articles and improving models for mass production."[15] It was the quality of the school's faculty, its wide-ranging interests, and the way in which it transcended the old generic, professional, and esthetic boundaries that transformed art education: painters designed furniture, sculptors worked in theater, and architects turned to crafts. "We are a guild of craftsmen," Gropius announced, "without class distinction." In fact, there was inevitable dissension within the faculty, between young and old, between the fine and applied arts, between the "German" influence, represented by Kandinsky, the apotheosis of subjective Expressionism, and the "Constructivist" (or "Russian"), represented by the Hungarian László Moholy-Nagy, who came to the faculty in 1923. The latter was convinced, as was Gropius, that the future belonged to rational, well-ordered design.

Furthermore, the school's impact upon its personnel was frequently demotic. Oskar Schlemmer came to Weimar a sculptor but turned to ballet and theater design. Moholy-Nagy—like Schwitters and Lissitsky—planned a *Mechanical Eccentric* stage, programmed to produce light and sound displays on its own. Gropius himself devised working plans in 1927 for a "total" theater, conceived by Erwin Piscator, but never built.

Despite this heterogeneity, the Bauhaus masters did in concert impress upon the entire architectural and design community in the Western world the need for economy in form, an economy best suited for mass production. The Bauhaus was not alone; French designers like André Lurçat and architects like Le Corbusier preceded them. By virtue of its public impact, though, the Bauhaus must be accorded the main influence upon both the International Style in architecture and the purist fringe of Art Deco. The school moved to new buildings in Dessau in 1925 but was abruptly closed in 1933 by the Nazis; its members quickly found teaching posts around the world, however, particularly in the United States, and continued to spread the Bauhaus gospel. Gropius went to Harvard, with architects Marcel Breuer and Hannes Meyer; the painter Josef Albers taught at Black Mountain College and later went to Yale. Moholy-Nagy assumed the greatest adventure of all, in Chicago, where he was invited to open a "new Bauhaus," the Institute of Design, a school he later made his own.

During its brief lifetime, the Bauhaus was affected by many outside ideas in addition to Expressionism and Constructivism. One major source was a loose association of Dutch painters and architects based upon a magazine called *De Stijl,* launched in Leyden. Holland, in 1917 by the dynamic Theo van Doesburg, a painter, writer, and architect. *De Stijl* ("the style," in Dutch) believed that a new, clean world of form was preparing to replace the old, tarnished one. In *Manifesto I,* published in 1918 and signed by van Doesburg, painters Vilmos Huszar and Piet Mondrian, architect Robert van't Hoff, and sculptor Georges Vantongerloo, among others, they announced a familiar theme: "The war is destroying the old world with its content: individual predominance in every field. . . . The new consciousness of the age is prepared to realize itself in everything, including external life."[16]

The group's principal figure was Mondrian, who insisted on a flat, neutral quality in painting, closer to the hidden structure in nature than to its representational appearance (an attitude he shared with Malevich). At his zenith, Mondrian used nothing but primary colors divided by vertical and horizontal lines. And he championed the rhythms inherent in modern life: "The metropolis . . . produced

Abstract Art: the establishment of the splendor of dynamic movement."[17]

The decades between 1910 and 1930 were characterized, then, by a flood of new movements, groups, and schools, most taking a firm stand on the key issue of the new century: whether art should ignore, oppose, or exploit the technology implicit in rising industrialism. There are many points of difference between these groups, between the Futurists and Constructivists, between the flat, well-ordered abstraction practiced by Mondrian and the equally geometric but complex collages of Schwitters, between the adherents of Tatlin and of Gabo, between even Gropius and Moholy-Nagy, within the broad complex of the Bauhaus itself. At the center, though, these points along the matrix join: by and large, the vanguard movement in Europe during these years supported the use of contemporary forms, materials, and ideas in art, no matter how threatening. They conducted a victorious paper war with manifestos as weapons. When finished, they had provided a theoretical platform for the public and for succeeding generations of artists, a platform that justified a series of radical mixtures—between tool and machine, art and craft, art and the contemporary world, and ultimately, the artist and the engineer.

The New Esthetic in Action:
Between the Wars

The emphasis in this discussion of the various isms behind the new esthetic platform has been upon theory and manifesto. It should be kept in mind, however, that the reality was not so tidy. In the first place, there were seminal artists like Kandinsky, Malevich, and Breton who did not share this belief in the art-machine symbiosis. Second, the evidence of the works themselves had as great an influence upon the new sensibility as the manifestos. It is to those works that I propose to turn and, particularly, to the cumulative directions in which they moved. Some of the works have already been mentioned: the appearance of the machine, for example, in the relatively representational paintings of Picabia and Ernst, prime exemplars of Dada and Surrealism, respectively. The same subject surfaced in other painters, not so closely identified with like-minded groupings, among them Joseph Stella, Robert Delaunay, Paul Klee, Alberto Giacometti, Lyonel Feininger, and Fernand Léger.

While Duchamp was desultorily engaged in

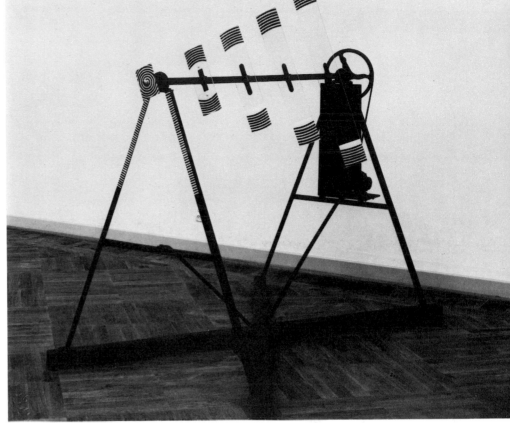

Marcel Duchamp. *Rotary Glass Plate (Precision Optics)*, 1920. Motorized construction in painted plexiglass and metal. 4'9" x 3'10" x 6'4". Replica built in 1961 by Per Olof Ultvedt, Magnus Wibom, and K. G. P. Hulten. When the blades are set in motion, the spectator sees one continuous circle, or the illusion that a three-dimensional object is two-dimensional. Courtesy Moderna Museet, Stockholm.

working upon his "mechanical" *Bride*, he experimented with movement of various kinds. While in the United States in 1920, he made a machine that he called *Rotary Glass Plate (Precision Optics)*, consisting of narrow, motorized panels revolving around each other: when viewed from the front, the panels appeared as one spiral, creating the illusion of flatness. He also tried to make a three-dimensional movie in the same year but failed to raise sufficient funds. He did manage several strips of stereoscope film, though, which projected the same spiraling illusion attained in the *Glass Plate*. Five years later, with the air of a mechanic, he produced his most complex "optic," the *Rotary Demisphere*. Duchamp painted a series of circles upon the face of a black demisphere; set in motion by the motor, the convex face of the sphere appears to be concave—yet another ironic denial of reality.

Duchamp was interested in both real and illusory movement, as were many other artists, including painters, composers, and sculptors. Duchamp's 1913 *Bicycle Wheel* could be spun

Marcel Duchamp. *Rotary Demisphere (Precision Optics)*, 1925. Motorized construction in metal, painted wood, velvet, and glass. 59" x 28" x 20". When the demisphere spins, it makes the convex surface appear concave. Courtesy The Museum of Modern Art, New York. Abby Aldrich Rockefeller Fund, Gift of Mrs. William Sisler.

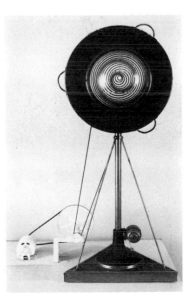

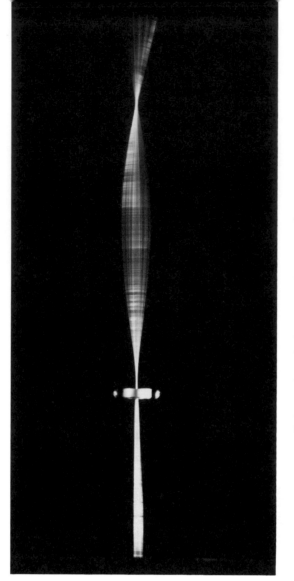

Naum Gabo. *Kinetic Sculpture : Standing Wave,* 1920. Metal rod vibrating by means of a motor. 23" high.

Naum Gabo. *Drawing for a Kinetic Construction,* 1922. Ink on paper. 12" x 14".

ments of Vladimir Baranoff-Rossiné, a Russian artist who developed what he called the *Piano Opto-Phonic* in 1914. He painted images on a glass disc and projected them onto a screen by means of a motor "played" by an electric piano. In 1922, he presented a visual concert at the Meyerhold Theater in Moscow with his wife. There, two electric pianos were employed with the painted disc, a kaleidoscope, and a second disc, which changed the predominant color hues. The effect on the eye was of layered, constantly changing imagery.[19]

It remained for Naum Gabo to create the first fully kinetic work of art, which he called *Kinetic Sculpture: Standing Wave.* Living in war-torn Moscow, he found materials scarce and finally built the work with a used electromagnet (taken from an old factory bell), a steel rod, and a pair of springs; the rod vibrated rapidly within a small circle anchored firmly to its base. It took Gabo almost nine months to complete the *Kinetic Sculpture.* When it was reconstructed forty-eight years later by engineer Witt Wittnebert, Gabo wrote a brief memoir, emphasizing the didactic motive of the work:

> The standing waves had attracted my attention since my student days, in particular the fact that when you look at a standing wave, the image becomes three-dimensional. In order to show what I meant by calling for the introduction of kinetic rhythms into a constructed sculpture, I chose that standing wave as a good illustration of the idea—so I decided to construct a standing wave which would be vibrating on one fixed point and rigid enough to be indeed a *"standing wave."*[20]

But Alexander Calder established kinetics as a medium upon which a complete esthetic could be based. The definitive year in this respect was 1932, when Calder's work was exhibited in two totally motorized exhibitions—at the Galerie Vignon in Paris and the Julien Levy Galleries in New York City—launching a body of kinetic work that extended into the 1970's. Duchamp apparently applied the term "mobile," which he and others had used before, to these early pieces by Calder; thereafter the work and the term were inseparable. The slowly moving parts in Calder's work were powered, as in *The Motorized Mobile that Duchamp Liked,* by tiny electric motors. Even then, Calder's ultimate direction—toward free-hanging, nonmotorized works responsive to "natural" and accidental forces, such as wind currents—

manually by the hand. At the same time Futurists like Giacomo Balla and Fortunato Depero experimented with moving constructions, some of them involving light. In 1918, the New Zealand-born sculptor Len Lye constructed a crude kinetic "machine," combining a wooden box with a system of handles, rollers, and pulleys.[18] In a widely publicized concert in New York in 1915, the Russian composer Alexander Scriabin accompanied a performance of his *Prometheus, Poem of Fire* with a rudimentary (and unimpressive) "light keyboard" positioned onstage, responding to the course of the music with changing nuances of illuminated and motorized color. Less publicized in the West were the experi-

was implicit. Although he was a mechanical engineer by training, Calder from the first evinced an interest in free-swinging play that motors only partly satisfied: they did not permit the freedom from system that Calder wanted to instill in the components of each of his sculptures. Two decades later, it was Jean Tinguely who discovered how mechanization might endow sculpture with random irrationality.

Kinetic art, in brief, was well established between 1915 and the advent of World War II. The impact of what Malevich called "the new life" was equally evident in areas beyond painting and sculpture. Breuer, Mies van der Rohe, and van Doesburg accelerated the direction in architecture toward functionalism begun by Corbusier and Gropius. The same sensibility was evident in certain areas of interior and applied design—Lissitsky's self-contained *Proun Rooms*, a visual unity from top to bottom; Buckminster Fuller's totally self-sustaining, prefabricated Dymaxion rooms; the sleek automobiles designed by both Fuller and the Italian Ettore

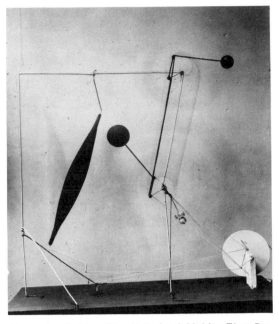

Alexander Calder. *The Motorized Mobile That Duchamp Liked,* 1932. Reassembled by the artist in wood, wire cord, and metal in 1968 from the original. 42" h.

Ettore Bugatti. *Bugatti Type 41—La Royale,* 1931. 20' l., wheel base 14'2". Courtesy Henry Ford Museum, Dearborn, Mich. Gift of Charles A. Chayne.

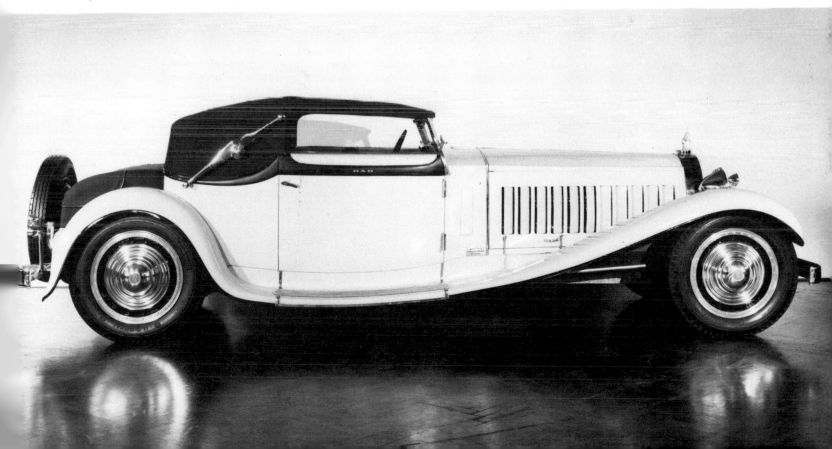

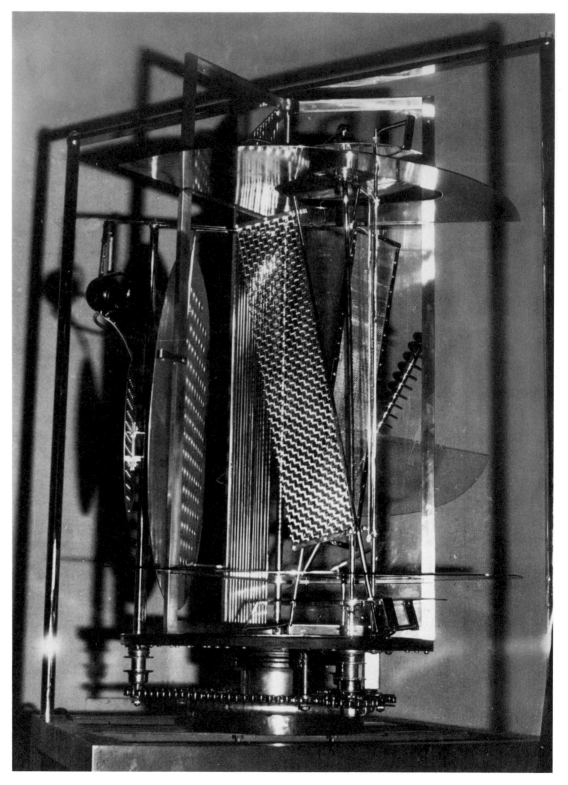

László Moholy-Nagy. *Lichtrequisit einer elektrischen Buhne (Light Prop for an Electric Stage),* 1930. This historic work came to be known as the *Light-Space Modulator.* The light prop revolved slowly, while 70 15-watt bulbs flashed at and through the sculpture in a 2½-minute cycle. The work was reconstructed in 1970 by MIT engineer Woodie Flowers, working in collaboration with critic Nan Piene and the artist's widow, Sibyl Moholy-Nagy. Two replicas were made, one exhibited at the Venice Biennale in the summer of 1970, the other at the Howard Wise Gallery in New York in the fall. The original, shown here, is in the collection of the Busch-Reisinger Museum, Harvard University, Cambridge, Mass. Courtesy Sibyl Moholy-Nagy. Photo by Galerie Klihm, Munich.

Bugatti. Among the many artists experimenting with film as a medium was Moholy-Nagy, who used his first kinetic-light construction as subject matter in 1931.

Luigi Russolo proclaimed "The Art of Noise" in a 1913 manifesto, celebrating the machine as a source for music, and gave concerts on his "Noise Organ." Edgard Varèse paved the way for "Concrete Music" by advocating "real" sounds in composition. More important, there was a great amount of work done during the 1920's and 1930's that anticipated later interest in multimedia techniques, for use both in the theater and in outdoor spectacles, such as Nicolas Schöffer's *Lumino-dynamics* and Otto Piene's sky events. Picabia designed the set of the ballet *Relâche* around 370 spotlights with metal reflectors directed toward the audience. Nazi architect Alfred Speer brought some of these dreams to ironic fruition when he surrounded a party rally at Nuremberg Stadium in 1934 with 130 anti-aircraft searchlights, creating a dazzling ceiling of light 25,000 feet up in the sky. He spoke of it later as "luminescent architecture."[21]

Moholy-Nagy's interest in light was the most sustained of his time. In a manifesto jointly authored in 1922 with Alfred Kemeny (*On the Dynamic-Constructive System of Force*), he predicted that light would bring forth an entirely new kind of art. Alone among the major artists of the 1920's and 1930's, he worked with both light and movement. His importance cannot be underestimated, particularly in view of his later move to Chicago, where he became a link between avant-garde Constructivism and the Americans. He began to dream about what he later called a *Light Prop* (*Lichtrequisit*) in 1922, which was built in 1930 in Berlin.[22] Moholy, never an adept hand at machines, was aided by Istvan Sebök, an architect employed by Gropius's firm, and a skilled craftsman named Otto Ball. This early collaboration was further aided by the large German firm A.E.G. (Allgemeine Elektrizitäts-Gesellschaft), which built a light-timing device for Moholy. A clean complex of rectangles and curves, the *Prop*—now known as the *Light-Space Modulator*—rotated slowly, humming and clicking as it moved. Ringed around it were colored lights wired to a timer; the lights were programmed to flash in a 2.5-minute cycle. The sculpture's shiny, reflective surface bounced light reflections back at the viewer; it cast three constantly changing shadows on the surrounding walls, two diffuse, the third sharp in definition. Despite the importance of this piece—among the first works of sculpture to use electric light and certainly the most successful—it was primarily intended as a prop for the film *Light Play: Black, White, Gray*. Moholy borrowed a battery of lights from A.E.G. and made the film in Berlin in 1931, one of at least six that he completed during his lifetime.

The evidence of these works, all executed between 1913 and the mid-1930's, indicates that art was beginning to involve itself with light, motion, noise, film, total design, architecture, and theater, in fact as well as theory. If Calder was the first thorough-going kinetic artist, Moholy-Nagy was the first artist to embrace the new technology in a multidimensional way, in film, photography, theater and kinetic-light construction. It is fitting that our focus upon Europe, both its ideas and its art, concludes with him. When the right-wing political tide rolled across Europe—and the inevitability of large-scale conflict seemed apparent—many artists fled to more congenial surroundings, either in England or the United States. The war that did indeed come suspended formal artistic invention in Europe for almost a decade. England, France, Germany, Italy, and the rest of Western Europe recovered their vitality in time, but art in Russia, the seedbed of Constructivism, lay dormant long after, suppressed by the heavy weight of "official" Soviet realism. Moholy's decision to go to Chicago is the most fitting demarcation point, however. He left Europe at the height of his powers; his impact as a teacher in the United States proved to be significant. Moholy's appearance in Chicago thus marks the beginning of a long, fitful, and inexorable rise in American artistic energy, much of it expressed through media generated by the new technology.

The United States, 1937-65:
Process in Triumph

From Moholy to Cage:
The Beginnings in America

The telegram that brought Moholy-Nagy to the United States, sent by the Association of Arts and Industries in Chicago in 1937, read:

> Plan design school on Bauhaus lines to open in fall. Marshall Field offers family mansion Prairie Avenue. Stables to be converted into workshops. Dr. Gropius suggests your name as director. Are you interested?

Moholy responded in the affirmative and opened the "New Bauhaus," as it came to be informally called, in the fall of that year. He was quickly disillusioned, both by the limited funds on hand and by the retrograde state of American art in general. The school closed after one year. Moholy—inventive and energetic as ever—raised funds for his own school, the Institute of Design, which he directed until his death in 1946. He proved to be a major influence on his faculty and his students, in both the fine and applied arts.

In addition, he imported his countryman Gyorgy Kepes to teach at the Institute. Kepes based his first book, *The Language of Vision* (1945), on his teaching experiences at the Institute. An analysis of visual communication, it brought him to the attention of Dean William Wurster at the Massachusetts Institute of Technology, where Kepes began teaching in 1946, extending the reach of Moholy's ideas to scientists, architects, and planners.

There were other European influences at work. Gropius and Breuer went to Harvard in the late 1930's to teach in the Department of Architecture, part of the Graduate School of Design. Mies went to the Illinois Institute of Technology, also to teach. Albers contacted young American artists at Black Mountain College in North Carolina, at Harvard, and at Yale. As World War II intensified, other European artists settled in New York City, contributing to the rich intellectual environment within which American art began to prosper following the end of the war.

Not all of these influences were Constructivist-De Stijl-Bauhaus in nature. Technology itself became a determining influence over the long run, as important as the complex of imported European ideas. American artists have rarely shown themselves susceptible to esthetic program or ideology. The advent of Moholy and all he represented is only part of the story that must be told about the growth of the fusion of art, technology, and science in the United States. World War II also spurred the developments of magnetic tape, the computer, and the cathode-ray tube, especially significant in the American context.

The condition of American art in the 1930's was resolutely retrograde in any case. What passed for the American vanguard—painters like Stuart Davis and Edward Hopper—were largely descendants of the School of Paris. With the exception of Calder, Feininger, and Man Ray, who made their homes primarily in Europe, few American artists were involved before World War II with the materials and methods recommended by Naum Gabo.

Thomas Wilfred is a striking exception, but he, too, began in Europe, studying in London, Paris, and his native Copenhagen between 1905 and 1911. He had made his first "light box" in 1905, using a cigar box, a small incandescent lamp, and a few pieces of colored glass. In Paris before World War I, he predicted the onset of "an eighth art in which the artist's sole means of expression is light." By 1919, he had completed a full-scale *Clavilux*, complete with keyboard, which he played in public performance three years later, creating spontaneous, totally silent color images on a large white screen. He called this new art form "Lumia" and extended it for decades thereafter, creating works that in essence composed themselves. In 1930, Wilfred founded the Art Institute of Light in West Nyack, New York, and in 1943 he sold the first of several giant *Lumia* constructions to the Museum of Modern Art, where they "played" for years thereafter.

The post–World War II flowering in the United States was not originally oriented toward the machine or anything remotely related to it. For a while, the war put an end to the appeal of "the new life." Europe lay exhausted and in ruins. The United States, while physically well off, was disenchanted, too: many of its artists and intellectuals were shocked and repulsed by the destructive po-

Mies van der Rohe. United States Court House and Federal Office Building, Chicago, 1964. Photo by Hedrich Blessing.

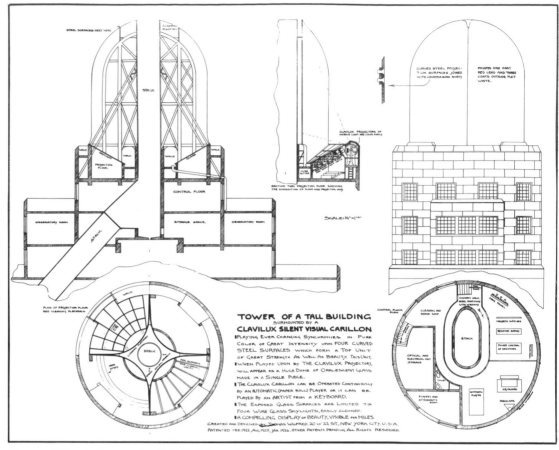

Thomas Wilfred. *Tower of a Tall Building—Surmounted by a Silent Visual Carillon,* 1928. Pencil and ink on linen-backed paper. 32⅞″ x 40⅞″. Collection Earl Reiback, New York.

Thomas Wilfred. *The Clavilux Silent Visual Carillon,* 1928. Gouache on paper. 11½″ x 8½″. Collection Thomas C. Wilfred, Palisades, N.Y. Courtesy Thomas C. Wilfred.

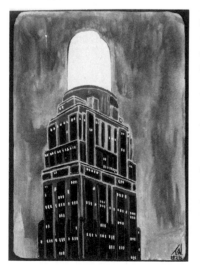

tential of technology. The art that emerged from the war through Jackson Pollock, Willem de Kooning, Adolph Gottlieb, Philip Guston, Ray Parker, Robert Motherwell, and others was predictably introverted and painterly. In their statements, these artists emphasized the solitary, withdrawn, apolitical nature of their work. "The artist's acts as artist," said Parker, "are confined to the studio." They dealt with the most traditional materials: oil paint and canvas. It was only through the energetic, inventive means of application used by Pollock and others that these materials were transformed into a new, invigorating art.

Contrary forces were at work, however. In the very heart of the New York school, Barnett Newman started both to "spray" paint on the canvas and to deal with clean, self-defined forms reminiscent of the Bauhaus and De Stijl. Albers, who came to the United States at the invitation of Black Mountain College in 1933, began his *Homage to the*

Square series in 1949, by which time he was influencing a new generation of students at Yale. In 1950, he was appointed chairman of the Yale School of Design. In the same year, Kepes used artificial light as a sculptural medium by designing a neon façade for the Radio Shack in Boston. The composer John Cage, who had been experimenting in an isolated way with new sounds in music (his "prepared piano," which altered sound by the placement of rubber, wood, glass, and other materials between the strings, dates back to 1938), developed slowly into an influential force on his own. In 1949, he went to Paris and met Pierre Schaeffer, the French composer who had extended Varèse by creating music directly on magnetic tape, collaging together segments of prerecorded "live" sounds. Shortly thereafter, Cage, the young pianist David Tudor, and composer Morton Feldman developed a close association that meant much, in time, for the direction of American avant-garde music. Cage's contact

with Robert Rauschenberg, Jasper Johns, and Allan Kaprow during the 1950's was equally important for American painting—and the development of the Happening. More than anyone else at this time, he stood for the uninhibited use in art of the materials "found" in the environment, an attitude derived largely from his study of Zen Buddhism; he also championed the use of "random" methods in composition—selecting the order of sounds in a concert by flipping coins, for example—in order to enrich the texture of the completed work. Cage taught at Black Mountain College in 1952 and later at the New School for Social Research in New York. He did not immediately turn to magnetic tape à la Schaeffer, but he did create a concert in New York in 1952 of special significance. Entitled *Imaginary Landscape No. 4*, it used twelve radios, each played simultaneously by two performers; the result was a "found" technological montage of static, music, and voices.

The facilities for electronically recording sound were increasing by quantum leaps. Magnetic tape was a fixture on the American commercial market in the 1950's, making it possible, as composer Milton Babbitt said, "to measure elapsed musical time as distance along the tape." Vladimir Ussachevsky used tape in a concert at Columbia University in 1952, the first such performance in the United States. By 1955, RCA laboratories had greatly expanded the variety of new and artificial sounds open to the composer by developing the first Olson-Belar electronic sound synthesizer. A later model, on which Babbitt worked, was installed at the Columbia-Princeton Music Center in 1959, directed jointly by Babbitt, Ussachevsky, and Otto Luening. The composer plays the synthesizer like a keyboard, creating completely artificial sounds of infinite variety—a purification of Concrete music with oscillators, filters, and other electronic mechanisms, listening to the results, and then recording them on tape. Until the advent of the computer, the synthesizer gave the composer the most complete control ever possible over his music, in both composition and performance. There were similar developments during this period among European composers, too, which I will discuss later.

The decisive period for the visual arts in the United States was the middle 1950's. Only then was the hold of Abstract Expressionism upon the younger painters and sculptors broken, a necessary step. Whenever art retreats into itself—into the self or the search for "purity"—the environment no longer functions as a primary stimulus. Gyorgy Kepes is testimony to this fact. He organized an unusual exhibition of photography at the MIT art gallery as early as 1951. "The New Landscape" was based on the same premise as his subsequent series of books, *The New Landscape in Art and Science*—that science had revealed a hitherto unseen world, through both micro- and aerial photography, that was viable material for art. But his message reached deaf ears, among his painterly colleagues, at least: "The idea appeared to be taboo in 1956," he recalled later, in a conversation with me. "Some art magazines refused to review the book [the first volume of the *New Landscape* series] on the grounds that art and science are unmixable entities."

The work of Frank Malina, largely unknown during this period, is another case in point. Malina, one of the first technicians of stature to devote himself fully to art, helped to design the first high-altitude rocket in the United States in 1945. Gradually he changed direction, however, at first with pastel drawings, then with a series of "Lumidyne" constructions in 1954–55. Malina combined electric bulbs, revolving discs, and opaque oil paint to project kinetic moiré patterns on full-sized screens. He continued to expand his ideas,

Milton Babbitt.

working much of the time in England and using images drawn from science—graphs, probability curves, microphotographs, and so on—into the 1960's, when he attracted the attention of the critic Frank Popper, who included him in the influential *Kunst Licht Kunst* exhibition at the Stedelijk van Abbe-Museum in Eindhoven, Holland, in 1966.

Two Decisive Figures:
David Smith and Robert Rauschenberg

It was hardly the examples of Kepes and Malina that softened the painterly attitudes then prevalent in American art, however. That remained for a complex of artists working within and alongside the New York mainstream, two of them particularly important: in sculpture, David Smith; in painting, Robert Rauschenberg. In very different ways, they began to create a new esthetic within the old.

Smith, born in Decatur, Indiana, in 1906, mixed his formal training with employment as a riveter and welder in the Studebaker plant at South Bend, Indiana. Later, when he turned from painting to sculpture, this training proved important. He managed to obtain working space at the Terminal Iron Works in Brooklyn, where—influenced by the iron sculpture of Picasso and Julio González—he began to weld in earnest in 1933. By the 1940's, Smith was recognized as a major figure in American sculpture, translating the pictorial tenets of Cubism into graceful, completely metallic structures. In the 1950's, he incorporated the methods, materials, and forms of his factory background more fully into his work.

David Smith at Bolton Landing, N.Y. Courtesy Marlborough Gallery, New York.

Though he worked primarily on his farm in Bolton Landing, New York, Smith kept the name "Terminal Iron Works" for his studio. He organized a factory-like production system, employing assistants and using industrial materials directly in his work, thus becoming the first American to exchange the studio ethos for the industrial. He applied color to his surfaces in auto enamel. The *Tank Totem* series, initiated in 1952, used the concave ends of steel cylindrical tank drums as basic components. He ordered industrially fabricated parts directly from catalogues, parts that appear virtually inviolate in his work. More important, his sculpture grew larger, cleaner, more monumental. In the late 1950's, he started to use stainless steel, polished to a reflective sheen, so that light became a major ingredient, particularly outdoor light, for which most of the later pieces were designed. His last series, the *Cubi*, was strong and simple in form, frontal in tone, and completely devoid of the romanticism in his earlier work. He was planning and writing about an 18,000-foot "airscape" at the last, about building sculpture to be placed on a railroad flatcar, about art "that men could view as natural, without reverence or awe."

Smith continually insisted on the importance of the factory and the machine in his upbringing and in his work. "Before I knew what art was," he said, "I was an ironmonger." He kept his union card (he was a member of the United Steelworkers) long after he stopped working in industry. Once he wrote:

> My method of shaping material or arriving at form has been as functional as making a motor car or a locomotive. The equipment I use, my supply of material, come from what I learned in the factory, and duplicate as nearly as possible the production equipment used in making a locomotive. . . . It is one part of art that can definitely be taught or learned by the American aptitude for technics.[23]

Smith made no claims for the primacy of his method. He also said that he had seen paper cutouts that excelled piles of "precious metals" as art. He never polemicized for his position. But the effect of it—and his work, which pointed American sculpture away from its esoteric moorings toward a scale and modality in keeping with the new age—was strong. In sum, Smith's work sanctioned the fuller use of new materials that was to come: one of his most accomplished colleagues

36

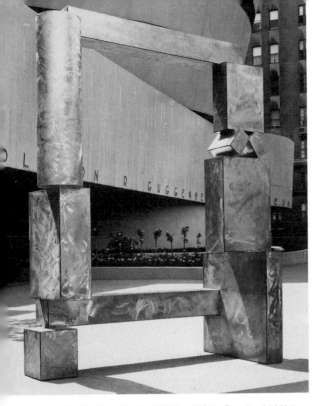

David Smith. *Cubi XXVII*, 1965. Steel. 111½" x 87½". Courtesy The Solomon R. Guggenheim Museum, New York.

and heirs was the English sculptor Anthony Caro.

The work of Robert Rauschenberg ventured further toward complete fusion. Cage's influence upon him has already been mentioned. In addition, Rauschenberg studied under Albers at Black Mountain College in the early 1950's. Though Rauschenberg's work later went its own singular way, this contact was a turning point in his career. Not in any methodological or formal sense: Albers's influence upon the younger man had to do with premise and attitude rather than function, with the unemotional approach to art—so different from the intensity implicit in the methods and results associated with the New York school of painterly abstraction.

In any case, Rauschenberg soon launched several strikes against the attitudes behind that school. In the summer of 1952, while at Black Mountain, he finished a series of all-white paintings (in this case, of course, the formal tie to Albers is quite clear). They were used by Cage in a theater piece at Black Mountain that later came to be considered the first Happening: Cage "set" the audience in the center of the auditorium; the action took place within and around them. To both Cage and Rauschenberg, these paintings were mirrors more than anything else: their surfaces changed with the light and the shadows that fell upon them. In time, Cage, inspired by the "white paintings," created a composition that achieved the same end. He called it *4'33"* and instructed the pianist simply to sit onstage, without striking a note, for 4 minutes 33 seconds. The sound for the piece thus became the noises trapped in the theatrical environment, including the audience itself, coughing, clapping, and complaining.

The white paintings signaled—both for Rauschenberg and for American art—a more direct relationship with the outside world. Allying himself (no doubt unconsciously) with Tatlin, Gabo, and the Bauhaus, rather than with Malevich or Pollock, Rauschenberg began to use the world around him, rather than the self, as both the source and the material for his art. At first the results took the form of traditional art, of paintings and objects closely related to sculpture. Late in 1954, he exhibited a series of red paintings at the Egan Gallery that were covered with bits and pieces of the outside world—rags, discarded scrap, bits of newspaper found in the street. They were as much "collages" in the old Schwitters-Dada sense as paintings. The following year, he stretched a quilt and painted on it, adding his pillow at the top. *Bed*, he called it, and disclaimed any Dada motives. To Rauschenberg, the quilt was legitimate material for a work of art, as was the rich stream of objects that followed, including stuffed goats, old photographs, snatches of discarded clothing, street signs, and Coca-Cola bottles. Recalling this period, which covered, roughly, the years 1955–60, he said that his prowls among the second-hand stores of New York's Lower East Side were the crucial moments in his work: "I felt as though I were collaborating with the neighborhood."

It was inevitable that he should one day incorporate active technology as well as the cast-off refuse of an industrial society. The starting point, perhaps, was *Broadcast*, a painting completed in 1959 and reminiscent of Cage's *Imaginary Landscape No. 4*, which incorporated three radios, their dials projected through the surface of the canvas; when tuned, they bark away at the spectator with an independent force, accompanying the work's visual content. In 1961, he went further; two fans played across the surface of *Panto-*

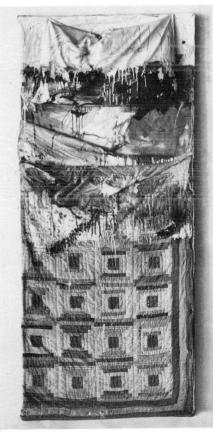

Robert Rauschenberg. *Bed*, 1955. Combine painting. 74" x 31". Courtesy Leo Castelli Gallery, New York.

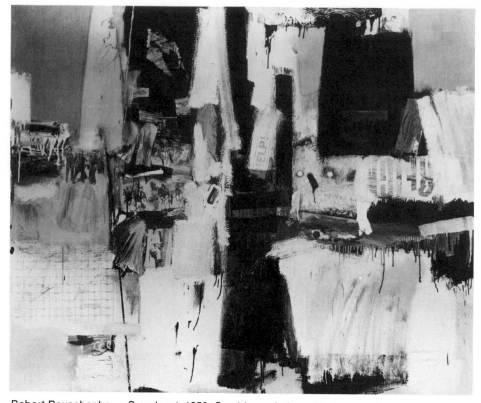

Robert Rauschenberg. *Broadcast,* 1959. Combine painting with three radios. 62″ x 76″ x 5″. The dials can be manipulated by the viewer, changing the audio environment. Collection Kimiko and John Powers, New York.

Jasper Johns. *Lightbulb II,* 1958. Sculptmetal. 8″ x 3″ x 4″. Courtesy Leo Castelli Gallery, New York. Photo by Rudolph Burckhardt.

these unlikely events that combined elements of theater, game, and art. Like Rauschenberg and Johns, Kaprow had been affected by John Cage, under whom he studied at New York's New School for Social Research. Among his classmates were George Brecht, Al Hansen, and Dick Higgins, all of whom began to produce Happenings, Environments, Events, and Theater Pieces based in one form or another upon the principle central to Cage's early performance at Black Mountain College—the full participation of the "audience" in the creation of the work itself (Cage put the audience in the center of his Black Mountain concert to make them see, he later confessed, that "their own experience completed . . . the concert"). In an essay published in *Art News* in October, 1958, "The Legacy of Jackson Pollock," Kaprow wrote, in words applicable not only to the direction taken by Rauschenberg and Johns but to the Pop art that was to follow:

> Pollock left us at the point where we must be preoccupied with and even dazzled by the space and objects of our daily life. Not satisfied with the *suggestion* through paint of our other senses, we shall utilize the specific substance of sight, sound, people, odors, touch.

Kaprow's early Environments and Happenings, which made heavy use of the urban environment—trash, old tires, cast-off furniture—directly influenced younger artists like Claes Oldenburg, Red Grooms, Jim Dine, Robert Whitman, Lucas Samaras, and George Segal, bringing all of them in closer touch with the new life.

Oldenburg embraced the industrial environment with a lust matching that of Cage, Smith, Rauschenberg, Johns, and Kaprow. After a joint showing with Jim Dine at the Judson Gallery in 1960, he transformed his studio into a "store" on East Second Street where he sold art objects like commercial goods, further narrowing the gap between art and life. Later, he incorporated this store as part of "The Ray Gun Manufacturing Company." He was no longer painting or depicting the objects around him, but making them, as plastic reliefs with garish, drippy paint marks all over them. He wrote in his diary at the time:

> The goods in the stores: clothing, objects of every sort, and the boxes and wrappers, signs and billboards—for all these radiant commercial articles in my immediate surroundings I have developed a great affection, which has made

mime, "keeping the painting cool," as he put it; *First Landing Jump* featured a blinking light and was anchored at the bottom by a tire; *Third Time Painting* had an electric clock mounted in its center.

Jasper Johns—Rauschenberg's friend and, for a time, studio partner—was equally energetic. Johns's work was both more precise and more painterly than Rauschenberg's. Like Rauschenberg's, however, it admitted the outside world to a degree that clearly divided it from the Abstract Expressionist esthetic. As early as 1954, he put together a "construction" combining graphite and collage materials with a toy piano. Later, he hung the most mundane objects on his canvases—knives, forks, spoons, cups, brooms, even doors. Following hard upon Cage, the work of these painters, together with Smith's sculpture, came as close to life as art had dared to come, at the time.

The Industrial/Environment Esthetic

The Happening went further, under the aegis of Allan Kaprow, who coined the term in 1958 while he was creating the first of

me want to imitate them. And so I have made these things: a wristwatch, a piece of pie, hats, caps, pants, shirts, flags, 7-Ups, shoe-shine, etc. etc.

The key word here is *affection*. Oldenburg's relationship with his environment, following Cage's, was direct and open, a relationship that not only carried into the later use of technology but necessitated it. Oldenburg's attitude toward his materials was not one of simple celebration. He twisted and enlarged his subjects in every case to his own half-ironic, half-comic purposes. He made giant hamburgers twenty times life-size and collapsible hats. He used burlap, plaster, vinyl, any material at hand. By the very act of use, however, he ennobled the products of a vulgar industrial civilization, according to some of his critics. Later, he made "soft sculptures" of such objects as toilets and car motors, the latter series based mostly on the old Chrysler Airflow engine.

Andy Warhol's use of the industrial environment was subtler than Oldenburg's; it was also more disturbing, mainly because his means of transformation were exquisitely slight. He started by painting comic-strip scenes in the Abstract Expressionist manner; with his first one-man "uptown" show in 1962, however, the surface had become bland, smooth, and neutral. There were, to take but

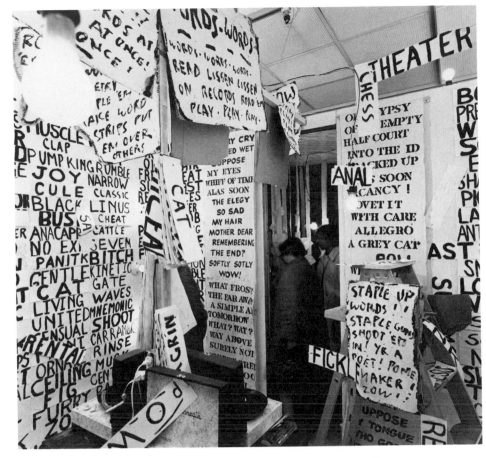

Allan Kaprow. *Words*, 1958. An environment. Photo by David Van Riper, Chicago.

Claes Oldenburg. *Store Object— Case with 6 Pastries*, 1960. Plaster and enamel paint. Courtesy Hayes Gallery, New York.

Claes Oldenburg. View from inside *The Store*, New York, 1960. Courtesy *Arts Magazine*.

two examples, a dead-pan painting of Coca-Cola bottles in sumptuous rows and another composed entirely of dollar bills repeated over and over. Warhol seemed determined to align himself with the machine on every level. He took photographs from the daily newspaper, sent them to the shop, where silkscreens were made from them by photomechanical means; often he would use the screens over and over, repeating the image endlessly, beginning with a serial portrait of Elizabeth Taylor. He credited the environment directly for his technique: "I liked the way newspaper repetition changed the same image," he said later. Like Léger, he understood that the new world permitted new ways of seeing: "I felt at the time, as I do now, that people can look at and absorb more than one image at a time." Warhol transferred these modalities into film. The early films, like *Sleep* and *Empire*, exploited repetition, focusing upon a single image—a man sleeping, the Empire State Building—from start to finish. In *The Chelsea Girls* (1966), however, he set two images side by side, maintaining two story lines at once through a split-screen technique, certain that his viewers could handle this overload with ease.

"I didn't believe in style," Warhol also said, striking at the egocentric tradition with Da-

Andy Warhol. *Green Coca Cola Bottles,* 1962. Oil on canvas. 82¼" x 57". Collection Whitney Museum of American Art, New York. Gift of the Friends of the Whitney Museum of American Art. Photo by Rudolph Burckhardt.

Claes Oldenburg. *Air Flow (No. 6), Soft Engine,* 1966. Stenciled and painted canvas with kapok stuffing. 53⅓" x 71⅞" x 17¾". Collection Dr. Hubert Peeters, Bruges, Belgium.

daistic force. "I want to be a machine," he said on another occasion. He called his studio "The Factory." Teams of assistants issued his canvas painting-prints in editions, via silkscreen. More conclusively than anyone else, Warhol fused art with the techniques of mass production.

Many of his Pop colleagues shared that impulse in lesser degree. Roy Lichtenstein issued baked-enamel paintings in multiple editions. Tom Wesselmann built constructions that incorporated live appliances, including radios and television sets. Neo-Pop assemblagists like John Chamberlain, Richard Stankiewicz, and César Baldaccini made art out of industrial detritus—the smashed and twisted fragments of old automobiles, compressed into tiny briquettes. Mainline Pop preferred brand new objects, however, shining and antiseptic. Oldenburg's objects, their surfaces covered with paint drippings, began as extensions of gestural painting. With the advent of his "soft" period, the romantic assemblagistic surface had been exchanged for bland neutrality. His vinyl-covered "engines" insisted that

they had never been used. "Edges became harder, clearer," Wesselmann said later. "The sound of the painting became sharper."

The formality inherent in pure, bland Pop relates it not only to the machine and to the Bauhaus–De Stijl look but to the surge of "minimal" or "literalist" sculpture and painting that followed it. The sources of this new work were many, ranging from Constructivism to the early field paintings of Barnett Newman (first shown at the Betty Parsons Gallery in 1951), plus the clean, precise works executed by David Smith in the years immediately preceding his death. The literalists were indirectly aligned, too, with West Coast painters like John McLaughlin and Lorser Feitelson, whose devotion to solid, clearly defined abstract forms and fields of color prompted critic Jules Langsner to formalize the term "hard edge" for application to their work, referring to the sharp divisions they made between solid fields of color. Finally, the literalists insisted on the necessity of complete abstraction, thus demonstrating a link, however fragile, with the painterly tradition that preceded them.

The alternative they presented was reductive in both the material and the esthetic sense. Nearly all of the new sculptors insisted on using the rankest industrial materials available, eschewing "fine art" media like bronze, marble, and wood. Their taste for organization was geometric, even banal, in the best Pop tradition. They indulged in formal overkill, repeating images and forms time and again, sometimes within the same work.[24]

The most pointed and polemical of these artists is Donald Judd. He began as a painter but changed to three dimensions in 1962, dissatisfied with the reticent, illusionistic qualities inherent in painting. "The main thing wrong with painting," he wrote later, "is that it is a rectangular plane placed flat against the wall . . . the shape of the rectangle is not stressed; the parts are more important, and the relationships of color and form occur among them." Painting, in other words, was involved in a kind of hypocrisy, a denial that it was what it was.

Judd wanted to deal with self-contained shapes lacking reference to anything outside or beyond themselves. He turned quite naturally to industrial materials, to galvanized iron, brass, stainless steel, and aluminum, all untainted by cultural associations. Judd's sense of color was industrial, too. He clung to hues like Harley Davidson Hi-Fi Red and 1958 Chevrolet regal turquoise.

But the key step taken by Judd was empirical in the most casual sense. He began to order his specific objects from a sheet-metal fabricator. In this way he could have pieces cut, shaped, and sheened to precise specifications, with an accuracy beyond his own hand, studio, and limited tools. "I just used what was available to me," he explained, "in order to finish my work properly." In the process, he defined a new attitude toward the creative act. The use of fabrication in art is hardly unique: in 1922, Moholy-Nagy ordered five enamel paintings by phone from a sign factory in Berlin. But Moholy's phone

Donald Judd. Untitled, 1966. Six galvanized boxes. 40" x 40" x 40" each. Courtesy Dwan Gallery, New York. Photo by John D. Schiff.

Donald Judd. Untitled, 1963. Painted wood. 19½″ x 45″ x 30½″. Courtesy Leo Castelli Gallery, New York.

Donald Judd. Untitled, 1965. Ink on paper. 11″ x 8⅜″. Courtesy Leo Castelli Gallery, New York.

Robert Morris. Untitled, 1965. Fiberglass. 2′ x 3′ x 3′ each, 9′ square area. Courtesy Dwan Gallery, New York. Photo by Rudolph Burckhardt.

Robert Morris. Untitled, 1967. Nine steel units. 36″ x 180″ x 180″ each. Courtesy The Solomon R. Guggenheim Museum, New York.

call was in itself an isolated act, made largely for experimental purposes (to prove that Malevich's forms were objective, not personal); it was hardly central to Moholy's career. Judd, however, did more than indulge industrial methodology. He thoroughly exploited it, producing in the process a stream of stark and beautifully finished objects that modulated the American sensibility. Judd's work eroded the idea that the personal hand of the artist mattered more than the product itself.

Robert Morris is another artist who moved early into both literalist shapes and industrial materials. Like Judd, he in no sense consciously attempted to involve technology in his work. Unlike Judd, however, Morris found himself involved more and more in a prophetic participation with industry. In 1967, he made this statement, which defines well the tie between literalist sculpture and the development, on a more conscious level, of the art-technology fusion:

In the beginning, I merely intended to use industry to implement certain ideas I had which were fairly clear in my own mind. I knew what I wanted and it was simply a matter of finding someone to build it. This approach changed in proportion to what I found about how things got made. It became less and less a matter of being in a studio thinking of things, making the plans and sending them off to the fabricator. More and more it became a matter of incorporating methods and materials I had found out about in the process of being related to particular fabricators. . . . The process of work became more direct and also more complex. . . . The more I found out and the more people I met who were interested in helping, the less it seemed necessary to plan everything either precisely or completely in advance. More work got made easier by leaving certain problems open for others to work out. . . . In short, less, not more, control was becoming desirable. The process of making art began to get ever so slightly corporate.[25]

Morris, too, dealt with simple shapes and organizational schemes so direct and repetitious that they verged, like Pop art, on the banal. In time he was to move away from these rigidities, in both ideology and performance, but before that he created some of the strongest works in the new idiom, arranging circular and boxlike components in perfectly symmetrical rows, spread out across the floor like lines of newly created appliances. Morris's work, unrelieved by any sensuousity of color, was more conceptually consistent than Judd's. Together these two men helped to mold a new generation in American sculpture.

They were not alone. Architect-sculptor Tony Smith went in the same direction, almost by accident. "In 1962 I had some steel boxes made," he recalls, "and placed them around my yard." This was the beginning of a series of imposing tetrahedral- and octahedral-based constructions in solid black that developed throughout the next decade. On the West Coast, in 1965, Larry Bell made perfectly square, gleaming glass boxes of complex reflective beauty ("I wanted to create a perfect work," he said, "complete unto itself, with no loose ends"). Ron Davis, another Californian, painted on fiberglass with liquid fiberglass that hardened to become a part of the surface itself. The results, coated with wax, were as much objects as paintings, hard and imposing rather than soft and retiring. "In my view," Davis said, revealing his intentions, "a new Chevrolet is more perfect than most art made today." In England, sculptors Anthony Caro, Phillip King, and others also demonstrated the new appetite for scale and strength, combined with vulgar industrial materials.

The mid-1960's were not fertile years for

traditional painting, thus dominated by a hard, lean esthetic that placed primary emphasis on aggressive confrontation with the spectator, to say nothing of an intense effort to avoid illusion, long the very basis of painting. Nonetheless, the same spirit also asserted itself among painters, as Clement Greenberg indicated in *Post Painterly Abstraction*, an exhibition he organized at the Los Angeles County Museum in 1964. His roster included Frank Stella, Paul Feeley, Al Held, Ellsworth Kelly, Alexander Liberman, and the "Washington Color Painters"—Morris Louis, Gene Davis, Kenneth Noland, Tom Downing, and Howard Mehring. All of them dealt with large areas of high-key color, well-defined shapes, and a smooth, almost bland surface, in contrast to the thick, carefully individualized surfaces preferred by the New York painterly school.

If Judd, along with Morris, was the most polemic of the new sculptors, Frank Stella was the most pointed and powerful of the new painters. First introduced to the public in *Sixteen Americans* in 1959, he immediately demonstrated a preference for starkly rectilinear stripes, applied either through the spray or through brushwork that left little trace of itself. In 1960, he started to "shape" his canvases to fit the forms he put upon them, anticipating Judd's criticism of painting's formed hypocrisies. In these works, surface and shape, form and medium became one. "My painting is based on the fact that only what can be seen there is there," he said several years later in a joint interview given by him and Judd to Bruce Glaser. "It really is an object What you see is what you see."

I just used what was available to me. The process of making art began to get ever so slightly corporate. What you see is what you see. How are these ideas, together with the work related to them, involved with the place of technology in contemporary art? In ways significant but not instantly apparent. The historians can easily make a case for the tie between the formalism of a Mondrian or an Albers and the use of recent technology advocated by their European colleagues, because certain statements and ideological alliances are on record to document it. With Americans like Judd, Morris, and Stella, who avoid articulation of this kind, there is no such evidence. George Rickey aligns these artists with the Constructivist tradition,[26] while others have charged that Americans

lack an equivalent political idealism (Hilton Kramer once called the Americans "engineers of esthetic sensation").

The case for the relationship between Judd, Morris, and Stella and their European precedents must be resolved on grounds of what the literalist sculptors and painters did instead of what they said or avoided saying. They worked in a time when the purist values of formalism, as advocated by the critic Clement Greenberg, were at the center of American esthetic theory. Like Malevich, Greenberg believed in an art involved with itself, not the outside world and not "content" in any traditional sense. But Greenberg's position proved to be a Trojan horse. In the pursuit of nonreferential forms, artists had nowhere to turn, save to "new" materials and "new" methods, because neither carried with them the hint of cultural precedence. *I just used what was available to me.* When Judd turned to his environment, in a sense, the environment was ready for him, in the form both of the fabricator and his materials. Judd maintained the formalist stance in theory to the end, of course, and kept all artistic prerogatives in his own hands. Morris was not so rigid; he gave way to a kind of unforced, unplanned, nonprogrammatic collaboration with industry—and therefore technology—that seems to me as significant, if not more so, as the *a priori* stances enunciated decades before in Europe. *The process of making art began to get ever so slightly corporate.* This statement indicates that the new life—the environment of the contemporary world—is a match for esthetic theory, no matter how entrenched.

What you see is what you see. The contribution of Stella and the new painting to the convergence of art and technics is more difficult to demonstrate but equally real, functioning on a purely conceptual level, although these painters utilized new materials and processes in various ways, from acrylics to spray cans. The search for non-illusive forms led Stella to a geometry reeking with industrial connotations. Thus did he establish a new kind of painting, unleavened by cultural reference. The industrial reference bothered him and his contemporaries not at all. "Many of the younger artists," John Coplans wrote, "feel more at home in a world dominated by science than their elders: they do not feel out of step."[27] The causes for that new, easier relationship with the environment are many, one of them being the idea behind Frank Stella's

Frank Stella. *Delaware Crossing,* 1961. Alkyd on canvas. 6'5" square. Collection Carter Burden, New York. Photo by Rudolph Burckhardt.

Frank Stella. *Ophir,* 1960–61. Copper paint on canvas. 8' x 2½" x 6' 10¾". Collection James Holderbaum, Smith College, Northampton, Mass. Photo by Rudolph Burckhardt.

work—that there is a distinctive pleasure involved in the use and the response to the *Ding an sich.* In Stella's case, the "thing" was line and shape, but in other cases it could be—and is—laser lights, videotape, or the computer.

New Materials in the Early 1960's

What happened in the mid-1960's, at least in the United States, had as much to do with process as idea, with the growth of a new computerized, transistorized, televised landscape. In the *process* of trying to make art based on this landscape, younger artists discovered more and more about the new ways open to them, from the mundane to the esoteric. Dan Flavin, the most important of the younger sculptors involved with light, is an example of the former. Like Oldenburg, he was fascinated by the "goods in the stores"—lightbulb goods. His early light constructions, such as *Corson's Broadway Flash* (1962), were composed of commonplace bulbs and fluorescent tubes, the kind found in any home. "I just used them because they were handy, cheap, neutral, and available," he said, disclaiming in the familiar American manner any ideological intention. Flavin shared with Judd and Morris a love for direct, repetitive assault, and thus the neutral quality of the ordinary lightbulb suited his intentions perfectly. Often Flavin would isolate single tubes in a corner or against a wall, thus freeing them from obvious artistic manipulation.

Even his more complicated structures, like the series in homage to Tatlin and *Greens Crossing Greens* (*to Piet Mondrian*), completed in 1966, showed an insistent banality of structure: in the latter work, rows of fluorescent tubes emitting green light are set at right angles to one another on the floor; other tubes, vertically and horizontally aligned, jut out from the wall, creating a total—but extremely simple—environment of steady, shadowless light. Flavin's sympathy with the Constructivist–De Stijl esthetic is underlined by his dedications to Tatlin and Mondrian, but his public statements were resolutely Pop in tone: "The contents of any hardware store," he stated in 1966, "could supply enough exhibition material to satisfy the season's needs of the most prosperous commercial gallery."

The work of Larry Bell involved technology of a far more esoteric sort. The environment of Bell's youth was the highly charged technical climate of southern California. Bell had no inhibitions about seeking out the best

means to make that "perfect" glass box he had in his mind, no fear of replacing the methods of traditional sculpture with new. What he discovered, finally, was the "High-Vacuum Optical Coating Machine," originally manufactured for the U.S. Air Force to coat the glass surfaces of the cockpits in their fighter planes. This machine lays an exquisitely thin coat of color onto glass, so thin it can be measured in the millionths of an inch. Bell learned to operate it himself, loading its filaments with colored crystals that, when vaporized, settle delicately on his glass plates. The plates then join to form a box with six surfaces of constantly changing hues, since the glass both harbors and reflects the subtlest patterns of light and color.

Fletcher Benton and Norman Zammitt, two other Californians, represent a similar pattern. Until 1964, Benton had been a painter. Then he turned abruptly to kinetic sculpture, convinced that "kinetic art was involved in moving time in the same way that society is," as he later stated. "It's more applicable to social change, say, than static culture." Within two years he produced more than 160 pieces, not without encountering and solving crucial technical problems along the way. His "color machines," or *Synchrometrics,* were powered by small, carefully timed motors, all of which had to be built to order. His preference for light-gauge metal forced him to seek a means of shaping it besides welding. Finally he decided to warp the metal

Larry Bell operating the "High-Vacuum Optical Coating Machine," 1967. Courtesy The Pace Gallery, New York. Photo by Jay Thompson.

Dan Flavin. *Monument for V. Tatlin,* 1966–69. Cool white fluorescent light. 103″ x 23″ x 4″. One of a series that Flavin began planning and sketching in 1964. He often attached the prefix "pseudo" to "monument" because the works are not meant to be cast in permanent form but to exist in a temporary state, determined by the life of the fluorescent tubes. Courtesy Leo Castelli Gallery, New York. Photo by Rudolph Burckhardt.

Fletcher Benton at work in his studio in San Francisco, 1967. Photo by Rudy Bender—Eye Now, San Francisco.

by gluing it to wooden supports, a decision that led to a crucial search for a glue that would firmly connect metal and wood. Fortunately, a number of appliance manufacturers, RCA included, had already developed a contact glue for their own products. Mixed with epoxies, this substance affixes metal and wood tightly together, thus making Benton's art possible.

Like many other artists, Benton organized a tiny factory of his own, complete with assistants, drill press, table saw, timers, switches, belts, and budgets. Furthermore, he began to issue instructions for use and guarantees of repair with each of his pieces. The grander his imagination became, the grander became his corporate structure. To build a large kinetic wall twenty feet long that responds to the environment around it—to light, wind, temperature, humidity—the estimated preliminary investment came to more than $25,000, $10,000 alone going to the engineer who wires it.[28]

Norman Zammitt involved himself even more deeply in process than Benton in order to achieve his own goals. He became, in time, an inventor on his own. His dream work was a transparent plastic block in which sheets of color might be suspended indefinitely. The technology of World War II had put the project within reach, through a clear, durable acrylic plastic used largely to build protective shields around fighter pilots. At first, though, Zammitt could not find a pigment that survived contact with the glue needed to fasten the sheets together. "The plastics people in Los Angeles told me I'd never find a glue that would fasten those sheets together without destroying the color coatings," he recalled.

Nonetheless, he experimented with various chemicals for more than a year until he discovered a successful mixture that is itself a variant of the plastic. When Zammitt's glue hardens, the box becomes one unit, not a glued construction—which clearly delights the artist. Zammitt was attracted to acrylic plastic at first because of its clarity, purity, and durability. His boxes can be heated or frozen without damage and can be left outdoors for hundreds of years, according to the chemists.

More went into its creation than mere chemistry, to be sure. Zammitt, like Benton, had to invent a complicated production system, which included a studio, vacuum chamber, a "clean room" in which the finished plates are pressed together, and specially trained assistants. "The comparison is often made between my 'clean room' and the clear air of the space industry," Zammitt says. "But they go to the moon by cold, hard math and logic.

Fletcher Benton. *Zonk II 1984,* 1969. Motorized aluminum and plexiglass. 23″ diam. Courtesy Galeria Bonino, New York.

Norman Zammitt emerging from his "clean room," a dust-free chamber, in 1967. Photo by Frank J. Thomas.

I can't. I go to the moon like Jules Verne and H. G. Wells—by the seat of my pants."

Bell, Benton, and Zammitt are representative of a group of artists working during the middle and late 1960's who were more involved with technology than the average; but the difference is only one of degree. The trend toward new materials and means, though unprogrammatic, was widespread. William Morehouse, another San Franciscan, surely gave not a thought to the political or social implications of the materials—urethane, acrylic, and polyester—that went into his painting *No. 35*, only to their color and texture. Robert Irwin, working in Los Angeles, seized upon aluminum as the medium for his sprayed-acrylic disc paintings (which he crosslit with four soft lamps of low intensity) in much the same spirit, as did Wallace Berman the verifax copying machine (which enabled him to create textural collages with paradoxically smooth surfaces). Some artists employed knowledge as a tool, notably "optical" painters like Richard Anuszkiewicz, Julian Stanczak, and the Anonima Group, consisting of Ernst Benkert, Edwin Mieczkowski, and Francis Hewitt. All employed what they had learned from optical science to create paintings that affected the retina kinetically, in the manner of Europeans like Vasarely and Bridget Riley. "Each painter in his generation," stated Mieczkowski, "is responsible for transforming painting in keeping with . . . increasing knowledge." John Goodyear added a Constructivist

dimension to this kind of painting by suspending slatted screens in front of undulating images, further complicating and intensifying the illusive effects.

For Craig Kauffman, another Californian, the vacuum-forming "method" utilized to create the plexiglass sculptures characteristic of his work in the mid-1960's was just that, a method, and no more. Edward Kienholz's *The Beanery* was similarly innocent, yet its creator glazed all of its parts with epoxy and fiberglass, toughening it in a way impossible before those materials were available.

Steven Urry, a Chicago sculptor who works in metal, also began using epoxy resin as a finish, both because it is impervious even to acids and because he was able to control the color of the finish. Like Benton and Zammitt, however, Urry had to experiment with a new material in order to perfect its use. He learned to mix it with acetone and "mist" the spray on his pieces, thus avoiding a shiny, reflective surface. Mel Johnson, also working in Chicago, learned how to use fiberglass and epoxy while employed by a display art firm. The knowledge and the materials transformed his art, which deals with dolls, balloons, and cast-off materials in an almost classically Assemblagist manner. The resulting works are as strong as the surface of a modern power boat. In one case, he took a group of balloons and dolls, tied them together with sticks, covered them with a glass cloth soaked in resin, and applied epoxy paint to the surface. "The paint," as he says, "is more permanent than the doll. . . . As a sculptor, I can do anything now. I can make my pieces flat, fly, suspend in the air, or radiate odors. The old esthetic laws based on physical limitations are invalid now."

Brooklyn sculptor Calvin Albert was discovering the same thing during the same period. In his case, the actifying material was styrofoam, a soft synthetic substance developed by Dow Chemical. It can be shaped or carved into the most complicated forms, then transformed by a stream of molten metal. "The styrofoam seems to melt upon contact with the molten metal," said Albert, who was one of several artists using this method in the mid 1960's before its application by industry, thus launching a new kind of "foam casting."

Perhaps the most spectacular process utilized during this period was "explosive forming." The artist was Piotr Kowalski from Poland, the collaborator North American

Aviation in California. Explosive forming is employed by North American and others to shape high-density metals underwater by controlled explosion. Kowalski's *Dynamite*, a stainless-steel work commissioned by Long Beach State College, was formed in this way, underwater, and then polished (conventionally, by the artist's hand) to a highly reflective sheen. The finished piece, in three components, fifteen feet wide at the base and twenty-five feet tall, still stands on the Long Beach campus.

Piotr Kowalski. *Dynamite,* 1965. Stainless steel. These photographs demonstrate the process known as "explosive forming," used by Kowalski in collaboration with North American Aviation, Inc., in California. The process is normally employed to weld and shape high-density materials underwater by controlled explosions. In the picture sequence, the workers attach explosive charges to a curved steel sheet; the explosion takes place; the sheet is raised from the water, its new creases visible; the completed structure is shown at its permanent site on the campus at Long Beach State College, California, after being polished to a highly reflective sheen. Kowalski sits in the middle. Courtesy North American Rockwell.

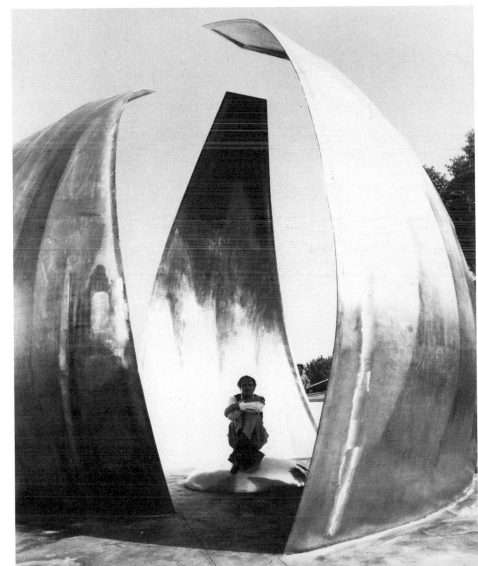

Len Lye. *The Loop,* 1965. Magnetized and programmed steel. 22' h. Resting on a magnetized bed, this work undulates slowly. Courtesy Howard Wise Gallery, New York.

Len Lye. *Fountain,* 1963. Stainless steel, motorized and programmed, 7½' h., 7' diam. The "fountain" vibrates, reflecting light in many different directions at once. Courtesy Howard Wise Gallery, New York. Photo by Oliver Baker Associates.

Kowalski's collaboration was far from the innocence of mere process. North American, his collaborator, contended that *"Dynamite . . .* made by space-age methods . . . is intended to reflect faith in advanced technology." There was very little innocence—for different reasons—in the work of veterans like Wilfred and Calder, or kinetic sculptors like Len Lye and George Rickey. Lye had been involved with technological innovation since 1918, when he made his first kinetic machine. In 1961, after years of comparative neglect, Lye was given an evening at the Museum of Modern Art, New York, where he displayed his "Tangible Motion Sculptures" in performance. Like Scriabin's keyboard and Wilfred's *Clavilux,* they bridged the dwindling gap between art and theater. They also incorporated an exceptionally violent kinetic and aural quality. In 1965, he displayed a group of "Bounding Steel Sculptures" at the Howard Wise Gallery in New York. *The Loop,* a twenty-two-foot strip of polished steel, rested on a magnetized and motorized bed, which activated the strip at programmed intervals, causing it to clang and undulate viciously. *The Flip and Two Twisters* turned itself out with a cascade of thunderous sound. *Ritual Dance,* six slender three-foot steel rods, swayed on a platform accompanied by ringing bells. At the end of each day, the entire group was programmed to quake and roar together, as a chorus. Rickey, meanwhile, reflected not only the Constructivist tradition in the tall, tapered steel pieces he began to build in the early 1960's, but Calder's mobiles as well: their blades, weighted at the bottom, swing gently in the breeze, allowing nature and chance playful participation in the work.

Kepes's activity mounted in variety and effectiveness. His influential series of books, *The New Landscape,* grew. In 1966, he organized an exhibition at Harvard's Carpenter Center for the Visual Arts devoted to *Light as a Creative Medium.* The year before, in an issue of *Daedalus* magazine, he announced an even more important step, his intention to found what later became MIT's Center for Advanced Visual Studies: "A closely knit work community of eight to ten promising young artists and designers. . . . It is assumed that . . . contact with . . . the academic community of architects, city planners, scientists and engineers would lead to . . . the development of new ideas."

If the use by Kepes, Mies, Rickey, and Lye

1. Kenneth Noland. *Up Cadmium,* 1966. Acrylic on canvas. 6′ x 18′. Courtesy
André Emmerich Gallery, New York.

2. William Pettet. Untitled, 1967. Acrylic on canvas. 6′ x 10′. Photo by F. J. Thomas.

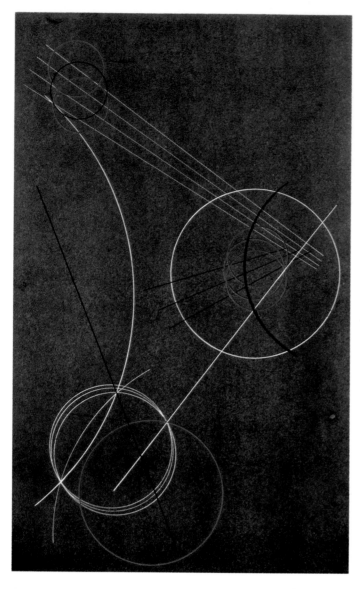

3. Alexander Rodchenko. *Line Construction,* 1920. Pen and ink on paper. 14¾″ x 9″. Courtesy Leonard Hutton Galleries, New York.

4. Liubov Popova. *Architectonic Composition,* 1918. Oil on board. 23½″ x 15½″. Courtesy Leonard Hutton Galleries, New York.

5. Victor Vasarely. *Alomie I,* 1967–69. Tempera on canvas. 78¾″ x 78¾″. Courtesy The Toledo Museum of Art, Toledo, Ohio.

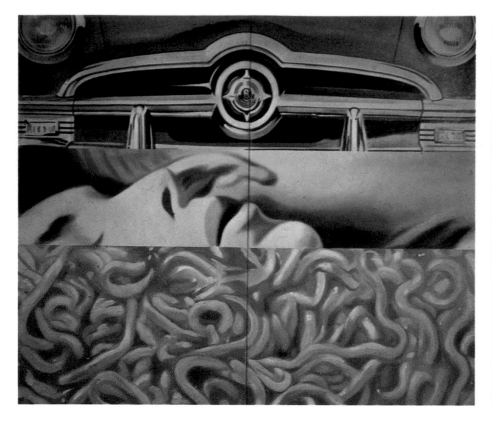

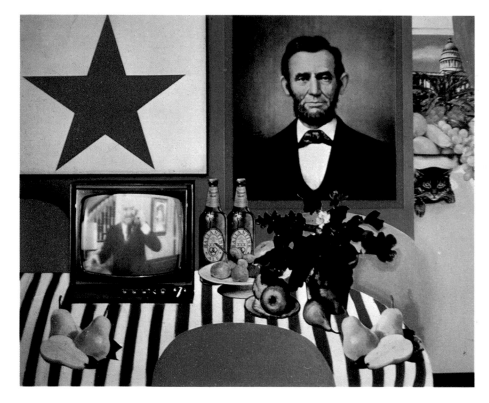

Above left:

6. James Rosenquist. *I Love You with My Ford,* 1961. Oil, two panels. 84¼″ x 95⅝″. Collection Moderna Museet, Stockholm.

Above:

7. César. *The Yellow Buick,* 1961. Compressed automobile. 59½″ x 30¾″ x 24⅞″. Collection The Museum of Modern Art, New York. Gift of Mr. and Mrs. John Rewald.

Left:

8. Tom Wesselmann. *Still Life No. 28,* 1962. Oil and collage elements with working TV set. 48″ x 60″ x 8″. Collection Harry N. Abrams Family. Courtesy Sidney Janis Gallery, New York.

9. Roy Lichtenstein. *Modular Painting with Four Panels, No. 2,* 1969. Oil and magna on canvas. 96¼″ by 96¼″. Collection Dr. Peter Ludwig. Courtesy Neue Galerie, Aachen, Germany.

10. Donald Judd. Untitled, 1968. Stainless steel and plexiglass. 135″ x 40″ x 30″. Courtesy Leo Castelli Gallery, New York.

11. Andy Warhol. *Electric Chair,* 1965. Acrylic and silkscreened enamel on canvas. 22″ x 28″. Collection David N. White. Courtesy Leo Castelli Gallery, New York.

12. Craig Kauffman. Untitled, 1966. Vacu-
 um-formed plexiglass. 77″ x 38½″.
 Courtesy The Pace Gallery, New York.
 Photo by Ferdinand Boesch.

13. Ron Davis. *Five Twelfths,* 1968. Fiber-
 glass. 60″ x 144″. Collection Dr. Peter
 Ludwig. Courtesy Wallraf-Richartz Mu-
 seum, Cologne, Germany.

14. Norman Zammitt. *Solid State Construction #12*, 1969. Acrylic plastic. 14½″ x 32¼″ x 7⅝″. Courtesy Felix Landau Gallery, Los Angeles.

15. Larry Bell. Untitled, 1966–67. Glass and metal binding. 18″ x 18″ x 18″. Collection Mr. and Mrs. Solomon, New York. Courtesy The Pace Gallery, New York. Photo by Ferdinand Boesch.

16. Eduardo Paolozzi. *Artificial Sun*, 1965. Silkscreen on paper. 29¼″ x 22″. Courtesy Philadelphia Museum of Art. Gift of Dr. and Mrs. Paul Todd Makler.

17. Rockne Krebs. *Aleph 2,* 1969. 6 helium neon lasers, 4 6′ x 10′ co-planar mirrors. The mirrors are slightly bent, giving the reflected images within the "room" a curved effect. Courtesy Corcoran Gallery of Art, Washington, D.C.

18. Charles Frazier. *Pacific Electric* (detail), 1968. 32″ long model for flying sculpture capable of takeoff and maneuver within one mile of space. It carries a smoke system and color filters.

19. Willard Van De Bogart. *The-Apollo 14 Collection,* 1971. Laser images created in concert with the Los Angeles Philharmonic Orchestra. The images were projected onto a 40′ x 40′ screen through a complex of optical glass, rippled plexiglass, fiber optics, and mirrors.

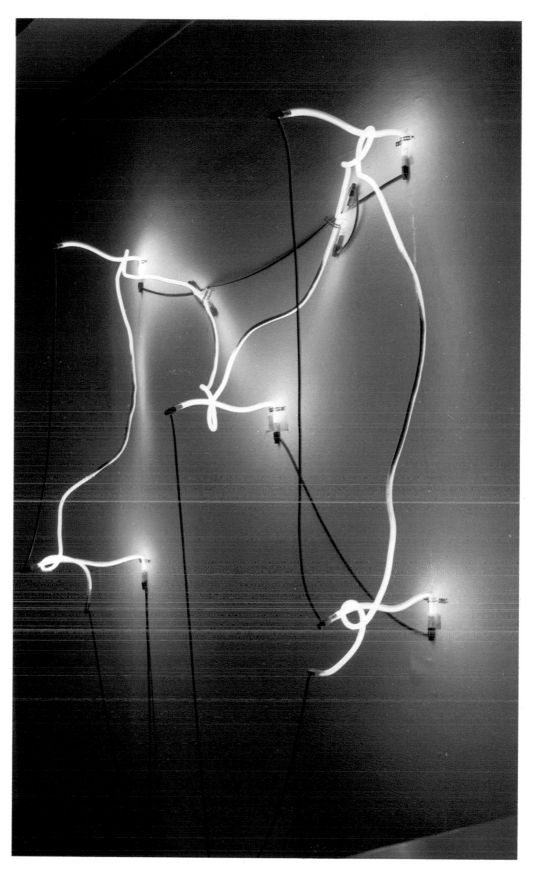

20. Keith Sonnier. Untitled, 1969. Neon.
Approx. 8' x 6' x 2'. Collection Dr.
Peter Ludwig. Courtesy Leo Castelli
Gallery, New York.

Above left:
21. Howard Jones. *Time Columns—The Sound of Light,* 1968. Aluminum and electronic components. Five units. 120″ x 10″ x 10″. Courtesy Howard Wise Gallery, New York.

Above right:
22. Ben Berns. *#11,* 1967. Neon plexiglass. 21½″ x 72″ x 82″. Photo by Roy Adams.

Left:
23. Dignac. *Neptune,* 1969. Plexiglass and fluorescent electric light. 26¾″ x 26¾″ x 5″.

Below left:
24. F. J. Malina. *Ladder To The Stars, I,* 1965. Kinetic painting, lumidyne system. 39″ x 78″. Collection UNESCO, Paris. Photo by Babbette Whipple.

of new materials and knowledge was self-conscious in the fullest sense, it was more than matched by the non-ideological empiricism of the younger Americans. Technology subverted American art between 1955 and 1965 largely through process, plus certain ideas and attitudes implicit in the Greenbergian esthetic and in the environment itself. The net effect of these causative agents was this: by the end of this middle decade, new materials and methods became common factors in American art, particularly sculpture.[29] Theory—with a full extension of the practice —was to come later.

American dance, music, and intermedia revealed similar patterns. Toward the end of the 1950's, Alwin Nikolais experimented at the Henry Street Playhouse in New York with an expressionistic use of light in relationship to his dancers; the light became as important as movement in the total effect Nikolais sought. By carefully relating his costumes and his lights, Nikolais created complete changes in color as the dancers moved from one plane of light to another, as in *Imago* (1963). In *Totem*, the dancers carried lights on stage, waving them under their costumes. Often the performers would stand motionless while the lights played across their costumes, changing colors and projecting complex shadow effects against the backdrop of the stage. Nikolais also composed— with the help of the sculptor-technician James Seawright—a series of electronic scores, completely surrounding his dancers with an artificial environment of light and sound.

Nikolais's attempts to fulfill the old dream of total theater were paralleled by film-maker Stan Vanderbeek's *Movie-Drome* project. Influenced by the wide-spanning dome structures being built by R. Buckminster Fuller, Vanderbeek planned in the late 1950's a spherical theater in which the audience would lie on the floor and look up—to watch multi-screen films employing thousands of streaming images. "My ideal theater is to be of infinite space," Vanderbeek wrote, "with no 'edge' to the screen—not a window effect as in the traditional theater—but a total Envelope-Environment—allowing an almost endless amount of image material to flow over you and around the Dome." He began making multi-screen films for the *Movie-Drome* in 1957, but construction could not be started until 1963. By 1966, a thirty-one-foot silo-top dome was standing near Vanderbeek's home

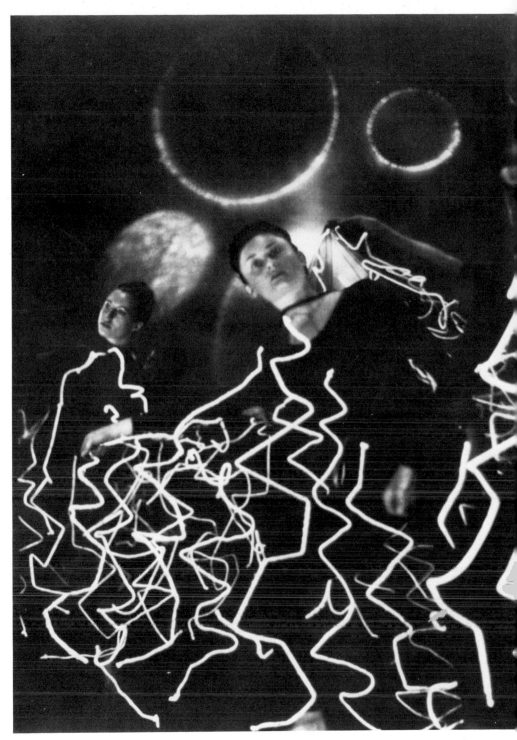

Alwin Nikolais. *Galaxy, A Dance Theater Piece, 1965.* In this work, the dancers carry the lights with them. Courtesy Chimera Foundation for Dance, Inc., New York. Photo by Susan Schiff-Faludi.

Stan Vanderbeek. *The Movie-Drome,* construction begun in 1963, at Stony Point, N.Y.

Merce Cunningham. *Variations V,* 1965. An intermedia dance piece. In this work, the dancers articulate not only the performance space but also the sound space: As they near the antennae placed onstage, which contain focused photocells and a vertical capacitance-sensitive system, sounds are triggered from within. Electronic materials by Billy Klüver; music by John Cage; film and TV projection, with which the dancers also interact, by Stan Vanderbeek. Photo © 1967 by Peter Moore.

in Stony Point, New York, and he was showing early multiscreen films to small groups of people.

The Nikolais-Vanderbeek direction had several additional American adherents. Painter Milton Cohen, working in Ann Arbor, Michigan, created what he called "The Space Theatre," presented at the Venice Biennale in 1964. It collaged films, slides, sounds, and a live dancer, whose movements triggered certain electronic sound sequences during the performances. Choreographer Merce Cunningham created a mixed-media spectacle of his own in 1965 for the French-American Festival at Philharmonic Hall in New York. Entitled *Variations V,* it combined his dancers with music by John Cage, visual materials by Stan Vanderbeek (films and television), and a series of electronic "antennae" constructed by engineer Billy Klüver. The dancers activated the antennae as they moved near and around them, creating their own sound accompaniment, a process that delighted Cage, who had been immersing himself all through this period in technology as a source for sound.

The Once group, also resident in Ann Arbor and related more closely to Cage and the Happening movement than to any traditional forms in theater and dance, was equally inventive. The group used technology to complement the special talents of non-trained performers and in doing so developed a series of works with provocative social connotations. *Public Opinion Descends Upon the Demonstrators* allowed the audience to control the texture of their sound environment and "mirror" their role in creating that environment through a responsive sound system that picked up "random" voices and amplified them throughout the theater; *Kittyhawk (An Antigravity Piece)* filled the performance space with huge and continually changing sculptural forms; in *Megaton* a large-scale surrealistic narrative was developed through performed electronic sound and light manipulation, anticipating the spatial quality of laser holography. In 1965, the group staged *Unmarked Interchange* on the roof of an Ann Arbor parking structure, the perfect site for the work's intention, which was to superimpose itself upon a "found cultural ritual," in this case an outdoor drive-in movie. A special screen was erected, measuring 24 by 36 feet, containing human-size, hidden panels, louvers, and horizontal stage surfaces. A

movie was projected on the screen, upon which the live performers superimposed themselves by manipulating parts of the screen. The sounds of the performance piece were integrated into the soundtrack of the film, and the performers were coordinated by radio communication.

I have touched on a scant handful of the developments in music, dance, and theater, limiting them basically to principals such as Nikolais, Cage, Cunningham, and the Once Group, who are closely associated with their colleagues in the plastic arts. But the picture that emerges is one of vigorous American activity during the mid-1960's. Some of it bordered on the slapdash, to be sure, and all of it encountered public resistance. The Europeans, if not wiser, were certainly more explicit about their aims. Girded by this—and the Bauhaus-Constructivist tradition—they met with less overt hostility from the viewers and the critics.

The Once Group. *Unmarked Interchange,* 1965. An intermedia theater piece. The "stage" was a screen resembling that of a drive-in movie, erected on top of an Ann Arbor, Mich., parking garage. While the movie (*Top Hat,* starring Fred Astaire and Ginger Rogers) was projected on it, live performers appeared on the screen through sliding panels, louvers, and a drawerlike section. "Live" sounds were mixed with the sound track, and the performers were coordinated in their movements by wireless radio communication. Photo © 1965 by Peter Moore.

Europe After the War

The Post-Bauhaus Renaissance

The situation in Europe between the end of the war and 1965 was vastly different from that in the United States. The rate of progress toward a symbiotic mixture of art with technology was faster, as well as more self-conscious. The cultural legacy I have already mentioned—and the manifesto tradition itself—made both possible. The *White Manifesto*, issued in 1946 by the Italian Lucio Fontana, then living in Argentina, is a case in point. A figurative painter until that time, Fontana reasoned that the old forms in art were no longer applicable to the new matrix of knowledge in which man lived. "We are abandoning the use of known forms of art and we are initiating the development of an art based on the unity of time and space," he declared. Obviously impressed with the new, flexible conceptions of time and space found in Einstein's theory of relativity, Fontana, like his Futurist predecessors, wanted forms that were not fixed in static properties or readily identifiable as "art" in the old sense: "Color (the element of space), sound (the element of time) and motion (that develops in time and space) are the fundamental forms of the new art." When he returned to Italy, Fontana put these ideas into effect by making his first "spatial environment" at the Naviglio Gallery in Milan in 1949—a completely black room lit by black wooden lamps, nothing else. Later he created a series of "spatial" paintings by cutting and slashing into the surfaces of his canvas, mixing art, in effect, with the forms of the outside world.

Bruno Munari, another Italian, and Victor Vasarely, a Hungarian living in Paris, moved in similar directions—away from the traditional modalities in art. "No more oil colors," Munari announced in his 1952 *Manifesto del Macchinismo*, published in Milan, "but jet-flames, chemical reactions, rust, thermal changes." Even before then, Munari had betrayed a strong Futurist-Dada influence. He had made what he called "useless machines" in 1935—a precursor to Tinguely. In 1949, he produced "travel sculpture," composed of wire mesh parts that could be folded flat and shipped for reconstruction elsewhere; he issued "unreadable books" that the reader could take apart and put together as he pleased. An industrial designer as well as an artist, he insisted, as had Gropius, on the necessity of working outside the studio in the environment of the real world. To that end he designed posters, book jackets, and department-store displays, as well as home furnishings.

Vasarely emphasized the necessity of synthesis between art and science; in the 1950's, he abandoned the "handmade" methods of traditional painting for the use of quasi-scientific approaches. He began to organize his paintings, drawings, and prints around a standardized system of forms (squares, blocks, circles, triangles, and lozenges), which lent all his works a consistency of effect." As Vasarely prospered, he employed a staff of assistants to execute his designs as if they were factory-made products: he would design the work himself, using pieces of colored paper cut into his standard vocabulary; his assistants then plotted the final work on a permanent surface and filled in the color with oil or acrylic pigments. This technique reached its logical extreme later when Vasarely designed participative boxes that enabled the buyer to assemble his own "Vasarely." One of these "multiple" works of art contained a twenty-inch square steel frame and 390 colored and magnetized squares and circles, with accompanying charts directing their placement.[30]

The example of Fontana, Munari, and Vasarely coincided with similar trends within the mainstreams of traditional painting itself. As in the United States, the course of European abstraction was strongly affected in the postwar years by a new interest in free-wheeling gestures and spontaneity, what Michel Seuphor called *Tachisme* (a term denoting either "staining" or "spotting" in English), an equivalent of American action painting. *Tachisme*'s opposite tendency, grounded in the clean geometrical abstraction initiated earlier by the Constructivists and De Stijl, remained alive. In 1930, Theo van Doesburg, the founder of De Stijl, suggested the term "Concrete" to describe abstract art, particularly the carefully ordered work that came from the hands of artists like himself, Sophie Taeuber-Arp, Hans Arp, Robert and Sonia Delaunay. After the war, the principal advocate of Concrete painting was the Swiss artist Max Bill, who had been influenced early by Mondrian and had worked as a student at the Bauhaus. Jean Arp and Georges Vanton-

gerloo—another friend of Mondrian's and an early member of De Stijl—shared Bill's position, as did Swiss artists Camille Graeser, Fritz Glarner, and Richard Lohse. Bill organized a series of important *Konkrete Kunst* exhibitions in the 1940's and 1950's, taught and lectured widely, particularly in Latin America, and produced large, well-defined canvases, organized—similar to Vasarely's—on a quasi-scientific system, in Bill's case, mathematics. In their devotion to system and geometry, the European Concrete painters both anticipated and resembled the "literalist" movement in the United States.[31]

In music, Karlheinz Stockhausen, Pierre Boulez, and others, along with Schaeffer, made breakthroughs of their own. Stockhausen, whose work became particularly influential, worked with Schaeffer in a Paris radio studio in 1952–53, experimenting with sine-tones on a modest synthesizer; he used plastic discs to record and mix the sounds he produced, since no magnetic tape recorder was available. *Electronic Study I*, the first composition based entirely on sine-tones, dates from this period. Later in 1953, Stockhausen became the first contributing member of the new "Studio for Electronic Music" at station WDR in Cologne, Germany, founded by Herbert Eimert, composer Robert Beyer, and others. "We wanted absolutely pure, controlled sound," recalls Stockhausen, "without any subjective emotional influence by interpreters." In some of his early compositions, Stockhausen mixed electronic sounds with live music. Later he mixed sounds from three specially constructed signal generators, one producing pure tones, another impulses, and the third what he called "white noise."

In the early 1960's, he composed *Mikrophonie I* and *II*, based on the inherent qualities of the microphone, which he modulated until it became, in effect, a new musical instrument; until, as he said, the altered microphone "gave form independently to pitch, harmonically and melodically, and to rhythm, dynamic level, timbre, and spatial projection of sound, according to composed indications." Like Cage, Stockhausen incorporated random, unpredictable qualities into his music, although he always maintained structural control. In 1963, he became artistic director of the Cologne studio. Both his music and his ideas gained in influence throughout Europe in the 1960's.

In another way, Yves Klein contributed to the impending conjunction of art and ma-

chine. His work radiated Dada. His all-blue monochrome paintings (like the all-black paintings of Ad Reinhardt in the United States) helped to shape the reductive sensibility growing among the younger European generation, a sensibility that lent itself readily in time to technological implementation, as it did in the United States. There also was the direction in Klein—like that in Rauschenberg—toward *actualité*, toward methods and attitudes that incorporated the outside world within the work of art. Klein launched himself into "space," jumping from a window for a photographer below; he opened an exhibition in Paris with the walls of the gallery bare, calling the show "The Void"; he directed the paint-soaked bodies of his models in a dance on white canvas in order to obtain what he called a "mark of life" in the resulting work; he mixed colored pigment with a large gas flame-thrower to make "flame" paintings. With Arman, Martial Raysse, Jean Tinguely, and Christo, he formed a loose alliance of artists that came to be called "The New Realists." Like their pop art colleagues in the United States, they preferred blatant commercial-industrial materials and imagery. Raysse, whose ingredients included neon tubes, dime-store objects, and mannikins, wrote: "I wanted my work to possess the serene self-evidence of mass-produced refrigerators."

All of this was merely a prelude for the tide of technologically oriented art that arose after the first important postwar kinetic exhibition, *Le Mouvement*, at the Galerie Denise René in Paris in 1955. The participants included Duchamp, Calder, Vasarely, Yaacov Agam, Pol Bury, Jesus-Raphael Soto, and Tinguely —plus one young American, Robert Breer. Vasarely contributed a long essay to the catalogue, "Notes for a Manifesto," championing the use of motion in painting, whether real or retinal. "The art of today," he claimed, "leads toward expansive forms."[32] Among the younger men represented, Agam, Bury, and Soto had been involved with movement for some time. Agam, born in Israel, was making paintings with modular reliefs the spectator could move about with his own hands. Later, like the German Gerhard von Gravenitz, he was to construct large transformable walls and murals. Soto, from Venezuela, introduced an illusive retinal element into his paintings and graphics, much like Vasarely, though subtler in effect. Bury, a Belgian, had forsaken painting for mobile reliefs in 1953: the com-

Max Bill. *Core of Three Groups of Four,* 1969. Gilded brass. Each bar 19¾".

Pol Bury. *One Hundred and Eighty-Two Balls on Opposing Planes,* 1967. Wood. 94" x 47" x 24". The balls move very slowly. Courtesy Lefebre Gallery, New York.

ponents of a Bury kinetic work are normally small in size, large in number, bland and symmetrical in organization, and programmed by motorized or magnetic means to move so slowly as to require the constant attention of the eyes. Three representative titles catch Bury's structural tone quite well: *80 Rectangles on 20 Sloping Planes; 15 Upright Cylinders, 6 Cubes, and 18 Balls; 31 Rods Each with a Ball.*

The preference in European kinetic-light art for slow, controlled movement and for subtle retinal effects—as opposed to the direct assault in Len Lye's clanging steel loops or Dan Flavin's unadorned fluorescent tubes—is marked, though Calder's work is certainly a major antecedent. The only younger American artist present in *Le Mouvement,* Robert Breer, the filmmaker-sculptor who lived and studied in Paris during most of the 1950's, is a reverse case in point. As his work developed, his preference for Europeanized "slow motion" set him off from most of his American contemporaries. In the mid-1960's, for example, he made a series of small, motorized styrofoam floats, to be set loose outdoors or within large indoor spaces; they wheeled themselves about like a pack of slowly moving animals. Later he graduated to large six-foot fiberglass slabs that inched

Robert Breer with *Floats,* 1967. Styrofoam blocks on battery-driven metal wagons. Courtesy Galeria Bonino. Photo by Peter Moore.

along almost imperceptibly, like a Bury relief, backing off any object they hit, dumb but autonomous.

The most colorful and influential artist to emerge from *Le Mouvement,* however, was the Swiss "junk" sculptor Jean Tinguely, who sacrificed subtlety for unpredictability. He plundered scrapyards for cast-off motors, wheels, and metals to make machines with a life of their own. Tinguely was never sure what his creations would do when activated. His contribution to the *Mouvement* exhibition was typical. Among the reliefs and motorized sculptures on display, Tinguely installed a *Meta-Matic* robot that painted its own pictures, in the process accidentally spraying the viewers. "Be static! Be static!" Tinguely told an audience at London's Institute of Contemporary Arts in 1959. "Movement is static! Movement is static! Movement is static because it is the only immutable thing—the only certainty, the only unchangeable. The only certainty is that movement, change and metamorphosis exist." One year later, he realized his obsession on a grand scale: he constructed a self-destroying machine that slowly tore itself apart in the garden of the Museum of Modern Art in New York, a machine he called *Homage to New York.*

The self-generating spontaneity in Tinguely's works had obvious ties with Calder and with the tachist-action painting going on around him. So did the work of the Greek artist Takis. He had been fascinated as a young man during World War II by both radar and explosives. He turned from static to moving sculpture in 1954, later employing "natural forces" as well as motors—specifically, the magnetic field and the oscillation of the sea. Like Yves Klein, he was interested in space travel; he even "launched" a friend by suspending him in a magnetic field. Takis attempted to make invisible forces visible, in effect, by inviting the spectator to throw nails against a magnetized plate, which automatically arranged them in a symmetrical pattern, or by using the movement of the sea to power *Hommage à Duchamp*, a floating sculpture designed in 1968. Takis's work was particularly influential among the younger British artists, such as David Medalla, who began to exhibit at London's Signals Gallery in 1964.

There was no equivalent in the United States during the 1950's and early 1960's for artists like Tinguely and Takis, both of whom developed by 1965 a mature and deeply personal body of work based on new materials

and knowledge. There is no American equivalent for Nicolas Schöffer, either, a Hungarian living in Paris. Schöffer explored movement in ways completely different from Tinguely and Takis. His works were both carefully programmed and large in scale. In the mid-1950's, he began constructing what he called "Luminodynamic Spectacles" in the parks and city spaces, primarily through audio-visual towers that responded with light and sound to the proximity of crowds and changing weather patterns. In 1961, he built a *Cybernetic Tower* in Liège, Belgium, that radiated music along with light and motion. Finally, like Vasarely, Schöffer tried to extend his ideas into architecture and city planning. Vasarely had designed visionary "Polychrome Cities" based on his vocabulary of shapes and colors. Schöffer designed "Cybernetic Cities," programmed to surround its citizens with an acutely sensitive environment, entire buildings and neighborhoods able to generate light-sound patterns.

The rapidity of the movement in Europe toward fusion can be seen not only in the maturation of figures like Tinguely, Takis, and Schöffer, but in the changing attitude toward multiple reproductions of original works of art, as opposed to limited print and

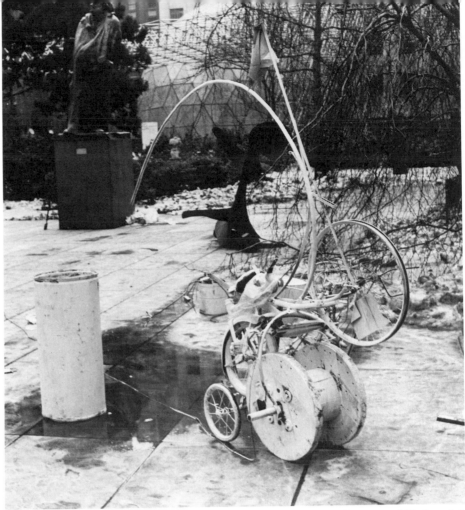

Jean Tinguely. Remnant, *Homage to New York,* performed at the Museum of Modern Art on March 17, 1960. Painted metal. C. 84" x 60" x 36". Collection The Museum of Modern Art, New York. Gift of the artist.

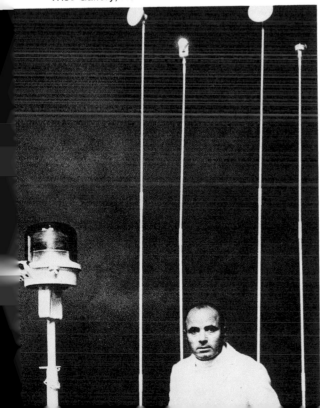

Takis with *Signals*, London, 1966. Courtesy Howard Wise Gallery, New York.

sculpture editions. Herbert Read had argued against the high value placed in the past upon the single, unique work, connecting this attitude to socio-economic systems long past. "What is the worth of such a quality?" he asked in 1934. "It is certainly not an aesthetic value. The sense of uniqueness—is it not rather an impulse . . . typical of a bygone individualistic phase of civilization?"[33] By the 1950's, many artists were able to answer in the affirmative, especially Vasarely and the Swiss-Rumanian assemblagist Daniel Spoerri. Vasarely said: "Without repudiating the principle of oneness, we choose that of multiplicity, as being more generous and human." His prints, three-dimensional works, and games appeared in large editions. Spoerri took an even more significant step. In 1959, he founded Editions M-A-T (the letters standing for "Multiplication Arts Transformable"). The first project was a series of three-dimen-

Jean Tinguely *Meta—Matic XII,* 1966. 15¾" x 27½" x 11¾". Courtesy Alexander Iolas Gallery, New York and Paris.

Otto Piene. First performance of *Archaic Light Ballet* in Piene's one-man show at Galerie Schmela, Düsseldorf, 1959. Piene projected his *Light Ballet* with hand-operated lamps through rhythmically moving, perforated stencil screens onto all surfaces in the room. The projections were accompanied by taped electronic piano sounds. Photo by Manfred Tischer, Düsseldorf.

sional objects designed to be reproduced in editions of 100 each, and sold at low cost. The first M-A-T artists included Calder, Albers, Agam, Bury, Frank Malina, Soto, Tinguely, Vasarely, Man Ray, and Duchamp. In time, M-A-T formed an alliance with the Galerie der Spiegel in Cologne, Germany, where a continuing series of multiples were fabricated for invited artists at the gallery's framing factory. M-A-T's example spurred similar projects throughout Europe.

The Early 1960's in Europe: *Nouvelle Tendence*

It was in this fertile climate that a remarkable surge of organizational energy occurred throughout Europe at the end of the 1950's. This surge consummated in many ways the fusion called for by the Futurists and the Constructivists, delayed by the war and reinvoked again during the immediate postwar years. Group after group suddenly formed in Germany, in the Low Countries, in France, in Italy, in Spain, all explicitly dedicated in various ways to the use of new means in art. Among the first was ZERO, founded in Düsseldorf by Otto Piene and Heinz Mack in 1957 (later joined by Günther Uecker in 1961). They called themselves ZERO because they wanted to make a new beginning, to start essentially from nothing. In their early statements, they clung to principles that characterized them separately and as a unit for years thereafter. First, an almost American disdain for ideology ("There is no president,"

Piene later wrote, "no leader, no secretary—there are no 'members,' there is only a human relation between several artists and an artistic relation between different individuals").[34] Second, a desire to work on a scale large enough to "reharmonize . . . the relation between man and nature." It was the second aim that led the ZERO artists to use recent technology in one form or another. Mack exploited reflective metal surfaces; Piene began to project light "paintings" on the wall, ceiling, and floor by placing a pre-cut stencil over a light source; Uecker later built programmed light environments, some containing fluorescent tubes. Uecker wrote, in *ZERO 3*, one of the group's several early publications: "Our projects of today are the realities of tomorrow. . . . Technics, as a medium of composition, offer great possibilities in the formulation of esthetic information."

ZERO also displayed a familiar impatience with the gallery system, in Düsseldorf and elsewhere, prompting the "Night Exhibitions" held in the lofts of Piene and Mack in 1958 and 1959. The exhibitions lasted for one evening only and radiated the aura of performance, especially in Piene's "Light Ballets," although the members presented objects in the traditional sense as well, frequently organized around themes like *Vibration* or *The Red Picture*. In 1961, ZERO conducted a series of "demonstrations," one on the streets of Düsseldorf, one on the banks of the Rhine, flying huge transparent hot-air balloons in the sky. In time, the strongest of the artists associated with ZERO moved toward more of these environmental spectacles, such as *The Proliferation of the Sun*, performed both in the United States and in Germany in 1967. Piene also extended his use of the sky as a space for spectacle, organizing a series of "sky events" throughout the late 1960's and early 1970's.

Most of the other European groups stressed an anonymity alien to ZERO. The climate in the United States, where collective creation caught on slowly, to say the least, proved in time more comfortable for Piene—and for Mack, too, on occasion. ZERO seemed romantic and idealistic at a time when the impersonality of science was a dominating goal. These other groups came collectively to be known as "The New Tendency," a label that referred, depending on its user, to individual artists as well. It grew out of an exhibition organized in 1961 by the Groupe de Recherche d'Art Visuel, along with Matko Mestrovic and others, in Zagreb, Yugoslavia.

Gunther Uecker. *Light Rain,* 1966. Light lines (tubes). 9′ h. The lights are programmed to go off and on in cycles. Courtesy Howard Wise Gallery, New York. Photo by John Naar.

Otto Piene. *Light and Movement,* 1966. Electronically programmed aluminum sculpture with 100 lights, stationary and moving parts, for 40' x 40' stainless steel façade, Wormland Department Store, Cologne. Photo by Schmuelz and Ullrich.

Julio Le Parc. *Continuel Mobile,* 1961. Motorized lights, on display at the Musée d'Art Moderne, Paris. Collection The Tate Gallery, London. Courtesy Howard Wise Gallery, New York.

Getulio Alviani. *Surface with Vibrating Texture, No. 7016,* 1967. Aluminum. Courtesy Alcoa Collection of Contemporary Art.

Most of the work on display there defied the strategies of traditional art, particularly as expressed by overindulgent Tachistic brushwork. The New Tendency eschewed pigment for light, motion, and sound with which the spectator could frequently interact. "[He] is not invited to contemplation or passive consideration of the work," wrote Mestrovic, "but should take an active part in its enactment."

ZERO's major rival, the Groupe de Recherche d'Art Visuel (GRAV), had been founded in Paris in 1960 by Julio Le Parc, Horacio Garcia-Rossi, François Morellet, Yvaral (Vasarely's son), and others. They set up a communal studio and constructed works under the group name alone. In their manifestos and declarations—as in the name they chose to work under—GRAV emphasized anonymity, research, and team effort. Under Vasarely's influence, GRAV also tended to produce works in large multiple editions. With varying degrees of emphasis, so did Gruppo T, founded in Milan (with Munari's help); Gruppo N, in Padua; Equippo 57, in Spain; and other groups in Holland and in Munich, Germany. In 1962, the Dvizdjene Group was

Gregorio Vardenega. *Relief Electronique,* 1964–65. Programmed colored lights and wood. 23½″ x 26¼″ x 8″. Courtesy Howard Wise Gallery, New York. Photo by Geoffrey Clements.

launched in Moscow by several artists and architects, among them Lev Nusberg, mainly to construct kinetic-environmental works verging on theater. Even at that far remove, Dvizdjene displayed several characteristics unmistakably allied with *Nouvelle Tendence,* including a preference for severe, orderly, anonymous forms ("It is more rational," the group wrote in 1966, "to seek with the help of absolute regularity"), an interest in new media ("We forget neither changes in temperature, nor the movement of air, odors, the technique of television and radio"), and a passion similar to GRAV's for involving the spectator actively with the elements around him. In 1963, GRAV moved further in this latter direction with its first *Labyrinth,* displayed in Paris. As the title of the work implies, it is a narrow, dark, and complex passageway-environment, the darkness broken up at each turn by flashing, aggressive light boxes that confront the eyes of the participants.

The year of 1963 also marked the beginning of the end for the group renaissance. GRAV called a meeting in Paris, attended by more than thirty artists, all related in one way or another to *Nouvelle Tendence.* The meeting was noisy, vigorous, and optimistic, but in the years immediately following, each of the groups slowly fell apart, in nearly direct proportion to the maturation of the individual members as artists in their own right. Although the group phenomenon spanned less than a decade, its influence lasted far longer. For one thing, a number of serious artists emerged from the interplay between rival ideologies and approaches. In addition to Le Parc, Piene, and Uecker, there were Hans Haacke, Gerhard von Gravenitz, Martial Raysse, Martha Boto, Gregorio Vardenega, and Yayoi Kusama, among others. The commitment of each to new materials and processes was clearly sharpened by the group dialectic.

Second, this commitment, which led inevitably away from the use of traditional painterly materials, led just as inevitably into the full use of movement and light. Tinguely, Takis, and Schöffer had already established the pre-eminence of European kinetics prior to the

Julio Le Parc. *Continual Light with Twisting Forms,* 1967. Motorized lights. Courtesy Howard Wise Gallery, New York.

advent of ZERO in 1958. But it remained for the new groups—particularly GRAV—to refine those techniques of movement and to introduce light as an independent medium. These artists domesticated both light and movement to a greater extent than anyone preceding them, particularly in the United States, and certainly including the Futurist-Constructivist-Bauhaus pioneers, who talked more about light (and movement) than they performed (an exception, of course, is Moholy-Nagy's *Light-Space Modulator*). Schöffer's motorized kinetic-light constructions had been carefully programmed: as they turned, light sources mounted beneath the polished metal constructions beamed through, projecting shadows and reflection onto walls and spectators. Schöffer was an exception. More often than not artists had used light unrelieved by either hand or timer, often as an esthetic relief or contrast within a larger context, as in Martial Raysse's canvases, edged with neon tubing, and Ben Berns's, studded with bug lights.

Le Parc and GRAV tried simultaneously to enlarge and to control this use of light. Le Parc's *Continuelle Lumière* series employed moving light in a variety of ways, often letting it play at programmed intervals up across a flat surface studded with semicircular metal strips, creating a constantly changing linear pattern of light and shade. Martha Boto—a member of Equippo 57—placed lights behind her *Polivision Lumineuse,* timed to alternate the intensities of repeated flashing. Alberto Biassi, of Italy's Gruppo N, projected small side lights through slowly revolving prisms onto a rectangular board, producing complicated shafts of moving, spectral light. This kind of work—a natural result of the cool, "scientific" tone and careful symmetry of organization that prevailed throughout all the groups (and, indeed, *Nouvelle Tendence* itself)—was not universally admired, but it demonstrated in its time the potential of the new media more dramatically than ever before. It is no accident that European museums opened their halls to one major exhibition of technologically oriented art after another in the late 1950's and early 1960's, including *Bewogen Beweging* ("movement movement"), a retrospective celebration of kinetic art from Gabo on at the Stedelijk, in Eindhoven, Holland, in 1961. The denouement, five years later, was a major exhibition devoted to light, *Kunst Licht Kunst*, also beginning at the Stedelijk. From ZERO to Gruppo N, the new groups had changed minds as well as media.

Anthony Caro. *Midday*, 1960. Steel painted yellow. 7'10½" x 12' x 3'2". Collection T. M. and P. G. Caro. Courtesy André Emmerich Gallery, New York.

England: The Aftermath

These years of organizational and ideological energy had parallels in Great Britain, although the tone there differed substantially. English art, architecture, and design had not participated fully in the esthetic revolution launched during the prewar and postwar years by the Futurist Dada-Constructivist–De Stijl-Bauhaus axis; and they did not readily join the reawakening of that attitude on the Continent that began properly in 1958. Nikolaus Pevsner aligns the early demise of the modern movement in Britain with the death of William Morris in 1896 and suggests sociopolitical reasons. The socialism inherent in Morris's position ("What is the use of making art," he once asked, "unless everyone can share it?"), as well as in the standardized, low-cost housing projects proposed by Muthesius, Gropius, and others, alienated the patrons of art in England. "As soon as the problem began to embrace the people as a whole, other nations took the lead," Pevsner wrote, "nations that did not accept or did not know England's educational and social contrasts between the privileged classes and those in the suburbs and slums."[35]

Whatever the cause, English artists and intellectuals rarely displayed an enthusiastic interest in new media. The influential British critic Roger Fry announced that a typewriter could never be beautiful, echoing his French colleague Amédée Ozenfant, who asked, contemptuously: "Has anyone ever seen a factory or piece of machinery that would move men to tears? The most elegant bicycle cannot do it." There were a few exceptions to this arcadian attitude, naturally. At the same time Futurism flourished, Vorticism rose in England, led by Wyndham Lewis, William Roberts, and McKnight Kauffer. Like Futurism, Vorticism was infatuated with movement and opposed to the static qualities of Cubism; the paintings, drawings, and posters that came out of this abortive "movement" (based on a single exhibition held in London in 1915) split up representational subjects—like birds in flight—into slivers of form and color, aiming to depict real-time speed. Painter Ben Nicholson, at first strongly influenced by Cubism, visited Mondrian in 1934 and became in time not only geometrical in his pristine paintings and reliefs but an active participant in the Constructivist movement. In 1937, he co-edited—with the architect J. L. Martin and Naum Gabo—Circle, an international survey of "Constructive" art (the term had come to include everything from Tatlin and Gabo to De Stijl).

These were isolated incidents at a time when British art was largely devoted to traditional media and figurative concerns.[36] They were augmented from the outside in the mid-1930's by the arrival of several seminal Bauhaus figures, however, all fleeing the rise of Nazism in Germany and the threat of war. Gabo antedated them, as I have already implied: he lived in England during the larger part of this decade and established personal contacts with sculptors Henry Moore, Barbara Hepworth, Kenneth Martin, and Mary Martin, all of whom betray varying degrees of Constructivist influence in their work, particularly the Martins, who became actively involved with kinetic forms after the war. Gropius, Breuer, Moholy-Nagy, and Kepes also came to work in England for varying lengths of time, on their way to the United States. Moholy's activity was splendidly energetic and eclectic: he was appointed art adviser for Simpson's department store in London, the Imperial Air Ways, and London Transport; he published three volumes of documentary photography; and in 1936 he was commissioned by Alexander Korda to design the special effects for an ambitious film, The Shape of Things to Come, based on the novel by H. G. Wells.

Finally, the importance of British critic Herbert Read's book Art and Industry: The Principles of Industrial Design should not be overlooked. Inspired by Gropius and the Bauhaus, Read was determined to turn the tide in design and architecture away from baroque redundancies, away from the imposition of "aesthetic values which are not only irrelevant, but generally costly and harmful to efficiency." In this remarkable book (discussed more fully in Chapter 3), first published in 1934, Read defined a series of provocative positions: (a) the machine is capable of producing "art," even by the most traditional formalistic definitions; (b) the most important "artists" of the modern period are the engineers and industrial designers behind such "streamlined" forms as the automobile and the airplane; (c) the ostentatious hand of the individual designer or artist has no place in industrial design; (d) the age-old distinction between fine and applied art must be discarded; (e) the artist must become an integral part of the industrial system. Complete with photographs of Bauhaus and allied experiments in furniture and appliance design, the book was widely read, discussed, and carried through several editions and revisions. The war brought a halt to its practical impact in Europe, of course, but in 1944 the Council of Industrial Design was established in Great Britain, charged with improving the quality of design roughly in accord with Read's "truth-to-machine" thesis.

Neither British art nor architecture followed suit. One critic has described the condition of British art in the late 1940's and 1950's as "bland and soggy," excepting only the biomorphic sculptures of Henry Moore and the savage, expressionistic figure painting of Francis Bacon. The Constructivist tradition maintained an attenuated life through Victor Pasmore and Nicholson (and a group of younger painters associated with him, living in Saint Ives, Cornwall). Kenneth and Mary Martin made mobile wire constructions in the early 1950's. At the same time John Healey created "light boxes" that projected moving forms onto walls and screens in the manner of Thomas Wilfred and Moholy-Nagy. With the exception of Frank Malina, who worked in England on and off during this decade, they were an isolated and derivative group.

The first signs of a sharp break in the

John Healey. *Box 3,* 1967. Motorized light box. 24″ x 38″. Courtesy Waddell Gallery, New York.

Richard Smith. *A Whole Year, A Half, and A Day I, III–XII,* 1966. Acrylic on canvas. 61″ x 61″ x 12″ each. Collection Richard Feigen Gallery, New York and Chicago.

gentle, arcadian tone of British art came in the mid-1950's, among a group of painters and critics associated with the gallery sponsored by the Institute of Contemporary Art in London. Prime among them was Richard Hamilton, a painter who gave a disconcerting exhibition of oversize photographic blow-ups in 1955, entitled *Man, Machine, and Motion,* celebrating the forms and impact of mass-media technology, together with its impact upon traditional culture. One year later, he created a collage-poster, *What Makes Today's Homes Seem So Different, So Appealing,* prominently displaying the image of a TV set, for an exhibition at the Whitechapel Gallery (entitled *This Is Tomorrow*). For Hamilton and the early British Pop and near-Pop artists —such as Richard Smith, Peter Blake, David Hockney, Allen Jones, and Joe Tilson—the discovery of contemporary culture as valid subject matter was an exhilarating experience. "In place of Roger Fry's disinterested contemplation," wrote critic Lawrence Alloway, "something both more simple and more intimate, more common and fantastic was being sought."

Both Hamilton and Alloway were key members of the tiny modernist ICA band, which became known as the "Independent Group." Two other equally important members were the sculptor Eduardo Paolozzi and the architectural critic and historian Reyner Banham. While British Pop was beginning to grow, Paolozzi was incorporating found industrial images in his three-dimensional metal collages, photo-lithographs, and drawings. Frequently, he juxtaposed these images with motifs drawn from classical art: in an early collage he combined a photograph of a man with a mechanical arm with a photograph of Michelangelo's *David*; in *Laocoon, Seen Through the Windshield of a Car* (1961), he juxtaposed a drawing of the dashboard of a car with a photograph of the writhing figure, who thus appears to have become an incipient traffic fatality. "I think that machines and fantasy go together," Paolozzi had said in 1953, influenced by the machine paintings of Max Ernst. Paolozzi's constructions, which included robot-like metal men, utilized second-hand machinery—used bombsights, radio chassis, and toys—but unlike Tinguely, Paolozzi covered up his tracks, in a sense. He pressed the machine parts on sheets of wax, which later were cast in bronze from maquettes.

The work of Hamilton and Paolozzi evinced an affection for the new technology that broke sharply with ongoing British attitudes. So did the writings of Banham, who in a series of articles and books urged architects to exploit more fully the possibilities inherent in new methods and materials. Like Gropius and Read, he wanted architects to focus upon efficiency and livability rather than either formal beauty or period chic. In his 1965 article "A House Is Not a Home,"[37] he advocated the idea that the outer structure counted for less than the inner: the outside should be mere envelope for an autonomous, electronic "servicing package" within. This idea was expressed most completely in *The Architecture of the Well-Tempered Environment,*[38] where Banham credits modern technology with the key advances made in twentieth-century architecture, from the skyscraper

Bridget Riley. *Untitled*, 1965. Lithograph. 18¼" x 15". Collection James Fitzsimmons, London.

Computer drawing (after Bridget Riley) based on repetition of sinusoid curve. Courtesy A. Michael Noll, Bell Laboratories, Murray Hill, N.J.

to movie drive-ins; the architect of the future, Banham argued, must concern himself, basically, with creating humane, low-cost environments, drawing on the potential of electronics and prefabrication, not formal beauty. Banham's ideas, and rhetoric—which includes the phrase "clip-on architecture"—were further implemented by the Archigram group in the late 1960's, an association of young London architects who designed fantastic schemes for "plug-in" cities and housing developments that can be put together like a Vasarely print, by the inhabitants themselves. "The prepackaged frozen lunch is more important than Palladio," announced Peter Cook, one of Archigram's leaders. "It is an expression of human requirement and the symbol of one efficient interpretation of that requirement that optimises the available technology and economy."

In addition to these articulate, conscious attempts to mix esthetic concerns with the new technology, there were trends in British painting and sculpture in the late 1950's that acknowledge this fusion obliquely, rather than directly, trends very close to those evident in the United States and Europe during the same period. One example is the sensuous optical painting of Bridget Riley, in which carefully structured black, white, and gray patterns turn the flat picture plane into an undulating surface, converting the tools employed so coolly by Vasarely and Bill into emotional statements. The sculptor Anthony Caro visited the United States in 1959, where he became a close friend of David Smith's, a tie that helped to confirm the direction he had already taken—toward clean, linear forms, new industrial materials such as steel and aluminum, and an attitude to sculpture sharply divergent from the genteel British tradition. Like Smith, Caro wanted to take sculpture off its precious pedestal, arrange it "non-hierarchically" on the ground, and force the viewer to see it on its own terms. "We encounter it like anything else," he said, and his example shaped the work of the next generation of British sculptors, beginning with his two prize students, Phillip King and William Tucker.

Despite these subcurrents, British art lagged behind the Continent in terms of its interest in new media and processes (even British Pop, after all, confined itself largely to pigment and canvas) until the mid-1960's.[39] It is against this backdrop that the first stirrings of an organizational energy resembling that just completed on the Continent surfaced

in the mid-1960's. In 1964, a group of artists working in London organized the Center for Advanced Creative Study, which announced as its basic purpose the collaborative fusion of art with industry. The idea was first proposed by Marcello Salvadori, an architect-artist who had been working—like John Healey—on mechanized boxes in which polarized lenses, motors, and lights combined to make slowly changing forms. The basic esthetic thrust of the artists associated with the Center was nonetheless in another direction, toward the use of the invisible "natural" forces that Takis first emphasized. The Center in fact named its bulletin and its exhibition gallery after Takis's *Signals*, his tall, blinking light pieces. In its prospectus, these artists declared they were interested not only in light and movement "but in heat, sound, optical illusion, magnetism, contraction and expansion of materials, water, the movement of sand and foam, fire, wind, smoke, and many other natural and technological phenomena." They also expressed their determination to involve art in architecture and city planning, rather than "decoration."

The most ambitious of the Signals artists

David Medalla. *In Agriculture, Learn from Tachai.* 1964. Mobile construction. This kinetic work draws patterns on sand. Collection Paul Keeler, London. Photo by Clay Perry.

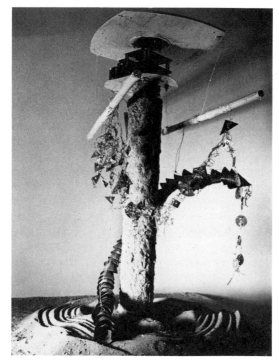

The Centre for the Studies of Science in Art, London. *Light as a System of Energy,* 1969. Lenses, design, projectors. 10' x 7' x 2'. A maquette designed to illustrate the action of light in the environment—on vegetation, marine life, etc. Courtesy Marcello Salvadori. Photo by Evelyne Kane, London.

was the Philippine emigré David Medalla. He combined the childlike wit of Tinguely with the invisible forces celebrated by Takis. He filled boxes with chemicals that produced thousands of tiny bubbles in response to low-level electrical currents and called them *Bubble Machines.* He also created a *Salt Machine* and a *Mud Machine* for an exhibition in 1967, all kinetic constructions interacting with natural materials. In 1964, he made a mechanized mobile that scratched patterns in the sand, an echo of Tinguely's earlier *Meta-Matics.* More important, Medalla announced in an early issue of *Signals* a series of fantastic projects, from "Hyprophonic Rooms" (filled with edible mushrooms and surrounded by melting walls) to "Braille Sculptures" and "Transparent Sculptures That Sweat and Perspire" (cooling down and reducing in size when the viewer fans them).

In time, the Signals group disbanded, but Salvadori carried on its philosophical purpose by opening the new Centre for the Studies of Science in Art in 1967. There Salvadori brought groups of artists, engineers, and scientists together for the study of related esthetic and environmental design problems. Far closer to the ground of the artists' immedi-

ate needs was SPACE and the Artists' Placement Group, or APG. The former group, led largely by Bridget Riley and the painter Peter Sedgley, sought out cooperative studio buildings, vitally necessary for artists involved with new and expressive media. The APG began under Barbara Latham, wife of artist John Latham. The APG's purpose, like SPACE's, was administrative, not esthetic. It tried to arrange places for artists within industrial firms, where each party could benefit from the expertise of the other. Backed by grants from the British Government's Arts Council, the APG managed just that, in some cases persuading large steel firms to pay stipends to the artists, as well as guarantee them access to materials and technical help. By 1969, however, John Latham admitted that the project, though often successful, was fraught with potential frustration: "The industry's organizational premise either repels an artist or it presents him with the most exciting, provocative context one could possibly imagine." In 1971, the APG declared itself a charitable trust and sought financing to continue its operations over a three-year period.

Gustav Metzger, a Polish-born London resident, manifested a unique attitude toward

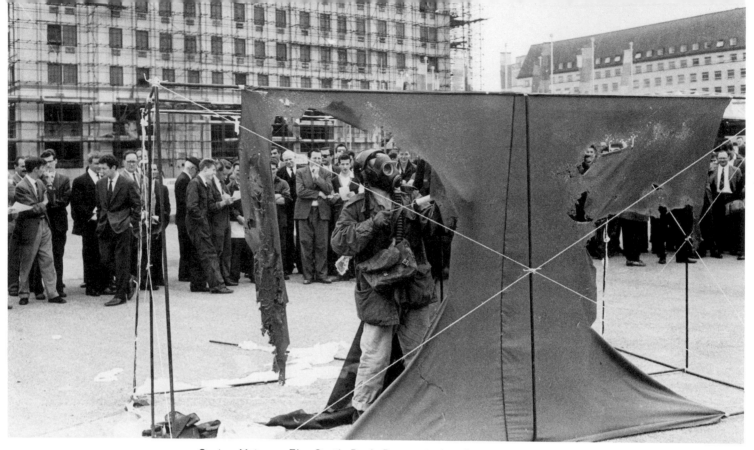

Gustav Metzger. *The South Bank Demonstration,* London, 1961. The artist sprays hydrochloric acid on a 7' x 12' nylon canvas; corrosion begins immediately upon contact. Photo by Syndication International, London.

technology, at least during this period. Like John Latham (who burned stacks of art histories in a series of gestural "performances"), Metzger had roots both in Dada and the early Tatlinesque phases of Constructivism. A painter until 1957, he turned in 1960 to a process he called "Auto-Destructive Art," at first pouring acids on nylon-covered stretchers that slowly devoured the canvases. In a lecture-manifesto delivered before the Architectural Arts Association in London in 1965, he declared that Auto-Destructive Art was motivated by "aesthetic revulsion" over the self-destructive course of Western society, implemented at every step by the negative forces implicit in new technology, particularly in modern weaponry. The only proper response, he maintained, was to create an art that forces the viewer to reject its destiny, that of slow, steady self-immolation. Interestingly enough, Metzger did not shrink from using technology in his own work. In the same speech, he outlined several visionary auto-destructive projects involving steel, moving parts, electronics, and a digital computer

(the latter employed to program the disintegration of 10,000 metal elements in five 30-foot walls over a period of ten years). Even at its most pessimistic fringe, the new art in Britain was now ready to draw on the environment as both material and subject matter.

Metzger was in no sense a mainstream artist, courted by galleries and press. Caro and his formalist colleagues stood in the center until the early 1970's, along with metropolitan Pop practitioners such as Hamilton, Billy Apple, Joe Tilson, and others, who grew increasingly adventurous. Apple made neon sculpture of great force and originality; Tilson adopted vacuum firing; Richard Hamilton based an interesting lithograph, *Kent State,* on a photograph taken of a television screen, about which I will write in the final chapter.

Beyond the center, however, the real vitality of the postwar British generation asserted itself, and not only among the conceptually oriented, nonobjective artists such as Richard Long, Sue Arrowsmith, and the Art-Language Press (organized in Coventry by Terry Atkinson, Michael Baldwin and others.)

There is much yet to discover about the multi-media events, happenings, and street performances that took place during the 1960's in such cities as Leeds, Liverpool, and Bradford. Many were rich with technological implications; Albert Hunt, an influential teacher at the Bradford College of Art, even managed a full-dress recreation of the Russian Revolution in the streets of the city in 1967, in the manner of the early Constructivist street spectacles. In London itself, John Hopkins established a center of sorts for both events and advanced rock music at the UFO, on Tottenham Court Road.

These artists—about whom Jeff Nuttall writes in *Bomb Culture*[40]—reflect the vitality of British popular music, the Beatles included. Like Metzger, they were repelled by the threat of technology; many of them had been involved in organizing the Campaign for Nuclear Disarmament (CND). The person and the novels of William Burroughs were a force in the British underground at this time, which maintained in a perversely vanguard manner the British arcadian tradition. The underground doubted the machine even while using it, in the manner of Metzger and of the iconoclastic novels that were collaged together by Burroughs from random tape recordings. A choice example of this strategy is the work of Mark Boyle, who developed a special brand of experiential art, recorded and transformed through contemporary media. He photographed, filmed, and videotaped "sites," insects, and microorganisms in the environment. Often the results of what he had seen were played back in slides, as environmental accompaniment (with light projections) for dance and musical groups. His *Son et lumière for insects and water creatures* spread blown-up evidence of wriggling, wormlike forms on the wall; *Liquid line* projections were combined with writhing dancers. Boyle declared himself "OPEN TO EVERYTHING WITHOUT THE FILTERING OF PSYCHOLOGICAL SHOCK BARRIERS OR THE DISTORTING OF INTELLECT OR DRUGS." At the ICA in London in 1969 his work—appropriately enough accompanied by "The Soft Machine," a rock group—surrounded the viewer with soft, organic imagery. He called the installation *Journey to the Surface of the Earth*; flames, waves, and tiny, struggling life surrounded the viewer, one set of images flowing easily into the other. No matter how radically expressed, the arcadian spirit was there, at one with the imagery.

Richard Hamilton. *Kent State*, 1970. Silkscreen. 34½" x 26½". Courtesy Galerie Dorothea Leonhart, München, Germany.

Mark Boyle. *Liquid Line Projection*, 1969. Slides, light, and live dancer.

The Radical Shift:
Technology as Creative Force

The Late 1960's in the United States:
The Movement Becomes Explicit

Just as there is no precise parallel in the American experience for the flood of manifestos and declarations that launched technological art in Europe early in this century, there is really no "group" phenomenon either. During the late 1960's, American art devoted itself to technology far more explicitly and self-consciously than before, but the causative agents were individual breakthroughs made by "artists" in the traditional sense.

Among the early exceptions were the Anonima Group, which confined itself largely to the production of paintings and drawings with strong retinal impact, and USCO, which pushed further in the direction of anonymity than any other American group. The "Us Company," formed in 1962, set up shop—plus a permanent environmental light display—in an abandoned Garnersville, New York, church. Including artists, engineers, poets, and filmmakers, USCO mixed film, tapes, slides, and light in its audiovisual performances, each in strong, unmodulated quantities. They gladly exchanged finesse for quantitative impact, the very "overkill" that the Korean artist Nam June Paik later associated with indigenous American art. USCO's leaders were strongly influenced by McLuhan's ideas as expressed in his book *Understanding Media.* Their environments—performed in galleries, churches, schools, and museums across the United States—increased in complexity with time, culminating in multiscreen audiovisual "worlds" and strobe environments. They saw technology as a means of bringing people together in a new and sophisticated tribalism. In pursuit of that ideal, they lived, worked, and created together in virtual anonymity. "We are all one," the group declared in a statement in the *Kunst Licht Kunst* catalogue, "beating the tribal drum of our new electronic environment."

USCO's open dedication to the use of technology in art is one of the earliest indications that American innocence in this regard, whether intentional or not, was at an end. By the late 1960's, the work that had been done in Europe was well known in the United States, much of it through the Howard Wise Gallery in New York, which helped to fill the vacuum left by American museums; the theories of both McLuhan and architect-designer-engineer-visionary R. Buckminster Fuller were by then common parlance. McLuhan had maintained in *Understanding Media* (1964) that the new communication media girdled the globe like nature itself, steadily altering both our sensibilities and our means of perception. The new man, he predicted, would be oriented by television toward his senses rather than his mind, toward broad tribal rather than nationalistic patterns of behavior. McLuhan linked specialization and fragmentation with the beginnings of man's dependence on print as information, in the Renaissance. Fuller had insisted from the beginning of his career in the late 1920's—from the days when he designed totally prefabricated and transportable "Dymaxion" homes, cars, and bathrooms—that the new technology would radically alter the entire globe. Between 1955 and 1965, however, when his spherical geodesic dome structures spanning wide spaces at low cost gained widespread acceptance, particularly from industry, Fuller's theories won new respect. His book *Nine Chains to the Moon,* first published in 1938, was opened and read again; there Fuller argued—like McLuhan—that technological change carried with it radical social and economic implications. If we properly organize and direct our new resources, Fuller claimed, we can rid the globe of physical and spiritual poverty. Like Banham's later writings in England, Fuller's stimulated a new generation of architects devoted to disposable and removable structures, designed for a kinetic society.

By 1966, a pivotal year in American art in any case, the idea that technology represented an alien, anti-human, anti-art force had been cast in doubt. In retrospect, the time appears to have been ripe for the project, launched by Robert Rauschenberg and Swedish engineer Billy Klüver, that culminated in the founding of Experiments in Art and Technology, Inc. (EAT). Klüver had appeared on the New York scene as technical assistant for Jean Tinguely in the creation of

USCO—"The Us Company"—at their church-studio in Garnersville, N.Y., 1965. A photo-collage. Courtesy Gerd Stern.

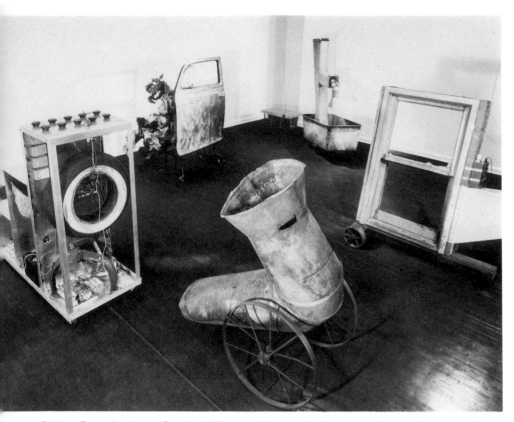

Robert Rauschenberg. *Oracle,* 1965. A radio-controlled construction in five parts. Music and sound are projected from each part in programmed sequence. Engineer: Billy Klüver. Courtesy Leo Castelli Gallery, New York. Photo by Rudolph Burckhardt.

the self-destroying machine, *Homage to New York,* in 1960. Employed by Bell Laboratories in nearby Murray Hill, New Jersey, as a research engineer, he gradually extended his ties with American artists during the next six years. He collaborated with Merce Cunningham on *Variations V;* with Warhol, on his floating, helium-filled "clouds"; with Johns, on paintings that employed neon lights as part of the surface; and with Rauschenberg on *Oracle,* a five-part piece of sculpture employing remote-controlled radios. These early collaborations were haphazard, of course, linked in nature with the nonprogrammatic American decade described earlier in this book. No controlling premise—esthetic, philosophical, or political—seemed to ground them. Klüver was available and the artists used him, no more.

Into this breach came a proposal from Stockholm, where a festival of "art and technology" had been scheduled for the fall of 1966. A number of artists in New York were to supply orders to Swedish engineers, who would then implement them. But by 1965–66 the conviction had been growing in Klüver's

and Rauschenberg's minds that the process of collaboration was all-important. The Americans wanted to engage with the engineers in an ongoing dialogue from the point of conception until the realization of the project. For a variety of reasons, some financial, Stockholm could not accommodate this demand; finally, there were two festivals rather than one. The American version turned into *Nine Evenings: Theater and Engineering,* presented in New York in October, 1966, at the 69th Regiment Armory on Lexington Avenue, the scene—in 1913—of the influential "Armory Show" that especially introduced European vanguard painters to the United States.

Behind *Nine Evenings* there was, from the first, a primary interest in the collaborative process itself rather than in either teamwork or anonymity. That interest stemmed from an attitude implicit in nearly all postwar American art, from action painting and Happenings to *Nine Evenings,* an attitude that placed as much emphasis on what it considered to be the process of making art as it did on the final result. Even the action painters, for all their traditional involvement with brush and canvas, betrayed this frame of mind when they emphasized the importance of "going with" the material rather than subjugating it to prior plan. Pollock enjoyed painting his canvases while they were stretched on the floor, he said, because he felt "literally in the painting"; and Allan Kaprow credited his interest in the Happening partly to photographs of Pollock at work: they intrigued Kaprow more than the paintings themselves. Kaprow's Happenings finally evolved to the point where they could be joined by participants only, a position close to that of Cage, whose music was based more and more on participation with the sounds in the environment, be they radio static or coughing in the audience. In the case of both Kaprow and Cage the end result was not of prime importance. Although each represented extreme positions in 1966, their ideas were widely accepted in New York and elsewhere, to varying degrees. When it came time, then, to cede a certain amount of creative control not only to the engineer but to the machine, the Americans were even readier than the Europeans to do so. The subtle control of technology I have already discussed in the work of Nicolas Schöffer and Julio Le Parc was not their prime concern; in some cases, it was anathema.

In any case, Klüver went immediately to work in 1966 organizing not only a group of

artists but a group of engineers, most of the latter recruited from Bell Laboratories (where he also worked, researching the physics of infrared lasers). What he finally came up with proved to be an undertaking larger than either he or his colleagues had believed possible. Over 850 engineering hours went into the preparation of *Nine Evenings,* worth at least $150,000, on paper. During the actual performance, nineteen engineers contributed more than 2,500 hours. The real cost of the extravaganza was more than $100,000, much of it begged and borrowed. The total audience for the nine days was 10,000.

Many of them, to say the least, were disgruntled and disappointed. Cage compared *Nine Evenings* to "the early movies," when camera, stage, and literary content seemed to function independently of one another. More irritating for many spectators were the interminable delays between performances and the frequent technical breakdowns, particularly in the public-address system. Each of the nine participating artists presented two performances, most of them without benefit of rehearsal time. Consequently, the second performances proved to be considerably better than the first. But the New York audience, conditioned by Broadway, packed in for the opening nights, as did the critics. The press reviews, needless to say, were uniformly bad.

This reaction was partly the result of the wide gap between the central idea motivating the artists and the audience's expectations. When it was all over, Klüver declared that it "makes no difference" whether technology actually works in art or not. In a conversation later published in *Art in America,* he went further: "The relationship between art and technology should be experimental and intuitive, in the same sense that scientific research is . . . and therefore full of risks. . . . We know for sure we can always make something work."[41]

In point of fact, *Nine Evenings* achieved more technical success than its critics allowed. There was, to begin with, the patchboard system. Each artist's performance was prewired: all of his equipment could be hooked up by inserting his particular patchboard. The system included amplifiers, relays, decoders, tone-control units, transmitters and receivers; it also included a "proportional control" network that made it possible to change the intensity and volume of both light and sound by moving a flashlight over sixteen photo-

John Cage, in performance of *Variations VII,* 1966. Part of *Nine Evenings: Theater and Engineering,* New York. "It is a piece of music indeterminate in form and detail," Cage stated, "making use of the sound system which has been devised collectively for this festival . . . using as sound sources only those sounds which are in the air at the moment of performance, picked up via the communication bands, telephone lines, and microphones, together with, instead of musical instruments, a variety of household appliances and frequency generators." Performance engineer: Cecil Coker. Courtesy Experiments in Art and Technology, Inc., New York. Photo by Peter Moore.

Robert Whitman. *Two Holes of Water,* 1966. An intermedia theater piece for *Nine Evenings.* Courtesy Experiments in Art and Technology, Inc., New York. Photo by Robert R. McElroy.

Yvonne Rainer. *Carriage Discreteness,* 1966. An intermedia theater piece for *Nine Evenings.* The dancers were moved about the space by Miss Rainer via walkie-talkies. Slide projections, lights, sound, and various photo-chemical phenomena were programmed and performed by TEEM (Theater Electronic Environment Modular Systems). Courtesy Experiments in Art and Technology, Inc. New York. Photo by Elliott Landy.

Deborah Hay. *Solo,* 1966. An intermedia theater piece for *Nine Evenings.* The dancers were guided around the floor on motorized platforms by remote controls. Performance engineer: Larry Heilos. Photo © 1966 by Peter Moore.

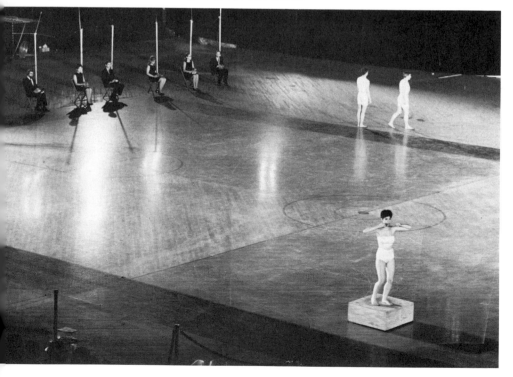

cells ("The idea," Klüver said, "was an onstage electronic system which could be carried around in your pocket"). There was a "ground-effect machine" for Lucinda Childs's dance piece, *Vehicle,* that lifted a performer off the floor to move about on a scant but real cushion of air. There were tiny but powerful amplifiers that magnified the internal sounds of Alex Hay's body as he sat before a huge television screen projecting his image in *Grass Field.* There were snow storms and an antimissile missile in Öyvind Fahlström's *Kisses Sweeter Than Wine.* There was an infrared television set for Rauschenberg's *Open Score,* which transmitted to the audience television pictures of a crowd moving across the Armory floor in total darkness, plus electronically wired tennis rackets that turned lights off every time they contacted a ball. There was a sensitive system that enabled John Cage to pick up sounds from the environment outside the Armory (including outer space, via telephone).

Finally, there was David Tudor's *Bandoneon!,* which took a significant step, little noticed at the time. *Bandoneon!* incorporated programmed audio circuits, moving loudspeakers, TV images and lights; both the sound and the images (which were projected onto large screens), filled the Armory. Far more important, however, was this fact, declared in the *Nine Evenings* program by David Tudor:

> *Bandoneon!* . . . is a combine . . . [it] will create signals which are simultaneously used as materials for differentiated audio spectrums (achieved through modulation means, and special loudspeaker construction), for the production of visual images . . . for the activation of programming devices controlling the audio visual environment. . . . *Bandoneon!* uses no composing means; when activated it composes itself out of its composite instrumental nature.

The composer-artist had ceded the final shape of his piece to the machine or, to be more precise, a combination of machines interacting with one another. Tudor had gone beyond programmed, self-playing instruments like Wilfred's *Lumia,* into unprogrammed self-creation. Rudimentary as *Bandoneon!* was, it heralded a series of related developments in the years to come, developments that brought technology more fully into the creative process.

If there was commercial "fallout" from *Nine Evenings* (among other things, a phos-

phor was discovered that has proved valuable in infrared laser research),[42] there was intellectual fallout as well. For better or worse, *Nine Evenings* put both the engineer and his media on equal footing with the "artist," whatever that term had come to mean. Rauschenberg had once spoken of collaborating with the neighborhood in the creation of his combines. Now he was collaborating in a very real sense with contemporary electronics, in the creation of *Open Score*. Without those wired tennis rackets and infrared television sets, the piece could not have existed. The object of collaboration between artist and engineer, Klüver pointed out, is a work neither could have created alone.

The Radical Shift:
The Artist-Engineer-Machine

Within the context of Klüver's position were genuinely radical seeds. As we have seen, the relationship between art and technology is in no sense brand new. In several ways, indeed, the relationship dates back to Leonardo and beyond. There is, first, the use by the artist of materials produced by recent technology (acrylic paints, as employed by Morris Louis; acrylic plastic, by Zammitt; photocells, in Cage's *Variations VII*, the *Nine Evenings* concert; styrofoam, by Mel Johnson and Calvin Albert). Second, there is the use of new methods derived from technology (Craig Kauffman's vacuum forming, Larry Dell's optical coating machine, Gustav Metzger's digital computer), and, third, of new knowledge, drawn from science and all its related disciplines (Leonardo's studies in anatomy, Lucio Fontana's readings in physics, Edwin Mleczkowski's in optical science). Fourth, there is the use of new imagery suggested by both science and technology: Bracelli painted knife grinders in the seventeenth century, the Futurists locomotives; Richard Hamilton used the TV image in collage, Lowell Nesbitt the IBM 1440 computer in painting.

The only difference between past and present in these four cases is one of degree, that is, of the radically shortened gap in time between the new product or idea and its use in art. The Bauhaus and the Artist's Placement Group in London were instruments that helped to narrow that gap, as have certain American organizations that sprang to life post-*Nine Evenings* (for example, Experiments in Art and Technology, Inc., and the Center for Advanced Visual Studies at MIT). Norman Zammitt was bequeathed acrylic plastic, but twenty

Lucinda Childs. *Vehicle,* 1966. An intermedia theater piece for *Nine Evenings.* This "dance" was lighted in part by incoming sound waves from radio station WQXR; depending on their frequency, the waves turned the lights on and off, thus participating in the creation of the visual structure. Performance engineer: Peter Hirsch. Courtesy Experiments in Art and Technology, Inc., New York. Photo by Les Levine.

Alex Hay. *Grass Field,* 1966. An intermedia theater piece for *Nine Evenings.* Photo © 1966 by Peter Moore.

years after its appearance—and then he had to struggle to gain the means of employing it properly. Larry Bell was operating across a twenty-year gap with his machine, as was Lowell Nesbitt (the first "modern" computer, ENIAC, did not appear until 1944).

Nine Evenings virtually eliminated the gap in time between idea and application in two cases—the phosphor and the unique proportional control system—although the average throughout the "performance" was more nearly one to five years. It is an average that artists have been able to maintain easily ever since. Laser light had barely reached the open commercial market in the mid-1960's when Robert Whitman employed it in a show at the Pace Gallery in 1967, intersecting two pencil-thin beams in a darkened room; California artist James Turrell used laser light in an exhibition at the Pasadena Museum the following year; so did Rockne Krebs, in a light performance at the Washington, D.C., Gallery of Modern Art. James Tenney, Gerald Strang, and others have composed music on the most advanced computers. Bruce Nauman seized on the hologram (a three-dimensional image produced by a laser and a photosensitive screen) before the public even understood its fundamentals.

The only radical alteration in this alliance lies in the growing willingness of the contemporary artist to cede technology—either the engineer or the machine—a full partnership in the creative process. The contributions of Klüver and other engineer craftsmen, stretching back to Moholy-Nagy's collaborators Sebök and Ball, signal this new phase. *Nine Evenings* in general, and *Bandoneon!* in particular, went a step further, thus mixing art and technology more evenly than had the Europeans, with certain exceptions.

I do not contend that it was Klüver's or Tudor's conscious intention to establish the creative equality I have been discussing. Klüver in particular has always disclaimed any pretensions to, or interest in, the artist's role. I do contend, however, that the process of collaboration itself has driven artists everywhere into a closer, more symbiotic relationship with technology than possible at any time in the past. The cause is clear. Collaboration enables the artist to obtain practical knowledge otherwise unavailable. He becomes familiar with his material. He discovers precisely what an audio circuit or a computer can do, when taken out of its original functional context. More often than not, he exploits what he knows far beyond the initial collaboration. He liberates the machine in spite of himself. He also liberates the engineer, to the point where the split between artist, engineer, and even machine ultimately disappears.

The American Platform: Toward Fusion

Collaboration was still rare in the United States at the end of 1966, but the principle had been affirmed by *Nine Evenings*. "I think of it," wrote Öyvind Fahlström, one of its participating artists, echoing Gropius, "as initiation rites for a new medium, Total Theatre."

Klüver and Rauschenberg followed their performances by founding Experiments in Art and Technology, Inc. (EAT), dedicated to matching artists and engineers throughout the country. Announced at the end of 1966, EAT was physically operative in a Manhattan loft by the beginning of 1967, compiling lists of engineers willing to collaborate with artists in specific fields of expertise, holding lectures and technical demonstrations each Sunday, publishing a newsletter, lending equipment left over from *Nine Evenings*, seeking support from both industry and business, and developing chapters outside New York.[43] At first, applications for membership from artists greatly outnumbered those from engineers. By the end of EAT's second year, however, the tide reversed; in the early 1970's, the 6,000 members were divided equally between artists and engineers. EAT also received support from the American Foundation on Automation and Employment, in whose new building, Automation House, it was granted exhibition space.

There were two major EAT projects: *Some More Beginnings*, an exhibition organized at the Brooklyn Museum in 1968, based on an open competition with prizes going to collaborating engineers (there were more than 100 entries with eight foreign countries participating); and The Pepsi-Cola Pavilion, opened in 1970 at "Expo 70," the World's Fair exhibition in Osaka, Japan. A team of artists and engineers, including Robert Breer, David Tudor, Klüver, and Fred Waldhauer, built a programmed environment of sound and reflected imagery inside the pavilion, within which live performances took place. EAT's goals during the 1970's included the promotion of artists-in-residence programs with industry and engineers-in-residence within the museum world.

The organization offended as many artists as it pleased, through its aggressive promo-

tion policy and its insistence on upgrading the status of the collaborating engineer. EAT was nonetheless responsible for a great many works otherwise impossible—nearly 500 during its first two years. They ranged from Carolee Schneeman's multimedia Happening, *Snows*, presented early in 1967, and Jean Dupuy's haunting *Heart Beats Dust*, a black box in which brilliant red dust reverberated to the amplified sound of live and recorded heart beats (constructed with the help of engineers Ralph Martel and Hyman Harris for *Some More Beginnings*), to Lucy Young's *Fakir in ¾ Time*, another entry in the open competition, a ribbon cord that holds itself continuously rigid in the air with a system of gear motors.

On a different level, Gyorgy Kepes's Center for Advanced Visual Studies evolved the same way, emphasizing activity rather than theory. In his first proposal, to be sure, Kepes had emphasized the development of "new ideas," not works of art. The Center opened in the fall of 1967 with the support of MIT and several industrial firms in the Cambridge area, one of them the Sylvania Corporation, with which Kepes had worked in the past. The Center's activities were at first more focused than EAT's: Kepes attempted to involve the handful of fellows in common projects, such as the tower of light he had dreamed about for Boston Harbor. As artists like Otto Piene, Takis, and Jack Burnham came into the Center, however, its real, empirical value began to be demonstrated, that of a dialogue between artists and the unparalleled scientific brainpower resident in Cambridge. Kepes himself sensed this. He began to stress the difference between his Center and the wider, necessarily looser nature of the collaborations generated elsewhere: "Close, ongoing contact with the man who sees the vista, that's what we are beginning to develop; so that the artist makes friends with more than a man: an idea."

As the second postwar decade came to a close, the interest in fusion was widespread, not only among artists but among engineers, scientists, businessmen, and even American museums all willing to collaborate in the production of works utilizing recent technology. The torch carried so long by the Europeans passed now—for a brief time, at least—to the Americans, who seized upon esoteric materials and methods with a zest approaching the uncritical. The zest was based on a variety of factors, from simple proximity to the new technology to the pervasive influence

Lucy Jackson Young. *Fakir in ¾ Time,* 1968. Aluminum, plastic, and motors: 30" x 25" x 16". The textile cord extends from 4" to 40" above the base. Engineer: Neils O. Young. Courtesy Brooklyn Museum, New York. Photo by Shunk Kender, Paris.

of the action painting–Happening esthetic. The next several years witnessed a substantial increase in American participation, matched by continuing European vitality. In both scale and open recognition of the technology employed, these experiments surpassed most of the work that had preceded them.

New Media/New Scale: Physical and Temporal

The theme yoking much of this work together was an extension into scale of all kinds, physical and temporal. Schöffer, for example, received a commission to build a giant cybernetic light tower in Paris. Tinguely planned a massive and ironic machine-cultural center, *The Gigantoleum*, to be constructed in Switzerland. In 1968, the Nelson Gallery in Kansas City invited eight artists, James Seawright, Stanley Landsman, and composer Terry Riley among them, to create environmental works, with the help of Kansas City industry, for a show entitled *The Magic Theater*. The results—by quantitative standards—were extraordinary. Seawright contributed an *Electronic Peristyle*, where twelve black formica columns, triggered by an electronic "brain" placed in the middle, performed light, sound, and wind maneuvers as spectators passed by the columns. Landsman constructed a *Walk-in Infinity Chamber*, containing 6,000 miniature lights, each reflected by mirrors forty to fifty times, in a ceaseless playback between source and reflection. Riley's *Time-Lag Accumulator* picked up the sounds of the spectators moving through one chamber, recorded them, and played them back two minutes later in another chamber. John Cage joined with Lejaren Hiller in 1969 to create a live concert of imposing technological means, *HPSCHD*, in the 18,000-seat Assembly Hall at the University of Illinois. The composition utilized not only computers but seven harpsichords, fifty-two tape machines, fifty-nine power amplifiers, fifty-nine loudspeakers, and two hundred and eight computer-generated tapes.

American museums discarded their reserve, for a brief period. *Focus on Light*, a retrospective of impressive quantity, took

Left: Christo. *5600 Cubic Meter Package,* 1968. Trevira fabric, wires, polyethylene ropes. Erected for the *Dokumenta* exhibition in Kassel, W. Germany. 280' h., 33' diam., 14,000 lbs. Five truck cranes were used to lift this giant inflated structure into the air. Engineer: M. Zagoroff. Photo by Thomas Cugini.

Ronald Bladen. *The X* in construction, 1967. Courtesy The Corcoran Gallery of Art, Washington, D.C.

James Rosati. *Wichita Tripodal* in construction, 1972. Courtesy Public Information Office, Wichita, Kansas.

James Seawright. *Electronic Peristyle,* 1968. Black formica columns, lamps, audio amplifiers and speakers, fans, electronic control systems. For *The Magic Theater* exhibition, at the Nelson Gallery in Kansas City, Mo. As spectators enter the space, they activate the columns to produce varying light, sound, and air patterns. Courtesy Nelson Gallery of Art, Kansas City, Mo. Photo by Larry B. Nicholson.

Terry Riley. *Time-Lag Accumulator,* 1968. Glass, aluminum, and mylar containing microphone and tape units. For *The Magic Theater.* A labyrinth of sound, made by visitors, whose voices are recorded and replayed an instant after they are heard. The artist's plan accompanies the photograph. Courtesy Museum of Contemporary Crafts, New York, and American Foundation on Automation and Employment. Left: Photo by Larry B. Nicholson. Right: Courtesy Nelson Gallery of Art, Kansas City, Mo.

place at the State Museum in Trenton, New Jersey, in 1967, calling attention to the link between painterly and mechanical uses of light as a medium. One year later, at the Museum of Modern Art in New York, Pontus Hulten's *The Machine as Seen at the End of the Mechanical Age* centered on the link between past and present, between Constructivism-Futurism and EAT. The most visionary of all these museum projects took place in California, at the Los Angeles County Museum of Art, where curator Maurice Tuchman persuaded a group of giant corporations, among them IBM, Lockheed, TRW Systems, The Rand Corporation, and Litton Industries, to donate time, money, and technical assistance to artists in residence.

The results were in the end physically impressive but conceptually disappointing. Claes Oldenburg exhibited a massive Pop icon—a salmon-pink ice bag that writhed upward, slowly and sensually, to a height of sixteen feet—made in collaboration with Gemini G.E.L., the Los Angeles graphics workshop. Andy Warhol covered a wall with 3-D flower images engineered by Cowles Communications Corporation. Roy Lichtenstein, with the assistance of Universal City Studios, set one of his "dot" paintings into motion by combining two films with a rear-screen projector. Robert Whitman, working with engineer John Forkner of Philco-Ford, created a labyrinth of reflective mirrors. Rockne Krebs created an

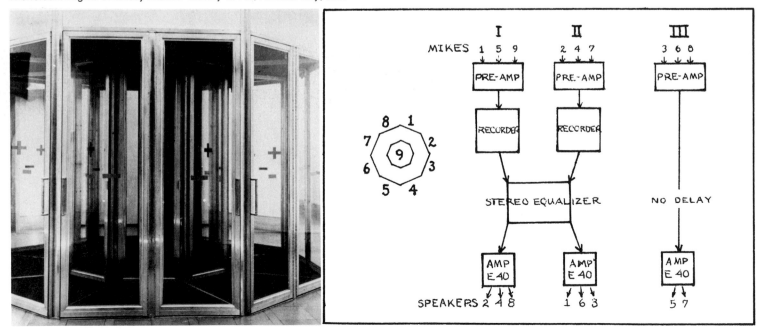

ambitious, city-wide laser display. Rauschenberg, aided by Teledyne, produced a responsive, interactive mud environment.

These physical splendors could not hide the difficulties involved in implementing anything resembling close collaboration. Genuine interaction between the two sides had been rare.[44] Frequently, the artist had ceded little to the other side, using the participating company as a glorified tool to execute images long since a fixture in his esthetic repertoire. Claes Oldenburg pointed out that the process of working with an engineer was "painful, for both sides. . . . It's a challenge to the artist's subjectivity."

Both sides, clearly, were being challenged and shaken. On a number of occasions, large companies began collaborations only to withdraw later, on grounds usually related to an insufficient return in terms of publicity or exhibition. Walt Disney refused to build Oldenburg's ice bag; it was contracted out to smaller companies. Philco-Ford withdrew sponsorship of Robert Whitman's mirrors after initial work had begun. French artist Jean Dubuffet clashed with American Cement, closing off a project completely. Beyond Los Angeles, there was also evidence of an unwillingness on the part of galleries and museums to install and maintain properly the new technological art. Time and again, exhibitions were opened with great flourish, only to run slowly down piece by piece, as time passed. The Smithsonian Institution in Washington, D.C., imported an entire exhibition, *Cybernetic Serendipity*, from the Institute of Contemporary Arts in London, in 1969, then decided not to install it because of its technical complexity. The Corcoran Gallery, its neighbor, invested in a team of three engineers who promptly put the pieces into working order. Even then, the space allotted *Cybernetic Serendipity*—and virtually every large "anthology" exhibition of the new art—was far too small. Rooms suited to the display of many paintings at once were not suited to the manifold presence of active constructions, competing with one another in several dimensions from sound to movement. Careless, inadequate installation reflected more than insensitivity on the part of the art establishment toward the new work; it often reflected a lack of commitment disguised by facile acceptance.

At the beginning of the 1970's, these difficulties simply emphasized the strength of the movement that had begun during the 1920's,

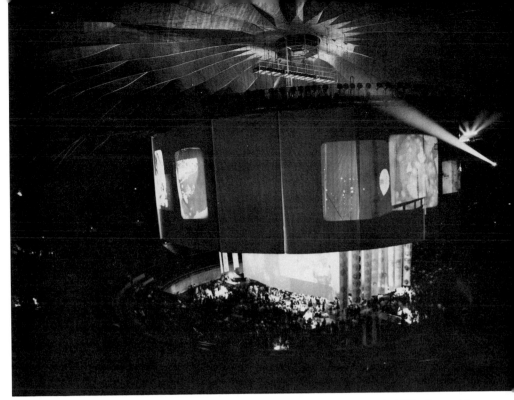

John Cage, with Lejaren Hiller. *HPSCHD*, a concert performed on May 16, 1969, Assembly Hall, University of Illinois, Champaign, Illinois. Among the sound sources were 52 tape recorders, 7 harpsichords, 59 power amplifiers, 11 loudspeakers, and 208 computer-generated tapes. Courtesy Assembly Hall, University of Illinois, Champaign.

Claes Oldenburg at work on his *Giant Icebag*, 1969. Part of the *Art and Technology* exhibition organized by the Los Angeles County Museum, the *Icebag*, when finished, rose and fell on its own motorized power, expanding to a height of 16½', in diameter to 18'. Courtesy Los Angeles County Museum of Art. Photo by Malcolm Lubliner.

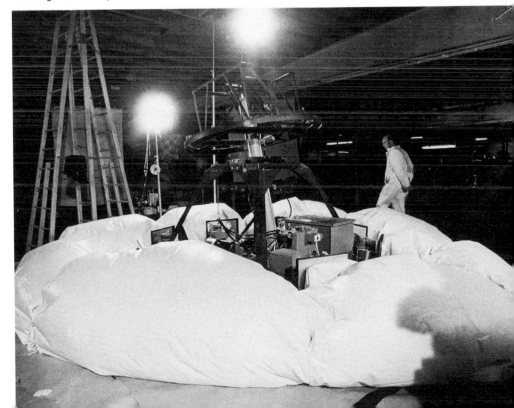

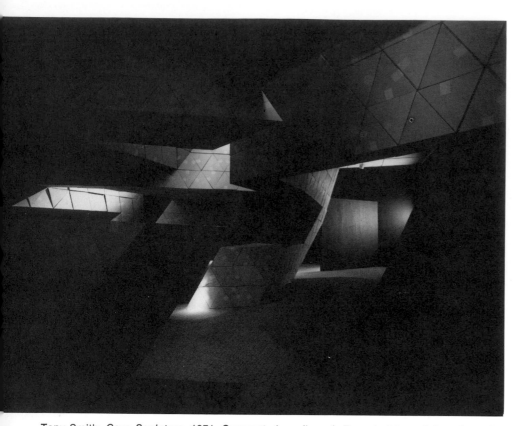

for it persisted in the face of old and stubborn fine art–commercial attitudes. Pontus Hulten's exhibition brought this era to a close, as he correctly suggested in his title (*The Machine as Seen at the End of the Mechanical Age*). To Hulten this meant the decline of machinery as a major esthetic medium in the new computer age, with its dependence on electronic circuitry. But the change has as much to do with the place and purpose of art as it does its media. The age of machinery was an age in which artists persisted in the attempt to adapt new materials to an acceptable "inside" esthetic, for quiet display in galleries, museums, and homes. As the 1960's ended, the new media were radically reshaping minds, guaranteeing that art was only beginning—along with society—to transform itself.

The interest in scale alone is a case in point. Aristotle said in the *Poetics* that no sane man would call an object one thousand miles long "beautiful." But the new artist, endowed by technology with the means to create in unparalleled scale, and with the vision needed to comprehend it, seemed quite ready to do just that. In 1961, the Italian artist Piero Manzoni drew a line—a kind of refutation of Aristotle—from Amsterdam to Milan.[45]

Tony Smith. *Cave Sculpture,* 1971. Corrugated cardboard. Executed in collaboration with the Container Corporation of America for *Art and Technology.* Courtesy Los Angeles County Museum of Art.

Richard Serra. *Untitled,* in process, 1969. A steel slag sculpture at Kaiser Steel Corporation, Los Angeles, for *Art and Technology.* Courtesy Los Angeles County Museum of Art.

Jackson MacLow composing a poem via computer at Information International, Inc., in Los Angeles, July, 1969. For *Art and Technology.* Courtesy Los Angeles County Museum of Art.

In the mid-1960's, pieces of sculpture were being turned out in lengths of twenty to thirty feet as a matter of course. The metal sculpture of Alexander Liberman, based in old boilers and junked farm machinery, became so ponderous that he needed a bulldozer to push and shape it into place. In 1968, Christo erected a "packaged" tower approximately 1,000 feet high at the *Documenta* exhibition in Kassel, Germany. The following year, Robert Israel displayed at the Whitney Museum a length of vinyl-covered tubing stretching 100 feet. Robert Smithson proposed a design for the Dallas-Fort Worth Airport that would function as a work of art "from the sky down." In the mountains of Colorado, Dean Fleming hung a series of paintings in trees that stretched back for miles, each painting larger than the last, so that the spectator saw in effect a series of identical paintings over a large landscape. Schöffer had used the entire urban landscape for his *Lumino-dynamic Spectacles*, particularly in the *Spatiodynamic and Cybernetic Tower* erected in Liège, Belgium, in 1961, which interacts with the lights of the buildings around it (the nearby Congress Palace is itself programmed; powerful interior projectors create abstract patterns on the Palace's glass façade, which faces the *Tower*). The *Tower* also reacts to environmental noise with sound patterns of its own, scored by composer Henri Pousseur.

American sculptor Charles Frazier attacked the sky itself in 1966, with sculpture designed to fly through the air, in response to remote controls on the ground, using a small gas engine to power a balsa wood, silk, and aluminum structure through a one-minute flight. Before them, Leonardo and Moholy-Nagy had both dreamed about art in the sky; Kepes envisioned programming an urban light landscape for planes coming in to land; Yves Klein and the German architect Werner Ruhnau devised projects for "aerial architecture." It was not until the 1960's, however, that artists began actively to utilize sky space. The ZERO artists sent dozens of white balloons into the air in 1960 and followed them up with searchlights. Both Hans Haacke and Otto Piene continued to use the sky as a portable gallery, Haacke by stringing up a series of large white balloons across New York City in 1968. When Piene went to work at the MIT Center for Advanced Visual Studies, he launched a Series of *Light Line Experiments* in the air, one of them utilizing a helium-inflated tube 1,000 feet long. In another

Charles Frazier. *Aerial Sculpture,* 1965. Early experiment with navigable forms. Radio controlled, gas-powered, ducted fan configuration, built to work within 1,000-foot cube of air.

Otto Piene. *Lift and Equilibrium, an Outdoor Sculptural Experiment,* 1969, Cambridge, Mass. Inflated polyethylene tubes.

Otto Piene. *Cityscape,* 1970. Inflated polyethylene tubes. 1,800′ l. A "Sky Event" in Pittsburgh. Photo by Walter Seng, Pittsburgh.

Rockne Krebs. *Walker Night Passage,* 1971. Argon lasers and photon structures. Courtesy Walker Art Center, Minneapolis. Photo by Eric Sutherland.

Carl Frederik Reuterswärd. *Study for "Swedenborg Dreams,"* 1968. Laser-video image.

event, Piene filled the air with helium-filled "word-poems" standing 100 feet in the air, controlled by strings from the ground. In 1970, he was able to involve the entire city of Pittsburgh in a three-day series of similar events, which he called the *Citything Sky Ballet.*

Laser light, which can be projected across vast stretches of space without losing its intensity, was employed naturally in this way. The laser (an acronym for "light amplification by stimulated emission of radiation") was discovered in 1960. Its intensity and purity, unmatched by any other form of man-made light, promptly attracted the artistic imagination. In Sweden, Carl Fredrik Reuterswärd began planning works based on the laser as early as 1962; in 1968, he used "soft," eccentric laser beams, reflected by metal foil, in studio performances. In 1967, Americans Robert Whitman and James Turrell used laser light in gallery-museum projections, as I have already noted. The laser was put to full environmental use by Rockne Krebs in Washington, D.C., one year later and by Mike Campbell and Barron Krody in 1969 (in the first substantial *Laser Art* exhibition, at the Cincinnati Museum). All three artists constructed rooms filled with mirrors and varying degrees of smoke that intensified the laser's inherently pencil-like form; as the beams criss-crossed these rooms, they created complicated linear networks of radiant light.

Carl Frederik Reuterswärd. Laser light employed as the "spirits" in a performance of *Faust,* Stockholm, 1968.

Barron Krody. *Search,* 1969. Laser beams reflected against mirrors. *Search,* an "environmental room," was constructed for *Laser Light: A New Visual Art,* an exhibition at the Cincinnati Art Museum in December, 1969. Collection The Cincinnati Art Museum.

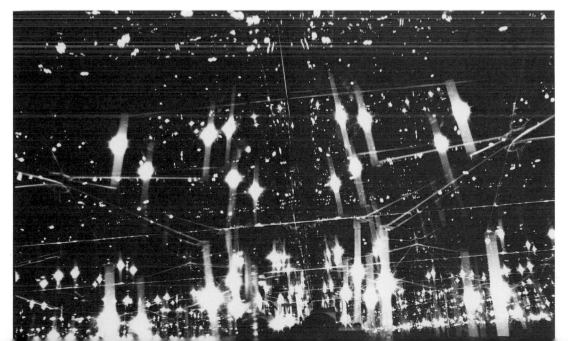

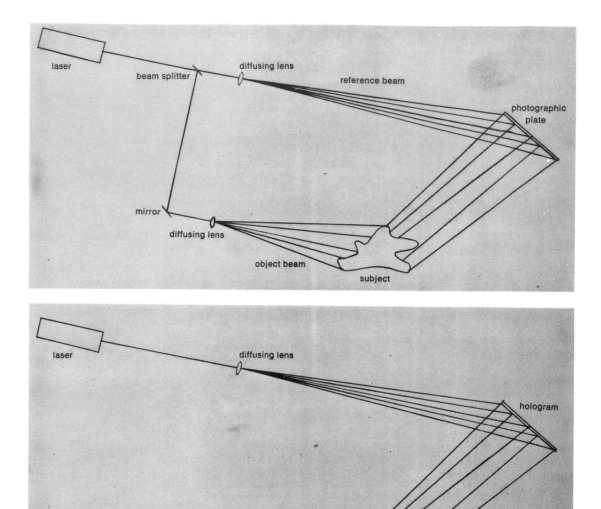

Bruce Nauman. *Holograms (Making Faces),* 1968. Photo image on glass with arc-light projector. 8" x 10". Courtesy Leo Castelli Gallery, New York. Photo by Frank J. Thomas.

Diagram: Making a Hologram. The beam projected from the laser is split in two by the beam splitter, then spread apart by diffusing lenses. One beam, top, goes directly to the photographic plate. The lower beam hits the object to be "photographed," illuminating it and scattering light onto the plate that interferes with the other beam. This interference creates the pattern that "stores" three-dimensional visual information about the object. Later this information can be re-created by projecting light beams through the plate. Courtesy Finch College Museum of Art, New York.

The laser had another expansive application to art. It could be employed to create, then to reproduce, three-dimensional images (or "holograms") by splitting its beam in half, directing one shaft toward an object, the other toward a photosensitive glass plate. When the two beams finally converged on the plate, the interference pattern is imprinted there, leaving three-dimensional information that can be reconstructed by shining another laser beam, or strong white light, through it. The

reconstruction is a "true" image, furthermore, in the sense that it is not an illusion, but exists in space, independent of the eye that perceives it. Bruce Nauman exhibited some early holograms at the Leo Castelli Gallery in the spring of 1969; that fall, the Finch College Museum in New York gathered together in *N-Dimensional Space* a variety of them by various hands. These holograms were crude and, in some cases, difficult to make out. But the potential was implicit in the evidence on

display, a potential with clear application to films and television (even then, experimentation with moving three-dimensional images was under way) and to art. Here, too, the thrust was environmental in nature: the "projected-image" hologram—as distinct from the receding image, which extends away from the eye—stands out from the glass plate, occupying the same space as the viewer. A hand could be passed through Lloyd Cross's holographic reproduction of a toy space capsule at Finch.

What lay ahead for both sculpture and the art exhibition, obviously, was an unsurpassed command of space through forms that appear material but are in fact evanescent. In these early explosions into scale—through sound, flying sculpture, and laser light—potential counted more than performance. Each took place with the most limited industrial and scientific cooperation. No matter how impressive each of these steps might be, it was (and is) clear that we are passing through a period of comparative infancy. There is no telling what kind of scale will be open to the artist of tomorrow.[46]

Below: Artist Robert Indiana and physicist Lloyd Cross collaborating on the creation of a hologram, 1970. Courtesy Finch College Museum of Art, New York. Photo by Tom Rummler.

Salvador Dali. *Holas! Holas! Velásquez! Gabor!,* 1972. Hologram with three-dimensional figures and canvas. The viewer looks through the holographic plate and sees images mingling back in real space with a stand-up collage of *Las Meninas* by Velásquez. Courtesy Knoedler Gallery, New York.

The New Audience:
Television and Videotape

Piene believed that technology would not only expand the artist's sense of scale but put him in touch—through the medium of television as well as the sky—with an audience of unsurpassed size. "Technology has most to do," he stated, "with increasing and intensifying communication." In 1968, he collaborated with intermedia pioneer Aldo Tambellini in *Black Gate Cologne,* a fifty-five-minute videotape made for telecast at WDR in Cologne; it may have been the first such "program" created entirely by artists for widescale reception (on the national German network early in 1969). The program mixed taped and live imagery with spontaneous audience reaction (some of it taped and replayed later) to events in the studio that included the inflation of a 1,500-foot-long polyethylene hose.

If *Black Gate Cologne* properly inaugurated "fine-art" TV programming, it was hardly the beginning of the recognition by artists of the medium's potential, both social and esthetic. I have already mentioned the appearance of TV imagery in the work of Richard Hamilton and a full-scale TV set in an early Tom Wesselmann collage-construction. There are many parallels with Hamilton and Wesselmann, but the mere appearance of TV as subject matter in accepted genres is not immediately germane. More to the point were the early TV constructions of Nam June Paik and the German artist Wolf Vostell. Paik's appeared first at the Galerie Parnasse in Cologne in 1963. They were secondhand sets that Paik had altered by rearranging the electronic components inside, until the viewer was confronted with surrealistic black-and-white abstractions rather than representational images (later, in New York, he introduced color, inserted coils that produced completely artificial abstract imagery, and "stretched" other images by holding a magnet near the TV tube). Vostell's exhibition, *TV-Décollage,* held at the Smolin Gallery in New York during the same year, presented TV sets out of focus or alignment; others were bashed in, smeared with paint, or riddled with bullet holes.

Both Paik and Vostell were clearly closer to Dada than to Constructivism. It remained for a whole generation of sculptor-constructionists to employ the TV set in anything resembling a straight manner, in an attempt to produce something approximating traditional

Wolf Vostell. *TV-De-Collage,* 1963. At the Smolin Gallery in New York, Vostell presented a series of TV sets tuned out of focus and alignment; some were battered, broken, and riddled with bullet holes. Courtesy Neue Galerie, Aachen, Germany.

beauty. In every case, this effort involved modulation of the TV signal. Thomas Tadlock's *Archetron*, completed in 1969 after several years of work, is a typical example. A large console, it employed electronic devices to produce brilliantly colored kaleidoscopic fragmentations of programmed images; by manipulating the *Archetron*'s dials, the viewer could "scramble" color and form even further. At about the same time, Ted Kraynik began working on his *Video-Luminar*, a photosensitive device that translated video imagery into abstract patterns of light on large plastic sheets. Eric Siegel, Boyd Mefferd, Peter Sorenson, and Earl Reiback, among others, also constructed works that disabled normal TV reception, turning the cathode-ray tube into an electronic canvas. Siegel's home-made system, *Color Through Black-and-White TV*, demonstrated in 1960 while he was a high school student, is probably the first of these constructions.

A distinctly different approach surfaced in works like Les Levine's *Contact: A Cybernetic Sculpture* and *Wipe Cycle,* by Frank Gillette and Ira Schneider. Both works dealt basically in pure "feedback," returning the viewer's image to him as he watched. The components of *Contact* were television monitors and four cameras, placed on two sides of a stainless-steel frame; the spectator saw himself at many different angles and in several different colors (the screens of the monitors were variously tinted) at once. *Wipe Cycle*, a "Television Mural," mixed live pictures of the spectators before it with videotapes previously recorded, plus normal TV programming.

This split—between those who wished to turn the TV set into an extension of sculpture and those content to employ it straight, as "software" visual information—manifested itself in the videotape medium as well. Paik was again the pioneer. In 1965, he acquired one of the first Sony "home" videotape recorders sold on the New York consumer market, recorded perhaps the first "personal" videotape made by an artist (mainly a record of his taxi drive downtown), and displayed it that night at a café in Greenwich Village. The statement that accompanied it predicted the onset of an era dominated by electronic art. In any case, the appearance of inexpensive Sony videotape-recorders in 1965–66 did encourage a number of artists to take on the new medium. Stan Vanderbeek, Les Levine, Andy Warhol, and Aldo Tambellini (who

Peter Campus. *Double Vision,* 1971. Videotape. Courtesy Finch College Museum of Art, New York. Photo by Mindy Duitz.

Gene Davis. *Video Puzzle,* 1971. Videotape.

Aldo Tambellini and Otto Piene. *Black Gate Cologne,* 1968. The videotape was made in Cologne, Germany, and broadcast in Europe early in 1969. The program combined electronic "mixing" done live in the control room by Tambellini and Piene together with the reactions of the studio audience, seen here in the midst of an environment of TV monitors, light sculpture, and slide projectors. The audience also participated in inflating and manipulating a transparent polyethylene tube, 1,500' long. Courtesy Otto Piene. Photo by Hein Engelkirschen.

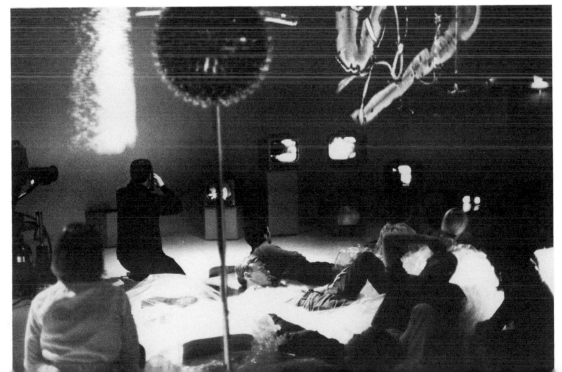

Ted Kraynik. *Electronic Amoebae,* 1968. Images produced on *Video-Luminar* with plastic sheets, lights, TV camera, monitor, sound equipment, control assembly. The *Video-Luminar,* first built by Kraynik in 1963, translates video pictures into changing patterns of light. Photo by Nishan Bichanjin.

Frank Gillette and Ira Schneider. Diagram for *Wipe Cycle,* 1969. TV camera, 9 TV monitors, and videotape. As the viewer watches, he sees himself "live," together with tapes of previous viewers and prerecorded programming. Courtesy Howard Wise Gallery, New York.

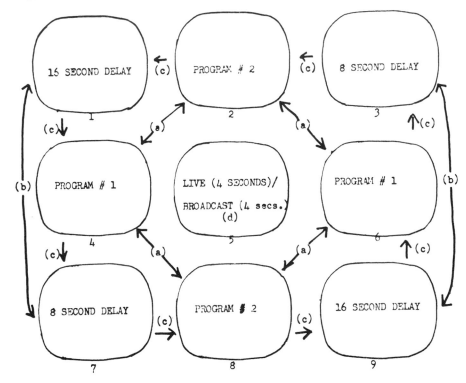

CYCLE (a) Monitors 2, 4, 6 and 8: Programmed change cycle, Program No. 1 alternating every eight seconds with Program No. 2.

CYCLE (b) Monitors 1, 3, 7 and 9: Delay change cycle, Nos. 1 and 7 and 3 and 9 alternating (exchanging) every four seconds.

CYCLE (c) Monitors 1, 2, 3, 4, 6, 7, 8 and 9: Wipe cycle, grey "light" pulse, moving counterclockwise every two seconds.

CYCLE (d) Monitor 5: Live cycle, four seconds of live feedback alternating with four seconds of broadcast television.

opened in 1967 what he called "the first electromedia theater," The Black Gate, in New York, for the display of both films and videotape) all made early tapes. It was the young Californian Bruce Nauman, however, who made and sold the first limited-edition "videoprints" early in 1970. The agent was Paris dealer Ileana Sonnabend, who sold an edition of three Nauman tapes to two private collectors and a museum.

This incident, together with an exhibition at Leo Castelli's gallery in the spring of 1970 by Keith Sonnier, Nauman's colleague, brought Paik's prediction close to reality. Sonnier blew his videotapes up to a scale approximately 12 by 14 feet with an Amphitron machine. The collector thus had not only limited videotape editions ahead, but life-size and wall-sized projections. Special adapters for the television set that permitted the viewer to play it like a phonograph, choosing from a personal library of prerecorded videotape film cassettes, cartridges, reels, and discs, began to appear on the Japanese consumer market in 1971 and in the United States in 1972, with large-scale screens that could be linked to regular TV sets following shortly after.[47]

The early videotapes, particularly those made by Nauman and Sonnier, together with the *Topothesia* series taped by Les Levine in 1970, were deliberately crude in form and intimate in contact, exploiting the condensed size of the TV image and the restricted size of its immediate audience, so different in both cases from film. Nauman recorded facial performances, smiling, frowning, pursing his lips; Sonnier focused on the interplay between his moving hand and a strobe light; Levine examined his own eye, mouth, and hands from extremely close range. In most of these cases, however, there was an obvious attempt to form, shape, and select the material recorded by the videotape camera. Like Paik, Tadlock, and all those who distorted TV images in behalf of abstraction, the Nauman-Sonnier videotapes clearly put "art" before information, a distinction that became more obvious with the advent of color recorders in 1971, at which time the incidence of sensuous visual imagery increased markedly among the creators of personal "videoprints." The lushness of electronic VTR color proved fatal, just as acrylic color had tempted painters fifteen years earlier.

In a great many other cases, artists and journalists alike viewed the advent of inex-

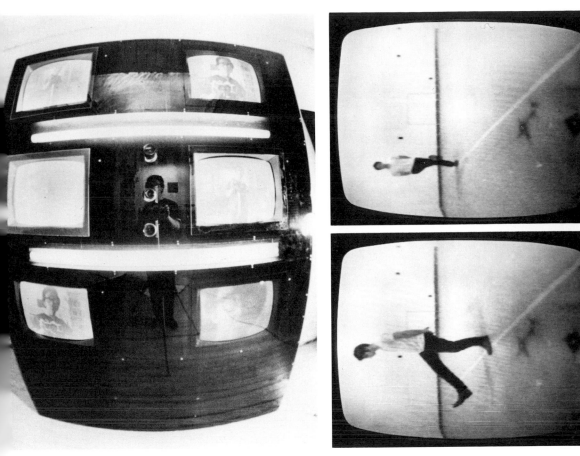

Les Levine. *Iris,* 1968. Three TV cameras, 6 TV monitors. 90″ x 60″ x 22″. This "cybernetic eye" projects what it sees through the cameras onto its monitors, which are covered with vacuum-formed bubbles of green, red, orange, blue, and violet. Collection Mr. and Mrs. Robert Kardon, Philadelphia.

Bruce Nauman. *Slow Angle Walk,* 1968. Videotape. Courtesy Leo Castelli Gallery, New York. Photo by Frank J. Thomas.

Keith Sonnier. *Dis-Play,* 1969. Videotape. Courtesy Leo Castelli Gallery, New York. Photo by Richard Landry.

Joseph Beuys. *Filz-TV*, 1970. Documentary videotape of an *Aktion* by Gerry Schum. The Video Gallery, Düsseldorf, Germany. Photo by Ute Klophaus-Wuppertal.

John Reilly and Rudi Stern. Detail from *Intertube*, 1967. A one-person TV environment. Inside this work, the spectator views images of himself through mirrors and a TV monitor. Courtesy Rose Art Museum, Brandeis University, Waltham, Mass. Photo by Jay F. Good.

pensive video-recording equipment and the proliferation of TV outlets (through adapters, cassettes, and an expanding number of broadcast stations, many of them broadcasting over cable television systems) as an opportunity to create alternative news, information, and documentation systems, outside the previously predominant commercial networks. Videotape "develops" itself, eliminating film and lab costs; more important, it can be played back immediately through a monitor, permitting instant correction and self-editing. Gary Schum, who opened "The Video Gallery" in Düsseldorf in 1969 with films of artists at work displayed on twenty simultaneous TV monitors, claimed that "one day the reproduction of art events . . . by the TV medium will be more important than selling art objects to a single collector." In Los Angeles, Charles Bensinger and Diane Baxter established the Video Technology Workshop and invited artists to acquaint themselves with the new tool. "Video has come of age," Bensinger declared. "The first TV generation now confronts its bewildered mentor."

New York groups such as Global Village, the Raindance Corporation, and the Videofreex sought pure "information," much in the manner of the Gillette-Schneider *Wipe Cycle*. They taped street scenes, political rallies, "real-life" intimacies, panel discussions, and played them back on wrap-around monitor environments for small-scale theater audiences.

Gillette, Schneider, and others envisioned the beginnings of a vast software network for tapes, carrying ideas and information then excluded by the mass media. Schneider—along with Allan Kaprow, who planned a "life styles" course at the new California Institute of the Arts in 1970—saw the VTR as a means of studying oneself, and others, in living situations. "When you can see yourself on TV," he wrote in an early issue of *Radical Software*, a Raindance publication, "and the back of yourself simultaneously [via two monitors]—something that we seldom ever get a chance to do —and if we extend this further into the notion of the environment, one can see oneself on a social, or a spatial, interaction."[48] Kaprow, meanwhile, incorporated videotape as the software for his course, the medium through which students would present their own daily, recorded "life systems" and study those of others. In this case, videotape had supplanted both paperwork and books as educational-communicative agents.

Much of this work was uncomfortably displayed in 1968–69 at two innovative exhibitions: *TV as a Creative Medium*, at the Howard Wise Gallery, and *Vision and Television*, organized by Russell Connor at the Rose Art Museum, a division of Brandeis University in Waltham, Massachusetts. Both demonstrated clearly that the new technology fitted less and less comfortably into the old exhibition context, inevitably oriented toward objects. Even

The Videofreex. *Coffin*, 1971. A continuous playback video system. Courtesy Finch College Museum of Art, New York.

works as bold as *Wipe Cycle* and *Contact* seemed, in these cases, dilutions of a medium essentially involved with software—with programming—not with static forms poised halfway between sculpture and electronics. What Levine himself called "the major visual influence in our time" had no business being locked into objecthood.

Thus, the most significant fusion of art with television took place beyond three dimensions, at least in the United States, thanks to a series of grants by the Rockefeller and Ford foundations during the late 1960's and early 1970's to public television stations KQED in San Francisco and WGBH in Boston. The grants enabled these stations to bring in artists from the "outside" to work with resident staffs in the creation of new programming forms.

At KQED, producer Brice Howard, director of the Center for Experiments in Television, which opened in 1967, extended with his colleagues the principle of "electronic mixing," wherein the producer-artist-engineer modulates previously taped representational images in the control room, altering form and color, inventing new matte configurations and adding brand-new feedback imagery generated within the equipment itself. In an unpublished manuscript entitled *Videospace* (1969), Howard argued that these swiftly moving electronic collages were the proper center of TV art, because the streaming images forced the viewer to participate kinetically in their formation—an extension of McLuhan's early contention that TV, unlike radio, was at best a "cool" medium, thanks to its small size and low definition, which forced the viewer to involve himself in the picture. Howard also emphasized (as had Tambellini and others before him) the unique nature of the TV picture: it is a "live" light image traveling through space, creating itself on the inside of the cathode-ray tube before the eyes of the viewer. The TV picture, in itself, is a living thing, demanding an esthetic based in movement rather than fixed forms.

Choreographer Alwin Nikolais had "mixed" for WCBS-TV in New York in 1968 when he collaged together a complex of images drawn from a master videotape of his company performing *Limbo*, overlaying the results with washes of abstract color. So did Piene and Tambellini in *Black Gate Cologne*, plus a number of producers and artists working at WGBH in Boston. But none demonstrated the full potential of video mixing as much as

HOMEMOVIES
A marriage Happening for Catherine + Daniel Schmidt some time after their marriage—July 11,12,13

Hello
TV recording of couple greeting each other somewhere
Friends of couple watch recording, imitate them
TV recording of imitation

Trip
TV recording of couple getting on a bus somewhere
Friends of couple watch recording, imitate them
TV recording of imitation

Goodbye
TV recording of couple saying goodbye somewhere
Friends of couple watch recording, imitate it
TV recording of imitation

Hello
TV recording of couple again greeting each other somewhere
Friends of couple watch recording, imitate them
TV recording of imitation

Copycat
Everybody watches whole TV coverage
Couple imitates imitations

A. Kaprow '69

Allan Kaprow. *Home Movies—A Marriage Happening,* 1969. Poster-score. 18" x 24". An early use of videotape in a Happening.

Howard's *Heimskringla!*, based on Tom O'Horgan's new play, created at the San Francisco Center in 1969 and broadcast nationally over the public television network in the same year: bodies drained themselves of color under Howard's hand, then filled up again; whole scenes were drenched in purple, then red, then yellow; actions taking place at different points in plot time appeared on the screen at once. In 1970–72, the Center extended its investigations into electronic collage by building a console that allowed individual artists to generate feedback images on their own, without control-room interference. Stephen Beck, who designed this video synthesizer, emphasized its ability to put the video artist "in a one-to-one relationship with his material." The Center also developed a wrap-around monitor environment for closed-circuit viewing, the "Videola." Despite this, the Center tended more and more to emphasize pure research rather than hardware or broadcast as it matured.

WGBH-TV was equally active. A steady stream of visiting artists performed a wide range of experiments. Among them were Paik, Tadlock, Tambellini, Piene, Seawright, Kaprow, and Stan Vanderbeek. A number of these artists collaborated with producer Fred Barzyk in 1969 on *The Medium Is the Medium* for the Public Broadcast Laboratory, a telecast that made extensive use of pure TV technology: Kaprow's Happening *Hello* employed a series of TV monitors, across which participants waved and shouted gleefully to one another; Seawright slowed down the sequence of color signals received by TV cameras to present three different images of a dancer at once; Piene mixed abstract color patterns with "natural" footage from one of his sky events. Barzyk, meanwhile, engineered the first two-channel telecast, programming two videotapes to run side by side while viewers were asked to turn on two TV sets at once, surrounding themselves with stereo sound and imagery. Early in 1970, Vanderbeek produced an ambitious *Violence Sonata*, combining live and taped accounts of violence in American life with multimedia projections and audience reaction in the studio and over the phone. In the same year, Paik introduced his own "mixing" console, built in collaboration with Japanese engineer Shuya Abe. A one-man unit, Paik's *Video Synthesizer* generated four hours of shifting luminescent abstractions during its maiden telecast. Paik called it "an electronic watercolor set for everyone to see."

Although the invasion of TV by art was still in its infancy, the potential—and the challenge—of the medium seemed unlimited. The loosening of the old monolithic TV structure created opportunities for individual expression and immediate communication with large audiences unimaginable before. Vanderbeek rated TV above film for this reason. My own belief, based on direct experimentation as well as observation, is that video differs radically from film. There is not only the luminescence of video color, caused by the projection of light through the screen, but also an unlimited potential for depth and complexity. While working on a segment of *Video Variations* (produced at WGBH in 1970 and telecast in 1972), the second "anthology" of experimental video art, I learned that as many as four layers of imagery can be cleanly superimposed upon one another, without the blurring and loss of definition that occurs in film. The entire *Video Variations* hour is dominated by a complexity of color and form that belies McLuhan's description of TV as "flat . . . non-visual," a description put forth in an earlier, less advanced stage of the medium. It has also occurred to me that video is essentially a private art, engaged in mind-to-mind

Joanne Kyger. *Descartes,* 1968. Videotape produced at the Center for Experiment in Television, with members of the KQED Television Project. Courtesy Center for Experiment in Television, San Francisco.

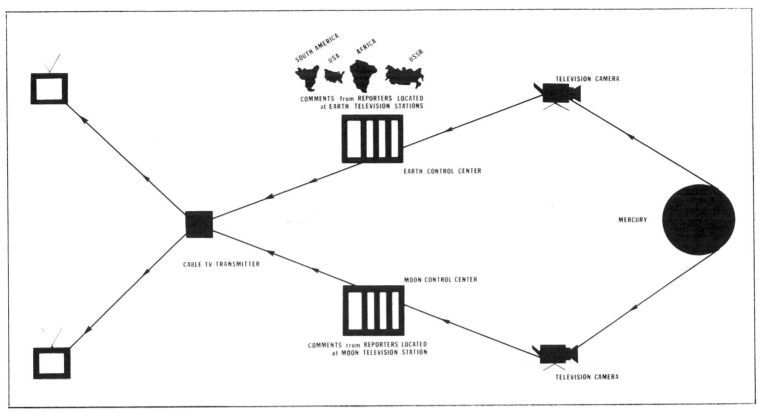

Fred Barzyk. *The Galaxy Double Channel Experiment,* 1970. Ink drawing. 14½" x 10".

communication, as opposed to the basically public art that is film.[49] With the advent of cable and microwave telecasting systems, each offering a wider selection of channels and therefore a greater fragmentation of the viewing audience, this intimacy will intensify. None of these qualities has yet been thoroughly exploited or considered.

The TV-computer interface has the further potential not only for creating TV pictures out of data transmission from outer space (amply demonstrated in 1970 when Jet Propulsion Laboratories in Pasadena "translated" satellite transmission from Mars into "live" TV), but for permitting the TV artist-producer-mixer an infinite number of variables in constructing visual collages. Paik has even proposed a VTR four-camera system to simulate the freedom of the eye, by taping scenes from several angles at once. By its very nature, television seemed to be drawing art away from its esoteric gallery-collector-museum nexus, much as the dynamics of the modern movement had drawn the Futurists toward its depiction and Constructivists such as Gabo to kinetics itself.[50]

Douglas Davis. *Talk-Out!,* live two-way telecast, 1972. In this 3½-hour experiment at WCNY-TV in Syracuse, N.Y., callers dialogued with the artist by telephone and print-out statement about the works they were viewing. Courtesy The Everson Museum of Art, Syracuse.

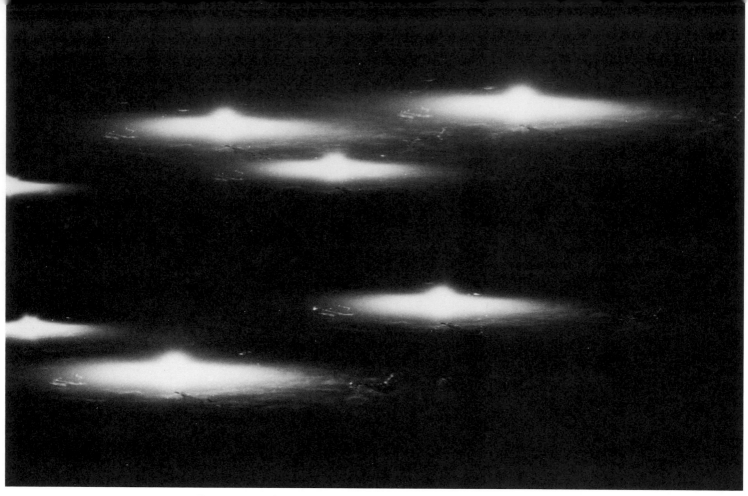

Pulsa group. *Boston Public Gardens Demonstration,* 1968. Fifty-five xenon strobe lights were placed underwater in the garden's four-acre pond, together with 52 polyplanar speakers above water. Both were programmed by computer and magnetic tape to emit cyclical light and sound flashes throughout the park.

Wen-Yeng Tsai. *Cybernetic Sculpture,* 1969. Stainless steel rods and base, motorized, with stroboscopic light. 72" h. The rods vibrate in response to the strobe patterns and to the sounds made by the viewers. Courtesy Howard Wise Gallery, New York. Photo by Philippe Halsmann.

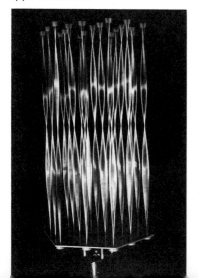

Environmental Space and Time: The "Living" Work of Art

The evidence of similar extensions abounded as the 1960's came to a close. There was widespread involvement in what is best called "environmental" forms—works of art that fill, activate, or respond to the surrounding environment, frequently including the viewer himself. Les Levine created *Slip-cover* at the Architectural League, filling three rooms with giant mylar bags that expanded and contracted, sometimes pressing spectators against the wall. The Intersystems group put together several technically sophisticated environments in Toronto, Canada, collectively entitled *The Mind Excursion Center,* where in addition to the usual barrage of light and sound there were changing shapes, smells and colors to experience. The Pulsa group, organized by seven artists and archi-

tects teaching at Yale,[51] performed an "all-weather" event in the Boston Public Garden, surrounding the audience with fifty-five underwater strobe lights and fifty-five amplifiers, which were programmed by computer to project streams of light and sound through the park at high speeds. The event, declared Pulsa, was "the first work which was conceived on a scale and system comparable to the scale and system of today." One year later, the group created another outdoor environment in the garden of the Museum of Modern Art for its *Spaces* exhibition, employing computer-programmed electronic devices that responded to heat, sound, light, and movement with heat, sound, light, and movement of their own.

Robert Whitman's *Pond,* installed at the Jewish Museum with the help of engineer Eric Rawson, enclosed the audience within a circle

of vibrating mirrors that altered sensory perception minute by minute. With a team of engineers, Robert Rauschenberg built *Soundings*, a plexiglass wall covered with silkscreened images that lit up in response to the voices of nearby observers. The slender, stainless-steel "cybernetic" rods of Wen-Ying Tsai vibrated in response to the clapping of hands, as well as to the flashes of a strobe light, simulating, as Tsai said, "the intensity of a living creature." Boyd Mefferd used the strobe more aggressively than anyone, surrounding his audience at the Los Angeles *Art and Technology* exhibition with 500 Universal television flash tubes. Their impact created "head art"—images that danced inside the viewer's mind when he closed his eyes, often in self-defense.

The sound-light environments of Keith Sonnier, which followed most of these works in time, advanced the responsive art considerably, in terms of esthetic control. Sonnier blended the spectator almost imperceptibly into the total work; in one such piece, typical of many others, the viewer entered a small room bathed in soft red light and filled

Robert Whitman. *Pond,* 1969. Installed at the Jewish Museum in New York, this electronic environment incorporated 8 vibrating concave mylar mirrors, 4½′ in diam., strobe lights, slide projectors, and a continuous tape-loop sound system repeating a sequence of single words and phrases, with long pauses in between. The room was dark. The viewer could see himself in the large mirrors but the oscillation of surface, sound, and light continually and subtly changed what he saw. Engineer: Eric Rawson. Courtesy The Jewish Museum, New York.

Robert Rauschenberg. *Soundings,* 1968. Silkscreened ink on plexiglass with electronic equipment. Construction 36′ l., made of 27 panels 8′ h., arranged in rows of three each. As spectators clap or call out, various parts of the work light up, revealing the images silkscreened upon its face. The Ludwig Collection, Wallraf-Richartz Museum, Cologne, Germany. Courtesy Dr. Peter Ludwig.

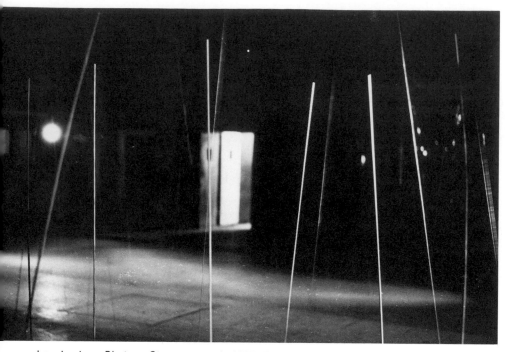

Les Levine. *Photon: Strangeness 4,* 1967. Performed in a room 100' x 50', filled with vibrating wires, moving fish-eye mirrors, electromechanically operated TV cameras, and monitors. The viewer sees himself in a variety of images and sizes as he moves through the room. He also feels as if the space is moving in all directions at once. Levine was assisted in planning the room by George Fan, an IBM research physicist.

Ted Kraynik. *Synergic Light Buoys,* plan, 1968. Floating in a city harbor, these buoys would respond to the city as an organic entity, their lights rising and falling in response to urban activity patterns—to the number of telephone calls, to traffic patterns on the streets and subways, to gas and electricity consumption.

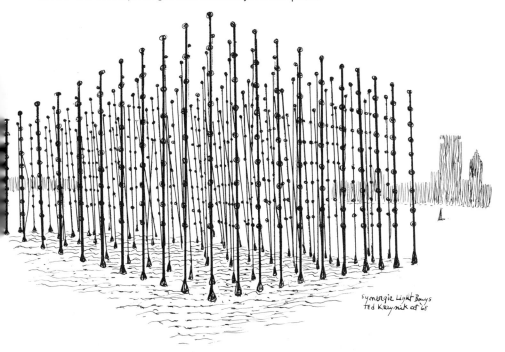

with video cameras. The images were transmitted into a second gallery activated by amplifiers and loudspeakers, thus linking man, image, and sound in a subtle unity. In the case of both Sonnier and his predecessors, the work defined itself by an active relationship between the materials employed and their surroundings. Participation was easily the dominant theme in the environmental art of the late 1960's.

The environmental movement concerned much more than response, however. There was concern for the "life" of the work of art, not only its form. This is a difficult concept to define. In his book, *Beyond Sculpture,* Jack Burnham equates it with "systems" thinking. Its major esthetic significance, however, is this: we equate art now as much with activity as with object. We expect art to do much more than stand before us. We want it to engage in a dialogue with the environmental life process.

The crudest signs of this can be seen in Fletcher Benton's concern for the "life" in his kinetic machines, as evidenced in the instructions he sends along with them, plus his stated willingness to repair them if necessary; in exhibitions like *NUL,* at the Stedelijk in Amsterdam in 1962, when the museum commissioned ZERO artists to construct works right on the exhibition site; and in the work of sculptors such as Robert Morris, who ship plans instead of objects to museums, where the work can be created in the very space it will occupy.

Similar tendencies can be found in Ted Kraynik's plans for a "synergic" object, to be floated on hundreds of aluminum poles near a large city. Each pole changes in hue in response to activity in the city, activity centered in its utilities. Every time a phone call is made or a light switched off, the work will change. Like a human, Kraynik's work will constantly react to its surroundings. Hans Haacke and his followers brought the metaphor full circle by approaching his subject on an organic level. Haacke began by making plexiglass boxes filled with fluids that responded to gravity and to changing temperature and humidity. Later he exhibited ongoing natural processes, including, in one case, a brood of chickens hatching. Alan Sonfist built superbly programmed glass spheres provided with mineral crystals; touched by heat or light, the crystals turned into a purplish vapor and settled in intricate patterns on the surface of the glass. Sonfist also worked with

Alan Sonfist. *Crystal Enclosure,* 1969. Three-dimensional crystals enclosed in a glass sphere, changing from solid to gas in relation to atmospheric conditions. 18″ diam., 23″ l.

Hans Haacke. *Hydraulic Circulation System,* 1969. Fluid in plastic tubing. Approx. 12′ x 24′. Courtesy Howard Wise Gallery, New York.

microorganisms that burst into iridescent colors upon contact with food. Newton Harrison extended both Haacke and Sonfist by exhibiting out-of-doors a salt-water "system" filled with brine, shrimp, and algae. Driven by the sun—the master engineer—the algae went through a continuing shift of blue-green and pink color changes.

In the foregoing examples, each representative of a wide variety of similar work, art came closer to the forms of contemporary life than to those of traditional painting and sculpture. Gabo used movement, but he anchored his vibrating rod in a static base. His work was fixed in a structure concerned more with esthetic theory than with the life around it, as was most of the art that followed Gabo, no matter how radical its intent seemed to be. The environmental-systems movement expressed itself normally in media unfit for static, esoteric space. Moreover, its implicit goal—classification, organization, and response on a broad scale—pointed toward collaboration with the computer, as well as with engineering and industrial implementation on a highly sophisticated level. The progression here, similar to that in television, is away from the past, toward hybrid forms and concepts poised between art and technology.

Charles Frazier. *Drift Structure,* 1969. Plastic, glass, electronic hardware. 2′ in diameter x 6′ in length. This transparent structure is designed to drift in a large area of water. It transforms sunlight into power through a small transistorized radio receiver.

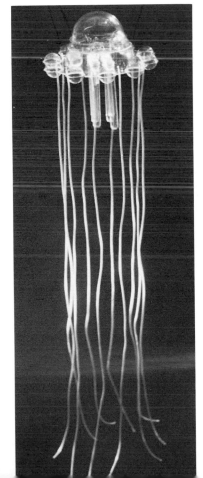

Hans Haacke. *Roller (and base),* 1969. Liquid and plexiglass. 20″ diam. Courtesy Howard Wise Gallery, New York.

Charles Csuri. *Sine Curve Man*, 1967. Computer drawing of human face based on a combination of sine curves.

The Computer: Final Fusion

The computer represents the ultimate creative tool for the artist-engineer-scientist, the ultimate fusion. It was the object of experimentation in music as far back as the 1950's, largely because musical patterns can be translated directly into mathematics. Lejaren Hiller (who later introduced the computer as a tool in music education at the University of Illinois) and Leonard Isaacson started to compose with an Illiac computer in 1954–55, using it to organize and select prerecorded sounds; in different ways, so did a number of engineers and composers at Bell Laboratories in Murray Hill, New Jersey. By February, 1965, Dr. John R. Pierce, Bell's director of research in communications sciences, was prepared to say, in an article published in *New Scientist*, that "a digital computer as a source of sequence of numbers, together with not very complicated equipment for turning this sequence of numbers into an electric wave that can drive a loudspeaker, is truly the universal musical instrument—the instrument which can, in principle, create any sound that can be created, any sound that can be heard by the ear." Later, he went further: "A composer equipped with a digital computer has no limitations except his own."

Initially, the Hiller-Isaacson-Illinois and Bell approaches varied. Hiller was mainly interested in the computer as a compositional device; like David Tudor, he programmed his machine to produce its own score, which then was translated into conventional notation for live musicians. Logically enough, John Cage studied under Hiller in the 1960's. Bell was oriented toward the production of computer sound; as early as 1927, its research people had talked with Varèse about developing electronic instruments for musical composition. In 1961, Bell engineers induced a computer to talk and sing and in 1967 to make remarkably faithful trumpet sounds. Composers such as Tenney, Babbitt, Ussachevsky, Hermann Scherchen, Gerald Strang, and J. C. Risset were invited to Bell to test the computer's music-making potential, through a system that Pierce developed in collaboration with engineer Max Mathews. The composer begins by feeding to the computer programmed instructions that cause it to transmit a series of numbers to a converter; the converter changes the numbers into a sequence of electrical impulses varying according to the original values chosen by the composer; the impulses are then smoothed out by a filter and materialize as sound through a loudspeaker.

Similar experiments were conducted, successfully and unsuccessfully, during the 1960's at MIT, Yale, UCLA, and in Great Britain, Germany, and Sweden. Mathews predicted that within twenty years 90 percent of all serious music would be composed through the computer. By 1970, in any case, Hiller's department at Urbana, Illinois, was attracting as many skilled students in composition as the more conventional one at Princeton. The difference between sound generated by the computer and by normal electronic means, such as Babbitt's synthesizer, was sometimes difficult to catch, but the new composers insisted upon the distinction. "What I am concerned about," said Gerald Strang, who refined the Mathews method at UCLA, "are the sorts of sounds and the sorts of manipulations and kinds of expressive possibilities which are not possible by other means." Tenney, one of the few composers working at Bell interested in using the computer to score (largely random patterns of sound), emphasized another factor, equally important. The

Lowell Nesbitt. *IBM 6400*, 1965. Oil on canvas. 80″ x 80″. Collection Dr. Peter Ludwig. Courtesy Neue Galerie, Aachen, Germany.

Jose Bermudez. Untitled drawing, 1969. Computer tape on paper. 29½″ x 22″. Collection Museum of Modern Art, Cali, Colombia.

John Whitney using a light pen as input to an IBM 2250 computer, 1969. Courtesy IBM Museum and Exhibition Department, Armonk, N.Y.

computer's ability to perform numerical feats with exceptional speed allows the composer to experiment freely with large symphonic forms that would otherwise take many months: "I'm interested in the computer in the same way that a geologist would be interested in flying over an area in an airplane," he said. "He can see from a great height formations that would otherwise take him years to study."

The computer developed more slowly as a draftsman, filmmaker, and architect than as a composer but eventually gained almost as many converts. In 1963, the electric microfilm recorder became available to programmer-artist-architects. With its camera and cathode-ray display tube mounted in a computer, the plotter composed and drew lines far more quickly and accurately than the human hand. The artist can use the plotter in two ways: first, by programming it through traditional punched-card instructions and observing the results on a cathode-ray display tube; second, he can use a "light pen" to draw lines and shapes on the tube, which the computer then straightens, implements, or elaborates in response to signals transmitted when the pen contacts a "light button" on the face of the tube. At first, the plotters responded with only the simplest of drawings. Toward the end of the 1960's, however, some of the plotters managed exceptionally complex responses. For example, the "Rand Tablet" system wired 1,024 lines into the cathode-ray tube, which could then trace elaborate paper drawings held in front of the camera. Other computer systems could add precise detail and perspective to any drawing or create, with the aid of statistical information, detailed graphs and charts, translating verbal and mathematical factors into visual displays.

Ben Laposky produced the first "graphics" generated by electronic machines in Cherokee, Iowa, in 1950, feeding electric oscillators into the deflector plates of a cathode-ray oscilloscope. John Whitney's work, which followed shortly after, was esthetically more interesting. He built his own homemade analogue computer from a surplus anti-aircraft gun detector and composed a series of elaborate circular abstractions that he called *Permutations*. In 1966, he became "artist in residence" at IBM in Los Angeles, where he gained access to equipment and information of the most advanced kind, further extending the visual complexity of his work.[52] At Bell,

research engineer Michael Noll created with the plotter elaborate linear variations of Bridget Riley and Piet Mondrian paintings, as well as compositions of his own; Noll's work, and that of his colleague Bela Julesz, made up the first American exhibition of computer graphics in 1965, at the Howard Wise Gallery. Two Germans, George Nees and Frieder Nake, had led the way in Europe, with exhibitions in Stuttgart earlier the same year. Kenneth Knowlton and Leon Harmon, two Bell engineers, meanwhile created the first "computer nude" in 1966; they scanned a photograph with a special camera, converted the electrical signals received by the camera into numerical symbols, which the computer then "read" and turned into a microfilm drawing.

Knowlton collaborated with filmmaker Stan Vanderbeek in 1964 on the first computer films; here, too, the plotter was employed to turn out a series of animated drawings in a fraction of the time otherwise needed. One of these films, *Man and His World*, was shown at Expo '67 in Montreal. Vanderbeek believed this was the dawn of "a new cybernetic movie art," when the filmmaker merely proposes images that the computer then composes, prints, and develops.

A. Michael Noll. *Gaussian-Quadratic,* 1963. The first carefully programmed composition by Noll, a Bell Laboratories engineer who was one of the early experimenters in computer graphics. Using a digital computer, Noll structured the work around a line that starts at the bottom and randomly zigzags to the top, where the original pattern reasserts itself. Courtesy © A. Michael Noll, 1965.

John Whitney. Computer graphics, 1964.

Kenneth Knowlton and Leon Harmon. *Studies in Perception I,* 1966. Computer-generated drawing. 6' x 12'. Perhaps the first "computer nude." Knowlton and Harmon, engineers at Bell Laboratories in Murray Hill, N.J., scanned a photograph with a special camera that converted the electric signals into numerical representations on magnetic tape. Later a computer "read" the signals and printed the picture on a microfilm output plotter. The microfilm was enlarged to make this picture. Courtesy Bell Laboratories, Murray Hill, N.J.

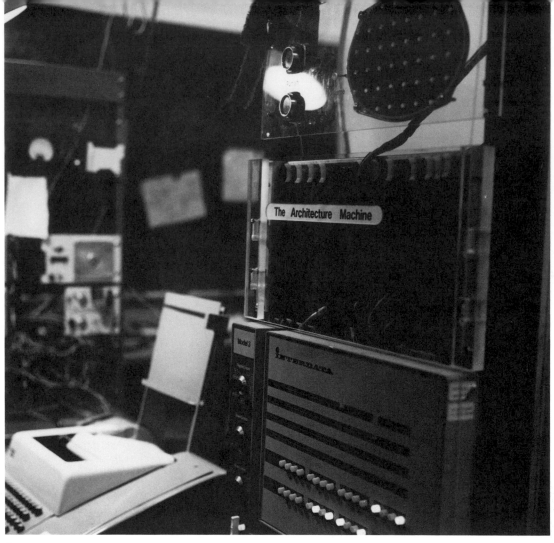

▲

Architecture Machine group, MIT. *The Architecture Machine,* 1970. A computer programmed to assist in the construction and depiction of architectural and urban planning models. Courtesy Nicholas Negroponte, Massachusetts Institute of Technology, Cambridge, Mass.

▼

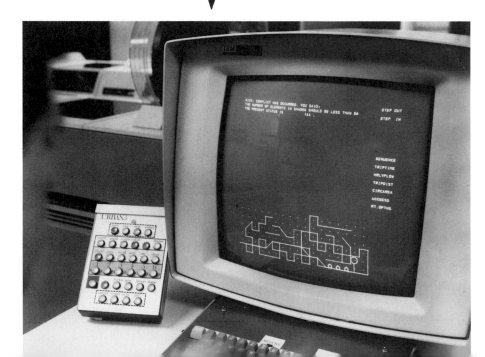

At MIT, the architect Nicholas Negroponte and his colleagues employed the computer to solve complicated design and construction problems during the late 1960's. With a passion reminiscent of Gropius, Negroponte declared in his book, *The Architecture Machine*, that social conscience dictated the use of technology rather than the avoidance of it. Society is now too physically complex to permit unsystematic planning and building, he argued:

An environmental humanism might only be attainable in cooperation with machines that have been thought to be inhuman devices but in fact are devices that can respond intelligently to the tiny, individual, constantly changing bits of information that reflect the identity of each urbanite as well as the coherence of the city.[53]

100

His book pleaded for the invention of "robot architects," machines that can collaborate with man as an intellectual partner. When the Jewish Museum in New York began to organize its *Software* exhibition—devoted to art based in information systems such as videotape and xerography—the Negroponte group at MIT submitted a three-dimensional example of its thesis. They called it *Seek*, a plexiglass construction in which tiny gerbils continually rearranged a series of small blocks; a computer-programmed arm then patiently rebuilt symmetrical structures related to the gerbil's implicit wishes—proof of a kind that the flexible robot architect was almost a reality.

Jasia Reichardt had assembled an early international survey of computer-inspired art at the Institute of Contemporary Arts in London in 1968, which included poetry, painting, sculpture, and choreography as well as music, drawing, films, and architecture. It demon-strated how widespread was the impulse to employ the new tool, for the contributions came from virtually every Western nation. Many critics and artists had reservations, best articulated by composer Dick Higgins in his pamphlet *Computers for the Arts*, issued in 1970. The new tool, he said, was just that, a tool, "deaf, blind, and incredibly stupid." He urged all poets, composers, and painters to learn a simple programming language, such as Fortran, which he had used in order to compose computer music, thus gaining direct access to the machine.

Evidence seemed to indicate that programming would soon lose its specialized vocabulary and tone, however, ending the era when artists were forced to instruct the machine through middlemen. Both Max Mathews at Bell and Jack Noland, former head of Research at MIT's Lincoln Laboratories (later appointed president of the Massachusetts

Duane Palyka. Untitled, 1971. Computer printout. Courtesy Tweed Museum of Art, University of Minnesota at Duluth.

Gilles Gheerbrant. *Positive/Negative #2,* 1971. Computer drawing. 15″ x 15″. Courtesy Tweed Museum of Art, University of Minnesota at Duluth.

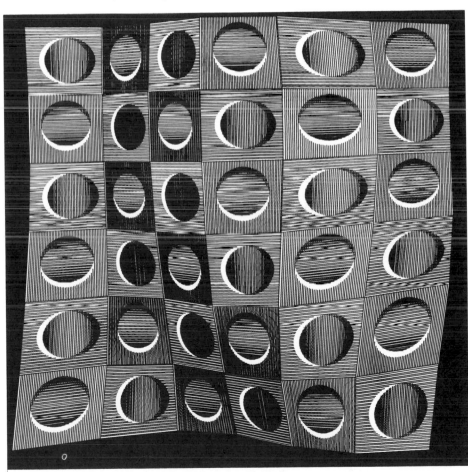

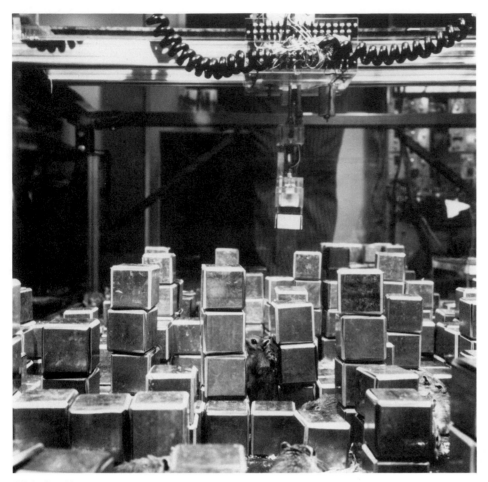

College of Art), worked on simplified languages accessible to all artists. There are strong indications that computers will yet program themselves, and that everyone will have direct access to them, either by telephone or by miniaturized computer units, some no larger than transistor radios. In that state, the new tool will be as accessible to the artist as the brush, pen, or camera is today.

Evidence also indicated that the esthetic parameters of the tool were inherently unpredictable. The computer "graphics" created by artist Charles Csuri and engineer Ivan Sutherland in the early 1970's transcended several genres. Supported by a grant from the Natural Science Foundation, Csuri developed programs for intricate linear abstractions that could be seen only on the surface of a cathode-ray tube (CRT). Shown at the IBM Gallery in New York, these programs were elicited from the computer's memory by touch-tone dialing; as Csuri's forms billowed, expanded, and contracted on the screen, the viewer could affect them by applying a light pen to the tube. For Csuri, movement was the key to this hybrid form of electronic drawing. "I can draw on the display tube, and move my drawing around the moment I create it, in real time," he said. "I can turn any form over and around, watching countless options, instantly. The moment of creation and editing become one."

Sutherland, the inventor of the first "sketchpad" CRT in the early 1960's, moved from MIT to the University of Utah, where he further extended hardware capacities. By 1970, he

Nicholas Negroponte in collaboration with the Architecture Machine group. *Seek,* 1970. Live gerbils, aluminum blocks, and a programmed mechanical arm, in plexiglass. As the gerbils moved the materials of their environment around, the arm "read" their behavior patterns and constructed a protective shelter by rearranging the blocks.

Lillian Schwartz. *Olympiad,* 1971. Stills from computer-animated film. Courtesy Bell Laboratories, Murray Hill, N.J.

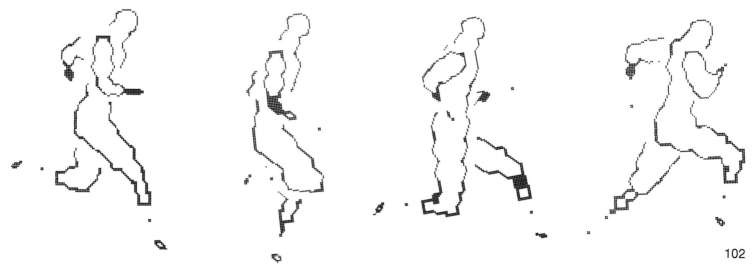

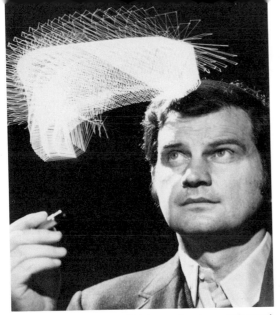

Charles Csuri using a light pen to draw animated objects on the video display terminal, which is connected to an IBM 1130 computing system. The computer can be instructed to put the object in motion or to change its size and shape. This photograph shows the blurred image of a helicopter in flight; the drawing is seen as it might be from inside the terminal looking out.

Charles Csuri. *Hummingbird,* 1967. Stills from a computer-generated film.

Stanley Landsman. *Barmecide,* 1968. Wood, glass, and electric circuitry. 74″ x 24″ x 18″. Many of Landsman's works create the effect of infinity. Collection Wichita Art Museum, Wichita, Kansas. Photo by Geoffrey Clements.

had added color to the art of computer display graphics. Furthermore, he had taken the first step into the realm of three-dimensional space. Sutherland developed a system wherein tiny cathode-ray tubes were mounted on the viewer's head, one tube before each eye. The computer thus extended the viewer's field of vision, surrounding him with a conceptual but visually real world. As he turns his head, the perspective of the "drawing"—in fact, a mixture of film and life—turns. The most bizarre effects are possible: "Through computer displays I have landed an airplane on the deck of a moving carrier," Sutherland said, "observed a nuclear particle hit a potential wall and flown in a rocket at the speed of light."[54]

Finally, it seems that the next fusion between man and machine may sidestep the intermediary of language. In one of his early papers, "The Computer as a Creative Medium," written in 1965, Michael Noll hinted

at this interface. "Man has created an intellectual and creative partner in the computer," he said. He added that the computer possessed certain rudimentary creative abilities, in the sense that it could generate unexpected graphic results. He foresaw a tightening of man-machine communication beyond the pushing of buttons or the drawing of patterns on visual display units into a feedback loop involving subconscious emotional states:

> The emotional state might be determined by computer processing of physical and electrical signals from the artist (for example, pulse rate and electrical activity of the brain). Then by changing the artist's environment through such external stimuli as sound, color, and visual patterns, the computer would seek to optimize the aesthetic effect of all these stimuli upon the artist according to some specified criterion.[55]

Ivan Sutherland. Front view of user wearing the head-set portion of the head-mounted computer-graphics display system at the University of Utah, 1970. The head-position sensor is shown attached to the head set. The viewer is thus visually surrounded by an imaginary three-dimensional world. Photo by Computer Science Communications, University of Utah, Salt Lake City.

Robert Mallary, a sculptor professionally adept with the computer, predicted precisely the same evolution in a 1969 article, "Computer Sculpture: Six Levels of Cybernetics," which I shall bring up in the last chapter.[56]

As bizarre as this seemed, the thesis was implemented in several rudimentary ways during the decade in which Noll wrote, both by art and by science. In the mid-1960's composer Alvin Lucier based his *Music for Solo Performer* on amplified brain-wave patterns, which in turn set a battery of percussion instruments vibrating. In San Francisco, at the Langley Porter Neuropsychiatric Institute, Dr. Joseph Kamiya was teaching people how to regulate brain-wave patterns by establishing a primitive feedback system between their minds and the electrical equipment involved in electroencephalogram (EEG) testing. Electrodes attached to the brain record brain-wave voltage on a graph in the typical EEG session. Dr. Kamiya began to correlate visual and aural signals with certain patterns; before long, many of the patients were able to generate these patterns at will, upon receipt of the signal. Dr. Kamiya's bio-feedback investigations were joined by many efforts throughout the United States, including Rockefeller University in New York. The Frenchman Roger La Fosse turned this principle into feedback visual art. He exhibited a *Corticalart* chair at the Howard Wise Gallery in 1970. The viewer seated himself in the chair, applied the electrodes, and watched the electricity generated by his brain waves alter a variety of surrounding electronic de-

Ivan Sutherland. Map of the United States as seen by an observer wearing the head-unit display, August, 1970. Photo by Computer Science Communications, University of Utah, Salt Lake City.

The Education Research Center, MIT. Stills from *A Relativistic Ride,* 1970. Computer-animated film. The viewer is sent speeding down a road in a car approaching the velocity of light. He sees the telephone poles along the road begin to "bend" as his speed accelerates, finally appearing to double over into the middle of the road. Courtesy Education Research Center, Massachusetts Institute of Technology, Cambridge, Mass.

vices, one of them a television tube that changed fields of color dramatically as the cerebral state changed.

Later in 1970, Dr. José Delgado announced at Harvard that he had established two-way radio communication between a computer and the brain of a chimpanzee; mind and machine were able to interact directly with each other, the latter "reading" wave patterns and returning signals that turned on and off various sections of the brain, now stimulating this area of mental activity, now depressing it. Aside from its obvious application to men-

tal illness, Dr. Delgado stressed the possibility of establishing direct, nonsensory communication between man and machine for the first time. Tests with human beings were scheduled to begin shortly thereafter.[57] In 1971, composer David Rosenboom took the Lucier-Kamiya-Delgado principle a step further into his New York concert, *Ecology of the Skin*. He wired alternating groups of ten participants into a brain wave–computer-synthesizer-loudspeaker system (ARP) and allowed them to generate musical tones on their own, in concert.

Harold Tovish. *Accelerator* (detail), 1968. Mixed media. 9' l., 5'4" h.

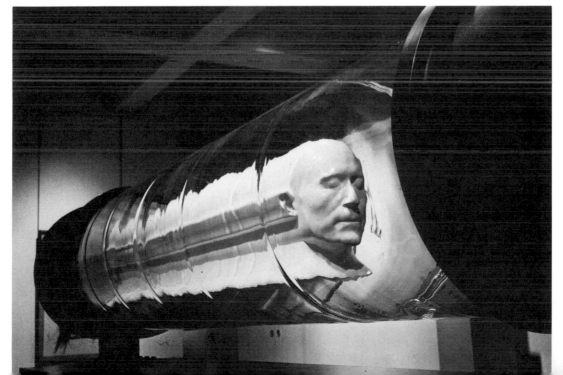

The Single Spirit

Counter Currents: Frankenstein, Reaction, Disillusionment

Nam June Paik had anticipated the tie between bio-feedback and art exemplified in David Rosenboom's *Ecology of the Skin*; he predicted the onset of "DIRECT-CONTACT-ART," a form of "Electronic Zen," in 1967.[58] By whatever name, the man-idea-machine symbiosis reinforced precisely those Frankensteinian fears that had attended the collaboration between art and technology from the beginning. In Noll's vision, La Fosse's chair, and Tudor's *Bandoneon!*, the machine usurped the hand, if not the idea. The critics and others who recoiled from that step were part of a long and honorable tradition. In his several essays touching upon the gulf between the two cultures, the scientific and the traditional, C. P. Snow associates the anti-machine intellectuals with the Luddites of the early nineteenth century. Literary Luddites or not, this list includes men and women of impeccable cerebral pedigree. Evelyn Waugh attacked Gropius in the thinly disguised character of Dr. Silenus, the rabid optimist in *Decline and Fall*. D. H. Lawrence—and his characters—rail openly against machines. Beneath the veneer of literary modernism, T. S. Eliot preferred the arcadian pre-industrial past, expressing his disgust for contemporary key-punch life with a scorn worthy of William Morris. Yeats's right-wing, anti-science opinions are well known.

According to Snow, this reaction is based, in part, on an elitist insensitivity to the material needs of the masses, who were substantially uplifted by the Industrial Revolution. He accused men of humanistic culture of hiding behind their privileged educations while the scientists—and the hybrid intellectuals of the emerging "third culture"—coped bravely with the real, swiftly changing world.

François Dallegret. *La Machine,* 1966. Aluminum. 30' l., 7' h., 1,000 lbs. Courtesy Waddell Gallery, New York.

Paul van Hoeydonck. *CYB Head and Arm,* 1969. Plexiglass, aluminum, and wires. Courtesy Waddell Gallery, New York. Photo by Paul Bijtebier, Brussels.

Paul van Hoeydonck. *Robot,* 1968. Steel, aluminum, and wires. Courtesy Waddell Gallery, New York.

industrial complex. When Negroponte's *Architecture Machine* broke down at the Jewish Museum in 1970, Thomas Hess stated this position deftly and wittily in an *Art News* editorial. He described the shipwrecked gerbils, cowering before the broken arm of the computer, covered—not incidentally—with their own excrement. "Artists who become seriously engaged in technological processes might remember," he concluded, "what happened to four charming gerbils."[59]

For the moment, I shall pass over the merits of the Luddite case simply to point out that the issue is very nearly generational or, at least, instinctive. What appears to Mumford and Hess as Frankenstein's monster appears to Negroponte as a collaborative, beneficial mind. The difference between them has rich historical analogies. Karel Čapek invented the term "robot" in the play *R.U.R.,* written in 1923; in it, the machines revolt and take over the world, imprisoning man. At about the same time, Duchamp, Ernst, and Picabia made jest of the man-machine analogy in their paintings. But Paul Haviland, an American, limns it poetically:

> Man made the machine in his own image. She has limbs which act; lungs which breathe; a heart which beats; a nervous system through which runs electricity. The phonograph is the image of his voice; the camera is the image of his eye. The machine is his daughter born without a mother.[60]

But the intellectual Luddites were prompted by more than mere reaction. Their position was best and most forcefully articulated by Lewis Mumford in an imposing series of postwar books that included *Art and Technics* (1952) and a two-volume analysis of what he called *The Myth of the Machine,* culminating in *The Pentagon of Power* (1971). What Mumford detested most about scientific-industrial civilization was its tendency to overvalue "efficient," standardized behavior—in brief, its inclination to imitate the machine, "with its repetitive motions, its depersonalized processes, its abstract, quantitative goals."

Mumford could not sense the difference between electronic and mechanical systems, nor the way in which the computer would expand rather than restrict personal options; he knew little about the esthetic interaction with new technology, furthermore, that continually subverts quantitative goals. But he spoke and reasoned for a generation that had much to fear from technics. As the Vietnam war spiraled in grotesque proportions, a few American critics insinuated that any artist collaborating with a large commercial enterprise was reinforcing the power of the military-

Peter Saul. *Society,* 1964. Oil on canvas. Courtesy Allan Frumkin Gallery, New York. Photo by Nathan Rabin.

Joseph Beuys. *How to Explain Pictures to a Dead Hare,* 1965. An *Aktion* (performance) in Düsseldorf, Germany.

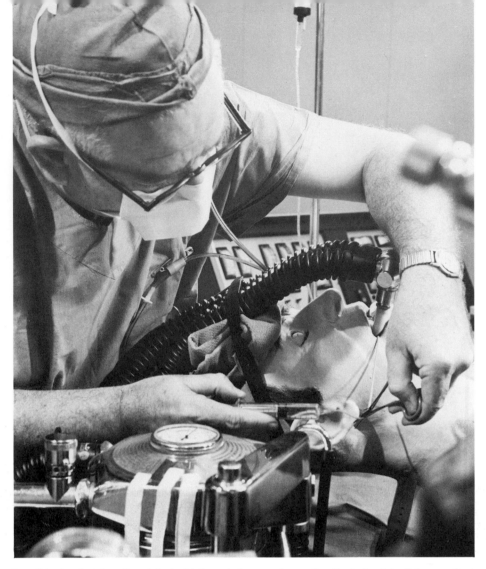

Possibly the first functional Android, here being used as a "patient simulator" for medical research, 1971. Courtesy School of Medicine, University of Southern California.

porary work that avoids the issue posed by an increasingly sensitized technology, or indulges it indifferently, like William Morehouse's *No. 35*, or Brancusi's classic *Bird in Space*. André Breton spoke for this attitude in the first Surrealist manifesto:

> Radios? Fine. Syphilis? If you like. Photography? I don't see any reason why not. The cinema? Three cheers for darkened rooms. War? Gave us a good laugh. The telephone? Hello. . . . Such and such an image . . . is to me, I must confess, a matter of complete indifference. Nor is the material with which he (the scholar/ scientist) must perforce encumber himself; his glass tubes or my metallic feathers. . . . As for his method, I am willing to give it as much credit as I do mine.[61]

Len Lye's reaction is similar. "Art and technology is to me the 'quill on the xerox,' " he said in a letter. "To me, the medium ain't the magic. The gene-pattern does the twanging. . . . The medium is no more magical than is a flashlight to an Ibo, or a laser to a truck-driver."

During the periods I have been discussing, romanticism flourished in painting and sculpture as well as literature, evenly balancing the homeostasis of the body esthetic, while on the other side there was a perceptible dampening of morale. The optimism with

Nam June Paik. *Robot K-456*, 1965. Motorized construction. 32" x 24" x 6' h. This walking man-lady responds to radio controls in a more or less faithful way. Courtesy Howard Wise Gallery, New York. Photo © 1965 by Peter Moore.

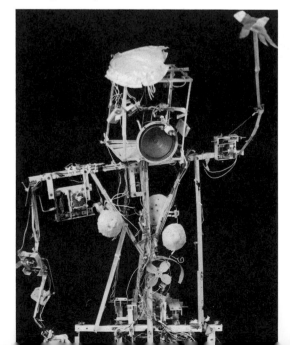

In the 1950's, Eduardo Paolozzi begins to work with the image of the metal man impassively, facing up to the reality as though it deserved esthetic neutrality. In the literature of science fiction, the Android, the humanized robot, takes on both positive and negative traits. Paik builds a robot, his tape-and-wire *K-9*, which clanks up and down the streets of New York, provoking awe but also laughter. At the present moment, MIT scientists are working successfully on a robot that can see, hear, and respond to voice commands with speech patterns of its own.

The Frankenstein-robot image, then, poses the central question of our time, esthetically as well as politically, dividing two very different sets of mind from each other. Needless to say, many artists operate outside this division. There is an enormous body of contem-

which many artists first courted industrial collaboration in the mid-1960's cooled considerably by the end of the decade. Oldenburg, Whitman, and John Latham were not alone in their disappointment with corporate collaboration. EAT suffered bitterly at the hands of the Pepsi-Cola Company, which withdrew its support after Klüver and his colleagues had designed an exceptionally intelligent environmental theater for the company's pavilion at the Osaka World's Fair in 1970. The decision, apparently based on a disagreement concerning the nature of the events occurring within the pavilion, cost EAT heavily in morale and public support. For the critics and artists who had opposed collaboration with profit-oriented firms from the start, the EAT crisis seemed to prove their argument.

By far the most determined of these opponents was the British artist Gustav Metzger. I have already described in brief his auto-destructive works of art and his 1961 manifesto, aimed against "capitalist values and the drive to nuclear annihilation." In the late 1960's, he moved into an active organizational role within the boundaries of traditional science. In 1970, he formed with other artists and scientists a subsection of the British Society for Social Responsibility in Science, dedicated to redirecting science and technology toward ends less destructive and militaristic: "We shall use science," he said, "to destroy science." In a letter he wrote me in late 1970, Metzger warned against affiliation with groups overly dependent on traditional industrial or gallery-museum support: "The artist committed to the use of computers and advanced technology needs to relate with those scientists and technicians fighting the system from within, trying to expose the disastrous alliance of science with the exploitative, destructive social systems."

Practical and political disillusionment was augmented by a mood of critical impatience with the esthetic results of matchings promoted by EAT, the *Art and Technology* exhibition in Los Angeles, and others. Too frequently, new media had merely been chained to forms and methods based firmly in the past. Michael Noll summed up this criticism when he charged, in a reevaluative essay pub-

Siah Armajani. *Fifth Element,* 1971. Electroplated aluminum, electronic components. A computer-designed control system kept the element suspended in midair. Courtesy Walker Art Center, Minneapolis. Photo by Eric Sutherland.

Left: Jud Yalkut. *Robot K-456* encounters the public on the streets of New York, 1965. From *PA- I (K),* a 16-mm. color film.

AUTO-DESTRUCTIVE ART

Demonstration by G. Metzger

SOUTH BANK LONDON 3 JULY 1961 11.45 a.m.—12.15 p.m.

Acid action painting. Height 7 ft. Length 12½ ft. Depth 6 ft. Materials: nylon, hydrochloric acid, metal. Technique. 3 nylon canvases coloured white black red are arranged behind each other, in this order. Acid is painted, flung and sprayed on to the nylon which corrodes at point of contact within 15 seconds.

Construction with glass. Height 13 ft. Width 9½ ft. Materials. Glass, metal, adhesive tape. Technique. The glass sheets suspended by adhesive tape fall on to the concrete ground in a pre-arranged sequence.

AUTO-DESTRUCTIVE ART

Auto-destructive art is primarily a form of public art for industrial societies.

Self-destructive painting, sculpture and construction is a total unity of idea, site, form, colour, method and timing of the disintegrative process.

Auto-destructive art can be created with natural forces, traditional art techniques and technological techniques.

The amplified sound of the auto-destructive process can be an element of the total conception.

The artist may collaborate with scientists, engineers.

Self-destructive art can be machine produced and factory assembled.

Auto-destructive paintings, sculptures and constructions have a life time varying from a few moments to twenty years. When the disintegrative process is complete the work is to be removed from the site and scrapped.

London, 4th November, 1959 *G. METZGER*

MANIFESTO AUTO-DESTRUCTIVE ART

Man in Regent Street is auto-destructive.
Rockets, nuclear weapons, are auto-destructive.
Auto-destructive art.
The drop drop dropping of HH bombs.
Not interested in ruins, (the picturesque)
Auto-destructive art re-enacts the obsession with destruction, the pummelling to which individuals and masses are subjected.
Auto-destructive art demonstrates man's power to accelerate disintegrative processes of nature and to order them.
Auto-destructive art mirrors the compulsive perfectionism of arms manufacture—polishing to destruction point.
Auto-destructive art is the transformation of technology into public art. The immense productive capacity, the chaos of capitalism and of Soviet communism, the co-existence of surplus and starvation; the increasing stock-piling of nuclear weapons—more than enough to destroy technological societies; the disintegrative effect of machinery and of life in vast built-up areas on the person,...

Auto-destructive art is art which contains within itself an agent which automatically leads to its destruction within a period of time not to exceed twenty years. Other forms of auto-destructive art involve manual manipulation. There are forms of auto-destructive art where the artist has a tight control over the nature and timing of the disintegrative process, and there are other forms where the artist's control is slight.
Materials and techniques used in creating auto-destructive art include: Acid, Adhesives, Ballistics, Canvas, Clay, Combustion, Compression, Concrete, Corrosion, Cybernetics, Drop, Elasticity, Electricity, Electrolysis, Electronics, Explosives, Feed-back, Glass, Heat, Human Energy, Ice, Jet, Light, Load, Mass-production, Metal, Motion Picture, Natural Forces, Nuclear energy, Paint, Paper, Photography, Plaster, Plastics, Pressure, Radiation, Sand, Solar energy, Sound, Steam, Stress, Terra-cotta, Vibration, Water, Welding, Wire, Wood.

London, 10 *March,* 1960 *G. METZGER*

AUTO-DESTRUCTIVE ART MACHINE ART
AUTO CREATIVE ART

Each visible fact absolutely expresses its reality.

Certain machine produced forms are the most perfect forms of our period.

In the evenings some of the finest works of art produced now are dumped on the streets of Soho.

Auto creative art is art of change, growth movement.

Auto-destructive art and auto creative art aim at the integration of art with the advances of science and technology. The immidiate objective is the creation, with the aid of computers, of works of art whose movements are programmed and include "self-regulation". The spectator, by means of electronic devices can have a direct bearing on the action of these works.

Auto-destructive art is an attack on capitalist values and the drive to nuclear annihilation.

23 *June* 1961 *G. METZGER*

B.C.M. ZZZO London W.C.1.

Printed by St. Martins' Printers (TU) 86d, Lillie Road, London, S.W.6.

Gustav Metzger. Auto-Destructive Art manifesto, 1961.

lished in 1970, that no one had yet produced computer art that was beyond the hand or true to its source:

> The computer has only been used to copy aesthetic effects easily obtained with the use of conventional media, although the computer does its work with phenomenal speed and eliminates considerable drudgery. The use of computers in the arts has yet to produce anything approaching entirely new aesthetic experiences.[62]

Noll's position applied to more than the computer. It implied that the day had passed when kinetic versions of static sculpture, flat canvases inlaid with neon tubing, and computerized nudes were esthetically relevant. It was time to allow the new materials to find suitable forms that reached beyond previous contexts, forms that had already begun to emerge in Schöffer's spectacles, Piene's sky events, and Paik's synthesizer.

As for the computer, it had been primarily utilized for its alternative, "fallout" capabilities, as Noll implies. Art has yet to exploit the computer as a brain. Siah Armajani, who moved toward this point in his film, *5,001 Ways of Viewing a Square*, which presents an exquisitely detailed study possible only through computer programming, says: "The computer is an alternate nervous system, not a slave." The computer's core is its ability to store, process, and organize information, not to draw or to make sounds. Industry, like science, understands this: the "systems" approach to empirical problems that flowered during the early 1960's depended heavily on the computer. At the base of the "systems" idea is simply the determination to consider every variant of the problem posed and every effect of the available possibilities. The perfection of environmental art awaits only creative computer collaboration.

Hybrid Art/Engineering/Science: Dada Vindicated

The proper resolution of the issue posed by art's flirtation with technology clearly seems to lie beyond the traditional parameters of the artist, the object, and the system within which the creative process normally occurs. The continuing growth of artist-engineer-scientist hybrids like Calder, Fuller, Malina, Seawright, Wen-Ying Tsai, Larry Bell, Zammitt, Paik, and others anticipates this development. In a sense, these men represent a

Robert Watts. *Neon-Signature,* 1965. Fluorescent tube. 15¾″ x 30½″. Collection Dr. Peter Ludwig. Courtesy Neue Galerie, Aachen, Germany.

triumph for the Dada spirit that has hovered over the art-technology marriage, rather like an old and discredited lover. Dada wanted to destroy nothing so much as the preciosity surrounding the artist. Rightly or wrongly, the Dadaists associated this preciosity with the unrestrained individualism they believed to be behind the horrors of war and social injustice. The new hybrid artist—like the hybrid forms he tended to produce—turned away from the ego to the machine to make art, satisfying Dada's central thrust.

There is another link between Dada and the movement that began with Futurism in 1910. Robert Motherwell claims that Dada was the first attempt to use the means of modern art as a sociopolitical weapon. At best, the credit must be shared with the Russians. Tatlin and Lissitsky explicitly set out to change the world, as did Gabo and the rest of the Constructivists, to a lesser degree. Time and again, the same pedagogic spirit pervades the work under discussion. Moholy-Nagy, speaking for himself and his Bauhaus colleagues, said, "Our art has a definite educational and ideological function." Similar sentiments have been expressed since then by Read, Fontana, Vasarely, Schöffer, Kluver, Kepes, and others. I intend to take up later the end to which their work seems to be heading in the social sense, the implicit ideology referred to by Moholy. For the moment, I still simply say that artists in this century have consistently regarded technology as both a philosophical-propagandistic and an esthetic tool.

Often they have failed and grown tem-

porarily disillusioned. But they have persisted with remarkable vitality. For this and other reasons, I believe their efforts constitute the major esthetic event in our time. The one characteristic that sets contemporary art apart from virtually every mode of plastic or visual expression prior to 1900 is its extensive physical and intellectual collaboration with new technology. The appeal of the machine to art was originally sporadic; now—with its

clanking, alien dress exchanged for a quiet electronic hum—the machine is irresistible. Each side attracts the other, of course, rather like two magnets set side by side. Once activated, however, once the decision is made to use new materials, the attraction expands in implication. Gabo deserted kineticism after building his first moving sculpture in 1920, but he is an exception. In every other significant case, the involvement has grown. Moholy-Nagy was led from sculpture to light to total theater, Tinguely from junk sculpture to the *Gigantoleum,* Rauschenberg from radios in the canvas to self-activating walls, Piene from room-sized light ballets to sky ballets, Babbitt from synthesizer to computer, Paik from TV constructions to programming— and art as a whole from the depiction of movement to movement itself, from a programming interface with the computer to the actual computer, from a lust for life to involvement within it.

The list is virtually endless. Its apparent inevitability, furthermore, is real. The decision to extend our hands, our minds, or our art through technology guarantees a direction away from ourselves and our past, even our decision to do so, with all its related motives. We are led as much by the future as by the past, which is the real cause of the fear-limned in the Frankenstein image and articulated in Mumford's books—that man is out of control in art and life. He is out of control by choice; he moves toward the unknown because he is attracted to it and repelled by the known. The past is no match for the future, nor *R.U.R.* a valid answer to Paul Haviland. In an engaging book about her friend Kurt Schwitters, Kate Steinitz recalls the text of a play that she, Schwitters, and others collaborated on for a Festival of Technology in Hannover, Germany, in 1928.[63] The crucial point is not the ludicrous line Schwitters put in the mouth of a character named "Spirit of Technology" ("Sparks! Lightning! Fire! Light! Machinery! Engines! Iron! Concrete!" she shouts as she enters), but that he made technology a character at all. If we do not learn to think metaphorically in this way, we cannot hope to see technology or its place in art clearly. Both sides are active; they are in fact one spirit, not two.

Hannover "Festival of Technology," 1925. Among the principal participants were, left to right, Friedel Vordemberge-Gildewart (whose painting hangs in the background), Nelly van Doesburg, Kurt Schwitters (who wrote for the festival a prophetic opera saluting the "Spirit of Technology"), Theo van Doesburg (a founder of the De Stijl group in Holland), Kate Steinitz, and Hans Nitzschke. Collection Kate Steinitz. Courtesy Los Angeles County Museum of Art.

II PROCESS: CONVERSATIONS, MANIFESTOS, STATEMENTS

Introduction

No summation of a crucial moment in the development of art could be complete without hearing firsthand from the people involved. In certain critical quarters, it is maintained that the artist is the least reliable guide to his own work. In fact, he is the best—not in terms of evaluation but in the transmission of information related to the work. It is Takis and Kepes who document the decisive influence that the experience of World War II had upon their work; Paik who emphasizes the importance of his first contact with John Cage, a contact that led directly to his decision to use the cathode-ray tube as a canvas; psychologist Edward Wortz who confesses his growing inability to draw clear lines between his own work and that of the artists with whom he collaborated.

In structuring this chapter on these grounds, I have attempted to present raw information from points spread evenly along the art-technology matrix. My object has been not to "cover" every key figure, but every idea and approach. To that end, I have omitted some artists of stature and included a few of lesser rank in order to present a meaningful spread of conceptual positions. In four cases, those of László Moholy-Nagy, the Bauhaus in general, Victor Vasarely, and John Cage, I have not attempted to present statements or information easily available elsewhere. Needless to say, the emphasis here has been placed on work done since 1945.

I hope the result will be a rich vein of informal information—supplemented here and there by formal documents, largely manifestos, of particular historical importance—that can be further mined by artists, students, and general readers. Most of the conversations or interviews took place in person, although a few were conducted primarily through correspondence. In every case, the principal involved was given the opportunity to check and correct the final text. The sources for the formal documents are indicated, where pertinent, in footnotes.

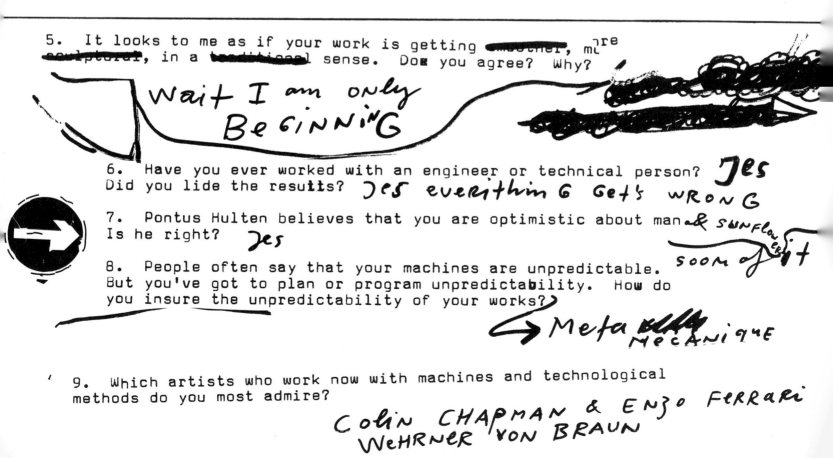

5. It looks to me as if your work is getting ~~smoother~~, more ~~sculptural~~, in a ~~traditional~~ sense. Does you agree? Why?

Wait I am only Beginning

6. Have you ever worked with an engineer or technical person? *Jes*
Did you lide the results? *Jes everithing Get's wrong*

7. Pontus Hulten believes that you are optimistic about man *& sunflower*. Is he right? *Jes* *soom of it*

8. People often say that your machines are unpredictable. But you've got to plan or program unpredictability. How do you insure the unpredictability of your works? *→ Meta Mecanique*

9. Which artists who work now with machines and technological methods do you most admire? *Colin Chapman & Enzo Ferrari Wehrner von Braun*

Gyorgy Kepes: The New Landscape

Gyorgy Kepes, painter, designer, photographer, teacher, has been concerned for several decades with the fusion of art and science. Born in Hungary in 1906, Kepes went to Berlin in 1930 to work with his countryman László Moholy-Nagy, who had come there after leaving the Bauhaus. Their association eventually brought Kepes to Chicago in 1937 to head the light-and-color department of Moholy-Nagy's "New Bauhaus," as the Institute of Design came to be called. Since 1946, Kepes has taught at the Massachusetts Institute of Technology.

Like Moholy-Nagy, Kepes has been an influential teacher and writer. His first book, *The Language of Vision,* was published in 1944; an analysis of visual communication, it has become a valuable handbook for those involved with education in architecture and the visual arts. *The New Landscape in Art and Science* (1956) may prove equally significant in time, calling our attention, as it does, to a rich and largely ignored assortment of images from the scientist's world—images produced by the computer, serial photography, photomicrography, and more. The theme of the interrelationship of art and science has been continued In the six-volume "Vision & Value" series, which Kepes edited.

In 1965, Kepes announced in *Daedalus* magazine a proposal that has since become a reality, as the Center for Advanced Visual Studies in Cambridge, Massachusetts. During the fall of 1967, with the support of MIT and several foundations, the Center began its work. The early fellows included Takis, Otto Piene, Harold Tovish, Jack Burnham, Charles Frazier, Ted Kraynik, Wen-Ying Tsai, and Stan Vanderbeek. The Center's early years were lean ones financially, and Kepes was kept from fulfilling his hopes in detail. But there was an evident emphasis on two points: common projects, which included a series of proposals to form a large-scale, luminous environmental structure in Boston Harbor; and the importance of establishing strong, continuing dialogues with the scientific community of Cambridge. Very few ties developed during the early years (there were exceptions, of course; Takis's collaboration with Ain Sonin being one of them), for reasons rooted in the provincialism of both art and science: neither side cared as much for intellectual

Gyorgy Kepes. Courtesy Massachusetts Institute of Technology, Cambridge, Mass. Photo by Nishan Bichajian.

enrichment as it did for professional production. But Kepes persisted, stating in a 1969 issue of *Arts Canada* that he wanted the Center to develop "networks of communication between individuals."

In 1970, he tried to organize an innovative exhibition for the Smithsonian Institution in Washington, D.C., entitled *Explorations.* He originally planned to commission a "community of works" that would relate one to another, thus avoiding both the egocentricity of art and the anonymity of science. "An exhibition as an anthology of individual works of art, spotlighting the quality of individual word and personal achievements," he wrote, "no longer seems a force in the new sense of life that motivates creative expression." Rebuffed again by limited funds, he was forced to settle for a group of thirty-two individually conceived works related basically through hidden timers that turned the works (most of

them employing light and movement) off and on in sequence. The concept embodied in the exhibition was nonetheless significant, and certain to be attempted again.

As he reveals in the following conversation, Kepes is at best guardedly optimistic about today's art, especially in its use of recent technology. For all his interest in new materials and methods, Kepes espouses what is essentially a Renaissance esthetic. He expects the artist to discipline and order his materials, to chart his way as much by reason as by instinct, and to express himself in humanistically meaningful terms. In the early 1970's, Kepes's center became involved in a series of architectural and urban-planning projects that evolved logically from this position. His paintings are lyrically abstract, but his thinking and his life are rooted, as was Gropius's, in the practical.

Could you tell me a little bit about your own background—how you came to work so closely, both as artist and as teacher, with technology?

I was born in Hungary and started to paint when I was very young; I was considered something of a wonder child—no doubt a rather confusing and troubled start for anyone. I went through, with many in my generation, the whole gamut of artistic exploration. I tried Expressionism, explored Cubist spatial analysis, built with Constructivist techniques, and finally made paintings that were a positive mutation of Dada. In the late 1920's, I became deeply disturbed by social injustices, particularly by the inhuman condition of the Hungarian peasantry. In this context, painting seemed a rather anemic tool of human expression; filmmaking seemed to offer a way to satisfy the needs of my visual sensibilities as well as my social conscience. With one single decision I gave up painting and left for Berlin to work with Moholy-Nagy, with whom I had had a long-standing correspondence. From 1930 to 1937, I collaborated with him intermittently. I learned a great deal from him about the creative potentials of artificial light while working on stage designs and his film *Black, White and Gray.* When Moholy went to Chicago in 1937, he invited me to come there and develop the light-and-color department of the Institute of Design—a challenge I more than willingly accepted.

When and why did you come to MIT? I gather that it played a decisive role in the development of your thinking?

In 1946, after having read by book, *The Language of Vision,* Dean W. W. Wurster invited me to come to MIT to introduce visual design as a discipline for architects and city planners. At MIT I was forced to face myself anew and to check what I knew and did not know about the world in which I was living. It was the first time in my life that I had had ample opportunities to be in close, continuous contact with eminent scientists and engineers. I discovered with joy a different, an inspiringly encompassing and more objective world; with dismay I also found out how uninformed I was about some of the majestic achievements of this century. At the same time, I learned to my surprise how uninitiated some of my scientist and engineer colleagues were when it came to the most basic values of artistic sensibility. Gradually I began to see that the world opened up by science and technology could offer essential tools and symbols for the reorganization of our inner world, the world of our sensitivities, feelings, and thoughts. Furthermore, I came to believe that artists and scientists could be equal partners in this great transformation.

It was early in the 1950's, if I recall correctly, that you began work on your book The New Landscape in Art and Science.

Yes. This book attempted to present in pictures the new vistas of the visual world revealed by science and technology, things that were previously too big or too small, too opaque or too fast for the unaided eye to see. In words, I tried to indicate that art and science are in a symbiotic relationship and that each grows stronger when nourished by the other.

It was, I learned, premature to imply such a connection in those days—the heyday of Abstract Expressionism. The idea appeared to be taboo, if not insulting to many artists, and the scientists were equally skeptical. In 1951, to break down what I considered unwarranted resistance, I organized at MIT's new art gallery a comprehensive exhibition of what I called *The New Landscape.* It is a welcome change in our cultural climate that recently a leading museum could present, as an important and legitimate enterprise, an almost identical exhibition with almost identical material [*Once Invisible* at New York's Museum

of Modern Art, summer 1967]. It was not so in 1951. When finally the book *The New Landscape in Art and Science* was published in 1956, the climate was still not very favorable. Some art magazines refused to review the book on the grounds that art and science were unmixable entities.

What do you consider to be the main purpose of the Center for Advanced Visual Studies?

The Center is planned first as a clearing house of artistic tasks that have authentic roots in our present condition. Second, the Center should be a laboratory where the most advanced technological tools can be tested for their applicability in the newly emerging scale of artistic tasks. Third, and above all, the Center is intended to become a testing ground for the needed collaboration among artists, scientists, and engineers. I sincerely hope that the Center will develop a work pattern—I can best suggest its nature through a physical simile, the dove-tail joint— in which the complementary characteristics of interacting elements combine to achieve an optimum strength.

It seems to me—after observing the Center at work—that its singular value lies in the potential for a very full and rich dialogue with the scientific brainpower resident in Cambridge, rather than in the production of specific works. How do you feel about this?

Explorations, an ''environmental exhibition'' organized by Gyorgy Kepes and the Center for Advanced Visual Studies at the Smithsonian Institution, Washington, D.C., in April, 1970. Installation photograph, detail. Courtesy Center for Advanced Visual Studies, Massachusetts Institute of Technology, Cambridge, Mass. Photo by Nishan Bichajian.

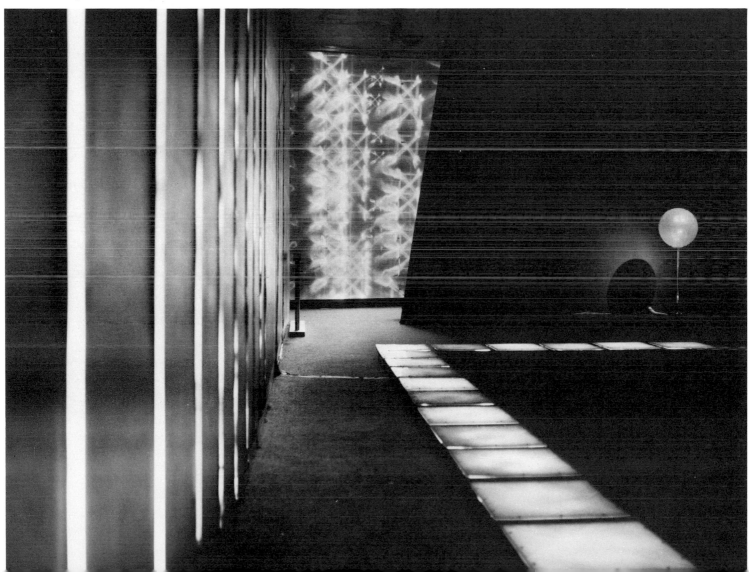

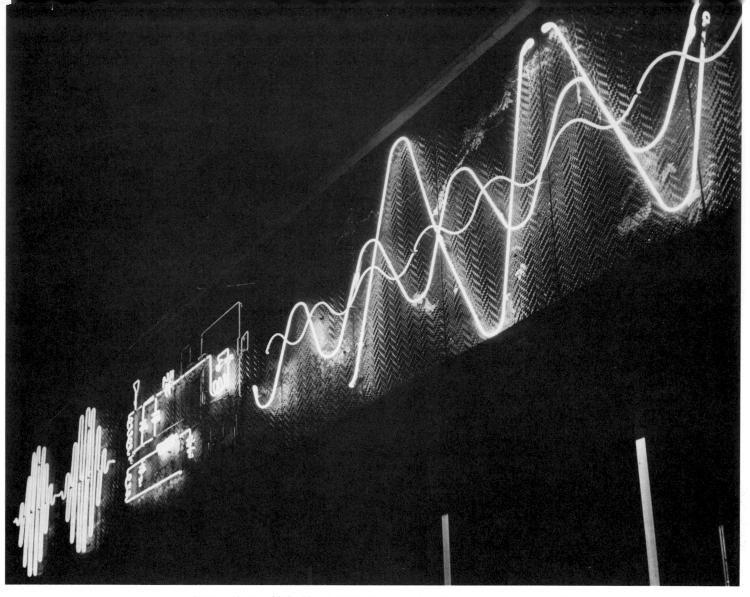

Gyorgy Kepes. *Light Mural,* 1950. Neon tubing. Commissioned by the Radio Shack in Boston.

Takis, for example, believes that collaboration with a scientist is far more rewarding for the artist than collaboration with an engineer, because it permits a strong conceptual as well as practical exchange. Do you agree?

Before, the channels of communication between artist and scientist were accidental. Now the Center does allow us to see scientific ideas in a certain profile. My old dream related to the issue of seeing the total horizon, of going up to the top with the scientist, in effect. That's absolutely essential to the re-orientation of the artist. Close contact with the man who has the vista is a very different type of communication. It makes for friendship with an idea as well as a man.

Does your interest in scale, evidenced in your thinking about the electronic monument, make you very partial to the use of the computer in making works of art? James Tenney points out, for example, that the computer allows one to work freely with large structures—the symphony form, say—because one no longer has to devote months, even years, to their physical preparation. The computer can accomplish this in a matter of minutes.

That's right, although it is not the physical scale itself, nor the scale of performance of the high-speed computer that interests me; it is the scale of the task that I think is important. Some time ago, while co-directing a major study of the perceptual form of the

cities, a project supported by the Rockefeller Foundation, I began to think about the artistic opportunities offered when artificial light is geared to an urban scale. If one looks down from the air on a city at night, there is a new scale of experience. The rich, unfocused, vibrating light carpet has no beginning and no end; it was not woven by a single weaver nor designed by a single master. Nevertheless, careful planned interference could amplify this vital richness. Programmed light patterns in some areas of the city could serve as potent foils. accenting the random background. It can be done. In Chicago during the war, Moholy and I were asked to help design a camouflage effect for the city. They wanted to create light patterns that would confuse enemy fighter pilots, so they wouldn't know where they were. We changed the light pattern of Chicago by floating lights on the lake and in the park, where they normally are not seen from the air. We also blotted out many busy centers of the city. All this was done without the computer. I could see then that we had a great tool in our hands.

The broad premise behind the Center is that artists and scientists must learn how to work together. Can the scientist profit from such a relationship in any practical or theoretical way?

I would be stepping on thin ice if I were to make concrete claims, but I am convinced that an intimate work contact between scientist and artist can lead to certain insights the scientist could not reach otherwise. By becoming involved in the artist's imaginative processes, the scientist can discover in himself avenues of imaginative power that might ordinarily be bypassed. Notwithstanding the highly abstract mathematical conceptual ways scientists approach their problems today, there is ample evidence that some major scientific insights and technological discoveries were initiated through visual, esthetic experiences.

Do you see your work as it is now developing, particularly with regard to the Center at MIT, as a logical extension of your early contacts with members of the Bauhaus?

The Bauhaus represented a very wide spectrum of values and attitudes, from Gropius to Klee, from Kandinsky to Moholy-Nagy, and to refer to it as a stylistic category is a gross oversimplification. My own interest is in continuing that strain in the Bauhaus which attempted to find an agreement across a wide spectrum of disciplines—science, engineering, art. Gropius himself wanted most of all to bring back the spirit of community—the attitude of the builders of the medieval cathedral, where everyone worked together. The use of new technological materials and the employment of the machine as tool represented only one aspect of the Bauhaus. Our interest at the Center is not only in new materials or technical implements, but in new knowledge. Today the possibilities suggested by new materials are much broader than they were in the days of the Bauhaus. Neither electronics nor the computer existed then.

Are you pleased with the work coming out of the new interest in technology?

In our confusing, compassless cultural landscape, it is inevitable that some people just jump on the bandwagon. No doubt there are some artists who are taking sophisticated technical implements, like the computer or electronic devices, and simply playing with them, not recognizing the essential promise of these devices. But if I am correct, concern with technology must be based upon a real understanding of what technology is today. Technology today does not simply imply a physical implement, a "machine," mechanical or electronic, but a systematic, disciplined, collaborative approach to a chosen objective. There is a new technology that Daniel Bell has called "intellectual technology"; this is what artists must accept and understand. The medium, in this case technology, is not in itself the message; it becomes a message when it is in a vital dialogue with our most authentic contemporary needs.

What do you think the art of the future will be like?

That is a brave question, and I wish the answer could be as brave, but to my regret it will only be a generality that has great meaning for me. I am sure you know about the concept of homeostasis, wherein the organism automatically adjusts itself to this or that excess in order to preserve its physiological equilibrium. This process, which exists on a physiological, individual level, must now be developed on the social and cultural levels. In this development, the artist's sensibility will play an immense role. The artist of the future must read our broad environmental needs and create large-scale forms that will help satisfy these needs. My hope is to contribute in developing the spirit and the tools for this task.

Nicolas Schöffer:
The Cybernetic Esthetic

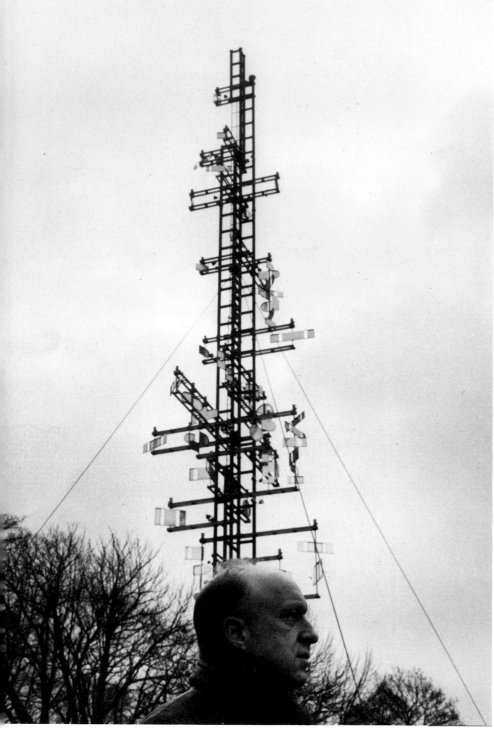

Nicolas Schöffer in front of his *Spatiodynamic Tower,* La Bouverie Park, Liège, Belgium, 1961. Courtesy Waddell Gallery, New York.

Nicolas Schöffer began his career as a painter and did not turn to kinetics until relatively late: his first show of kinetic sculpture, at the Galerie Breteau in Paris, took place in 1950, when he was thirty-eight. Despite that, he is an imposing senior figure, not only in terms of kinetic art but in terms of the collaboration between artist and engineer. Before the advent of the "group phenomenon" in Europe during the late 1950's, and the later birth of EAT in the United States, Schöffer was constructing his own formal alliances with the other side. In 1950, with the help of engineer Henry Perlstein, he built a "spatiodynamic" electric clock; in 1954, with composer Pierre Henry and engineer Jacques Bureau, of the Philips Company, he constructed a sound-equipped "Cybernetic Tower," fifty meters in height, at the Salon des Travaux Publics in Paris; in 1956, along with François Terny, another Philips Company engineer, he made the first in his "*Cysp*" series—*Cysp I*—a programmed, cybernetic piece of sculpture; in 1961, he designed another large tower, this time fifty-two meters high, for La Boverie Park in Liège, built by the Philips Company. A giant piece of abstract sculpture, in effect, the tower contains sixty-six electronically controlled mirror plates that create audiovisual "luminodynamic" spectacles, the music programmed by composer Henry Pousseur.

These were merely beginnings. The main characteristic of Schöffer's work—in addition to its programmed, controlled quality, so distinct from the free-wheeling approach of Tinguely, say—is its scale. He has always wanted to get his art "outside," in a sense, not only into the parks of Liège and Paris, the perfect settings for his luminodynamic spectacles, but into the environment itself. The endless plans he has devised for cybernetic cities and spatiodynamic buildings are continuing evidence of this concern. So is the kind of work to which he has applied the term "chromodynamics," discussed here. The chromodynamic work, in Schöffer's mind, changes like man and nature, avoiding the fixed state. A certain indeterminism, in other words, can be programmed into art either by natural means (the work responding

120

through electronic sensors to changes in the weather or the presence of crowds) or by the action of an interpreter—his *Musiscope,* completed in 1960, can be played by its user. It is no wonder, then, that he has written that the employment by the artist of electric power or electronics makes his work "more and more obviously the biological extension of man," a position close to the ideas expressed by John Cage and Nam June Paik, artists with whom Schöffer is rarely linked.

Like Kepes, Vasarely, and Moholy-Nagy, Schöffer was born in Hungary. He took up permanent residence in Paris in 1936. Although his work is well known in Europe, he did not begin to reach an audience in the United States until he was paired with Jean Tinguely by the Jewish Museum in an important exhibition in 1965, which later traveled to Washington, D.C., Minneapolis, Pittsburgh, and Seattle. His first American one-man show followed three years later, at the Waddell Gallery in New York. At the beginning of the 1970's, he was pressing on to even larger schemes for his work, convinced, as he says in this interview, that "art should be essentially exploratory, now more than ever."

Among the major artists in our time committed to the uses of technology, Schöffer remains, as he demonstrates here, committed as well to goals that are social in nature. That these commitments are fused in works bearing the strong, unmistakable stamp of their creator's personality is a paradox. The young European artists following him found it an uncomfortable paradox—particularly those, such as the Groupe de Recherche d'Art Visuel, who stressed "anonymity" in execution. Despite his scientific rhetoric, Schöffer is indeed a "maker" in the grand, romantic tradition, in total and personal control of his media.

You once stated in your doctrine of non-formalism that a work of art "must be absolutely separated from the problem of form." Why "must"? Is there something inherently wrong with volumes and surfaces, with static works?

It is undeniable that the first phase of the history of art was dominated by the object. The apparent goal of art was the work of art; the general interest was focused on the object, on its intrinsic qualities as an object. The problem of the effect was hardly touched upon. It was the apparent success of the object that determined in the immediate present the artistic success. The idea remained more or less in shadow, even with the majority of the great creators.

The apparition of the idea as the basis of artistic creation came timidly to light in the nineteenth century with Émile Bernard, the Pointillist; the Impressionists, at least at the beginning; the Fauvists; and the Cubists afterward—but even in this phase the object is still supreme. It is still true today. An abstract painting—concrete, figurative, Dada, Pop, or another—is still an object. But the essential thing in artistic creation, I think, is to evoke the effect of the idea, even if one goes beyond the object.

Technology has enabled me to do this. My chromodynamic techniques are after precisely this end. In conventional cinema, the film is programmed after the idea. In chromodynamism, the programming directly permits the effect, reducing the intermediary object to its strictest role. By thus transferring the programming of the idea to the programming of the effect, the object in artistic creation has been irrevocably broached, proving what has always been true. That art is not made with the hands and the muscles but with the creative imagination.

You have suggested that there is a relationship between the way some of your "environmental" works function and the disciplines of city planning, land development, and architecture. What is that relationship? Why are you so interested in city planning, for example?

I believe there should be esthetic products within the urban environment. Esthetic hygiene is necessary for collective societies, for any social group residing together on a large scale. How? By programming environments that obey rigorous esthetic criteria. Each time the inhabitant walks around in the city, he must bathe in a climate that creates in him a specific feeling of well-being, invoked by the massive presence of esthetic products in the environment. Each group of buildings must generate esthetic sensations, surrounding the citizen in an almost permanent way. Within this varied topology, there will be esthetic culmination points, of course, of a very high frequency.

We ought to envision a plan for an ensemble of spatial structures luminous and temporal, organized and programmed to respond to information coming in from outside

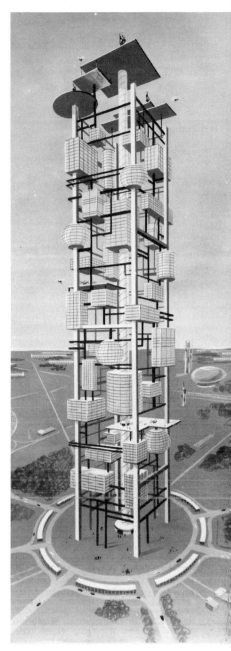

Nicolas Schöffer. *Ville Cybernetique (The Cybernetic City): Centre Universitaire,* 1966. Ink drawing. Courtesy Waddell Gallery, New York. Photo by Studio Yves Hervochen, Paris.

activity and from needs articulated by their users. The structures can be either fixed or mobile.

I suppose this is why you have made so many drawings of a "cybernetic city." You seem to use the term "cybernetic" over and over, in a "systems" sense.

Yes. Though a rational and esthetic organization in the urban or rural sectors poses complex problems linked to the enormous investments that have so far been diverted toward other objectives, most of them sterile and injurious, such as the military. It is nonetheless certain that the course of events must bend in another direction. Rivalries will continue, but on a constructive level; wars, or rather antagonisms, will be essentially psychological, economic, technoscientific, and artistic. The cadres of the future world form already, making themselves more and more evident.

The fact that most of your works are so carefully programmed—in contrast, say, to Tinguely's creations, which are open-ended and unpredictable—points to a view of art as essentially stable. Is this so?

Perhaps. An authentic creation-invention that evokes a valid artistic effect not only does not deteriorate with time, but constantly improves. It is the only nonentropic phenomenon in human creation. In all other domains, ideas, objects, and effects return immediately into the entropic cycle, as do we. But Vermeer, Shakespeare, and the Greeks have created ideas, objects, and effects that constantly show their validity. This faculty of survival and self-validation is the special quality of artistic creation. As perfect as it is, the technological object cannot have the same destiny. A locomotive of 1890 is today a carcass without significance, and in fifty years an atomic submarine or a Concorde airplane will become equally insignificant pieces of metal. None is based in an ideological fact that goes qualitatively beyond the linear and normal level of creation. The objectives of the technician-scientist and the artist are radically different.

Why did you first turn toward the media offered by recent technology, away from the traditional media? Do you think the artist has any moral obligation to deal with new media?

Traditionally, the energies deployed by the great artistic creators have pushed society forward. Each evolutionary passage from one phase to another is achieved by art. It extrapolates the essential from each phase, which remains through all the esthetic products, however different. Paradoxically, we are watching a rebirth of artistic creativity, thanks to both science and technology. One day, esthetics will have to serve both.

It sounds as though you feel art has a clear social role—indeed, almost didactic—in the sense that it both anticipates and prepares us for massive evolutionary changes. Am I right? Is this the effect you hope your works, now and future, will have on the people who see and participate in them?

Art should be essentially exploratory, now more than ever. Otherwise, man will never adjust to accelerated change. I hope it will impose subtle changes in him that will lead him to control his destiny rather than accept it. What art can add to this evolution is its extraordinary conceptual and imaginative freedom, which has always permitted it to escape mundane pressures.

Jean Tinguely. Courtesy Alexander Iolas Gallery, New York and Paris. Photo by Shunk-Kender, Paris.

Jean Tinguely: Be Movement!

Although he affirms his debt to Dada, Jean Tinguely is in a specific way unique. He is not the only artist to "free" the machine, endowing it with non-functional, non-purposive life. But he was the first to demonstrate that capacity (inherent in all technology) with worldwide success. Born in Switzerland in 1925, he began putting together awkward pieces of kinetic sculpture during the early 1950's, most of them based on secondhand motors and scrap materials collected from the junkyards of Paris, where he then lived. He was intensely involved at that time in the concept of motion, as opposed to static forms, in sculpture, a struggle dating back to

the Constructivist manifesto and reflected in the statement presented here, made at London's Institute of Contemporary Arts in 1959.

From the beginning, Tinguely's machines have reduced their audiences to laughter and often performed in ways that surprised their creator. His early "metamatic" machines, which were intended to make their own abstract paintings, often sprayed paint on the spectators instead. *Homage to New York*, which he engineered with Billy Klüver's help to destroy itself at the Museum of Modern Art in March, 1960, unpredictably blew smoke in the eyes of the spectators gathered there to see the feat. The playful *Rotozaza*, con-

Jean Tinguely. *La Rotozaza No. 1,* 1967. Iron, wood, rubber balls, and motorized elements. 7'3" x 7'7".
Courtesy Alexander Iolas Gallery, New York and Paris. Photo by André Morain, Paris.

structed in 1966, catches balls thrown at it and often returns them far beyond anyone's reach. Tinguely encourages this wanton behavior, of course, by setting gears at odds with one another and using old parts likely to break down at any moment.

Toward the end of the 1960's, he began working on his most ambitious project: the *Gigantoleum,* a "cultural station" to be built—as the funds came in—in Bern, Switzerland, in collaboration with Bernard Luginbühl. Its creators promised facilities for almost every non-purposeful activity, including art exhibitions, burlesque movies, life-size bear sculp-

tures, an aviary containing 10,000 sparrows, a dairy bar with a real cow on grass behind a glass window, a tactile labyrinth, "strange automatons," an ice cream factory, and "an automatic flag raiser." The most important feature, which echoes Tinguely's historic statement on "static," as well as Julio Le Parc's insistence on *l'instabilité,* is described as follows:

> The station should be planned so it can continually be transformed, enlarged, or painted a surprising color, and consequently must not have a definite form, and should thus become a center of unexpected surprises.

Dear Mister Davis: 1 XII 69

I wanted to make → **Mouvement** ←

1. What led you to use motors and machines in your work? Another artist? Or was it something in the world around you, something beyond art, whatever that is? *Jes: OUR civilisation*

↙ *Alexander Calder* → *Jes: FUN & everythinG*
Picabia – Duchamps *Meta*

2. It is often said that you are anti-machine. Are you? If so, why? What's wrong with machines?

↙ *They are crazy Not wronG*

3. Are you anti-computer? If so--again--why?

I am Anti-NoτHiNG

4. You have been quoted to the effect that you use the machine because it permits you to make poetry. Why? What is poetry? *: life*

5. It looks to me as if your work is getting ~~smoother~~, more ~~sculptural~~, in a ~~traditional~~ sense. Do you agree? Why?

Wait I am only BeGiNNiNG

6. Have you ever worked with an engineer or technical person? Did you lide the results? *Jes everythinG Get's wronG*

7. Pontus Hulten believes that you are optimistic about man & sunflower. Is he right? *Jes* *soon a bit*

8. People often say that your machines are unpredictable. But you've got to plan or program unpredictability. How do you insure the unpredictability of your works?

→ *Meta MecaNique*

9. Which artists who work now with machines and technological methods do you most admire?

Colin Chapman & Enzo Ferrari
Wehrner von Braun

10. Is there any broad difference between American and European artists who work this way?

Sure
its Not sure there is any difference.

Jean Tinguely

A letter from Jean Tinguely, 1969.

Tinguely's response to a letter sent him early in 1969, soliciting information, is also reproduced here, exactly as it arrived. It is very nearly a work of art in its own right; in any case, it beautifully summarizes his irrepressibly playful spirit.

Static, static, static! Movement is static! Movement is static! Movement is static because it is the only immutable thing—the only certainty, the only unchangeable. The only certainty is that movement, change and metamorphosis exist. That is why movement is static. So-called immobile objects exist only in movement. Immobile, certain and permanent things, ideas, works and beliefs change, transform and disintegrate. Immobile objects are snapshots of movement whose existence we refuse to accept, because we ourselves are only an instant in the great movement. Movement is the only static, final, permanent and certain thing. Static means transformation. Let us be static together with movement. Move statistically! Be static! Be movement! Believe in movement's static quality. Be static!

The constant of a movement, of disintegration, of change and of construction is static. Be constant! Get used to seeing things, ideas and works in their state of ceaseless change. You will live longer. Be permanent by being static! Be part of movement! Only in movement do we find the true essence of things. Today we can no longer believe in permanent laws, defined religions, durable architecture or eternal kingdoms. Immutability does not exist. All is movement. All is static. We are afraid of movement because it stands for decomposition—because we see our disintegration in movement. Continuous static movement marches on! It cannot be stopped. We are fooling ourselves, if we close our eyes and refuse to recognize the change. Actually, decomposition begins only when we try to prevent it. Decomposition does not exist! Decomposition does not exist! Decomposition is a state envisaged only by us, because we do not want it to exist, and because we dread it.

There is no death! Death exists only for those who cannot accept evolution. Everything changes. Death is a transition from movement to movement. Death is static. Death is movement. Death is static. Death is movement.

Be yourself by growing above yourself. Don't stand in your own way. Let us change with, and not against, movement. Then we shall be static and shall not decompose. Then there will be neither good nor evil, neither beauty nor unsightliness, neither truth nor falsehood. Conceptions are fixations. If we stand still, we block our own path, and we are confronted with our own controversies.

Let us contradict ourselves because we change. Let us be good and evil, true and false, beautiful and loathsome. We are all of these anyway. Let us admit it by accepting movement. Let us be static! Be static!

We are still very much annoyed by out-of-date notions of time. Please, would you throw away your watches! At least, toss aside the minutes and hours.

Obviously, we all realize that we are not everlasting. Our fear of death has inspired the creation of beautiful works of art. And this was a fine thing, too. We would so much like to own, think or be something static, eternal and permanent. However, our only eternal possession will be change.

To attempt to hold fast an instant is doubtful.

To bind an emotion is unthinkable.

To petrify love is impossible.

It is beautiful to be transitory.

How lovely it is not to have to live forever.

Luckily, there is nothing good and nothing evil.

Live in time, with time—and as soon as time has flickered away, against it. Do not try to retain it. Do not build dams to restrain it. Water can be stored. It flows through your fingers. But time cannot hold back. Time is movement and cannot be checked.

Time passes us and rushes on, and we remain behind, old and crumbled. But we are rejuvenated again and again by static and continuous movement. Let us be transformed! Let us be against stagnation and for static!

Jean Tinguely
September, 1959

Takis: The Force of Nature

As both man and artist, Takis was formed by World War II. He served in the Greek underground, and what he saw of both radar and the effect of explosions upon metal greatly influenced the course of his art. As an unseen force, radar's example led him in time to an absorption with magnetism, an invisible source of energy he began to make visible in his sculpture. As for the explosions, they led him to believe that "the secret of sculpture lay not only in individual genius but in the force of nature," a position not too different from Cage's.

The war seems to have instilled in Takis more than an involvement with technology, to be sure. There is a strain of libertarian fervor in him, as his response to the last question in the following conversation bears out. His dis-

agreements with the late Yves Klein were partly political: Takis felt that Klein's sympathy for De Gaulle was rightist in nature. For this and other reasons, they became permanent enemies. Later, in 1968, Takis participated in the founding of the Art Workers Coalition in New York, a group dedicated to social and political reform within and without the art world.

The period of maturation for Takis was centered in Paris during the 1950's. It was there that he met, befriended, and then began to rebuff—in his work—Giacometti. He began to exploit the magnetic field, both in sculpture and in the atmosphere (he put a man—poet Sinclair Beiles—into space, by suspending him in a magnetic field), an interest that persisted into the 1970's. It was in Paris he befriended

Takis at work in his studio at MIT's Center for Advanced Visual Studies, 1968. Courtesy Center for Advanced Visual Studies, Massachusetts Institute of Technology, Cambridge, Mass.

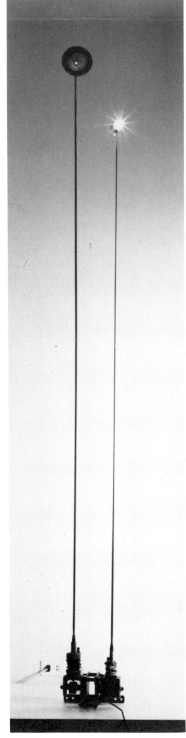

the American Beat poets, Allen Ginsberg and Gregory Corso among them. Oddly enough, his greatest influence in time was upon a group of young British artists led by David Medalla: they met in the early 1960's and formed a loose association, leading to a joint manifesto, *Toward the Invisible*, issued in London in 1965. Along with Takis, the other members of the group were interested in the use of natural phenomena, like light, water, and fire. They included Paul Keeler, Guy Brett, Marcello Salvadore, and Liliane Lijn, along with Medalla.

Takis's early sculpture had been vertical, straight, proud, and figurative, very much in the Giacometti tradition, but after he made the great discovery described here—when, purely by accident, the cords of a piano intended to be part of a "music machine" broke and floated toward the magnet he was using in the same piece—his attention focused upon forces rather than objects. His work now avoids the static condition as a matter of course, mostly through the use of the unseen magnetic field, commonly manifested by the response of some moving part to the source of the attraction. Takis's sculpture has also been resolutely related to the technological facts of our environment. He has produced an extensive series of tall, vibrating light-and-wire constructions called *Signals*, dating back to 1955, which suggest everything from traffic to tall railroad lights, and another series of dials, with needles flickering ingeniously across their surfaces.

When he came to MIT's Center for Visual Studies in 1968, he turned to yet another natural source of hidden energy, the oscillation of the sea, to power his *Hommage à Marcel Duchamp*, a perpetually moving bicycle wheel to be floated in a city harbor. His technical adviser on this project was Ain Sonin, associate professor of mechanical engineering at MIT, who later expressed delight and satisfaction with their collaboration. "I was familiar with electromagnetic theory," he wrote, "but Takis came and made sculpture out of it, by suspending a shimmering needle in a magnetic field."

Apparently you were influenced in the beginning by what you learned about radar from British propaganda films.

When the English arrived in Athens in 1944, they showed us through newsreels how their scientific knowledge saved England from total

destruction. It was an impressive film. It showed in detail and in diagram how their radar system could spot an airplane just after taking off at a certain height. This impressed me enormously and never left my memory. Neither did the explosions created by the Italians to destroy war materials in the Greek countryside.

Did those impressions affect your work immediately or much later?

Later. Both impressions stayed strong in my mind for a long time. After watching the explosions in the ravines, I came to believe that the secret of sculpture lay not only in individual genius but in the force of nature—what it could do to exposed materials. I thought, an artist has just to follow the laws of nature. He should imitate precisely—a stone in the river, for example, submitted because of its own volume to a certain (a) heaviness, (b) friction, and (c) the direction of the water. But throw the stone into the sea and it would follow the same three laws plus (d), the change of directions. I began to notice in the museums, too, that the sculptors of the past had probably worked with similar ideas. Of course, I was influenced by the metals themselves and what happened to them under the tremendous heat created by the explosions. I made many experiments, casting, boiling iron, and throwing it into the water, observing the reaction of metal to different elements.

Takis. *Anti-Gravity* (detail), 1970. Three sections, 3' x 3' each. Electromagnet and nails. Courtesy Howard Wise Gallery, New York.

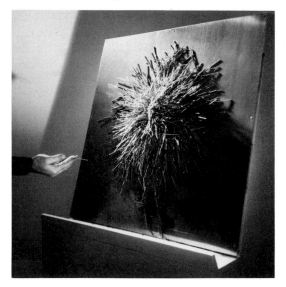

Takis. *Signal, Amber and Green,* 1965. Steel aerial, aircraft lights, bronze isolator base. 118" h. Photo by John Palmer.

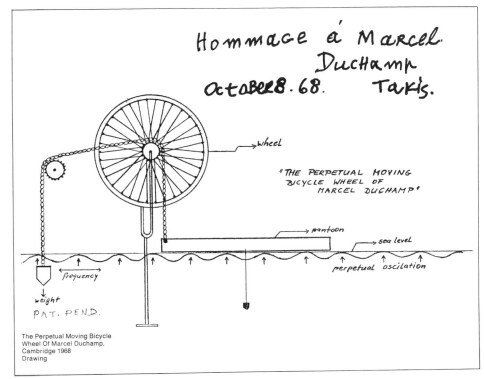

Takis. Drawing for *Hommage à Marcel Duchamp*, 1968. Courtesy Howard Wise Gallery, New York.

What you're saying now makes it easy to see why you became interested in magnets. When did that happen? Was there a specific observation behind it?

During the late 1950's, while I was living in Paris, I had no friends except the American poets Allen Ginsberg and Gregory Corso. I was surrounded by sculptors like César and Giacometti, more or less Baroque artists. My existence was at stake. Because of the radar newsreel, I knew that radar itself functioned through magnetism. I bought my first magnets in the flea market; they were the same kind used in the first airplanes. Well, I tried to make the machine described above, which looked like the radar machine. It was a very light construction; I used the cords of a piano as a grill, hoping to make mysterious music as well. But all of a sudden one day, the cords broke because of their tension and floated toward the magnet, which was next to the machine. Then I said, To hell with music and the moving machine; I had found` what I wanted. I tied a blank with a string and held it next to the magnet; miraculously—for me—it floated. I attached the string more permanently to a base and carried the object to a café and showed it to my friends, shouting all the while that I had finally destroyed iron sculpture. "This is the end," I cried, "of César's and Giacometti's pretentious iron shapes. I bring energy and life to dead materials!"

It was about this time, or a little later, I believe, that you tried to send a man into space. Why?

I published many statements and dialogues at this time in the so-called underground press. In one of them, I said that for me Daedalus is a creator and his masterpiece, Icarus. I also believe that most human beings want to liberate themselves from the earth's gravity. The significance of the act was to show that an artist can interfere in scientific society, symbolically if not in fact. In the catalogue that accompanied my launch, I reprinted Khrushchev's statement: "No man in space yet, but we are ready." You see, I was competing with the scientists in both the U.S.A. and Russia.

*When did you get interested in the movement of the sea? How were you able to get the proper scientific help at MIT to realize the project—*Homage to Duchamp—*that uses sea movement? You might also touch on the pleasures of collaboration with scientists. I know you believe it is better for an artist to work with a scientist than an engineer.*

My first observations were in Venice during 1957, when I saw a loaded boat moving slowly, without obvious reason. I was persuaded that the sea has a perpetual movement, since the day was calm and there were no waves. I kept this fact in mind, although I understood that any experiment would be impossible without the help of a scientist. An engineer would be impossible, I knew, since my experience with technical helpers has been that they work well only when they have something precise to go on. This time I was both vague in my own mind and uncertain about the originality of my idea. When Professor Kepes invited me to come to the Center for Advanced Visual Studies at MIT, it was like a dream realized. Finally, I could begin a dialogue with a scientist. After meeting Professor Kepes, I put my problem to him on my second day at the Center. He reacted with enthusiasm. He immediately phoned Professor Schapiro in Washington and we talked over the phone. It was an agonizing moment for me, waiting for Professor Schapiro to call back, as he was in

conference at first. But finally we talked and he encouraged me. He said he was extremely interested, but away from Cambridge. He proposed his assistant, Professor Ain Sonin.

I met with Professor Sonin that very day. His reaction, too, was inspiring. He came the next day with a book to show me the research already conducted and classified on the motion of the sea. I saw that my idea that the sea is oscillating perpetually was not a dream. Professor Sonin also told me that this movement had never been properly exploited, in his opinion. Each curve in the sea's oscillation is called a frequency; the length of the frequency varies with the distance to the shore. Therefore, if we know what the length of the frequencies in Boston Harbor are, we can create a sensitive machine that will accumulate energy, release it, and create movement. Professor Sonin guaranteed me the oscillation could at the very least rotate a disk, if not create electricity. Well, you can imagine my enthusiasm for a collaboration. He looked at my magnet with floating needles and said it was fascinating to see, which was a surprise to me. He had worked often with magnets but never thought they could be fascinating, you see. And so I made *Homage to Duchamp*, which would have been impossible with an engineer, even the best. First, a technician would not have been informed about my problem. Second, the collaboration would have been basically an unenthusiastic exchange of materials. The best technician cannot follow a vision, but a scientist, by his very nature, does so easily.

Why did you pay homage to Duchamp? Do you feel any connection with Duchamp's work?

Being an artist himself, Duchamp recognized the importance of my direction in a statement he wrote for me in 1961. I found it extremely generous. Then, too, Duchamp liberated himself from his own work in his own lifetime. He managed to establish himself in a position as a human being who thinks, that's all. That fascinated me and was sufficient, i thought, to make my homage to him.

What are your most important visions right now, the ones you would like to realize in the future? Would you like to get the Homage *out into the water somewhere, for example, perhaps Boston Harbor?*

Yes, among other things. I would like to develop the sea machine to the point where it creates electricity, very inexpensive electricity, for the city public at large.

Once you said that artists can both please and displease the establishment by utilizing the new technology. How? What's the difference?

Until now the scientist, all over the world, has been the beloved child of government. The artist is tolerated because he keeps cultural tradition alive, but there is no artist who has anything to do with the leading class. When an artist gets too annoying, in fact, he is either suppressed (as in Russia and the Communist bloc) or bribed (as in America and the capitalist countries). I suspect that no government likes to see its scientists involved with artists, on the ground that artists represent the bohemian, the uneasy spirit. I cannot believe the leading class is so innocent it is unconscious of this threat. If the artist works only with technicians, however, he does not penetrate the government, because only the scientist is close to the leading class. I feel that governments now depend on scientists. I cannot imagine any government, therefore, happy about the scientist-artist union. On the other hand, technicians represent no threat. If we work with the technicians alone, we will only publicize the products of government. And that, for them, is most welcome.

Two Groups: ZERO and GRAV

ZERO, founded in Düsseldorf, West Germany, in 1957, and GRAV (Groupe de Recherche d'Art Visuel), established in Paris in 1960, effectively span the philosophical and esthetic terrain occupied by the many European "groups" formed during the late 1950's and early 1960's. ZERO stood at the romantic extreme, emphasizing an intuitive and ambitious relationship with technology. GRAV, as the accompanying *Charter of Foundation* indicates, occupied the other flank, advocating a puristic and scientific approach to new materials. GRAV is, in fact, the clearest exponent of the artistic goals normally associated with the movement known as the New Tendency (*Nouvelle Tendence*), which influenced many sectors of European art at this time.

Much of ZERO's history is documented in the following brief conversation with Otto Piene, its strongest figure. GRAV is a more complex phenomenon, and not only because its roster was longer than ZERO's (properly speaking, there were only three consistent ZERO members—Piene, Heinz Mack, and Günther Uecker). Vasarely's influence upon GRAV is obvious. His son, Yvaral, was a founding member. The 1960 statement emphasizes qualities inherent in Vasarely's work: careful research, collective effort, anonymity in joint exhibitions, and the avoidance of subjectivity.

This is not all. As GRAV developed, its members began to manifest their own characteristics. By various subtle means, Yvaral, François Morellet, and Stein invited the participation of the eye of the viewer in the surface patterns of their works (Morellet, for example, constructed aluminum matrices that appeared open or closed depending on the position of the spectator). Later, the group built complex environmental *Labyrinths* that forced the public to crawl through passage-

Otto Piene at work in Nuremberg, Germany, in 1968. One mile of polyethylene tubing is being draped on and around the façade of the Deutscher Kunstlerbend by Piene and 20 assistants, using compressed air from a mobile generator.

Groupe de Recherche d'Art Visuel (GRAV), Paris. From left to right: Guy Sobrino, Jean-Pierre Yvaral, Julio Le Parc (standing), Francois Morellet, Horacio Garcia-Rossi, and Joel Stein. Courtesy Denise René Gallery, New York and Paris.

ways, manipulate mirrors, and play visual games of many kinds. This encouraged *l'instabilité*, meaning a situation in which the permanent form of the work of art became impossible to discern. No one became more skilled at *l'instabilité* than the Argentinian, Julio Le Parc, who finally emerged as GRAV's central force. His kinetic-light murals and small constructions used bland and repetitive forms, allowing the play of light and shade across their surfaces to create a continually shifting impression upon the eye. The spirit of Le Parc is found in the statement issued by GRAV in 1966, for the *Kunst Licht Kunst* exhibition in Eindhoven, Holland:

> It is not the purpose of the Group to create a super-spectacle, but . . . by producing an unexpected situation, directly to influence the public's behavior and substitute for the work

of art and the spectacle an evolving situation calling for the active participation of the spectator.

As an organization, GRAV had run its course by 1968, although its members remained in close touch with one another and occasionally coordinated efforts on large projects. Le Parc grew increasingly politicized, a "cultural guerrilla," as he put it. His interest in kinetics and light remained firm, and he even returned for a brief time to painting, completing the color experiments he had begun in 1959. But much of his newer art had an incisive polemic edge. For a retrospective at the Kunsthalle in Düsseldorf in 1972, he arranged a participative environment of large punch-me dolls. Painted on their faces were the pillars of established society: priests, policemen, politicians, journalists, and, yes, the artist.

Otto Piene: Group ZERO

When and where did you begin to involve yourself, as an artist, with technology? Why did you continue?

In 1957, I punched three or four dozen stencils, each one with up to 10,000 holes. At first I used them for vibrating light paintings of a certain serial regularity. The paintings were mostly monochrome, silver, white, yellow, gold. In 1958, I began shining light through the stencils to create a changing light environment besides light paintings. In 1959, I gave my first public performance of what I called the "light ballet."

Because I used hand lamps the light performance or light environment disappeared when the performer (myself) stopped performing. If the changing light projections on all the surfaces of a room were to last without the presence of a performer, a machine had to take his part. Therefore, I started building light machines that were linked together by timers. In 1960, I presented for the first time what I called the "mechanical light ballet."

Once I had started involving machines, the whole delight and misery of making them and using them was upon me.

How were these beginnings related to the formation of Group ZERO?

It emphasized our belief in light as *the* expansive medium and light's ability to carry energy from the artist to the spectator. I had first pointed out this potential of light in my text in *ZERO 1*. My involvement—or any ZERO participant's involvement, for that matter—in technology had nothing to do with the *formation* of Group ZERO but it had a lot to do with the *development* of Group ZERO.

Technology enabled me—and some of my friends to go beyond the production of parlor pieces (conventional art objects) as in the early ZERO years, 1957 and 1958—that is, to address larger audiences (*Light Ballet*) and to approach nature on an appropriate scale (flying sculptures and outdoor performances).

The original impulse toward technology was older than the formation of Group ZERO. In 1953, together with Heinz Mack and Egon Schneider, I designed the Science and Research pavilion of a national exposition of economic progress in Düsseldorf. During the preparation of that large show, we met many influential and impressive German scientists and technologists. The main artistic influence on our design was Alexander Calder.

Otto Piene. Drawing for *Octopus,* 1964.

Otto Piene. *Octopus,* 1965. Rubber, cloth, wires, and timed blower. 5' h., 4½' diam. The arms expand to 15', inflate, deflate, stretch, and curl. Eight open-ended pipes protruding from the core allow spectators to change the air stream and thus the shape and movement of the arms. In collaboration with Clifford A. Hendricksen.

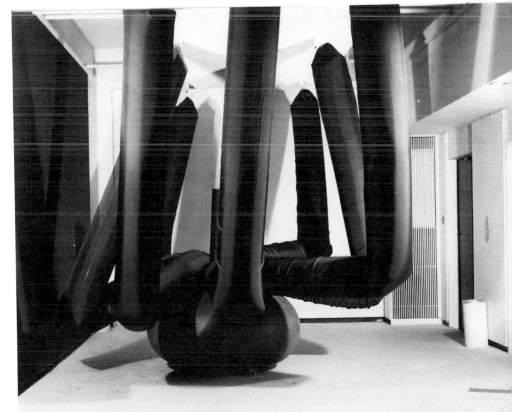

ZERO was not the only group of artists involved with technology that sprang up throughout Europe in the late 1950's and early 1960's. What set you apart, in your own minds, from the other groups—GRAV, for example?

ZERO, formed in 1957, was the first one of those European groups, possibly along with Equippo 57. What distinguished ZERO from the other groups was, first, the understanding that ZERO was a changing group of voluntary individuals with personal identity, a free community without a formed manifesto to swear by; second, the understanding that visual and sensual perception could be induced by partly systematic and partly controlled means without eradicating chance, the irrational, and the artist's subjectivity; third, the understanding that LIGHT is a leading force of life; fourth, the understanding that man has to live *with* and not against the elements, *with* and not against technology; fifth, the understanding that it's the artist's part today to change our environment on a large, as opposed to a mere petty, scale.

GRAV. Diagram of *Labyrinth,* 1965. An environment presented in New York at the Contemporaries Gallery, it was based on a series of similar installations in Europe. The spectator walks and crawls through *Labyrinth,* following the direction of the arrows. Courtesy Editions Denise René, Paris and New York.

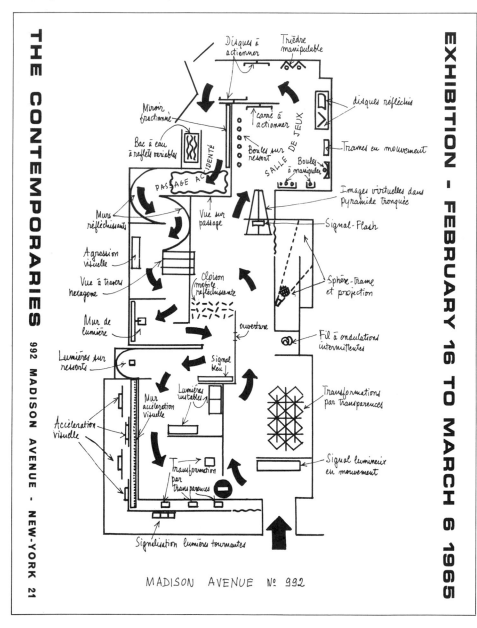

Also at that time, if I recall correctly, you began to give "night exhibitions." Why? Weren't the galleries and museums hospitable?

Until 1957–58, there were few galleries in Düsseldorf, and the museums paid no attention to my work and to that of my friends. I preferred relying on our own activity to waiting until the establishment—then deeply involved in decorative abstractionism—would or would not decide to come around.

I therefore emptied my studio in an old loft building of paints, easels, and lights once a month or so and turned it into a provisional gallery. Once or twice Mack's neighboring studio was also included. Each show lasted one evening only, with a few exceptions. We had openings without consecutive shows, so to speak. We used to mail out crude announcements. The shows had to be at night because many of the participants, including myself, were teaching or holding other jobs during daytime hours.

You have come to work more and more in the United States. Why? Has your stay—in a new kind of environment—affected your work in any way? Did ZERO survive your transplantation and that of several other key members?

Several forces and phenomena have impressed and influenced me since I came to the United States for the first time in the fall of 1964, to teach at the University of Pennsylvania and to co-organize a ZERO show at the ICA there.

One of these is the large scale of the American landscape and the American cities. Another one is a general attitude toward technology in the United States: in the pursuit of answers to new technological problems, no one here gives up until he reaches a solution. A superior technology is the positive result of American materialism. Here people do and

make things, as opposed to merely thinking about them. . . .

ZERO—and its consequences—does exist or surface in many obvious ways in current efforts all around us—in elemental art, light art, sky art, and the performing arts. ZERO, as a group, ceased to exist after the *ZERO in Bonn* show, late in 1966. *My* ZERO goes on living as long as I live.

Groupe de Recherche d'Art Visuel: Charter of Foundation

This day, the undersigned declared the Center for Research in Visual Art to be founded.

By the creation of this Center, they want:

- to compare their personal investigations or those of small groups in order to intensify them;
- to combine their plastic activities, efforts, talents, and personal discoveries in an activity tending toward that of a team;
- thus to overcome the traditional image of the artist as a unique genius, creator of immortal works.

They will leave their individual plastic activities and by means of organized investigation, supported by comparison of one another's work, concepts, and plastic activities, little by little they will establish a solid theoretical and practical base from the collective experience.

Toward this end: the Center for Research in Visual Art will be a center free of all esthetic, social, or economic pressure.

- The character and goal of the investigations that the members of the Center for Research in Visual Art pursue will be submitted to analysis by the Center, which will issue its opinion.
- These investigations can constitute the point of departure for other investigations that will be carried out by the same persons who initiate or by other members of the Center.
- Each of the members of the Center for Research in Visual Art must submit his individual activities, when they concern the Center, to the Center, in order to obtain the most appropriate solution to the problems that may thus arise.
- A register will be established wherein will be recorded the Center's activities, the history of its investigations, and the possibilities for its development, theoretical as well as practical.

Julio Le Parc. *Continuel Lumière, #4,* 1963–65. Light boxes with aluminum. 59″ x 27½″ x 10″. Collection Mr. and Mrs. William Wolgin, Philadelphia. Courtesy Howard Wise Gallery, New York.

- Likewise, classifications can be established concerning the origin of the investigations, their objectives, the relationships existing among them, or their contradictions.
- The members of the Center for Research in Visual Art will create the detailed regulations necessary for the Center to function in accord with the general principles set forth above.

DEMARCO, GARCIA MIRANDA, GARCIA ROSSI, LE PARC, MOLNAR, MORELLET, MOYANO, SERVANES, SOBRINO, STEIN, YVARAL

Paris, July 1960

Billy Klüver: The Engineer as a Work of Art

J. Wilhelm (Billy) Klüver was born in Monaco in 1927. He graduated from the Royal Institute of Technology in Stockholm in 1951, and six years later received a Ph.D. in electrical engineering at the University of California at Berkeley. From 1958 to 1968, he was on the technical staff at Bell Telephone Laboratories in Murray Hill, New Jersey, working on the physics of infrared lasers. He has published more than a dozen technical papers, and as many on art. He holds numerous patents.

As soon as he arrived in Murray Hill, near New York, he renewed an involvement with living artists that dates back to his student days in Stockholm. He contributed his engineering skills to works undertaken by Jean Tinguely, John Cage, Robert Rauschenberg, Jasper Johns, and Andy Warhol. He also organized a number of art exhibitions, coordi-

nated the historic *Nine Evenings: Theater and Engineering*, and founded EAT (Experiments in Art and Technology, Inc.), in collaboration with Rauschenberg. He became EAT's full-time chief executive officer late in 1968.

In this multi-dimensional way, Klüver has exerted influence on the shape of contemporary art, particularly as it is practiced in New York. The influence bears the brand of those who molded Klüver's ideas, of course, from his old friend Pontus Hulten, director of the energetic Moderna Museet in Stockholm, to Tinguely, Cage, and Rauschenberg. But there is much that is his own. All of his theoretical statements push limits of several kinds, esthetic, social, and philosophical. When pressed to explain the most controversial of his ideas—for example, that it makes no difference whether technology actually works in

Billy Klüver (far left) conducting one of the early meetings of EAT, New York, 1967. Courtesy Experiments in Art and Technology, Inc., New York. Photo by Peter Moore.

art—Klüver often responds with a directness that invites both confusion and disbelief.

Needless to say, both Klüver and EAT have their enemies, in the arts and in industry. Critic Alex Gross, writing in the *East Village Other* in 1970 and speaking for a group of disgruntled artists, charged that EAT selected artists for its several projects on the basis of rank favoritism, and that its funds were channeled primarily into staff salaries and soliciting funds from the foundation and industrial worlds. In the same year, the Pepsi-Cola Company dismissed EAT as the administrator-programmer of its pavilion at the World's Fair in Osaka, Japan, at the end of a series of disagreements with Klüver and his colleagues. Klüver maintained that the Pepsi pull-out was motivated by esthetic differences; the company complained largely of mounting costs.

None of these developments could eclipse EAT's substantial record for achievement, however. Through its matching system, the organization had brought hundreds of artists and engineers into contact with one another; as for the Pepsi Pavilion, it was by any standards an engineering feat of considerable magnitude. Klüver gathered together a complex array of engineers, artists, architects, and scientists to design and supervise construction of the spherical structure. When finished, it featured the first light-sound system ever designed for a spherical environment; the largest spherical mirror ever made, which produced "real" three-dimensional reflections of viewers on the 90-foot-high dome ceiling; and a man-made water cloud, the largest yet created without the use of chemicals, which floated gently above the pavilion dome. Because of its scale and complexity, one critic called the pavilion "the greatest art and technology venture ever undertaken."

From the first, the central theme of the pavilion was open-ended experience, an idea basic to Klüver's view of the art-technology fusion. Long after the tumult had subsided, he wrote:

> The initial concern of the artists who designed the Pavilion was that the quality of the experience of the visitor should involve choice, responsibility, freedom and participation. The Pavilion would not tell a story or guide the visitor through a didactic, authoritarian experience. The visitor would be encouraged as an individual to explore the environment and compose his own experience.[1]

E.N.A.E.T.W.S.

Volume 1, No. 2 June 1, 1967

Experiments in Art and Technology, Inc. 9 East 16th Street, N.Y., N.Y. 10003

The purpose of Experiments in Art and Technology, Inc. is to catalyze the inevitable active involvement of industry, technology, and the arts. E.A.T. has assumed the responsibility of developing an effective collaborative relationship between artists and engineers.

E.A.T. will guide the artist in achieving new art through new technology and work for the professional recognition of the engineer's technical contribution within the engineering community.

Engineers are becoming aware of their crucial role in changing the human environment. Engineers who have become involved with artist's projects have perceived how the artist's insight can influence his directions and give human scale to his work. The artist in turn desires to create within the technological world in order to satisfy the traditional involvement of the artist with the revelant forces shaping society. The collaboration of artist and engineer emerges as a revolutionary contemporary sociological process.

Initially, a successful working relationship between artists and engineers will require that each operate freely within his own environment. The function of E.A.T. is to create an intersection of these environments.

To ensure a continued fruitful interaction between a rapidly advancing technology and the arts, E.A.T. will work for a high standard of technical innovation in collaborative projects.

E.A.T. is founded on the strong belief that an industrially sponsored, effective working relationship between artists and engineers will lead to new possibilities which will benefit society as a whole.

Billy Klüver Robert Rauschenberg

The first issue of the EAT newsletter, prefaced by its statement of purpose, 1967. Courtesy Experiments in Art and Technology, Inc., New York © 1967.

Neither Klüver nor any of the EAT artists wanted completely to program the uses to which the interior environment might be put; they wished to leave the details to other artists to discover throughout the summer of 1970, in a series of quasi-theatrical performances canceled by Pepsi in favor of more traditional theatrical activities. Klüver's attitude toward the pavilion is concisely summarized by the following:

> The Pavilion is a work of art with its own unity

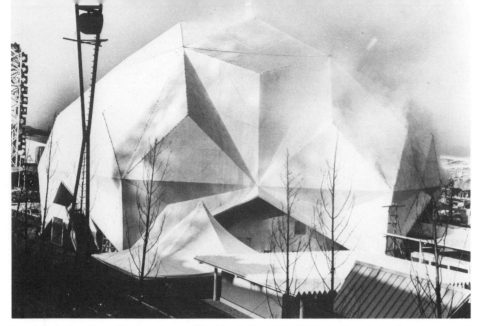

Pepsi-Cola Pavilion, Osaka, Japan, World's Fair, 1970. EAT designed the "environment" within and without the Pavilion, from the cloud that floated above the dome (designed by physicist Tom Mee) to the responsive sound, light, and mirror systems inside, most of them triggered by the movement and behavior of the spectators. Among the engineers involved were Klüver, Larry Owens, T. Fujiwara, Elsa Garmire, Witt Wittnebert, and Fred Waldhauer. Courtesy Experiments in Art and Technology, Inc., New York.

Interior, Pepsi-Cola Pavilion, Osaka, Japan, World's Fair, 1970. The spherical mirror at the top of the dome was the largest made to that date. The viewer could see above a life-sized visual image of himself floating in space. The artists and engineers who collaborated on the mirror included John Harris, David MacDermott, and Ardison Phillips. Courtesy Experiments in Art and Technology, Inc., New York.

and integrity, an unexplored theater and concert space, a recording studio for multi-channel compositions and a field laboratory for scientific experiments.[2]

Quite clearly, Klüver is in no sense the brooding humanist, obsessed with technology's negative potential, in either art or life. He is profoundly experimental, ready to "try" first and judge second. Unlike Kepes, Klüver finds satisfaction in art on the level of sensory pleasure alone (he tried to get Pepsi to agree to destroy the pavilion when Osaka closed down: "Permanence," he said, "is not experimental"). At the end of Klüver's little-known essay about his early collaboration with Tinguely, he states:

> Jean kept saying that he was constantly thinking about New York as his machine took form. There are probably many connections, the most obvious being a machine that has rejected itself and become humor and poetry. New York has humor and poetry in spite of the presence of the machine, whereas in a purely technocratic society the machine must always be a functional object. Failures of the machine can therefore never be allowed because the control is the necessary element of the society. It is

when the machine must function *à tout prix* that there can be no *Homage to New York.*

From the beginning of this century, certain artists have evinced a strong interest in technology, both its products and its processes. Do any of the earlier activities—on the part of the Futurists, the members of the Bauhaus, even Duchamp—resemble those of the artists and engineers involved in Nine Evenings *or in EAT?*

Marcel Duchamp initiated the artist's active commitment to the external world and made it the artist's responsibility to look without prejudice. This involvement in the physical world is the basis for the interest of contemporary artists in technology. Duchamp's commitment to reality is now becoming accepted. EAT is a result. The Bauhaus and the Futurists were, I think, involved with the process of seeing and with preserving certain idealistic notions about the world. The function of technology as a material is not to put previous esthetic concepts into new forms but to provide the basis for a new esthetic, one that has an organic relationship with the contemporary world.

You seem to see the difference between the

old fusion of art and technology and the new in terms of passive versus active. Is this why you once declared yourself a work of art?

I did so in an attempt to clarify the relation between the artist and the engineer. We cannot say that the engineer is creative in the artistic sense, nor that he is a performer, like the violinist. Until we understand this, many social and personal attitudes will come into play that have no significance for the ultimate collaboration, where, in fact, the contributions from the artist and the engineer are indistinguishable. Unlike the relation between the scientist and the engineer, the artist-engineer relationship is intimate and has no vertical components. The engineer's work does not follow the artist's, as it does the scientist's.

Considerable time has passed since the presentation of Nine Evenings *in the fall of 1966. What do you now consider its most important contribution?*

Presentation of ten very good contemporary works for a large audience.

The press and audience got quite agitated over what they understood to be technological breakdowns during Nine Evenings. *Shouldn't we expect the technology involved in works of art, even "experimental" works of art, to work? To put it another way, isn't technological failure or success a valid criterion, if not the only one, for judging the work? At the very least, success will affect our reaction one way, failure another.*

During *Nine Evenings* the audience was almost completely unaware of the technical elements; it found failures where there were none and technical successes where no technology was involved. The difference between the technical elements and the rest of the artist's material has not been grasped by the audience, except for very trivial use of blinking lights and reflections and the use of sound.

The idea that technical elements have to work puts a foreign constraint on the use of technology in art. When we worked on Jean Tinguely's *Homage to New York* in 1960, the decision was made to spend our time adding more to the machine rather than testing what we had built. We also decided not to interfere with the machine once it was put into operation. Some of the things that went "wrong" could very easily have been fixed during the twenty-seven minutes that the machine lasted. People did not like this decision. As our understanding of technology increases, the question of success or failure will disappear. The focus of the interest will then be on the incredibly rich and varied possibilities of technology.

We have to live with a work of art or fight it. Technological success or failure cannot be a criterion for judging the work. A work of art loses its interest if it is only judged according to predetermined norms.

In other words, you want technology in its relationship with art to be adventurous rather than mechanical.

The relationship should be experimental and intuitive in the same sense that scientific research is—I am not using the word "experimental" as it is used in connection with art—and therefore full of risks. Whether the technology works or fails is not a very important aspect of this relationship. We know for sure we can always make something work.

I remember your saying you hoped EAT would fade away someday. Why?

It is pleasant thinking to assume that institutions can fade away, particularly if they have to do with art. Another possibility is always to stay "ahead" of the artists.

Why are artists and engineers attracted to the idea of working together? Why did you begin doing so?

The artist cannot handle the complexities of technology all by himself—even if he has proper access. For the engineer, working with the artist means taking on new, complex, and interesting problems that will help increase his professional standing. A different approach always stimulates new ideas. I began working with artists because they asked me to.

What, in other words, makes such a collaboration successful, from the engineer's point of view?

The Tinguely collaboration was, if you wish, the most innocent of them all.

The collaboration is a success when the artist and the engineer can see each other's works and get stimulated by each other's contributions, so that the work changes organically to something other than what it was in the beginning. The greatest handicap is not knowing how to talk to each other. Professional recognition of the work within the engineering community represents the best "reward" for the engineer.

Are engineers as eager to work with artists as the reverse?

It is not possible to say yet who is running after whom, since the artists know more about

the situation than the engineers. There are more engineers than there are artists, so the collaboration may well lead to an increase in the artistic population. But the technical-scientific community tends to isolate itself. In many respects, it will be up to the artists to convince the engineers to participate. I have yet to meet a scientist who would collaborate with an artist—or who could.

Why do you say that? How are scientists different from engineers? There are many people, you know, who are banking on the probability of an alliance between art and science.

The engineer and the artist deal with the physical world and work for direct solutions of problems. The scientist is not trained to deal with and handle the physical world. His goal is to understand it in terms of a specific language of little interest outside science. The scientist's dedication to his work has much the same quality as the artist's, but the areas of vision and realization are widely different. They simply cannot understand each other. A relationship between an artist and a scientist would be incestuous today. Let's hope that it is not so tomorrow!

Jack Tworkov implied, in a panel discussion at the YMHA in New York, that you, John Cage, and others deeply involved with the fusion of art and technology are trying to rush us along toward utopia. Are you?

No. I can make no claims about the importance of the art and technology collaboration.

Larry Owens, EAT engineer, at the environmental control board in the Osaka Pavilion. Courtesy Experiments in Art and Technology, Inc., New York.

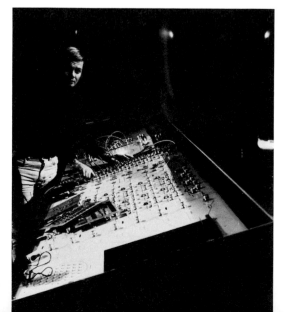

It will not give people food and housing, and it will not stop wars.

What motivates you, then, in your drive to establish EAT? The motivation cannot be exclusively practical or esthetic. You must have some special end in mind, at least partly. Lewis Mumford and those who share his views want art to "humanize" technology in some way.

My motives are: one, artists are incredibly neglected by society. In spite of all the foundations and publicity, most artists starve or waste their lives on silly projects. We give many billions to scientists; we should give at least a few to artists. Of course, no one would dare tell a scientist what to do. But we hamper the artist with our preconceived notions. "The artist should grind his own pigments," people say. Everyone knows what art is and hence who is the "real" artist. It is a disgusting situation.

Two, pleasure. Technology is for pleasure, variety, change, respect for individual choice and human relationships. Art and technology go well together in a world run by people who consider boredom the greatest virtue.

Which of EAT's early organizational problems were the most profound—and perplexing?

In the beginning, it was the obtaining of professional advice from individuals able to understand and sympathize with the extent and seriousness of the problems facing EAT.

Could you single out any one area in which EAT made its impact felt most strongly during its first two years?

One area in which EAT has made an impact is in establishing and making acceptable the collaboration between artist and engineer-scientist as a functional means of producing art. Also, EAT has clearly demonstrated the reality of the C. P. Snow gap between art and science, and has to a certain extent measured its dimensions. A third important area explored by EAT has been the beginning of a serious and honest communication with industrial leadership.

Based on your experience to date, how do you feel about the possibility of industry's opening its facilities to artists in any broad, socially relevant way?

Any such development will be a slow process because of the very different environments and modes of operation of the businessman and the artist. This separation means that a whole new language for communication has to be developed.

Robert Rauschenberg: Technology as Nature

Robert Rauschenberg is central to this book for a variety of reasons, both historical and philosophical. Born in Texas in 1925, he was the first major American artist to commit himself to a thorough-going collaboration with technology (initially through Billy Klüver) in the creative process itself. Thomas Wilfred, Man Ray, Alexander Calder, and others preceded him in terms of interest but not commitment. They thought of technology (broadly defined) as material, nothing more nor less, a position from which Rauschenberg here disassociates himself with decided emphasis. He also participated with Klüver in organizing *Nine Evenings* and founding EAT. Finally, his work from the first has exemplified that open, receptive attitude toward the environment around him recommended by John Cage, from the days when he combined stuffed goats and old radios in his paintings, to the time when the ingredients became wired tennis rackets and electronic panels.

All of these activities are discussed elsewhere in this book. Not thoroughly covered, unfortunately, are two extremely important facets of Rauschenberg's *oeuvre*, his theater pieces and his prints. They are, to my mind, the best of Rauschenberg, formally speaking. The theater pieces grew out of his close association with Cage and with the innovative group of choreographers and artists that explored new dance forms at New York's Judson Memorial Church during the early 1960's. Rauschenberg's pieces collaged together bits of movement, props, colors, and stage business in a free, unabashedly lyrical manner. The outstanding example is *Open Score,* his contribution to *Nine Evenings.* He used a tennis court as his stage and central metaphor; each time the players struck the ball, a loud *bong*—produced by contact microphones installed in the rackets—filled the Armory hall, turning out one of the forty-eight lights illuminating the game (via Actan switches) in the process. When complete darkness finally enveloped the Armory, 700 people entered from the far end, advancing slowly, their voices low and muffled. They were visible only through two infrared TV cameras set up in front of the audience, cameras that allowed the viewer literally to "see" in the dark. After the 700-man throng departed, Rauschenberg appeared

Robert Rauschenberg at work on the *Stoned Moon* series of lithographs at Gemini G.E.L. in 1969. Courtesy Gemini G.E.L., Los Angeles.

on the darkened court himself, carrying a girl, Simone Whitman, wrapped in a coarse canvas bag. Several times he stopped, placed her on the floor, and waited, bathed in the light of a tiny spotlight, while she sang, in a high, plaintive voice that was barely audible. *Open Score* ended in silence and darkness, after the artist had exited, carrying his mysterious burden.

Open Score had no meaning, in the normal sense of the word. It simply brought together disparate images, much like Rauschenberg's

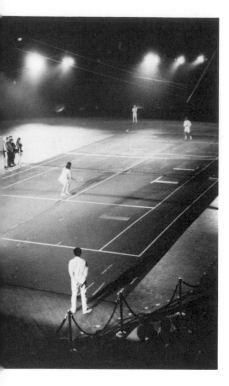

early paintings and later lithographs. Did he mean to imply a unity among the parts? The answer is very likely no. Cage, writing about the illustrations for Dante's *Inferno*, which also combine diverse images, said: "It seems like many television sets working simultaneously, all tuned differently." At his best, Rauschenberg endows the parts of his work with an independence that forces the viewer to unify the whole in his mind, or leave the work to stay as it is, rich and complicated, like life itself. Rauschenberg's lithography radiates this quality, too, particularly in the two series devoted to the American space program. The first, the *Booster* series, executed in 1967, is based on rocket imagery. The second, the *Stoned Moon* series, grew out of a commission granted Rauschenberg—and eleven other artists—by NASA. Rauschenberg attended the Apollo 11 launch at Cape Kennedy and later followed its journey from the Command Center in Houston. The *Stoned Moon* prints, thirty in all, were completed in early 1970. Two of them, *Waves* and *Sky Garden,* represented the largest hand-rolled lithographs made until that time, measuring 89 by 42 inches. *Sky Garden,* in its dense, shifting imagery and brilliant color, suggests how far Rauschenberg had come, formally, since the first crude Combine painting.

Robert Rauschenberg. *Open Score,* 1966. An intermedia theater piece for *Nine Evenings.* Performance Engineer: Jim McGee. Courtesy Experiments in Art and Technology, Inc., New York.

It also demonstrates why the artist's work often seems formally uneasy when yoked to motors, circuits, and lights. His forays into technology (among them, *Soundings,* already discussed; the "Revolvers" that collage motor-driven plexiglass discs together, each one imprinted with his characteristic imagery; even the macabre "mud field" he worked on with the Teledyne Corporation of California, his contribution to the Los Angeles *Art and Technology* exhibition, in which bubbles erupt in response to outside sound sources) come off as gestures rather than as legitimate Rauschenbergs. For all his conceptual daring, he succeeds best as an artist in media with which he is thoroughly at home, media (such as the silkscreen, the brush, and the theater) susceptible to touch that is inescapably light and lyrical.

Art is one thing, though, and society another. Only the traditionalist would censure Rauschenberg for attempting what he has in new and uncomfortable media—in technology, that is. There he has become a historical and social force of consequence. There he has led the way, for reasons carefully outlined in the following interview. It caught him at a time when he was preoccupied with political issues. He had been deeply involved with the "Artists' Strike" that followed the American invasion of Cambodia in the spring of 1970. He had put together a poster for the "Earth Day" protest. He was about to fly to Pasadena, California, for the opening of a show devoted to his huge silkscreen print, *Currents,* fifty-four feet long and based on nothing but newspaper fragments gathered over a two-month period of representative reporting. In a statement prepared for the show, he referred to *Currents,* which is filled with a sense of impending doom, as "an active protest attempting to share . . . my response to and concern with our grave time and place."

He did not try to keep that preoccupation out of this interview, in keeping with his esthetic: "I could never refuse to use something I knew about." In that sense, it is verité Rauschenberg, and the more valuable thereby. EAT was at the very moment absorbed with similar problems, as Rauschenberg's opening remarks—referring to the organization's Artists in India project—demonstrates. EAT hoped to send artists to India to work with young Indian artists as well as in the creation of video "software," relayed via satellite

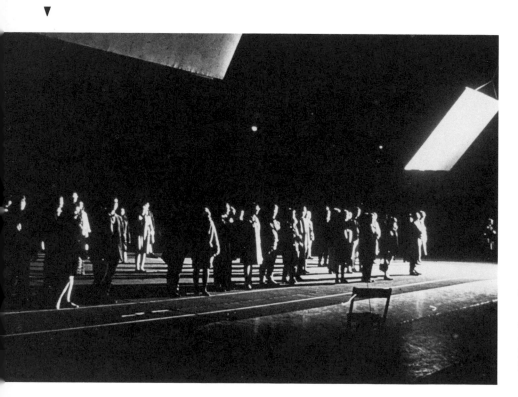

Robert Rauschenberg. *Studies for "Currents," #13,* 1970 Silkscreened collage. 30" x 30". Courtesy Castelli Graphics, New York.

to remote villages. The India project clearly pleased Rauschenberg, as did another EAT innovation, "Projects Outside Art," also in progress at the time of our interview. This program brought artists, engineers, scientists, and educators together on problems in the real world—among them, experimental learning environments for children and hydrophonic roof gardens for inner city areas. As Rauschenberg says, "Artists can very well employ themselves in such ways."

Also included here is a brief note he sent me once, in response to a series of questions long since lost, touching upon the subject of this book.

Aside from the steadily increasing use of materials derived from the new technology—and your exploration of lithography—the most noticeable change in your work during the late 1960's was a direct confrontation with political and social issues; witness your Earth Day poster and your huge silkscreen, Currents. *Why?*

Harold Rosenberg took me to task once for not doing precisely that. He said I gave politics no place in my art. I believe that if you begin by deciding to make a political painting or a humorous painting, you will fail. You just start working and whatever is in you just starts coming out. Your most current

concern is the content of that work. I've never been able self-consciously to inject politics. But we cannot and should not escape politics. Mature professional people cannot take the easy way that the young can take, to go off into communes and live away from the world. We can't imitate them and we can't withdraw. That's why EAT is interested in India. Why shouldn't artists be involved in problems like that?

Once you said that in your early Combine paintings, which incorporated objects and materials found in the streets and shops of Lower Manhattan, you felt as if you were collaborating with the neighborhood. With an attitude like that, your later use of technology was inevitable, wasn't it?

It's part of what's out there. I could never refuse to use something I knew about. As a painter, the hierarchy of materials has been my constant concern. I mean that the hierarchy is nonexistent. It only includes everything as the best stuff to use.

That attitude also deemphasizes personal

Letter from Robert Rauschenberg in response to questions from Douglas Davis, 1970.

1. TECHNOLOGY DOESNT MEAN IT IS MEANS.

2. ORACLE I CANT REMEMBER DATES. WHY? I COULDNT DO IT WITHOUT AN ENGINEER. I ALSO CANT WEAVE CANVAS.

3. SUCCESSFUL IS NOT AN ARTISTIC CONCIDERATION. WORKS + DONT WORKS ARE PART OF DEVELOPMENT.

4. TECHNOLOGY IS CONTEMPORARY NATURE. (NOT IN PLACE OF ANYTHING, THERE LIKE EVERYTHING ELSE)

5. E.A.T. CAME OUT OF A COMMUNITY NEED. ITS END IDEALY WOULD BE WHEN IT HAS CATALIZED ENOUGH CHANGES TOBE A REDUNDENT ORGANIZATION.

control and selection, doesn't it, minimizing the role of the ego in art?

The ego is an inhibition, a restriction.

What about EAT, which you helped to found? Are you satisfied with its progress? There is lots of criticism, as I'm sure you know.

People grow dissatisfied with us because we're involved with the sociology of art, not the esthetics. For years now we've been in the middle of the conflict involving art, money, power, and ethics. EAT has been resisted from both sides, by the artists and by industry. We knew we were going to have trouble with the latter, because industry is not noted for its conscience—therefore pollution—but the artists turned out to be impatient, too, because they misunderstood our purpose: they expected us to be a kind of library or source for new materials. But EAT was interested in a total and mutual commitment. We didn't want the artist to use an engineer or an industry merely to execute preconceived ideas but to conduct research in which both sides would share and grow.

Isn't that kind of collaboration rare?

It always happens. It's very hard to initiate one of these projects, but when they do happen the individuals involved share and change. The forces implicit in the collaboration are stronger than the competitive instincts that flourish in the art community. It flattens the ego.

You're obviously talking about a collaboration that goes on for a long time, as did yours with Klüver, rather than a one-time project, the kind organized by the Los Angeles Museum for its Art and Technology *exhibition.*

Yes. The one-shot collaboration usually does not insist on enough commitment to involve industry in any depth. I don't need one more piece of art and I'm sure the company I worked with doesn't. It's almost like a wild card in a poker game. If you're a research scientist somewhere and you meet a perfectly strange person, the artist, who is asking you to do strange things and you know when he is finished he will go away, I don't think the collaboration will make any considerable change in you. I was happy with the work I did in California with Teledyne because of a couple of people. We have established some important personal relationships, but they aren't influencing the company. After me, I feel fairly certain that the company will not be open to working with artists. Their social structure isn't changing at all.

144

Social structures are hard to change, of course. The best things that came out of *Nine Evenings* were personal involvements with engineers and scientists, plus some physically important breakthroughs in research. A lot of projects begin and fall through. EAT's relationship with Sweda broke down. The problem is mostly social. The structure of authority is our worst enemy among the companies. Most of them are run on a medieval structure of responsibility. It all starts with the boss, and by the time it gets to the bottom —that's where the research is done—there's no contact. It's all organized in the middle by someone who has no idea of what research is about and no idea of what the boss wants. It's easy to get understanding and permission from corporate presidents; it's easy to get the interest and cooperation of the research people. It's impossible to deal with the middle stratum, though you must move through it in order to succeed at anything.

You make it sound hopeless.

I wouldn't know what I do if we hadn't tried our invasions. You have to discover a disease before you can cure it. If EAT dies tomorrow, it will have been a success, because there will be a well-documented record of where we went wrong.

Is "success" or "failure"—in conventional terms—relevant to judging EAT?

If EAT were successful, it would be unnecessary. Something like EAT can't be judged on its accomplishments. What it achieves in attempting something and failing at it is the beginning of its success. Most industrial firms consider that a research man who fails 96 per cent of the time is more valuable than one who succeeds more often, because he is involved in truly important experimentation. Success in art is very easy; how to fail is the problem.

You certainly achieved the latter with Some More Beginnings, *the exhibition in 1968 at the Brooklyn Museum. Over and over again, that show is cited by EAT's critics as proof of your shortcomings. The quality of the works there was uneven, they say. There was resentment, too, over the awarding of prizes to engineers, not artists.*

We accepted for exhibition everything sent us because we are not involved with esthetics, as I said before. In terms of awards, the Brooklyn show was a major step. We worked with a museum, not to give an artist a prize, but an engineer. Every artist says prizes are useless and corrupt. There we gave them a beautiful opportunity to ignore prizes, and they complained.

Though you participated actively in the direction of EAT in the early days, you began to withdraw from day-to-day participation in 1969–70. Why?

My co-founder responsibility was choking off the development of other leaders. My idea was never that EAT would be my baby. Billy [Klüver] is running it full-time, and that's fine. My job is to be an artist. Otherwise I'm not very effective, even in EAT's behalf.

What can industrial firms across the world specifically do to help artists?

They should have departmental structures to handle these kinds of collaborations. As for the artists, we're all gypsies and ready to work anywhere. What we need is a contact point, someone to talk with. The company should employ a man to deal with us, a man who could make clear what areas are open to artistic experiment. I'd like to work with Eastman Kodak, for example, but I don't know whom to call. When I do reach someone, he'll tell me it can't be done, whatever it is.

He'll be wrong. Is anything impossible now?

No. If you can think of it, it can be done. You'd better be careful, though. If you can think of it, it probably has already been done.

It is often said that the work so far produced through the collaborative process is ungainly, to say the least, parading its technological qualities to the detriment of the "art part." What do you think?

Harold Rosenberg once said—I'm back to him again—that the most beautiful instrument an artist has to work with is a pencil. Well, he certainly knows more about a pencil than he does anything else. I think that in the beginning collaborative work is going to be necessarily self-conscious about the technology, no matter who the artist is; parallel to the first drawings he made, when he was admiring what he did with the pencil. A mature esthetic is the result of familiarity with, and accomplishment in, your medium.

As I listen to you, though, I get the impression that you value the art-technology collaboration for reasons beyond esthetics.

I'm talking about conscience in industry, and individual responsibility among artists, scientists, engineers, bankers, politicians, and doctors, leading to a more realistic structuring of the earth and its activities.

What about art?

Art is a natural result of society.

Nam June Paik: The Cathode-Ray Canvas

Nam June Paik at work on his *Video Synthesizer,* constructed with the assistance of engineer Shuya Abe in 1970. Photo by Jock Gill.

The significance of Nam June Paik's work was not fully appreciated until the late 1960's, when television became a subject of prime interest for artists, on many levels. TV attracted them as a component, or material for sculpture and construction; as a "theater" or electronic gallery of sorts, in which imaginative work might be presented, either through the medium of personal, one-man-to-one-man videotapes or large-audience programming; and, finally, as a nucleus of power in a society increasingly dependent upon electronics for communication, instruction, and pleasure.

In all of these areas, Paik had been working or thinking, with attendant prophecies and calls to arms, for a decade. In the following discussion, he refers to a letter he wrote John Cage in 1960, predicting, in effect, that TV and art would be, one day, the same. Three years later, in Cologne, Germany, he displayed ten fiendishly altered TV sets as part of an "Exposition of Music/Electronic Television" at the Galerie Parnasse. In 1965, he acquired one of the first Sony videotape recorders sold to a consumer in New York and made what must have been the first "personal" videotape created by an artist; when he showed it to an audience the very same day, he passed out a mimeographed handbill, heavy with portents for the future ("As collage technic replaced oil-paint," he wrote, "the cathode-ray tube will replace the canvas"). From the earliest days, he seems to have envisioned a proliferation of TV stations, thanks to the laser, which can carry much more "information" than the media now used to transmit TV electronic signals, a proliferation that meant the end of the mass-network stranglehold and the beginning of a complex, decentralized TV system. Thus Frank Gillette was right when he said, on the occasion of Howard Wise's exhibition in the spring of 1969, *TV as a Creative Medium,* which assembled much of the new TV art together: "Paik is the George Washington of the movement."

Not that Paik can be completely explained in this way. He is a leader only in the most playful and elusive sense. The figure cut by both himself and his work is far from clear. On the one hand, he seems engaged in a

146

humanistic attack on technology via the methods normally associated with comedy. Much of what he says in the following interview substantiates that, as do his ridiculous TV sets, his absurd robot, his TV bra, his patch-and-paste technology; he is the antithesis of such carefully programmed artist-engineers as James Seawright. Paik humanizes electronics by subverting it, in a way that even Lewis Mumford might enjoy. He once referred to himself as a conservative in his esthetic tastes, a remark fully in accord with his background. Born in Korea in 1932, he studied the piano, composition, art history, and philosophy, graduating from the University of Tokyo with a degree in esthetics in 1956.

On the other hand, he is thoroughly at one with the avant-garde in his distaste for the ego and for subjectivity. He uses technology, he says, because it permits him to make something he could never make alone. "My TVs are more the artist than I am," he says. And again: "In engineering there is always the other, The Other; it is not you."

It is not Paik's work that has made him the elusive leader, interesting and entertaining as it has often been. The key lies in his visionary thinking. The cut of his mind is overlooked because it lurks behind a childish, half-Dada front. But time and again, Paik has grasped the implications of this or that technological breakthrough long before his colleagues; he has told them about it and broadened minds in the process. The more time passes, the more this side of Paik will be seen. We may also come to see that the playfulness in him clears rather than hinders his vision. History is rarely as serious as historians, the future rarely as sober as the futurists. Paik's sense of the absurd—his conviction that one day Wittgenstein's theories will program a TV channel and children paint with electronics as they now paint with watercolors —may well be a sense for the facts.

When and how did you become interested in electronics and television as media for art?

It was a very slow process. I began as a traditional composer, as you know; then I went from Japan to Germany in 1958, to work at the electronic-music studio in Cologne. I met John Cage there. He was a great influence. Also, if you work every day in a radio station, as I did in Cologne, the same place where television people are working, if you

Nam June Paik. Distorted television set displayed at Galerie Parnass in Wuppertal, Germany, 1963. One of the earliest appearances of "video art" in a gallery.

Nam June Paik. Image from distorted black-and-white TV set, 1965. This set was shown at the Galeria Bonino in New York. Photo by Peter Moore.

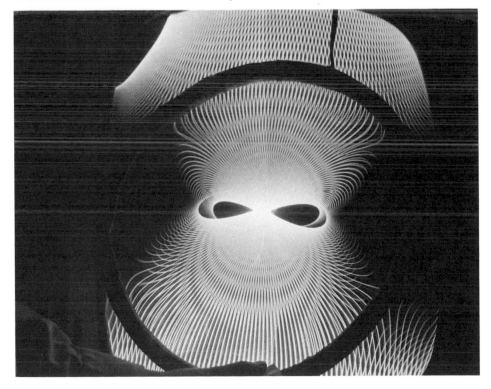

147

NAM JUNE PAIK

ELECTRONIC VIDEO RECORDER

Cafe Au Go Go • 152 Bleecker • October 4 & 11 1965 • World Theater • 9PM

(a trial preview to main November show at Gallery Bonnino)

Through the grant of J D R 3rd fund (1965 spring term), 5 years old dream of me

the combination of Electronic Television & Video Tape Recorder

is realized. It was the long long way, since I got this idea in Cologne Radio Station

in 1961, when its price was as high as a half million dollars. I look back with a bitter

grin of having paid 25 dollars for a fraud instruction "Build the Video Recorder Yourself"

and of the desperate struggle to make it with Shuya Abe last year in Japan. In my

video-taped electro vision, not only you see your picture instantaneously and find out

what kind of bad habits you have, but see yourself deformed in 12 ways, which only

electronic ways can do.

 *It is the historical necessity, if there is a historical necessity in history,
 that a new decade of electronic television should follow to the past decade
 of electronic music

 **Variablity & Indeterminism is underdeveloped in optical art as parameter
 Sex is underdeveloped in music.

 ***As collage technic replaced oil-paint, the cathode ray tube will replace
 the canvass.

 ****Someday artists will work with capacitors, resistors & semi-conductors as
 they work today with brushes, violins & junk.

 Laser idea No 3
 Because of VVHF of LASER, we will have enough radio stations to afford
 Mozart-only stations, Cage-only stations, Bogart-only TV stations, Under-
 ground Movie-only TV stations etc. etc. etc.

Nam June Paik. Statement passed out at the showing of what may have been the first "personal" videotape made by an artist, on October 4, 1965, at the Café Au Go Go in New York.

work with all kinds of electronic equipment producing sound, it's natural that you think that the same thing might apply to video. At the same time, I read in the paper in 1960 that electronic stock is soaring. K. O. Goetz published an essay around that time, on computer-programmed painting, which I read. So I could feel that things were going on inside electronics. I wrote a letter to Cage that year about television, predicting that art would come into it.

I still thought that television was a painter's job. Then one morning I woke up and said, why not make it my job, since nobody else is doing it? I rented a small studio outside Cologne so nobody would know, and bought ten TV sets. I hired an engineer and some of his friends and worked day and night. One afternoon, in the fall of 1962, shortly after the first Fluxus Festival, I invited seven friends—they included Dick Higgins, Alison Knowles, and Wolf Vostell—to my secret studio. They were very surprised at what I was doing. At that time, I developed the horizontal modulation, that stretches the faces, and also vertical modulation, which I've never been able to reproduce on American television sets for some reason. I hadn't thought of the magnet at that time, but I was working with sync pulses that warped the picture with sound waves. I also made negative TV, a set in which the blacks and whites were reversed; the picture was without sync, too, so that it just floated across the screen, always in motion. I made a set with a microphone so that when you talked, the TV line moved. I remember Joseph Beuys, the German artist, playing all night with that one. A number of the sets you could change by playing with the dials. There were some very complicated setups there, which I find hard to reproduce now, for I had engineers helping me, but all the variations were inside my head. I wanted to make a video feedback system, but I couldn't afford a TV camera; in Germany at that time, they were very expensive.

You're talking now about your first TV show, at the Galerie Parnasse in Cologne in 1963. What was the reaction of the press? Of collectors?

No one bought anything. The sets were just one part of a big musical exposition, a twenty-room participative environment. People walked around the sets, sat on them, played with them. I worked two years preparing the exposition. After it was over, I had finished in Germany. The press paid the TV sets almost no notice. The people were mostly interested in "hot" objects, like the destroyed piano.

You say you left Germany in 1963. Where did you go?

To Japan, for two purposes. I wanted to make an electronically controlled robot and work with a color television set. I made a set with three cameras, feeding colors onto the

same screen. I also made a spiral generator with Shuya Abe, the Japanese engineer, where you see a spiral on the screen. Since 1963, Mr. Abe has been my major collaborator in TV art. I cannot thank him enough.

Why did you want to build a robot?

I had read about robots in electronics magazines. I also discovered the equipment used in radio-controlled airplanes in Cologne, and I thought how to use it. I was dying to use every phase of electronics—audio, visual, tactile, and then radio controlled, a radio-controlled robot to walk the streets. So in Tokyo, I worked on the unit and made the robot. I had a thirty-channel control unit.

Did you think of the robot in any sense as a work of art?

I thought of it mostly as a Happening tool. I thought it should meet people in the street and give one second of surprise. Like a quick shower. I wanted it to kick you and then go on. It was a street-music piece. I took the robot with me to the United States in 1965, where it opened the Second Avant-Garde Festival that fall, in Judson Hall. Later I brought it to the streets of New York, to 57th Street, and then Park Avenue, and one sunny Sunday in Washington Square. All the people screamed when they saw the robot coming. One half-crazy black man screamed over and over: "God made this robot." The happiest moment in my life was when I brought the robot to Washington Square: it was really a big sensation.

When did you have your first one-man exhibition in the United States?

Galeria Bonino, in 1966. But before then I showed the TV sets at the New School, also in New York. It was jammed. I showed the robot and the ten TV sets. The New York *Herald-Tribune* wrote about one of my sets that the picture looked like the upset stomach in the TV commercials. I asked Billy Klüver to bring the heaviest magnet that Bell Labs owned for the show. But I never thought of putting the magnet on the TV screen. I just held it in front. During the exhibition, while the people were playing with the sets, someone put the magnet on top of the screen, and it made a marvelous picture. So my most famous work was not done by myself; somebody in that crowd did it. That's very funny. The Bonino show came shortly after that, in the winter.

What was in it?

Well, the best thing I learned in America is the overkill. Like all of John Cage's pieces,

putting in everything, that's the real American spirit, thirty amplifiers, thirty contact microphones, and so forth. I generally include many things. I put the ten TV sets into the Bonino show, including the RCA color TV I had bought and worked on in Tokyo, plus my first videotape, plus the robot.

When did you make the videotape?

On October 4, 1965. I already had a camera then. I bought a Sony videotape recorder and monitor with some tape at the Liberty Music Shop, on Madison Avenue, for $1,000 that day, made the tape, and showed it that night. It wasn't easy to get. There was a waiting list for Sony recorders at the time, but the Institute of International Education helped me: they were handling my grant, which came from the John D. Rockefeller, III, Fund. They pushed the Liberty Shop. They said look, this is a Rockefeller Fund buying the set, you have to give that priority, so we grabbed the first videotape recorder available. I taped Pope John's visit to the city, on my way downtown in a taxi. I showed the tape at the Café Au Go-Go in Greenwich Village that night. I had announced I was going to do it ahead of time. I made a statement, too, about videotape, which I passed out at the café.

How many people saw your first tape?

Oh, twenty. On the second night, October 11, John Cage came, and Merce Cunningham.

Had any other artists made a videotape?

I don't think so, because nobody else had access to a videotape machine at that time. I got the first one.

Did you experiment with the process when you first bought the camera, or did you make "straight" videotapes?

The first thing I discovered was the stop-frame technique, the freezing that makes strange images. Also, repetition of the same thing, with a videotape loop. I made a tape of Lindsay's election eve, too, the next month, which was a very moving thing, when he got elected Mayor of New York. But I made a very funny tape out of Lindsay, and with Jud Yalkut we turned it into a film.

Did you make any other important videotape "programs" before late 1969, when you went to WGBH-TV in Boston as resident artist?

There was an important program about Marshall McLuhan, made by NBC in 1967 or early 1968. Charlotte Moorman and I were on that program. By that time, I had developed various colorizing techniques, with the magnet inside the set. So I thought I might make

Nam June Paik. *Random Access*, 1963. Audio tape pasted on wall. By placing a movable magnetic head on the tape, the spectator was able to create sound at any point along the tape.

an electronic movie of Marshall McLuhan, and I videotaped the program while it was on the air. I put various electromagnets on the set and turned McLuhan right and left. What I wound up with was a McLuhan videotape loop that can be played around and around. I also showed some TV sets at Howard Wise's *Lights in Orbit* show. Then I had another large TV show at Bonino in 1968. It was then that I made a real breakthrough, with what Fred Barzyk later called the "dancing pattern." I had discovered it in 1966 or 1967 and showed it at the Museum of Technology in Stockholm in 1967. Mr. Abe believes that the dancing pattern is more financially viable than the Video Synthesizer. I made it from internal modulation of three audio signals. I feed the audio signals into the set and they make variable patterns, particularly on color sets. I think my two technical breakthroughs were placing magnets on black-and-white sets and the dancing color pattern. The dancing patterns form themselves directly out of the studio signals. You can never reproduce them with an oscilloscope, though the computer can produce them after much programming effort. The patterns move very slowly, and I can control them by modulating the sounds. They are like the Pop mentality, a very slow thing.

You were also performing with Charlotte Moorman, the cellist, at this time. And you made the first "TV bra" for her to wear and play in, right?

If it hadn't been for Charlotte Moorman, I would have stopped making music altogether. But I thought when I met her and discovered she played the cello that music had never been married with sex, and they should because they are both nice things, music and sex, like franks and beans. So I wrote several pieces for her, action music mostly. Then I thought to combine the electronics into the concerts with her. I went to Howard Wise with my idea about the TV bra, and he liked it but said he didn't want his gallery invaded by police. But I made it anyway, in a very hectic way, so that the two pictures on the bra changed as Charlotte plays the cello. The bra is wired to the cello.

It was in 1967 that you made your statement about the importance of video cassettes. Why?

Since the early 1960's, I had been reading all kinds of electronics magazines, so I knew what was coming. For me, the cassette is important. I am trained in classical music, so

I make very serious art, higher than popular commercial art. This is a minus for me. I always thought television was a great medium, but I hated the mass-media part. I thought that I can control my audience with the videotape cassette. I can make television for the mini medium rather than the mass. I thought I could put very difficult things—like Wittgenstein—on it. I wanted to make high art inside videotape cassettes. That was my main interest in the cassette, to free us from the mass-media pressure.

That's a personal explanation. What will cassettes mean to society?

I think they will change society. They will change completely the video structure—and if you change television you change the world.

How?

Let me answer in a broad way. The cassette will diversify the video culture. Now there is only one television structure in the United States, one-way communication from three major networks. You get their kind of television, or you must cut it off. But in the future world, you will have cable TV, video cassettes, and picture phones. You will also have video tranquilizers, like my Synthesizer Machine. If the video structure is diversified, one of the first results will be less pollution. It will be a major solution to the ecology crisis. Why move, why drive somewhere in your car, if you can do everything right at home?

You began working on the Video Synthesizer, the "ultimate machine," in 1969, just after you came to WGBH-TV in Boston. An engineer there told me you made it because you were frustrated by the bureaucracy of the control room.

He is right. Norbert Weiner was very conscious of the difference between "machine time" and "human time." It is a delicate and horrible difference. Now machine time is faster than human time. That is why a car crash occurs, because machine time is faster than the human hand. It was a great conflict for Weiner, and he tried his best to recover the difference between human and machine. I experienced exactly the same thing at WGBH. Once you are in the studio it's just as expensive. You have already spent $2,000 just to get there. You are completely at the mercy of machine time; you cannot experience solitude, which is necessary to create any art work. Meanwhile, you cannot offend anybody, least of all the engineers who have come to the studio to help you. So I decided to com-

press the whole studio into a piano keyboard.

When you first thought about making the machine, what quality did you want it to have, above all else?

Real-time access. That's important. The editing process in VTR is very clumsy, worse than in film. I wanted a piano keyboard that would allow me to edit seven different sources bang-bang-bang, like that—real-time editing. The first thing I thought of was seven cameras with seven sources that could be mixed instantly by a console. So the machine has two suites: the piano keys for instant mixing and also a tiny clock that turns the color around, from ultrared to ultraviolet. The player can change the colors. The seven cameras are keyed into seven different colors themselves: one camera makes only red, another only blue, another so and so. The seven rainbow colors are there. Mixing them together makes what you see.

When you first unveiled the machine in 1970, with a four-hour telecast on WGBH, I noticed some traditional Paik imagery on the screen.

The magnets, of course. On the first show, I tried the variations on a face, playing with the knobs of the receivers, which I did first in 1967. And I used the "dancing pattern," which I make through audio signals, as I explained before.

In essence, what the Synthesizer comes down to is a one-man TV control room, which almost anybody can play. Correct?

Yes. I am out of it now. You saw me shouting during the first telecast. That's all I was doing. Mr. Abe was mixing, and anybody can do that job, play with the keys.

You and Mr. Abe are applying for a patent for the synthesizer. What, specifically, will the patent cover?

It is for how to make low fidelity. Everything has been to date designed in TV for high fidelity, for clear, representational pictures. Now for the first time Mr. Abe is purposely designing a low-fidelity amplifier. It's more than just the console and the mixing. The console can distort the pictures once they come in from the cameras. Inside there are many delicate devices. He put many controls into the console—contrast controls, brightness controls, color-contrast controls. Every knob on it is functional, and there are sixty of them. All distort the picture in different ways (I wish I didn't have to use a word like "distortion," which is really an undemocratic word). Our patent is not only for the general

Nam June Paik. The Paik-Abe *Video Synthesizer* in performance at the Galeria Bonino, New York, 1972. Courtesy Intermedia Institute. Photo by Peter Moore.

151

system, though, but for a specific invention—our "Encoder," a device that turns monochrome pictures into color. We can ask for a very specific, precise color and get it, from the Encoder.

What future do you imagine for the Synthesizer—esthetically, technically, or in terms of widespread use?

We have already sold two copies to colleges for use in teaching TV art. I think many new and small cable TV stations will want to use it. In size, it will get smaller and smaller, until it can be part of the home and used there like we use watercolor sets today. The pictures will get better. Mr. Abe says, so far we have used only 7 per cent of the machine's potential. Even so, I can't believe my eyes sometimes when I am looking at the color. At the end of the first program there was this blue-green mix that reminded me of Monet's water lilies. Exactly the same, only better. Monet's colors will fade as time goes on. But with magnetic storage, I can show you the exact original of that mix any time in the future. There is a parallel between art history and TV. From Giotto to Ingres there is a steady search for more perfection in high fidelity. Then Monet made it low fidelity. TV has been searching for high fidelity, too. The whole electronics industry has had but one purpose to serve: reproduction of the original signal. They never question that signal. This is so obvious that no one is conscious of it any more. The whole multimillion-dollar electronics industry has one purpose—re-creation of the source. The nature of the source is not their problem. Electronics has thus been used for military purposes, for censorship, for eavesdropping. I want to make electronics more humanistic, more conscious of the problem of source material—which isn't a difficult problem at all. For example, many millions of engineers knew that you could distort TV signals with a magnet; millions knew

it, but no one did it. They were trained never to question the source material, like soldiers at West Point. Mr. Abe says, everything in TV is now set for high fidelity, but there is nothing to do. Therefore, now is the time in TV for low fidelity. Hi-fi is dead in music with Stockhausen and Cage, dead in marriage with Dr. Kinsey, and dead in TV with us.

The tone of the technology incorporated into your work has been the same from the beginning—crude and rough, as though it had been put together with scotch tape, very different from the smooth, polished execution found in a piece by Seawright, for example. Is that a matter of choice? If you had all the time, money, and expert help available, would you still keep that roughness?

Yes. With the arrival of Mr. Abe, you see, I have the best quality of engineer you can get anywhere in the world. I can now make very good things. But Mr. Abe says the age of hardware is over; it's now the age of software. So my scotch-tape technology was the most advanced technology. It's very soft, you know. It's all about process. I hate the usual technology. I hate playing with videotape, too, all those knobs and things, I hate that.

But you must get some pleasure out of what you do. Is it subverting technology?

Yes, in a way. I am always overwhelmed by my engineering. My TVs are more the artist than I am. I can compose something through technology that is higher than my personality or lower than my personality. In painting, you can compose as much as you want, but de Kooning cannot make anything that is deeper or more profound than what he has, inside himself. But in engineering, there is always the other, The Other, it is not you. I believe that is what Norbert Weiner was talking about in discussing the difference between human time and machine time. Your work is not yourself. Sometimes your work has nothing to do with yourself.

James Seawright:
The Electronic Style

James Seawright grew up in Mississippi, where he attended college, graduating in 1957. The obvious influences upon his work appear to have come afterward, although he has admitted to a lifelong interest in gadgets and machines. The influences seem to have been the U.S. Navy, which he served principally as an engineering officer; the choreographer Alwin Nikolais, whom he served as a stage technician in 1962 and 1963 (not long after, he moved to New York with his wife, a dancer) and with whom he collaborated, not only in an imaginative fusion of light and sound with dance, but in the composition of electronic music; and, finally, the Columbia-Princeton Electronic Music Center, where he has served both as technician and as instructor since 1963, working with composers like Milton Babbitt. During his early years in New York, he also studied at the Art Students League and sculpted for a while in bronze.

It was in 1963 that Seawright began experimenting with electronic sculptures, following, in a sense, the direction taken in dance by Nikolais, and in music by Babbitt, toward the fuller use of technology in art. He did not show his work publicly until 1966, at the Stable Gallery in New York, but it gained instant attention, particularly from private collectors. Seawright has since shown in many places, including the Whitney Museum, the Guggenheim, the New Jersey State Museum, and the Nelson Gallery in Kansas City, for which he created his imposing *Electronic Peristyle*, discussed here.

Like Kepes, Seawright approaches radically new materials and processes with an attitude grounded in tradition, though his is a working rather than a philosophical tradition: it is simply that of the artist in determined pursuit of beauty, by whatever means. The means have grown organically out of his own experience, to be sure. Seawright moved slowly into new forms and materials, as the following interview reveals. At the time of his Stable Gallery show, he told me it was now time "to make valid art out of materials that are shaping the world." It is a statement that could apply to almost any artist at any time— Michelangelo with marble, Kepes with artificial light.

Seawright plans his pieces carefully in ad-

James Seawright. Photo by Peter Moore.

James Seawright. *Tower,* 1967. Metal, plastic, electronic parts. 45" h. Courtesy Stable Gallery, New York. Photo by John D. Schiff.

vance and executes them by hand, with meticulous attention to detail. He talks as slowly as he works, with studied deliberation, integrating words as if they were plugs, wires, and lights. Perhaps it is not an accident that his pieces move slowly, too.

Clearly, Seawright prefers control to chance, perfection to error, but he is no enemy of spontaneity. His pieces seem to blend perfectly the contrasting strengths of the positions taken by Babbitt and Cage, positions relevant to contemporary art and dance, as well as music. The forms of Seawright's pieces seem fixed and finished, their light-and-sound pattern lively and free. It is not meaning that Seawright imposes on the chaos of life or upon his materials: it is himself, a self that provides inherent order.

Did your work at the Columbia Electronic Music Center in any way stimulate you as a sculptor?

I was enormously influenced by my work at Columbia. First of all, I think the whole development of electronic music has been a remarkably lucid and portentous illustration of the applicability of technology to art. Many of the most basic questions of music have been reexamined and an almost endless number of insights have been gained. The particular approach I have taken toward applying technological principles to sculpture has been determined in large part by my reaction to the example I have seen set in music.

Why did it take you so long to begin working on electronic sculpture?

I began to work only after a relatively long time spent in consideration of various questions. I had, of course, to learn a great number of special techniques and skills. At the same time, I was working with conventional sculptural media, and this experience has certainly proved valuable. I think my primary concern was that any work I might attempt to produce would have to have some essential validity within the electronics medium; that is, it would have to be more than merely a motorization or electrification of an idea otherwise suited for conventional media. I generally think of motors, lamps, circuits, and so on, as they are used in my sculptures, as having little interest in themselves; it is the way they are integrated into a functioning system that strikes me as the essential application of contemporary technology.

Is there anything inherent in the materials

you use that rules out spontaneity and chance, or is it your personal preference that leads you to do so?

There is nothing about the materials that imposes a different kind of limitation than the limitations any other materials impose on a sculptor. There is a difference in degree, perhaps, owing to the many different kinds of things that might be used in the same piece. Working directly with the materials as I do, I find that there is a great deal of spontaneous arrangement and rearrangement possible with the possible components of a given piece, at least as far as the visual appearance of the sculpture is concerned. Often there may be many possible arrangements of a certain functioning device, all of which are visually interesting. This can be fortunate if motion is involved, for then one has to expect many arbitrary combinations of arrangements to occur as the piece moves. Therefore, chance is certainly involved in most of the things I do, though not without certain limits or controls being imposed. I prefer to control as many aspects of a sculpture's appearance and behavior as possible, at least those aspects that seem to me to be other than trivial. I don't feel, however, that this rules out a certain element of surprise; but if a piece is to be consistently surprising, it usually must be designed to be so. Most chance occurrences are extraordinarily dull.

Would you describe your first electronic piece, its conception and creation?

My first piece, *Tower,* was the result of an idea that came to me after a long period of thinking about lights and structures of lights. It is basically a column of wires arranged in layers and vertical rows and supporting nearly a thousand little indicator lamps. The idea essentially had to do with a simple and elegant way of switching on the lamps in succession, so as to give the effect of a moving light passing in and around, up and down, through the structure. At times two, and at other times four, lights appear, moving together or contrariwise. After I finished the piece, I was so taken with the way it worked, the way the manifestation of the moving lights so completely transcended the structure itself, that I really began to try to discover the ramifications of the relatively simple devices and techniques I had used. I was very excited by the work I had done.

When did you begin to utilize programming in your pieces?

Actually, I have used programming in all my electronic pieces. In *Tower*, the programming is achieved by means of gear-driven mechanical linkages that scan across fields of switch contacts. Thus, an enormous amount of information can be contained in a simple device in the form of an inherent capability of motion. There are many ways to program or to record the information of which the program consists. I avoid devices that require that every detail of the desired instruction be spelled out at whatever length the period of activity is going to be.

I much prefer to use a device that possesses a complex periodic behavior (systems of gears, numerical permutations as exemplified in circuitry), thus allowing a translation of the information content of this behavior into a behavior of the components of the sculpture itself. This approach is, in my experience, economical, reliable, and almost as flexible as the unlimited programming flexibility of the spell-it-all-out approach of a punched tape or drum switch. When programs are compounded or made to multiply or add to each other's effect, a great range of activity can be obtained, and it will have the capacity for spontaneity I mentioned before.

What objective did you set for yourself after you completed Tower?

Watcher was the fourth electronic piece I finished, and it was a development of the ideas first employed in *Tower*. One element not previously used was the introduction of self-generated electronic sounds. In addition, I did not conceal any of the components responsible for the programming, or control, of the sculpture's behavior, but rather tried to make the sculpture totally visible—somewhat the opposite of a quasi-theatrical approach in which phenomena or a performance of actions are visible and the means by which they are produced are not. Thus, the circuits are all constructed out of the actual, functioning components, and even the power supplies and supporting structures are integrated into the visible whole.

One new element present in *Watcher*, and further exploited in *Searcher*, *Captive*, and *Scanner*, is the use of external or environmental factors as information inputs. Certain of the sculptures' behavioral patterns are determined in part by environmental light levels; the electronically generated sounds are determined partly by the light patterns produced by another part of the sculpture and partly by light patterns produced as viewers move about the room. The later pieces—*Searcher*, *Captive*, *Scanner*—go much further in utilizing external light sensing. In addition to sensing light within the environment, they produce light in various ways and have the capability of modifying their own programs. In the presence of one another, the pieces interact and provide a continually varying pattern of independent and collective activity.

What did you learn from your work on the Magic Theater *show at the Nelson Gallery in*

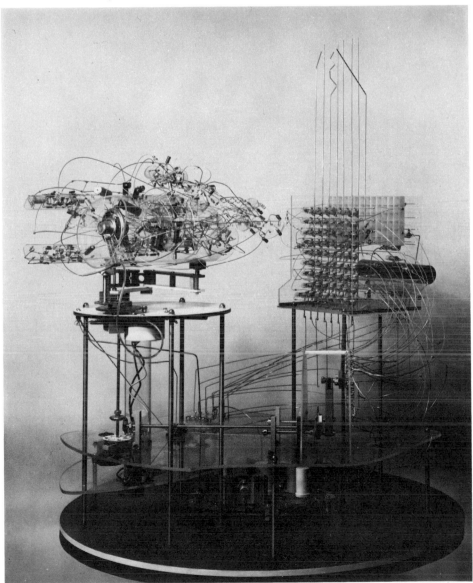

James Seawright. *Watcher*, 1965–66. Metal, plastic, electronic parts. 37″ h., 30″ diam. Collection Howard Lipman. Courtesy Stable Gallery, New York. Photo by John D. Schiff.

James Seawright. *Network III,* 1971. Computer-generated environment. The spectator walks over a carpet underlaid with thin pressure plates that activate a pattern of ceiling lights. Courtesy Walker Art Center, Minneapolis. Photo by Eric Sutherland.

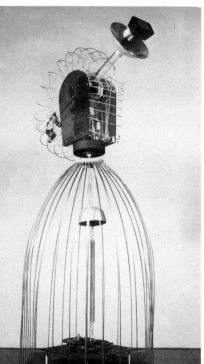

James Seawright. *Searcher,* 1966. Metal, plastic, electronic parts. 52″ h. Courtesy Stable Gallery, New York.

Kansas City? I know you created a large piece, the Electronic Peristyle, *part of which was manufactured for you there.*

I found the experience quite instructive. To begin with, it was a great pleasure to be involved in what eventually became a massive community effort. The opportunity to do work on a very large scale was also a most rewarding aspect of the project.

Many of the pieces in the show, including my own, were reactive environments. During the show there seemed to arise a very basic conflict between the expectation of the majority of the public and the ideal situation with regard to individual participation or involvement in a given environment. Speaking for myself, I think that there really is no practical compromise between environments that entertain or provide a superficial display for groups of viewers and those that offer the greatest possible perceptual engagement for one person. The necessity of providing a stable (and rational) solution for every possible combination of group activities or stimuli highly restricts the available degree of interaction, at

least for real-time systems or systems where time-delay response is involved.

Since my own ideas are becoming less and less involved with theatrical performance, as exemplified by programmed environmental phenomena, and more concerned with viewer-controlled (consciously and unconsciously) situations, I am thinking now of ways to extend individualization of the response of systems. One way that seems logical at this point is to try to build reactive environments that can be "taught" by the viewer. The responses of such systems could be refined by the involved viewer, or rejected and restructured as often as desired, while many of the stability problems or feedback systems are avoided. Group activities in such environments could lead to interesting competition.

You are in a unique position to compare the work being done by composers and by artists who utilize the recent fruits of technology. Do the two camps differ in any way, qualitatively or quantitatively?

There seems to be surprisingly little difference. Electronic music is perhaps more highly developed at this point, but the same basic dichotomy is present: on the one hand, those composers and artists who are concerned only with the *act* of being involved with technology; and, on the other hand, those who use technological means to achieve an end more relevant to the world we live in. Much of the interest in the former approach tends to die out as the novelty wears off; this is particularly noticeable in the musical world, and I suspect that as more and more artists begin to concern themselves with the possibilities of technology, there will emerge a more general view that technology simply offers extraordinarily powerful tools for accomplishing the aims of artists, just as it has enabled people to fulfill many of their material needs.

What objectives do you have in mind for future work?

I would like to proceed in the direction I mentioned before, toward more complex ways of controlling reactive environments. The degree of complexity achieved so far is very primitive when considered in the light of the possibilities of present computer technology. Complexity for its own sake is of course absurd, but human perceptions are wonderfully complex and subtle in themselves and seem to invite engagement on an equally sophisticated level.

Gerd Stern and USCO: The Experiential Flow

Gerd Stern.

As he so pointedly reveals in the following conversation, Gerd Stern and his work represent a major theme in recent technological art—an increasing involvement with the outside world. A founding member of USCO, the pioneer American kinetic-light art group, he became president in 1970 of a unique business firm, Intermedia Systems, Inc., of Cambridge, Massachusetts. Intermedia bridged many gaps in its personnel, which included artists, psychologists, economists, and educators. Its principal aim was the construction of both hardware and software for audiovisual environments in a wide variety of sectors, from education to industry. At its heart, though, was a direction rooted in Stern's work from the beginning: an "experiential flow of information," as he puts it. Like McLuhan, Stern believes in the efficacy of communication both above and below language, communication implemented by electronic media of every kind. He began with slide projectors and audio tapes, as he explains here, and ended with complex computer-programmed environments, in a display created by Intermedia for the New England Electric Systems.

USCO itself was a unique phenomenon. As I have already pointed out, it was the only valid American counterpart to the several technologically oriented groups of artists that formed in Europe around 1960. Within the United States, USCO's emphasis on group creation was far ahead of its time, in a culture strongly devoted to the ideals of individualism. USCO did not seek anonymity in the manner of GRAV—to achieve the impersonality and precision of science. For the Americans, "anonymity" was a natural extension of the way they lived, communally, in an abandoned church in Garnersville, New York. The key phrase in their work was *We Are All One*, which came in time to be the title for their mixed-media environments.

USCO was oriented as much toward experience as the creation of art. Their object from the first was affecting and involving their audiences by any means possible, not just perfecting kinetic-light form. USCO worked through art to change the world, and themselves, if possible. This is an orientation very much apart from the New Tendency in Europe.

It is far more personal, emotional, high-spirited, and, as Stern says, "funkier."

The artists, writers, and engineer-scientists associated with USCO were a talented lot. They included painter Steve Durkee and Robert Dacy, engineer Michael Callahan, and filmmaker Jud Yalkut. But Stern was always

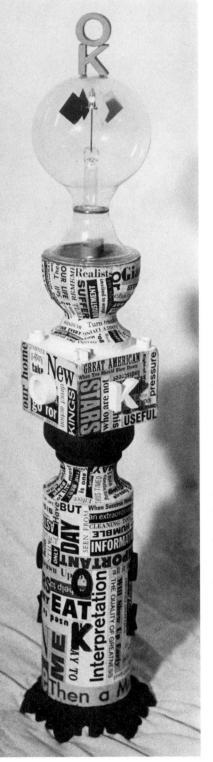

Gerd Stern. *Column Commemorating and Recording Various Agreements,* 1963. Newspaper collage, paint, raised letters, and broken radio-meter. 21″ h.

the prophet and the spokesman. This conversation took place shortly after he became president of Intermedia, an act that symbolized a direction implicit in his art from the first. Stern's early poems were drawn from words and phrases taken from billboards and neon signs in the streets; in 1963 he created an ambitious multimedia environment at the San Francisco Museum, combining verbal and sensory messages. The later USCO media mixes invited the interaction of people coming into them. Stern's Intermedia projects produced responses from the people involved—students working within structural learning environments, for example—that deeply pleased him. "The problem with the museum and the gallery," he told me once, "is that you hang your work up there and that's it: you're left with your impression of it but very little process feedback."

Like Rauschenberg, Stern wants to affect and change life directly. When USCO split apart in the late 1960's over the issue of art and commerce, as well as drugs versus nondrugs, and the "sacred" wing went off to New Mexico to live apart from life, Stern and his friends stayed in the East to found Intermedia, pursue the "profane," and build yet another bridge between art and life.

I'm afraid we have to pick you up in mid-career, when you were living in San Francisco. You began as a poet, started thinking about media because of McLuhan's books and your own work at radio station KPFA in San Francisco, and finally organized an extensive media event at the San Francisco Museum in 1963, entitled Who R U and What's Happening? *I believe USCO formed later, around some of the people who worked with you on that event.*

There wasn't any formal beginning. It was a group attribution, a recognition of multiple contributions, and we never copyrighted or incorporated USCO. I left the Coast with my wife, Judi, on a cross-country tour that year. Michael Callahan, who was then technical director of the San Francisco Tape Music Center and had worked on *Who R U,* joined us at our home base on Maverick Road in Woodstock, New York, and we started working with painter Steve Durkee, at his recently acquired church-studio in Garnersville, New York, which later became the headquarters for USCO.

One of the key components of the early

USCO *mixed-media environments was the slide. I think you made more imaginative and extensive use of slides to wrap around the audience than anyone else, in the United States or in Europe, and you were widely copied, of course. When did you get into that?*

I used slides as poems in San Francisco, but the key development took place on that cross-country tour. We carried nothing but software with us, the slides, films, tapes of radio mixes, nature sounds, and so forth. Then at the University of Wisconsin's Union Theater at Madison, we ran into our first carousel projectors. It is the basic multimedia tool. Practically speaking, the carousel was a liberation. Until then we had to stick single slides into the projectors and pull them out on the other side by hand. One person for each projector. Slides are cheap to begin with. Add the carousel projector, and slides become programmable. You can resequence and reprocess your image-ideas through the matrix of slides continuously, whereas in film your elements freeze in sequence. With the carousel you can insert the element directly into a program container. To change program, you pull the elements and reinsert, substituting new material at any point. It's an 81-digital-increment programmer and with multiple carousels, the possibilities are endless. The advent of the Bolex 16-mm. reflex camera changed underground filmmaking just as drastically. Filmmakers were able to single frame, wind back, and superimpose inexpensively, without special lab effects. McLuhan understood these phenomena. In *Understanding Media,* he wrote that you can tell the work from the tool or extension used to make it. It's just as evident in technological art, where the hardware defines your software, or display; in primitive art, the tool defines the artifact.

What were the first USCO multimedia exhibitions like? The ones that came out of the Garnersville community, that is.

Mostly extensions of *The Verbal American Landscape,* one of my early poetry environments. We traveled from university to museum to gallery, exhibiting kinetic pieces, paintings, objects, and assembling environments. The multimedia performances were characterized by complex sound-image information matrices. It was after our Kresge Auditorium performance at MIT that we changed our attitudes about the process of overloading the audience. We called the show at that point *Hub-*

bub, drawn from a quote of Martin Luther's, "The whole universe is God's masquerade in which he hides himself while he rules the world so strangely by making a Hubbub." It was an intentional overload, hitting people with everything we could get together, from beginning to end.

At first the intensity and polarization of audience response excited us; we left our audience jangled, some unhappy, some delirious, most questioning. Our motorcycle piece, *Ghost Rev,* is a good example. We would start with five films of the same bike ride side-by-side, projected with multiple sound tracks. Then we would speed up and slow down the films, superimpose the images, allow the sound and image to get out of phase. As far as I was concerned, this was an experimental display of time space contraction-expansion, exploring the reality of film process; what the audience received was noise and image overload. The overload experience also clashed with the meditation techniques we were practicing at Garnersville to establish group harmonies. So we changed.

I want to talk about the change, but I'm also interested in the fact that it was partly dictated by the USCO living situation. From the first, it seems to me, your art and your life, so to speak, were inseparable. You had a dimension beyond the production of kinetic-light experience and objects, unlike most of the European groups—and without any American parallel, particularly in your insistence on anonymity.

But the name USCO didn't connote anonymity to us. It seemed simply a beautiful way to credit everyone. All kinds of people sent work that was included, and all kinds would come and stay at Garnersville at the church, work for a while, then go on: Stewart Brand, now publisher of the *Whole Earth Catalogue,* and his wife, Lois; filmmaker Jud Yalkut; many photographers like Brian Peterson, Charles Rotmil, Chris George; painters like Bob Dacy and Steve Durkee, who was the center of our visual consciousness; Owen Jones; Paul Williams; Walter Gunday; and so many others. We were part of the first wave of extended family, cooperative economic living, now fairly common.

I suppose that experience is reflected in the way we solved overload. We began to think in a more traditionally dramatic sense, composing our shows in movements that flowed into each other. We found ourselves dealing with the multiplicity of life and the resolution of that multiplicity into unity, calling the performances *We Are All One.* From a multi-level matrix of associative images and sounds, we merged into one oscilloscope sine-wave image, slowly revolving in phase-shift, and one *om*-like sine-wave tone, modulated in volume to near silence. The result was a meditation environment in which often the audience would remain for an hour or more, because we wouldn't turn on the lights, just dim up a bit. This experience became the centering of our exhibition at the Riverside Museum, which was the peaking of our work in the traditional art world context.

But before that, in 1965 I believe, you made another major step, by constructing the environment at The World *the first multimedia discothèque.*

Yes, this was easily the most ambitious media environment assembled at that time. We had over twenty programmed slide projectors, arc film projectors, a closed-circuit television projection system with three cameras, and a huge screen. It was Michael Callahan's first chance to build a large-scale punched-tape programmer, which allowed us to compose and synchronize all these elements. The World was a great popular success for about six months, and then the real-estate people shut it down over a lease technicality.

About this time you were gaining recognition within the context of that "traditional art world." USCO was included in the Kunst Licht Kunst *exhibit at the Stedlijk van Abbe-Museum in Eindhoven, Holland, the most important of the early light art exhibitions. Did you see any affinity between yourselves and the rest of the work displayed there? Most of it was European in origin.*

No. We were amazed to find out that so many people and groups were working with kinetic and light objects in Europe, but it seemed to us mostly Bauhaus-based, puristic traditionalism. We were much funkier, though the things shown at Eindhoven—pieces picked by the curator when he came to the church—were not our multimedia works. He took the seven-foot *Contact Is the Only Love* kinetic octagon, a very Pop-Indiana style piece. He also took the stroboscopic *Diffraction Hex,* which was in a severe formal box when he first saw it, but by the time it got to Holland we'd collaged it in an old American flag with a US eagle on top (the US in USCO of course).

Gerd Stern. *Over,* 1962. Kinetic poem with programmed lights. 4' x 8'. Collection The Oakland (Calif.) Art Museum.

USCO. *Resurrection,* 1963. Programmed poem out of pinball and bowling alley. Collection Immaculate Heart College, Los Angeles. Courtesy Gerd Stern.

It wasn't only the European work that seemed overly cold and simplistic. The minimal light art from the United States didn't really do it for us.

Why? Dan Flavin is the best American example of "minimal" light art. What's wrong with it?

In general, that art has great architectural potential, but it doesn't take my head into process, into the information-matrix possibilities that contemporary technology opens. There's a lot of self-definition involved and we wanted to go beyond that.

Which brings us roughly to 1966, the Riverside Museum show, which was USCO's finest hour, and also the hour during which internal schisms began to break the group apart. What was so good about the Riverside context?

Oriole Farb, the director of the museum, gave us four rooms to do whatever we did. It was the challenge we wanted and needed; we appreciated the extent of that opportunity, spent months working toward the show and weeks installing it. It was our first major walk-through, sit-in environment; we referred to it as the *Human Be-In.* The response was fantastic. Nobody had expected crowds, but they came, mostly kids from college and high school. Some would come early in the morning and stay all day, and lots came over and over again.

That summer we'd put together our first uptown stage show in collaboration with Tim Leary and the Castalia Foundation, at the New Theater. We called it The Psychedelic Theater. At the same time, Steve Durkee was out looking for land so we could have a low-energy center, as well as the high-energy center in Garnerville. Eventually he found a fantastic mountain top in New Mexico and established the Lama Foundation. Some of the USCO people went there, some stayed at the church. Through John Brockman, we got into a lot of projects, some commercial, like Scott Paper and Metromedia. There were other art-world events, like *The Lower East Side, Past and Present* environment for the Jewish Museum.

The basic schism had to do with what's life (not what's art), what's right, whether to use drugs or not, eat meat or not. The profane and sacred extremes were pushed very hard. When Steve left to establish Lama, we were separated geographically as well as spiritually. In 1967, André Ruedi, who's helped us build the Tabernacle and worked on other USCO projects and who was getting his doctorate at Harvard Business School, introduced us to one of his professors, Dr. George Litwin. George's field was organizational climate. He was interested in using our multimedia techniques to simulate those climates, and he suggested we work together. That same year I started teaching at Harvard part-time, and we formed Intermedia Systems.

How did you feel about moving so completely into commerce, conceptually, that is?

I really felt we were at a dead end in the art world. We had had the available experiences. Also, our ideas were too ambitious for our means. We always felt financially limited. The Riverside was our best thing, and we put $6,000 of our own bread into that.

The New England Electric System Visitor Center is the kind of project we always wanted to do in the art world, but it evaded us. One of my basic concerns as poet and media artist has been the electric metaphor. I wanted to communicate the information people need to understand the energy behind the new culture: what the working relationships of process flow voltage, current, phasing, and so on, are really about and how the network is programmed. The program for the Bear Swamp Pumped Storage project is called "The Six-Minute Day," a time compression of twenty-four hours into six minutes through which we can simulate the energy flow of the entire New England electric power network, all controlled through a small computer. It's our first chance to work with a computer-programmed on-line environment, and it's a poetic experience beyond those we've had available to us. As you know, we've also explored the possibilities of broad-scale environmental and community design.

You lose identification as an "artist," of course, among those who define the term in traditional ways.

Once I started working in media, the poets decided I wasn't a poet, and the artists didn't think I was an artist because I had been a poet; and besides, they felt media isn't really art. I've never felt that the artist is a special kind of person, anyway. It's much better to do your work and be whoever you are. Why should the artist be any different from a carpenter or cab driver or anybody else? We're just working at communicating with and about the society, trying to make and love and influence, in positive ways.

25. Bruce Nauman. Making Holograms (Untitled), 1969. Photo-lithograph. Courtesy Leo Castelli Gallery, New York.

26. Nam June Paik. Selections from a videotape portrait of Allen Ginsberg produced on the Paik-Abe *Video Synthesizer,* 1971. Courtesy Galeria Bonino, New York.

Left:
27. Stephen Beck. Images from his *Video Synthesizer,* 1971. Courtesy Center for Experiment in Television, San Francisco.

Above:
28. James Seawright. *Two Schönberg Pieces,* 1970. A videotape produced at WGBH-TV, Boston. Choreography by Mimi Garrard.

Below:
29. Douglas Davis. *Numbers: A Videotape Event for the Boston Symphony Orchestra,* 1970. Produced at WGBH-TV, Boston. Photo by Peter Moore.

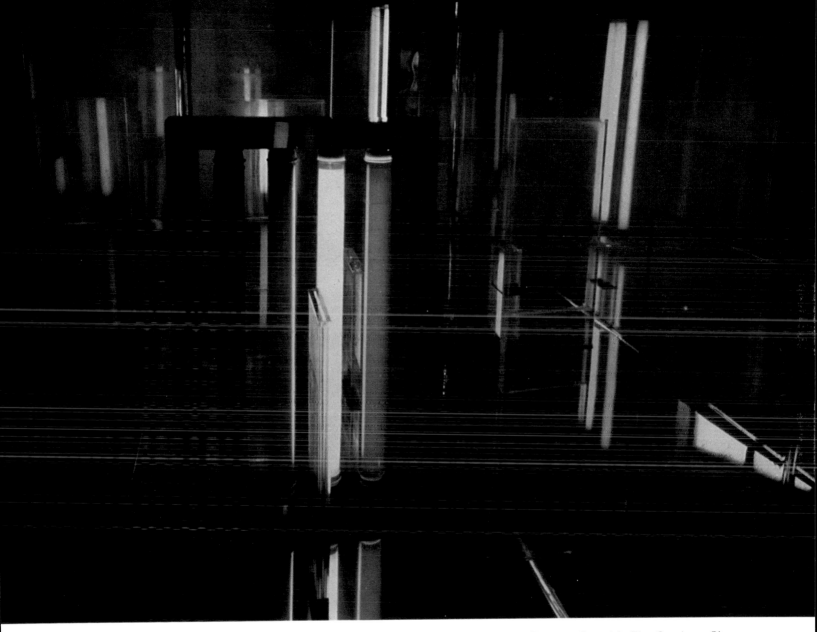

30. Michael Hayden (Intersystems group, Toronto, Canada). *The Goodman Piece,* an audiohydrokinetic presentation, 1968. 4′ x 8′ x 5′. A stainless steel, mirror-finished box. From the top face of the box 8 hollow columns protrude, filled with 8 different fluorescent liquids. A timing system regulates the intensities of light within these tubes, the revolution of the box itself, and sound patterns broadcast from 6 speakers under the main body of the piece. Sound composed by John Mills-Cockrell on the Intersystems Moog Electronic Music Synthesizer. Designer: Dick Zander.

31. Stan Vanderbeek. Film strips from *Poemfield*, 1967–69. A computer-generated animated film, made in collaboration with engineer Ken Knowlton of Bell Laboratories. The resulting black-and-white film was "colorized" with a special process developed by artists Bob Brown and Frank Olvey.

32. Charles Csuri. Computer-generated drawing, 1970.

33. Frieder Nake. *Matrix Multiplication*, 1967. Computer drawing with colors assigned by mathematical process. Courtesy F. Bruckmann, München.

34. William Morehouse. *No. 35,* 1967. Urethane, acrylic, and polyester on aluminum armature. 43¾″ x 62½″ x 10″. Courtesy University Art Museum, University of California, Berkeley. Gift of Elmer Schlesinger, San Francisco. Photo by Ron Chamberlain.

35. Alan Sonfist. *Micro-organism,* 1968. Living and changing cells under glass. 3′ x 3′ x 3′.

36. Gyorgy Kepes. Detail of *Light Mural for KLM,* KLM Building, New York, 1959. Neon tubing.

37. Otto Piene. *Electric Rose,* 1965. Timed neon sculpture. 82⅔″ h., 5¾″ diam. Polished aluminum globe covered with 170 red neon glow lamps, standing on chrome pipe and polished aluminum foot. The *Rose* is timed in four phases. Horizontally divided halves of the globe turn on and off, alternating with total blackout and total light.

38. Robert Rauschenberg. *Sky Garden,* 1969. Lithograph. 89″ x 42″. Part of the artist's *Stoned Moon* series of prints, commissioned by NASA and based on the Apollo 11 manned voyage to the moon. Courtesy Gemini G.E.L., Los Angeles.

39. Nicolas Schöffer. *The Spatiodynamic Tower,* Liège, Belgium, 1961. 170′ h. The *Tower* is programmed to respond to light and sound with light, movement, and sound of its own. On holidays it participates in the "Luminodynamic Spectacle" projected from within onto the glass façade of the adjacent Congress Palace. Courtesy Agence Rapho, Paris and New York.

40. Gil Henderson. *The Marvelous Electronic Device for Young and Old Alike,* 1963. Wood and lights. 53½″ x 65½″. Courtesy Ruder & Finn Fine Arts, New York.

41. Computers. Courtesy Magnum. Photo by Elliott Erwitt.

42. Rockne Krebs. *Day Passage,* 1971. Argon and helium-neon lasers, mirrors. Executed in collaboration with Hewlett-Packard Corporation for *Art and Technology.* Courtesy Los Angeles County Museum of Art.

43. Information International. *The Earth*. This visual image was composed by a computer and based on telemetry signals from a satellite orbiting high above the earth. Courtesy Information International, Los Angeles.

44. View of the rising earth as seen by the Apollo 8 astronauts as they came from behind the moon after the lunar orbit insertion burn in 1968. Courtesy National Aeronautics and Space Administration.

James Turrell/Robert Irwin/
Edward Wortz: The Invisible Project

The collaboration between artists James Turrell and Robert Irwin and psychologist Edward Wortz, initiated in 1969 by the Los Angeles County Museum, is chiefly valuable because it produced substantial changes in the participants. No "objects," in the traditional art sense, resulted from their work together, but each man pronounced the project a complete success, in conversations with this writer. They struggle to explain why, falling short each time, but the effect of their interaction is abundantly clear. As Dr. Wortz says, leaning on the old Zen story, "Everything is still the same as it was, but it's different." I am furthermore impressed by the difficulty each man has—after a year of confrontation—with the

traditional distinctions between "artist" and "scientist." The following conversations are thus notes for a serious change in our attitude toward both sides.

A few quick facts to set the stage. Irwin, whose carefully executed aluminum disc "paintings," combined with indirect lighting, have already been discussed, was a strong influence on California art at the time of his selection by Los Angeles Museum curator Maurice Tuchman for an *Art and Technology* "project." Irwin immediately looked for another artist to join with him; his choice, finally, was a younger man, James Turrell, whose impressive reputation rested on one major show—at the Pasadena Museum, in

Robert Irwin, James Turrell, and Dr. Edward Wortz (at right). Courtesy Los Angeles County Museum of Art. Photo by Malcolm Lubliner.

1967, where he displayed a series of ingenious kinetic-light constructions, some of them involving lasers. Dr. Wortz directed the Life Sciences Division at Garrett Airesearch, where he was deeply involved in the Apollo project. His division was responsible, on contract from NASA, for projecting the life-support needs of each astronaut who walked on the surface of the moon. Shortly after the completion of the Apollo 11 mission, Dr. Wortz began studying the "environmental" qualities required within spaceships embarked on long journeys, perhaps to Mars.

He was thus well into broad-based environmental thinking when he first met Irwin and Turrell in early December, 1968. Irwin and Turrell, for their parts, were involved in conceptual crises as well. Neither was comfortable within the orthodox confines of art; both, furthermore, had shown in their work a concern with problems far beyond the qualities of the art object alone. Irwin's softly lighted discs are exercises in perception, with changes carefully installed to challenge the eye at distances of at least forty feet. Turrell also cared more for perception than for the object perceived. "I don't think my medium is light," he said, on the occasion of his first exhibition. "It's space and projection."

Given this background, it is no wonder the three men instantly agreed on the goal of their project—the creation of certain "inner states" difficult to define. During the first half of 1969, they conducted experiments leading toward a chamber or room where viewers could enter and experience something closely resembling a pure meditative state. The experiments included a soundless, anachoid chamber at UCLA and an attempt—in Turrell's studio—to demonstrate a relationship between the senses (in this case, the effect that sound has upon taste). The three also collected data based on previous experiments, all leading to the conclusion that our environment subtly modulates not only our bodies but our minds.

The direction of their project, in other words, was toward issues beyond the production of art alone. More and more, their energies were devoted to the quality of the whole environment, not merely the artificial one that might be created inside a special museum chamber. At the time of the conversations presented here, each man was planning his part in the First National Symposium on Habitability. Organized by Dr. Wortz and held

in 1970, its participants included ecologists, spacecraft engineers, architects, psychologists, and artists.

It is particularly interesting to me that the Wortz-Irwin-Turrell project was proceeding toward its conceptually sophisticated end at precisely the time that critic Jack Burnham was preparing a book articulating an identical position. In *The Structure of Art,* published in 1970, he announced "the death throes of the classical art impulse," superseded by an intensely esthetic concern for the non-art environment. Burnham also organized the *Software* exhibition for the Jewish Museum in New York, which emphasized communicative rather than material modes of art as content. "*Software* makes none of the usual qualitative distinctions," he told Willoughby Sharp, in an interview, "between the artistic and technical subcultures. At a time when esthetic insights must become part of technological decision making, does such a division still make sense?" The Wortz-Irwin-Turrell project felt its way to this point— the Habitability Symposium—and is particularly interesting for that reason. What Burnham conceived, they found, by necessity. These dialogues thus record the philosophical death of art, while Burnham merely imagines it.

A brief note about the conversations. They are as a group atypical in this section. The interview with Dr. Wortz follows the conventional dialogue form and is reprinted in full. The conversations with Irwin and Turrell were monologues; I have reprinted Irwin's in this manner, but substantially cut to include only those passages directly involving Wortz or the specific issues raised by their collaboration. Turrell's monologue covered many of the same points. I have thus omitted it because of space limitations, but I would like to quote Turrell on a theme of major importance in this book: "If we were considered artists in this project, so should he. Our involvement with Wortz is on an equal level. The same."

Robert Irwin

The first thing we tried to do is break down our dialogue differences—the way we approach a situation, structure our information, and so on. Also our verbal differences and our disciplinary differences. The point of it is that I can't know all of his information, and I don't have to learn it if we can learn to think and function together. So what we had to do, in

essence, is find an operable relationship so he can bring to bear his information and I can bring to bear mine and James his, without having to know each one of our things.

So what we did first was play games with one another. Games in which we all take common positions and experience them together and talk about them and kick them around with the idea of seeing how each deals with the experience, how each extracts information—what kind, how we order and structure it to use. All of these, of course, having the possibility of fitting in somehow at some point. In terms of some of the things we've investigated together, if I were to quit tomorrow or James were to quit, he, Wortz, wouldn't. And the reverse is true. So we have had that effect. We've changed his operational mode, we've changed what he's working at, to some degree, and he has changed ours. . . .

The possibility is that the modern artist has involved us in our sensate awareness and we could change our sensate threshold. It is my contention that modern art has been principally involved for twenty years in a disengagement from literate thinking, to place an emphasis on sensate awareness. . . . We are not now willing to make the necessary commitments to change our environment because we are not fully conscious of our need. We, in our project, started talking about developing spaces that are not going to tell you anything or lead you to anything or interpret anything for you, but are going to lead you into situations where you are pretty much the *actor*. Beginning with sensory deprivation, putting you in a space where you're not getting any of the information you usually get, altering your threshold and order of sense dependence, making you first aware that you are the perceiver.

But let's assume that that somehow changes your sensory threshold so that you're getting more information. That means you could be adjusting your nose up, instead of down. And that the point of crisis in terms of smog for civilization happens here rather than there. That actually is one of the consequences of contemporary art, because it's talking about adjusting that whole thought form, how you go about extracting information—what information you are structured to get and what information you honor. The beauty of sequential thinking is its task orientation. . . . is that out of a gross amount of information, it becomes very specific and eliminates all but that information absolutely necessary to accomplish that task, keeps us from being intimidated by excess sensate input. And that's the strength of that thought form. When you let in all that information, the first thing that happens is the illusion that you can't operate. I mean, if you sit down in an automobile and let in all that gross sensory information, you'd be a terribly bad driver. But at the same time, to make the kinds of human decisions that are necessary to our survival on the minimal awareness of literate consciousness is equally ridiculous. Each has its strengths and areas of competence. The weakness of pragmatic thinking is that it extracts a very fine, thin line of information.

In the fifteenth century, the major adjustment was to sequential thought, away from an overdependence on a limited sensate thinking, for reasons very necessary at that time. And I'm not talking about replacing one with the other. I mean, all that has happened in between is absolutely there and it has its purpose, it's not an obsolete form. So obviously what we're talking about is a high marriage of some kind. So the idea of marrying the artist, the sensate being, with technology, which has arrived at a fantastic level of proficiency—putting them together—it could have made a really interesting, crucial kind of consequence. To put it in the context of Billy Klüver's doing things for the artist, or in the context of doing something in time for the show, it's just ludicrous. I'm not oblivious to all those considerations, but when you play it out you realize *Good god! That's ludicrous.* . . .

It (the collaboration) is indeed altering our esthetic, and that's what's important. You cannot judge or value your own thing, but in a sense for me, although I live right now in a very great state of confusion because all it has done is put everything into question, I would say that, for me, the project is already a success. How many times in your life do you bring everything you value into question?

Edward Wortz

I don't know whether to raise this issue right away. I gather from my conversation with Irwin, and with Turrell to some extent, that though the idea of production for its own sake was abhorrent, the idea of interaction definitely was not. They both had very strong

motives for going into this. Their search was for a man, not a company, and the man turned out to be you. What was your reaction to them, can you recall?

We communicated very readily. We were able to discuss things of mutual interest. I don't think anything specific was discussed in respect to the project. It was more a discussion of perception and world-views and so forth.

Do you see any relationship between their work and perception, which I understand is your academic base?

More than the work. I see a relationship in their general philosophy with perception per se. In their general attitude and perception of life. That's one of the conceptual problems in the project. The thing we are jointly trying to express is very difficult to state. I think that caught me by surprise. I'm not sure they were surprised.

What was the next meeting like, and what did you talk about?

I don't recall precisely, but I usually try to structure problems—like, okay, fellows, what is this game all about, what do you want to do, how can I help you? Because that's what I considered my role to be—to provide assistance however I could, in achieving whatever they wanted to do. So they started climbing all over me: You're involved in this, too, you know, they said. I said, Wait a minute, I don't even know what you're talking about.

They proceeded to get me on the hook, though, so I had to start asking stupid questions like, What is it that you guys do? What do artists do and why do you do it? So, it was questions like that, understanding those questions, finding out that the things they do are not a hell of a lot different from my own—the reasons they do them and so forth. From my own objectives.

As we proceeded along, I developed a great respect for them. Not just as artists, because although I like the things they do, I'm in no position to criticize their art. But I was impressed by their modes of thought, impressed by their diligence.

There has been a lot of discussion about the difference between art and science, art and technology, the artist and the scientist, and so on. For me, the distinctions have become somewhat shadowy, at least in a qualitative sense.

We discussed this several times. What's pretty for me is a straight line. They said, What do you mean, a straight line? Well,

when I can plot a straight line in relationship between two variables, *a* and *b*, that's beautiful. I've understood enough about the pieces of the world to be able to push them around and get this straight line: that's pretty fantastic. It's interesting also that I enjoy the occurrence of these straight lines even though I may be aware that the relationships between *a* and *b* that produce these straight lines aren't necessarily real.

I'm not sure that I entirely follow you here, but . . .

Well, it's providing some momentary order, understanding the relationships.

What I want to plug in here is a definition of art that occurs throughout art history, depending in its nature heavily upon the person who is saying it and the time he is living in, but it has something to do with . . . well, someone recently stated it this way: Art is what we do when we lavish a great amount of care and attention on something without knowing why. Is that in any way related to your work? I would think not. You pretty well know before you begin, perhaps not the answer but the problem you're working on, right?

Yes, but the problem as stated in science has no more of a specific "why" than anything else. Bob and Jim used that point with me very specifically. I asked them, Aren't you guys supposed to communicate things? They said, You're out of your skull; we don't communicate anything to people. When you undertake an experiment, you're not trying to communicate anything to people, are you? I said, No, I'm just curious about what happens. They said, Well, that's the same way we do things.

I think they were oversimplifying, but at least they were able to communicate to me along that score. The line on which we were able to relate with respect to utility was pretty good. This doesn't mean that these things don't have any value, eventually, but that they were produced for themselves. And the utility is either indeterminable or irrelevant.

So the early conversations were just a general feeling out of positions more than anything else?

Yes.

At what point did you begin talking about what the project might ultimately do? Because I know that at some point you began conducting experiments.

Well, this is another point of similarity in the ways we work, in that we decided to go through a period of data collection. We tried

to get information from various people and conduct little pilot experiments on things that we were interested in, to see if we could just get a lot of information about them—and try to then, later on, shut down this flow of information. . . . I think that the objective of the project was determined within each of us immediately, although it went unstated for a long time, except in some general terms about how it might operate. Again, always with the understanding that this all might be a head game and might not turn out to have any substance in terms of the project itself. That's when the experiments started. We would see people sometimes singly, sometimes together, and play a few games.

You said that the objective was understood from the beginning. Is there any way of defining that objective?

The method of going about it we could verbalize; what we wanted to achieve isn't verbalizable. In fact, one of the objectives we stated among ourselves was that the event, if it were brought off, would be such that no one could do a good job of verbalizing, and if he participated a second time he would have a difficult time relating the two encounters and certainly no two people would agree about it. Now, if we had achieved that, we would feel we had brought it off. That was our objective. But the quality of the internal state that we wanted to achieve was the real objective; these other things are just the procedures. . . .

When did your experiments stop?

Around June of 1969, primarily because they were following an uninteresting line. They started off with great interest, but it pursued they would have become boring. And there was enough information from the experiments, in any case, to lend credence to the general direction in which the project was headed. Everyone was reasonably confident that the effects could be achieved.

Effects that would affect or create inner states verbally indefinable.

Right. Except that the quality of those states was the key. There are many ways of affecting internal states—you can sneak up on a guy or bang a gong and create fantastic internal states. But that wasn't what we were after. In one sense, our concern about the characteristics of this internal state has spilled over into another endeavor, which both Bob and Jim are pursuing with great enthusiasm, and that's an assault on our environment in general.

Before we get to that, you said that there was a certain quality of inner state that you were interested in. Was that basically the meditative state?

No. I think it's better described as trying to achieve the same objective that the meditative state is trying to achieve.

Which is what?

That's the indefinable something . . .

I gather that you decided to include Irwin and Turrell in the conference on Habitability, along with a bevy of scientists and educators. What do you think they bring to a group like that? I begin to see how their interest in it is related to the interest that the three of you have in the project.

All of that is involved with the quality of life, which is a prolongation of this quality experience. So if it's not an achievement of the goal of the project, it's still right along the lines of the objective of the project, and is shooting for perhaps a more meaningful, objective fulfillment of these concerns.

Yes, one of the things that Turrell said, and I quote from memory: "The Habitability problem seems much more important to me now than the project under original consideration. I mean to stop now and produce something for the exhibition is like taking millions of dollars to make some little thing."

The project might be considered the toy version of what we're actually up to.

Well, again, what do you think people like Irwin and Turrell bring to a venture like that?

Things relating to the quality of life. No one that I know can handle the business of stating things relative to the quality of life in verbal terms. Enter the artist. There are things that need to be stated, things that need not so much to be communicated in the usual sense but brought out of people, things that are really there but need to be released. . . .

Let's talk now about a theme that came up consistently in my discussions with Irwin and Turrell. They felt that the collaboration with you had really changed their whole mental set.

Yes, it has with me, too.

And they explained in various ways what they meant by that, and I wonder whether you could do that, too, and talk about the ways in which you have been changed, if possible.

Well, I'm trying to find out what are the ways in which I've changed. I'm more certain that the changes have taken place than of my ability to describe them. I think I'm aware of many things in a slightly different perspec-

Robert Irwin and James Turrell testing equipment in UCLA's Anechoic Chamber, or "soundless room," 1969, in connection with the Los Angeles County Museum of Art's *Art and Technology* program. Courtesy Los Angeles County Museum of Art. Photo by Malcolm Lubliner.

ness of the relationship the three of us have had. . . .

In another sense, their being artists might have a great deal to do with the changes, because they are coming from a very unique frame of reference, even though we have in common the same concepts and the same value system. Which gives all three of us a hell of a lot more credence in what we think is right, in what we think is valid. Which I don't think I would have had if I hadn't experienced what I did as a psychologist. But here are some guys from very unique backgrounds, about as disparate as professional people could be from what I'm in, and I certainly had no expectation of ever communicating with these people in these terms.

Now we're back to where we began, which is the value system you think you share. I wonder if we could discuss that now.

That's like trying to ask a mother why she likes her child. In part it's because the child is something of her. But there are other things involved, too.

Maybe it has something to do with an openness toward the environment. If you live in a constantly open state with respect to your environment, you live in a constant state of discovery. Your chamber would have enforced that sense, as I understand the plan. Very few people enjoy that kind of discovery. Most of us prefer certainty, about what is there in the environment.

If I find out it's really there, I'm surprised. Then I don't believe it.

If that's a level that you share, then that gets rid of all the terms—artist, scientist, engineer, and so on.

You may have a much better perspective on this than we do. As you see, my life is very different from Irwin's and Turrell's. . . . Here is something you might be able to make sense out of. It has been a long time in science since we've had the universal scientist, the guy who knew it all; we were just deluged by this fantastic flow of information. Now here we are, still being deluged, but people are becoming less specialized. They are working in more and more areas, and I think that in the colleges, in the science divisions, the departments are just starting to fall down. . . .

Isn't it an order of values you share with Turrell and Irwin? Don't you think that is a better term for it than world view? An order of priorities, really, rather than a specific—

To my mind they are the same. You can't separate them.

tive, but I don't know how to describe the perspective. It's like the old Zen story: Everything is still the same as it was, but it's different. Because that's the way it is.

But I don't know that the changes were caused by Turrell and Irwin's being artists per se. I think it's primarily due to the deep-

III PROPHECY: THE ART OF THE FUTURE

In this chapter I propose gradually to leave behind the facts that dominate this book. The facts themselves make this flight into prophecy possible. They are a necessary thematic prelude to the future that must be discussed. It is often said that contemporary art is a meaningless kaleidoscope of conflicting styles, with few connecting threads. The evidence thus far presented—in text, photographs, and dialogues—strongly contradicts this assertion. The threads become clearly visible despite my attempt to present conflicting points of view, in both theory and practice. Art's expansion into new scale, into organic life patterns (birth, environmental interaction, decay, death), into symbiotic collaboration with "non-art" forces, with the engineer, the scientist, the computer—all these are self-evident unities. So are their consequences in terms of form. The oft-discussed dematerialization of art is the strongest of these: the more painters, sculptors, and all their allied colleagues discard their preoccupation with carefully crafted objects made for interior use and preservation, the more they use materials difficult to order in traditional ways (such as earth, loose pieces of felt, or feedback electronic imagery), the more they exchange static strategies and display spaces for conceptual and performance structures (such as billboards on the street, the earth, the sky, and television), the less inevitable becomes the association between the fine arts and the physical. For a generation raised on television rather than print, indeed, on a medium of communication that is sensory and evanescent rather than iconic and static, able to focus easily on multiple monitors and screens, the inevitability turns in another direction.

These themes run throughout this book, sewing it together by themselves, with their own presence. But when I talk about "themes," I necessarily mean verbal constructs, summations of many scattered and independent integers. I would like the reader to keep in mind certain sensory images as

well, which serve as metaphors for these themes. There are ten key images in this book: Moholy-Nagy's *Light-Space Modulator,* the first esthetically successful work incorporating light and movement, reaching out to contact the surrounding walls and play upon them; the burnt and twisted fragment left over from Jean Tinguely's *Homage to New York,* the machine that destroyed itself; Robert Rauschenberg's giant plexiglass wall, *Soundings,* flickering back at the clapping, shouting viewers before it; Hans Haacke's plexiglass tube, filled with liquid silently responding, rising and falling, to the environment outside, whether warm or cool; Otto Piene's long, slender polyethylene forms sailing indifferently through the towering cityscape of Pittsburgh, at home with its scale; Richard Hamilton's *Kent State,* that blurred electronic-message lithograph, its dancing cathode-ray beam frozen into place on paper; Nam June Paik's *Video Synthesizer,* a sprawling complex of circuitry, console and cameras, escalating the television picture from realism to Impressionism, from high fidelity to low. And then, in a rush, two thinking, self-directed works, unimaginable even for Herbert Read, each unique to the complex of ideas and materials loose in the 1960's and early 1970's: the *Architecture Machine* built at MIT and celebrated by Nicholas Negroponte, the crude forerunner of creative cybernetic decision-making; and, of course, David Tudor's *Bandoneon!,* that programmed set of interactive machines, sitting silently on the floor, creating music without hands, its significance hardly noticed by those (out of the photograph's range) who are listening. Finally, the image based in the realpolitik of the "Invisible Project"—Irwin, Turrell, and Wortz at rest in a classroom, talking, simply talking.

As these images are metaphors for the themes stated at the start, the themes are themselves metaphors. The significance of art marrying technology is not rooted in art alone. This is primarily why I want to hurry beyond the mere restatement of esthetic modulations implicit elsewhere. The expansion of the sense

of scale is a major step in art history, yes, but that import pales next to what this expansion means to all history. The mere fact that painting can now be implemented with light, or sculpture with computers, is not the *raison d'être* for this book, nor should it dominate any longer the level upon which the subject itself is discussed. Neither the death of art (widely predicted) nor the death of science (widely wished) is half as important as what those deaths might signify. This book, like the subject it treats, is a metaphor.

For what? "Metaphor" is the literary label we apply to any term or activity that represents figuratively something else—the "literal," or realistic truth. The figurative end of our equation is clear enough in the images I have just described and in the themes they represent. What is at the other end? If I were a Structuralist, I would claim that art and technology = the cultural = the natural, that this fusion of cultural forces represents a fusion of natural equivalents. But Structuralism makes such links too clean and simple. There is a danger in identifying dichotomies like "natural" and "cultural," particularly when the relationship between them—as in this case—is symbiotic, each mixed with the other. I prefer the term metaphor because of its elusiveness. All I wish to say now is that the literal end of our metaphor is the object of this book; it is the object, too, of the fusion between art and technology itself. Its definition lies immediately ahead of us.

A way to begin is with the term "art," in whose name so much is acclaimed and so much assailed. I have noticed that orthodox critics rarely address themselves at any length to the fundamental act of definition. You will go far in either Clement Greenberg's or Michael Fried's essays before you find any direct statement of the premise underlying all their value judgments, or even a definition of "quality," their favorite adjective. To be sure, the traditionalist rarely feels the need to define himself, because he shares with his audience an unspoken consensus on the nature of art, which in post-Renaissance Western society has been dominated, visually, by painting and sculpture. For a Marxist historian like Ernst Fischer, however—and many others—the issue is not only in doubt but fascinating as well:

> We are inclined to take an astonishing phenomenon too much for granted. And it is certainly astonishing: countless millions read books, listen to music, watch the theatre, go to the cinema. Why? To say that they seek distraction, relaxation, entertainment is to beg the question. Why is it distracting, relaxing, entertaining to sink oneself in someone else's life and problems, to identify oneself with a painting or a piece of music or with the characters in a novel, play, or film? Why do we respond to such "unreality" as though it were reality intensified? What strange, mysterious entertainment is this?[1]

Fischer's examples are all resolutely conservative, as befits a Marxist writing in Vienna in 1959, but the questions he asks also pertain to Paik's robot and Tudor's *Bandoneon!*

Nor is he alone. As the forms of visual art have multiplied during the past two decades, a number of scholars and critics have attempted to find anew an understanding of this mysterious thing, "art." On an etymological level alone, it is clear that the formal, physical view of "art" is wrong. Both terms, "art" and "artist," have their root in the Latin, *in artem* and *artista*, each of which referred broadly, at first, to scholarship and to men of learning. Not till the sixteenth century did the present-day link between art and the practice of painting begin to occur. As late as the nineteenth century, "art" identified skills mechanical and cerebral, as well as decorative. In the seventeenth century, it included astrologers and alchemists—anyone, in the words of the *Oxford English Dictionary*, "who pursues some practical science."[2]

Even beyond this, the work of investigators such as E. H. Gombrich, Morse Peckham, and Jack Burnham establishes at once the complexity of the "art" phenomenon and, beneath it, the clarity of its purpose in Western society. Both Gombrich (in *Art and Illusion*) and Peckham (in *Man's Rage for Chaos*)

Photo by Peter Moore.

stress the synergic nature of the art process —that it involves a complex system of roles far beyond the simple matter of finishing and presenting a work of art to the world. Artist, perceiver, curator, gallery, museum, critic, all take a hand in codifying, presenting, and explaining "art"; the work alone, while the focus of this attention, is still one cog among many. Burnham, borrowing heavily from Structuralism, believes that the function of all these cogs is to mediate between the raw facts of nature and the human mind. Fischer traces the origins of art back to magic: the earliest amulets, charms, and cave paintings were means of controlling nature. Art, in Fischer's eyes, is therefore a tool, an instrument of power like any other, corrupted into its present decorative, commodity status by the onset of capitalism. Sans politics, Fischer's conclusion is analogous to Peckham's. The argument in *Man's Rage for Chaos* is that the mysterious persistence of art is the result of its utility, not its decorative qualities. Through the art "system," Peckham says, in effect, ideas are promulgated that might be suppressed elsewhere, ideas essential to the preservation of the species. Like science, art keeps man alive, on a hostile planet, through its exploration of ideas beyond the prevailing consensus of logic or society.

Another way of stating the link between all these men—and my own esthetic premise —is that art is information. The "system" we know as art in this culture is there because we need it. The need may be subconscious, and the information available through art highly esoteric, but the phenomenon is biologically necessary, at base. The implication of what I am saying for criticism is less revolutionary than it sounds. Before the onset of the art for art's sake esthetic in the late nineteenth century, and the triumph of formalist criticism in our own time, art had always been "read" for messages beyond itself, as a medium of communication (witness Aristotle's *Poetics*). I don't propose a return to heavily interpretive criticism, of course. The information inherent in art has very little to do with the specific intent of individual works or artists, but with the broadest social and metaphysical issues.

An illuminating example of the "reading" I have in mind occurs in Walter Benjamin's striking essay, "The Work of Art in the Age of Mechanical Reproduction," completed in 1936. Benjamin, like Fischer, was a Marxist critic; he thus had no stake in the idea that

art begins and ends in decoration. From this vantage point he was able to see clearly and freshly the socio-political implications of the art-technology marriage, before anyone else. Above all, he lacked that instinctive scorn for tool and craft endemic to Western intellectuals, dating back to the Greeks. *Techne* may have implied a combination of art and craft, but few Greek intellectuals recommended the art of the hand, as opposed to the mind; Aristotle and Plato both reserve their highest praise for leisure and contemplation.[3]

Much of what Benjamin tells us has the embarrassing clarity of the words that declared the emperor unclothed, mainly because he sees with eyes unclouded by the dogmas of contemporary art history. Like Fischer, he identifies the beginnings of art with magic. The unique, precious object preserves the "aura" of magic because it demands the viewer's personal, ritual presence, usually in some rare and sanctified spot—a museum, a cathedral, a rich man's villa; during the medieval period, obviously, divine as well as magical associations invested this moment. In any case, the magic-ritual structure demanded that the pilgrim leave his hearth to seek the work of art. Viewer comes before object.

With the advent of the printing press, art begins to get up and go on its own, leaving its sacred seclusion to meet the public. The woodcut is the most spectacular example, but the portable bust (as opposed to the frieze or full-length figure) is movable, too, and the painting is a step out from the fresco

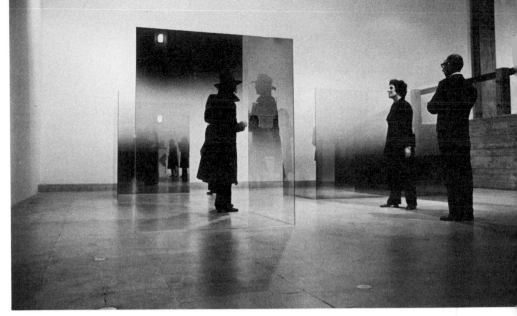

Larry Bell. Untitled, 1971. Treated mirrors. On display at the Tate Gallery, London. Photo by Edward Lucie-Smith.

or cave. With photography, this process accelerates. With film, it hits top speed: "Its social significance, particularly in its most positive form, is inconceivable without its destructive, cathartic aspect, that is the liquidation of the traditional value of the cultural heritage."[4] In this sense, technology is anything but the inhuman force assailed by conservative critics, particularly when it comes together with art. Mechanical reproduction steadily reduces the hold of the elite upon art and steadily inculcates classless esthetic

Allan Kaprow. Tire event in Central Park, New York, 1966.

Maurice Agis and Peter Jones. *Space Structure Workshop*, 1971. Performed at The Serpentine Gallery, London. Photo by Edward Lucie-Smith.

171

Steve Paxton. *Field Dance*, 1965. Photo © 1965 by Peter Moore.

values. It leads such men as Herbert Read to see high art in an object stamped out in large quantities on the production line. It leads him to reconsider the private, reserved arts. There is no way to turn a painting into a collective experience. Vanguard explorations in film, a social art (Chaplin, for instance), are widely understood. Picasso's experiments anger all but the few. More importantly, creative access spreads in context with the proliferating print and photograph. Before 1900, Benjamin points out, there were a few writers and thousands of readers. Now, with the proliferation of trade and technical journals, to say nothing of "Letters to the Editor," the public has become the writer.

Benjamin is valuable not only because he "reads" art on a broad scale but because he provides insight into the social and political biases that cloud our own reading. I am no Marxist myself, but it seems clear that the moral fervor implicit in the attacks on technology by many social and literary critics are not based in esthetic disgust alone. The term "fine art" itself bears a divisive connotation, excluding as it does the vulgar masses. In the capitalist West, it is almost axiomatic to say

Larry Poons. *(Not Yet Titled)*, 1968. Acrylic on canvas. 101" x 153". Collection Mr. and Mrs. Ron Davis. Photo by Rudolph Burckhardt.

Radiograph of lake deposit disturbed by turbulence and penetrated by roots. Collection E. L. Krinitzsky, U.S. Army Waterways Experiment Station, Vicksburg, Miss.

172

Michael Heizer. *Gesture,* April, 1968. Mojave Desert, California. 16″ deep, 12″ to 24″ apart with one offset. Courtesy Dwan Gallery, New York.

Walter de Maria. *50 M³ (1,600 cubic feet),* 1968. Level dirt. Installation view at Heiner Friedrich Gallery, Munich, Germany. Courtesy Dwan Gallery, New York.

that works of art open to a large public suffer critically, unless they are bad enough to be discussed ironically, as Camp. Yet technology renders the inaccessible constantly accessible. We must remember this fact in accounting for the reaction to the kind of art we have been examining—our own reaction, as well as others. As I write, I sense a growing disenchantment inside the art system with laser light as a material. At precisely the same moment, the laser has become broadly accessible: Bell Telephone is marketing a low-cost, pocket-sized infrared laser; a firm called Sonovision is marketing for the home an audio-responsive device that converts sound into complex, moving laser patterns on the wall. I cannot believe that this convergence is either accidental or prompted by esthetic exhaustion (the possibilities for laser art are

Dennis Oppenheim. *Boundary Split,* 1968. Cutting and hooking patterns in the frozen ice (St. John River at Ft. Kent, Maine, near Canadian border). 150′ x 200′. Courtesy Sonnabend Gallery, New York.

Robert Rauschenberg. *Mud-Muse* (detail), 1971. 4′ x 9′ x 12′. Driller's mud, sound, and air value system. Executed in collaboration with Teledyne, Inc., for *Art and Technology.* Courtesy Los Angeles County Museum of Art.

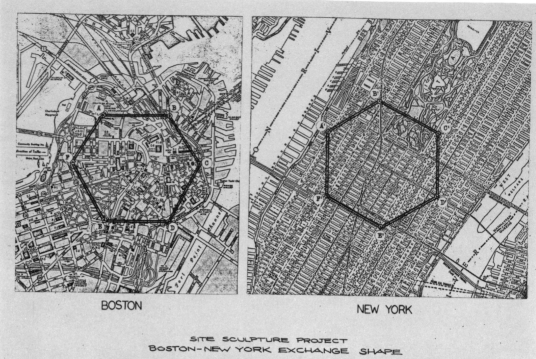

BOSTON NEW YORK

SITE SCULPTURE PROJECT
BOSTON—NEW YORK EXCHANGE SHAPE

6 SITES ABCDEF -A'B'C'D'E'F' LOCATED IN EACH CITY BY MARKER
EACH SIDE OF SHAPE (BETWEEN ACTUAL SITES) 3,000' LONG
AFE-A'F'E' NEARLY DUE WEST BCD-B'C'D' NEARLY DUE EAST

Douglas Huebler. *Boston—New York Exchange Shape,* 1969. Documentation drawing, ink on paper. Two identical hexagons, each side measuring 3,000', were marked in each of the two cities by white stickers, 1″ wide.

180-degree panoramic aerial photograph of freighter crossing the Chesapeake-Delaware Canal. Taken by a jet plane flying at 600 knots at 1,000 feet. Collection Fairchild Space and Defense Systems. Courtesy The Museum of Modern Art, New York.

Robert Smithson. *Aerial Map (Proposal for the Dallas–Fort Worth Regional Airport),* 1967. Drawing. 50″ x 70″ x 8″. Collaborating artists: Robert Morris, Sol LeWitt, and Carl André. Courtesy John Weber Gallery, New York. Photo by Walter Russell.

endless). Beneath it, there is a natural but dying human desire, whetted by the capitalist structure, to stake out preserves that exclude others. I say "dying" because technology renders all materials and ideas accessible as a matter of course. The number of esthetic preserves available diminishes yearly.

Benjamin felt that more than art itself was being reproduced. He believed that the creative act could be widely shared now: "The public becomes the writer." The significance of this statement has been multiplied by time. Benjamin wrote before the computer, before the laser, before videotape. He had never seen, or heard about, the Happening. The concern throughout his essay was largely with arts that became public by their very nature—like the photograph, the film, and the print. He had scant idea that the most sacred of the fine arts would be ransacked by technology. Even so, he greeted with scorn Aldous Huxley's lament—an echo of similar complaints by Mumford, Wylie Sypher, Hilton

Kramer, T. S. Eliot, ad infinitum—that technology had increased the production of art while the sum of geniuses remained small ("The proportion of trash . . . is greater now," wrote Huxley, "than at any other period"). Benjamin's grim reply: "This mode of observation is obviously not progressive."

Technology attacks not only the aura surrounding the work of art but the artist himself, romantically defined. Imagine Benjamin and Huxley standing before *Soundings*! The delight of the one, the distaste of the other, would be difficult to measure. In the past, the role of the artist could be tightly controlled. A certain mode of dress, background, and physical, craftsmanlike skill with the hand demarcated the possibilities. Now the dividing line is blurring. The films of John Whitney, produced by a trained engineer in concert with a digital computer, are one example out of many. Even the most orthodox critic would find it difficult to deny these films the label art, or refuse to call Whitney himself an artist. Technology steadily reduces the need for specialized physical skills in art. The computer promises to end it (*Bandoneon!* signifies that step). Men differ widely in imaginative and conceptual power, of course, but these differences are exquisitely subtle and difficult to categorize. Unlike the critics, who often react to these developments like a labor union threatened from without by automation

Electricity-seeking automation. Courtesy George A. Carlton, Johns Hopkins University, Baltimore, Maryland.

Max Neuhaus. *Maxfeed,* 1967. By playing with its dials, the owner creates static and screech in varying patterns from the *Maxfeed*. Photo by Peter Moore.

Linda Berris. *Tactile Film* for Vision Substitution System, 1970. The tactile images are simulated by the chair system, developed by the Smith Kettlewell Institute of Visual Sciences. Courtesy Ruder & Finn Fine Arts, New York.

Picture phones. Courtesy Bell Telephone System, New York.

or by scabs, many artists welcome this expansion of the license granted them by society: "Man is only truly alive when he realizes he is a creative, artistic being," states Joseph Beuys, a key figure in the European avant-garde during the 1960's:

> I demand an artistic involvement in all realms of life. At the moment art is taught as a special field. . . . I advocate an esthetic involvement from science, from economics, from politics, from religion—every sphere of human activity. Even the act of peeling a potato can be a work of art if it is a conscious act.[5]

When I spoke earlier about the "implicit ideology" realized in the work and activities of such men as Herbert Read, Lucio Fontana, Vasarely, and Klüver, I meant this, the program enunciated by Beuys. That ideology directs itself against the exclusivist theories of taste and quality promoted and maintained in the past. All that is necessary for us to improve industrial design, to turn it into art, says Read, in *Art and Industry,* is to recognize the possibility. He calls the engineers who built the Crystal Palace and designed the form of the airplane "artists." As for the sacred value assigned uniqueness, "an esthetically unworthy impulse typical of a bygone individualistic phase of creation," he insists that it be dismissed. On this ground, Read and Benjamin stand together: both "read" the larger issues implicit in the merg-

IBM System/Model 145. More than 1,400 circuit elements are contained on a single "chip" of silicon. Two chips are shown here, mounted on a memory module. Courtesy International Business Machines Corp., New York.

Forrest Myers. *Moon Museum,* 1969. Miniaturized and iridium-plated drawings on ceramic wafer. Plate measures ¾" x ½" x 1/40". The drawings are by Myers, Rauschenberg, Oldenburg, Warhol, David Novros, and John Chamberlain. The plate was made at Bell Laboratories in Murray Hill, N.J., for eventual deposit on the surface of the moon.

ing of art and technology. Beuys's statement is the next ground higher, built upon the one below.

It is still not high enough. My own belief is that the information generated within the art system has to do with matters above both sociology and politics. It is, in fact, metaphysical. This calls up two more images. One of them is Paik's *Video Synthesizer*; specifically, the four-hour telecast that launched it, at WGBH-TV in Boston in August, 1970. When these diffuse abstract images began floating across the home screen, the announcer (prompted by Paik, of course) cautioned the viewers at home to regard what they saw as "electronic wallpaper," with no beginning, no end, no progression. By this means, the wallpaper image, Paik was able to relate the *Synthesizer* to an objective, functional element in the life of the society tuned in. In Paik's first proposal for the *Synthesizer,* soliciting from both WGBH and the Rocke-

feller Foundation funds with which to build his "Ultimate Machine," he claimed that the uses of his machine were endless, ranging from a "tranquilizing function" in the home, akin to *Time* magazine, to "background scenery" for music programs or TV "talk" shows. Paik finally acquired the funds, using these rhetorical props as a medium to explain his purpose, but, in, fact, the *Synthesizer* is an end in itself: the images it makes are as abstract in purpose as the machine. They are inherently unpredictable, resulting from the spontaneous coincidence of the mind, imagination, and hand operating the dials plus the performance of the electronic circuitry wired into the console, to say nothing of the state of the seven "feeding" cameras. There is no consistent, functional rationale for the *Synthesizer* other than its ability to produce images that we can neither predict beforehand or fully understand afterward.

Now an outside image: man walking on

Joseph Beuys and his students at the Düsseldorf, Germany, Academy of Art, 1971. At this meeting he founded a new political entity, the Organisation fur Direkte Demokratie.

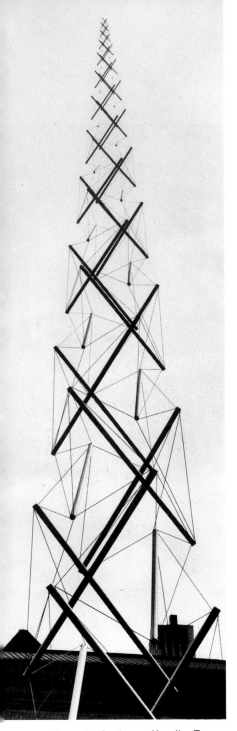

the moon for the first time, with the great globe known as Earth over his horizon. Here, too, much has been claimed, on the level of function. Initially, of course, the United States undertook to land on the moon in response to a Soviet challenge that was mostly political in nature. With the passing of time, however, and the waning of political competition in space, at least for the present, the existential nature of the enterprise is exposed. To clothe it, the space authorities constantly resort to strategies resembling Paik's. They point to fallout "uses" resulting from the space program: here the conversion of this sensing device into medical technology, there the savings in crop failure resulting from weather readings conducted by space satellites. It is not that these arguments are wrong; it is simply that they clearly avoid naming the central issue—why the voyages were taken in the first place, and why they continue, despite strong political pressure to the contrary. Like Paik, the space authorities do not dare even a humanistic argument: not even the thesis that the space voyage expands and exhilarates the human imagination is worth a single chip on the public counting board.

If we could but drop our cause-effect training, and beyond that, the Judeo-Christian progressive ethic, even for a moment, we would see the similarity between both the *Video Synthesizer* and the space program. Neither is useful, in the functional sense. Both are ends in themselves. We already are beginning to discover some empirical changes in the body politic to prove this: the public seems to have learned from the moon program that nothing is impossible, nothing beyond technology, once the decision is made to reach a goal, no matter how existential. We see evidence of this in the oft-repeated demand that the same commitment of funds and imagination be put into housing for the poor, or reclamation of the ghetto. Neither art nor science—if I "read" them rightly—lend themselves easily to reclamation, however. Their inner logic demands pursuit of the future, since both are essentially engaged in the discovery and promulgation of truths ignored by other parts of society.

I am not the first to claim this identity between art and science. Ernst Fischer's contention that art began in magic, that it functions basically as power, as a means of controlling nature, implies that identity. Art came first, perhaps, but science is closing fast, as a tool for dealing existentially with the environment. Even Kenneth Clark, in the conclusion to *Civilisation,* surely the apotheosis of the popular romantic, post-Renaissance

Kenneth Snelson. *Needle Tower,* 1968. Anodized aluminum and stainless steel. 60' h., 18' w. at base. Courtesy John Weber Gallery, New York.

George Rickey. *Six Lines at AT,* 1965–66. Stainless steel. 78½" x 128". Collection Storm King Art Center.

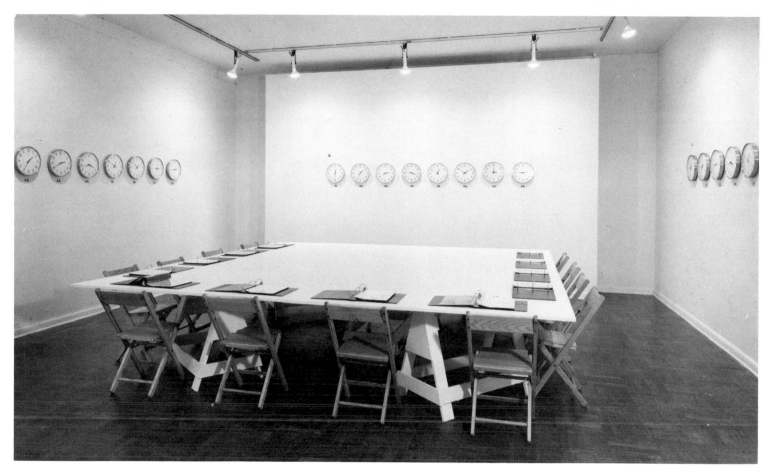

Joseph Kosuth. *The Eighth Investigation (A.A.I.A.I.), Proposition One*, 1971. Collection Dr. Giuseppe Panza, Milan, Italy. Courtesy Leo Castelli Gallery, New York, and The Solomon R. Guggenheim Museum, New York.

Light fixture. Design by Peter Hamburger, 1970. Courtesy *Industrial Design* magazine.

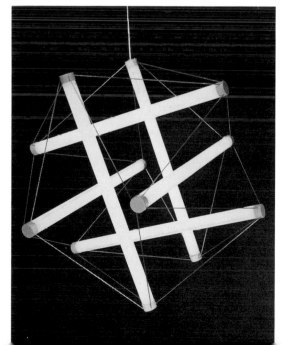

conception of art, concedes this. With Einstein and the advent of theoretical physics, he says, when men reached the point where they could affect the material universe by thinking, by scratching out numbers and equations on a blackboard, the scientist assumed a "magical" relationship with the world, very much like the artist's. We have already seen considerable evidence of the fact that the artist performs functions close to "science," as the public understands it (namely, Norman Zammitt, Larry Bell, John Whitney, and others); this metaphor becomes a literal fact in conceptually oriented art, wherein the mere statement of an idea, or the display of source materials (as in Joseph Kosuth's *The Eighth Investigation*), stands for the work. Kosuth puts it bluntly: "Art deals analogously with the state of things 'beyond physics' where philosophy had to make assertions."[6]

Robert Cumming. *Sentence Structures,* 1970. Painted wood, 115 alphabet forms, each 12". The location for this piece was the corner of University and Prior Avenues in St. Paul, Minn. Courtesy Walker Art Center, Minneapolis. Photo by Eric Sutherland.

Equally to the point is a remarkable speech made in 1966 by Dr. Robert Jastrow, director of the Goddard Institute of Space Studies, to the alumni of Columbia University. Entitled "Science, Politics, and Art," it attempted to persuade the layman that the differences between the artist and the scientist are less clear-cut than he thinks. Both artist and scientist operate on the basis of hunch, intuition, and imagination, Jastrow insisted. For a host of reasons, some of them political in nature, science tries to hide this fact: "When [the scientist] has reached a significant result, he covers up his tracks in the sand, replacing intuitive reasoning by a logical, objective discussion designed to convince his colleagues." This also convinces the layman, Jastrow pointed out, a necessity at a time when vast public funds must be appropriated—and justified—to support scientific investigation. Science is hardly the absolute standard of truth it claims to be, however, for it changes necessarily, from century to century. The "truth" of any scientific proposition is finally as subjective and tentative as the "quality" of any work of art.

In his speech, Dr. Jastrow did not touch upon the basic dispute in theoretical physics concerning the proper "reading" of Heisenberg's famous uncertainty (or indeterminacy) principle, a major component of the new quantum physics formulated during the 1920's. Briefly, Heisenberg held that we cannot codify or predict the behavior of subatomic particles in nature; it is only through "averages" that we can determine the molecular behavior of gases let loose in a room, for example. For some physicists, such as Heisenberg, this means there is an element of mystery in nature, which we cannot fathom with either our instruments or our knowledge —since the very act of observation affects the events observed. For others, including Erwin Schrödinger, the "indeterminacy" in physics is tentative, waiting only a fuller understanding of its laws, which are rigidly deterministic and cause-effect in nature.

We are not talking here about surface issues, but about the center of modern physics; at that very core, around which discoveries have been made that led to the development not only of the hydrogen bomb but of the computer and the laser, there is fundamental disagreement. Because science is the new religion, that news is shaking, perhaps (as shaking as theological disputes must have been in the Middle Ages), but it ought not be. I do not claim—and neither does anyone else I have cited—that science as we currently understand it is identical with art. The scientist currently sees himself as an investigator whose insights must be proven in the external world: he thus exhibits not merely his conclusion but his process (however bowdlerized, to cover the "tracks" mentioned by Jastrow). For the artist, the "proof" lies only in the conclusion. His concern is with ends, not means, and he feels no necessity at all to

prove his discovery in lay terms. What unites both, it seems to me, is the drive to find truths —information, if you will—outside the prevailing consensus.

To date, technology has been a tool for both art and science. The alien, clanking phenomenon that appears so often in Mumford's *The Myth of the Machine* is completely true to the machine age of human experience, which ended with the construction of the first computer in 1944. Now, in the electronic age, technology is taking on an independence of mind and spirit. The first known machines, dating back to the birth of Christ, extended the hand-held tool, performing simple operations over and over (pumps, waterclocks, and so on); in the eighteenth century, with the onset of the dread Industrial Revolution, looms and piston steam engines were further extensions in degree of simple, repetitious tasks. The typewriter permits more options, and the electric "robot" typewriter introduces —metaphorically—automatic controls. The computer adds to automatic control a learning capacity of its own. It is no accident that computer circuitry resembles the structure of the human brain. These new "machines" must make complex decisions, remember them, and use previous experience in later decisions.

It ought to be added, furthermore, that electronic technology is dematerialized, too, along with the new art and the new physics. Its "power" can be generated out of chips so small the eye can barely see them. The laser moves through immaterial space, like natural light itself.[7] As the power of artificial thinking increases, and as artificial aids to the human brain come into being, the "tool" we know as technology will become itself a probe, along with art and science. All three lock into place as the most distant extension of man. This is why Schwitters's decision to make technology a character in his little play, discussed at the end of Chapter 1, is so important. He stated, metaphorically, the case made both by Fischer, in his contention that man and tool are one, and by Donald Schon. Art and technology are two parts of the triad that makes one structure, and science is the third.

This is very different from predicting the death of art, in the manner of Jack Burnham. Vasarely once said, "I have banished the word 'art' from my vocabulary." What he meant—what I mean—is not the end of the

Walter de Maria. *Mile Long Drawing,* 1968. Mojave desert, Calif., 2 parallel chalk lines 12′ apart. Courtesy John Weber Gallery, New York.

Gene Davis. *Franklin's Footpath* (in process), 1971–72. When finished, this acrylic-on-concrete painting stretched down 76 feet of road. Courtesy The Philadelphia Museum of Art. Photo by Patric Radebaugh.

impulse to make art, to discover truths beyond empirical logic. What Vasarely banishes, what I banish, are signs that deny the function of art. "The word 'art' is evocative," Vasarely went on to say, "old-fashioned, uncontrollable. The function of the artist in our society is 'to give to see.' . . . The great adventure today is science." This is merely a restatement of Beuys's program. Here and there, certain "artists" sense that their *raison d'être* is spreading out, spilling over the divides established by classical terminology. Art can determine the nature and purpose of man in company with "non-art," with technology, with science, and beyond.

If this is so, if art is probing now to the very purpose of man and the universe, what messages are returning? I said before that I intended to "read" the fusion of art with technology on ground higher than Walter Benjamin's, higher than Marxism took him. If so, what do we see from there? Once again, for the moment, I return to the images I placed in the reader's mind at the beginning. Haacke's plexiglass-encased fluid, at one with the environment around it. Piene's *Cityscape*, forms floating within the city. Negroponte's self-automated architect. Tudor's *Bandoneon!*, of course, a sign for the entire book. And the "Invisible Project," Irwin, Turrell, and Wortz,

Joseph Kosuth. *The Seventh Investigation, Proposition One*, 1970. Courtesy Ruder & Finn Fine Arts, New York.

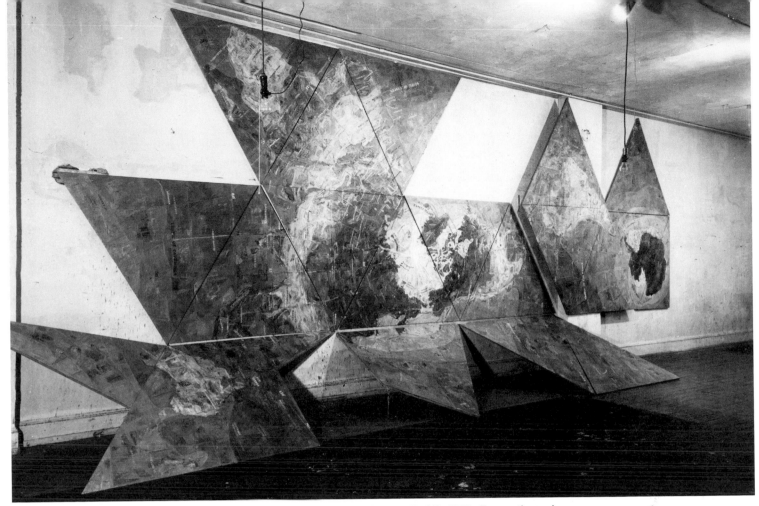

Jasper Johns. *Map (Based on Buckminster Fuller's Dymaxion Air-Ocean World),* 1967. Encaustic and collage on canvas. 186″ x 396″. Courtesy Leo Castelli Gallery, New York.

Computer-enhanced photograph of the planet Mars, transmitted in 1972 from television camera at a distance of 1,376 miles. It catches the planet in a mini-eclipse. The shadow on the left is that of Phobos, Mars' tiny inner moon. Courtesy National Aeronautics and Space Administration.

Computer-enhanced photograph of Phobos, transmitted in 1972 from a moving television camera in Mariner 9. The distance of the camera is approximately 3,440 miles. Courtesy National Aeronautics and Space Administration.

talking comfortably in a classroom, chalking formulas on the blackboard behind them, talking about a work of art that never materialized except in the words used to describe it.

Each of these images points directly to the purpose I mentioned before, and to the evolution of art itself. One "proof" is how closely they fit the rush of futurist ideology all around us. Extravagant claims are insistently made by men such as Herman Kahn, Marshall McLuhan, Alvin Toffler, Arthur C. Clarke, Buckminster Fuller, Victor Ferkiss, and John McHale, often in rhetoric so alarming that it feeds the very fear (of the unknown) that it hopes to disperse. In no specific case do I wish to deny any of their claims (as Robert Mallary observes, we have learned not to discount even science fiction), and Clarke, I might add, predicts that the option of immortality will be available by the year 2010. It is simply that I wish to go beyond this or that technological milestone immediately ahead to the most distant and metaphysical goal. By far the most striking writer on this last-named subject is the scientist J. D. Bernal, whose little book, *The World, the Flesh, and the Devil,* published in 1929, is the most complete analysis I have yet encountered on the destiny of man read in the context of developing technology.

There is an image in the conclusion of Bernal's book to which I now turn. It is his contention—admirably supported by the accuracy of his other predictions, most of which have been uncannily borne out since 1929 (particularly in the area of space travel)—that the logic of evolution is leading man progressively away from matter toward mind. In concert with art and with technology, man himself is dematerializing. "Normal man," writes Bernal, "is an evolutionary dead end; mechanical man, apparently a break in organic evolution, is actually more in the true tradition of a further evolution." In 1929, Bernal predicted the onset of Cyborgs—men functioning with vital artificial organs, by now a reality. He saw the gradual acceleration of the process, through artificial brains to the preservation of the brain after the breakdown of the body, in an artificial environment. He saw connections being established between these disembodied brains and the emergence of "compound" thinking. These complex minds could—granted longer life and division of tasks—"extend their perceptions and understandings and their actions far beyond those of the individual." Please note that, in this stage, the basic components, what we now think of as "human" and "artificial," are inextricably mixed together. At the last, Bernal sees an escape even from the solidity implied in the compound-mind image:

Otto Piene. *New York City on a Hill with Mirage of New York City on a Hill,* 1969. Lithograph. 35″ x 25″.

NEW YORK CITY ON A HILL WITH MIRAGE OF NEW YORK CITY ON A HILL

Finally, consciousness itself may end or vanish in a humanity that has become completely etherialized, losing the close-knit organism, becoming masses of atoms in space communicating by radiation, and ultimately perhaps resolving

itself entirely into light. That may be an end or a beginning, but from here it is out of sight.[8]

This is a fantastic vision, and an acutely uncomfortable one. I endorse neither its reliability nor its attractiveness. Bernal's image is as repugnant as the image of the Manhattan subway would have been to a caveman. I introduce it only to expand our scale of reference, to indicate alternative ways of reading images closer to home, images like the *Architecture Machine* and *Bandoneon!* A century of scientific and political indoctrination inhibits us from metaphysical speculation; we read the political implications in the woodcut and the film, with Benjamin, with ease—once our formalist blinders are removed. We need to read over Bernal's shoulder, too, easily.

Finally, the concept of the "world mind" is conceptually alive now, in Buckminster Fuller's *World Game,* employing the talents of students throughout the world to compile an efficient record of the globe's resources, "enabling all of humanity to enjoy the whole planet Earth without any individual profiting at the expense of another and without interference with one another." It is not so much the idealism that interests me here as the metaphors, the "whole planet Earth," a metaphor made real and convincing by the photographs taken from the moon and from orbiting satellites. Men have argued in the past against destructive individualism, but never from the framework provided by distant film, videotape, and photography, all of which position man himself in space, looking at his own place there.

Bernal's vision of the dematerialized person needs to be imagined in the context of Michael Noll's theories as well, the human mind creating and feeling in symbiosis with the computer. Irwin, Turrell, and Wortz "created" a project we begin to understand as art through conversation; already conversation, of a kind, between man and machine, can effect real changes in the world—in architecture, planning, and design—much as the theorems of physics expand the power of man to travel as fast as light, and destruct on a scale unimaginable. Engineer-sculptor Robert Mallary, in discussing six possible stages of man-computer sculpture, concludes with two levels that involve the machine alone. In the last, the computer creates without any relationship to "human" energy at all. The fifth state interests me even more.

Stanley Landsman. *Infinity Chamber,* 1968. 6,000 lights and mirrors. Courtesy Nelson Gallery of Art, Kansas City, Mo. Photo by Warner Studio.

Douglas Davis. *Images from the Present Tense I,* 1971. Working television set. Photo by Robert R. McElroy.

001000001000000001100
111000000000100000001
000111000000000010000
100000000000011100000
011000001110000001000
000110000110000110000
100000001110001100010
000011100011000010001

Hypothetical interstellar message. Courtesy Holden-Day, Inc., San Francisco. From Carl Sagan and I. S. Shklovskii, *Intelligent Life in the Universe* (San Francisco, 1961).

Here, he suggests, "the computer, while not alive in any organic sense, might just as well be, if it were to be judged solely on the basis of its capabilities and performances—which are so superlative that the sculptor, like a child, can only get in the way.[9]

I am moving quickly now, trying to link together metaphors and events that skim the surface of logic, not with a view toward proving this or that contention, only in the pursuit of higher ground. There are two images to keep in mind. First, Tinguely's self-destroying machine. "Be movement!" he said in London in 1959. "Movement is static because it is the only immutable thing—the only certainty, the only unchangeable." The second image is the oscillating universe. The information being brought to us by "science" at this hour indicates that we are on the verge of discovering form in the universe. As we have become increasingly aware of the size of the universe, our minds and imaginations have been seized by the notion of infinity, which by its very nature implies formlessness. Now it seems clear that the stars and galaxies, though expanding away from one another, are slowing down; now we see and hear through our instruments of detection out to a point at least near the end of the *observable* universe, because the most distant quasars are traveling almost as fast as light itself: beyond that speed, nothing can be seen. Already, we calculate distances based upon the assumption of a curvature in space. A curved universe that oscillates between expansion and contraction is a universe with a kinetic shape. At this time, the best calculation is that within ten years we will have amassed enough data on the differing rates of speed among the galaxies to definitely establish or disprove the inevitability of contraction.

It is certainly a universe teeming with life. In their book, *Intelligent Life in the Universe,* published in 1966, the astronomers Carl Sagan, an American, and I. S. Shklovskii, a Russian, indicated not only that communication with a civilization beyond earth was imminent but that it could easily be transacted through the medium of mathematics. Since then, both American and Soviet astronomers have met to plan large-scale, on-going attempts to make radio contact beyond our solar system. There is little doubt that advanced civilizations anywhere in the universe will share the understanding of objective physical laws, expressed through equations.

Our involvement not only with mutable form but with the language of the universe itself is deep. Even Wylie Sypher, in *Literature and Technology: The Alien Vision,* acknowledges that the major shift in the arts during the past century has been away from "imitation of form," or *mimesis,* toward participation, or *methexis,* a shift that begins—for Sypher—in the English romantic poets.[10] The shift has been considerably augmented by technology, of course.

This returns us to Bernal's image of the world mind, evanescent, a cloud in the void. As we look and listen through our telescopes to the end-beginning of creation, we move as a metaphor toward that image. We extend our eyes away from the self. Recall Paik's statement. In working with television, there is always the non-self, "the Other," in the work: "It is not me." At the beginning of his series of books aimed at re-evaluating and re-interpreting technology, Mumford claimed that the central human trait, the central definition of the animal, is in effect his attachment to self, "this capacity for conscious, purposeful self-identification, self-transformation, and ultimately for self-understanding." Further: "Every manifestation of human culture is directed ultimately to . . . the expression of the human personality."[11] Mumford sees quite correctly that this trait has been eroded by technology; he differs only with a writer like Benjamin in deciding that tool and man are separate, not a single spirit. By the terms of the trinity I defined before, Paik's Other is himself.

Little minds demand coda for the future. John Whitney warns that we know nothing about the media ahead for art, since their capacity is unknowable. In this uncertainty, I find a paradoxical comfort. It relieves us from the banality of specific prediction. It forces us to concentrate on the larger sense of things, on the reliable ground of sensory intuition. If I have selected my images correctly, we know where the path leads. *Be Movement!* says Tinguely; the present kinetic sense of the universe confirms him. The next forms in art will not give way to life; rather, the reverse is true: life becomes art. Richard Hamilton's *Kent State* is hardly a formal or decorative triumph, but its provenance is impeccable. Somewhere, in life, a body falls to the ground, shot dead by a trooper's bullet. A cameraman is there, jostled, frantic, working too quickly for accurate focus. The event

is recorded in emulsion, processed, and bounced by electricity off a satellite in the sky, and thence to a cathode-ray tube in a London home. The CRT sprays a stream of electrons on the screen; the artist, excited, appalled, snaps a picture with a still camera. Once again, the student's fall is recorded, is rendered in emulsion, inside a layer of gelatin shrouded by darkness.

When information moves that easily and quickly, so must art and life: Hamilton erred only in attempting to freeze the evanescent in static form. In that cultural time-frame, he had no choice but to do so. The image silk-screened on paper became "art." It attained a heightened level of reality. When I talk about art becoming life, I mean the time when events reach that reality in our minds, not through the imposition of static materials. Kent State was a tragic fact in the electronic spray; what came after was cultural lag. The means are now at hand to end that lag.

One last time we pause for *Bandoneon!* I was present at its first performance and recall vividly not so much the sounds, not so much the lightning-like images flickering across the display screen, but the reactions of the audience. With each new combination of sound and sight, the excitement mounted. I remember people near me jumping to their feet, shouting with each image. There, at least, the alien vision was absent. There, at least, was a sense of participation in the Other.

Of course, it is difficult now to believe in the Other. Art, technology, and even science seem to me three veils for the same face, three metaphors that cover, then dissolve into a single reality. That central fact is the probing, discovering purpose of man. It is hardly a comforting conclusion. Most of us would prefer, with Mumford, to realize the selfhood based in our animal nature. I doubt that we have any choice, however. We are doomed to the excitement of going on. With each day our position in the environment grows more existential, more like the artist's. With each day the decisions before us admit less physical necessity. We are conditioned now by freedom, not slavery. To retreat from science, technology, and art would be to abandon that freedom, robbing life of the one value beyond itself. It would surrender the implicit goal of humanism, which is an expansion of both our consciousness and our condition. The end of man is apparently the future of art.

David Tudor. *Bandoneon! (A Combine)*, 1966. Photo © 1966 by Peter Moore.

Glossary

This brief list of terms is drawn mostly from the text and captions, where there is little opportunity or need to provide extensive technical definitions. I have also added a few general items, in the hope that this glossary will not only serve as a thumbnail reference source for readers, but stand alone. It can thus function as an introduction to the technical language often encountered by unwary artists, critics, students, and non-engineers venturing into the subject—or into collaboration itself—for the first time.

After-Image: A visual image that appears (on a screen or television tube, for example) after the sensation that caused it has disappeared.

Analogue Computer: A computer using electrical circuits constructed so as to behave analogously to the real system under study. The analogue computer is cheaper, faster, and more flexible than the digital computer, but less accurate. (See also *Computer* and *Digital Computer.*)

Anodization: The application of a surface coating to a metal—aluminum, for example—by electrolytic or chemical action.

Arc Lamp: A bright, sharp source of light created by passing an electrical current through a small gap between two carbon rods.

Atomizer System: A series of jet-spray nozzles that fills the atmosphere with a foglike substance composed of water vapor.

Bit: In information theory, a bit is the basic unit of information, expressed in terms of "yes" or "no" signals transmitted from source to source (from man to computer, for example) in one second of time. A TV picture carries almost 100 million bits per second.

Bolex 16-Millimeter Reflex Camera: A motion picture camera that allows its user to see the image received on a ground-glass screen. In other words, the cameraman sees what the camera sees "through the lens."

Cable Television (CATV): The transmission of video signals from a master antenna to subscribers via coaxial cable, usually for a fee. At first CATV systems were prevalent only in rural areas, where strong video signals could not be received in TV sets by normal means. Now they are economically viable in cities as well, where strong signals are needed for adequate color reception.

Cathode-Ray Tube (CRT): A vacuum tube within which the inner portion of the glass envelope has been coated with a phosphor. Images can then be created on the face of this tube by directing an internally generated beam of electrons at specific places in the phosphorous matrix. This tube is the "screen" on the TV set. CRTs are also display units for air traffic control systems, radar presentations, and computer graphics. (See also *Phosphor.*)

Chip: A small substance on which there are many solid-state circuits.

Chroma-Key: A video circuit that detects a color in the scan line of one TV camera and inserts the color seen by another (synchronized) camera. Chroma-Key is thus an electronic mixing device that permits a visual play between images and colors received on two different cameras.

Circuit: A closed network of electronic components which have a certain task to perform, e.g., "amplifier circuit."

Closed-Circuit Television (CCTV): A non-broadcast system of TV cameras and monitors in which the latter directly display what the camera sees. CCTV systems are extensively used for surveillance in apartment lobbies, garages, large stores, banks, and so on.

Compiler: An internal device that translates "input" programmed instructions into specific electronic-mechanical instructions for execution by the computer.

Computer: An electronic or electromechanical device that accepts "input" information, processes or modifies it according to a logical, predetermined sequence and produces "output" information. (See also *Analogue Computer* and *Digital Computer.*)

Console: A control and monitoring station at which an operator can observe and modify a sequence of events under his control. An example is the console instrument at the center of Nam June Paik's *Video Synthesizer* (see pp. 151—52).

Contact Microphone: A microphone that picks up and transmits vibrations from the surface with which it is in contact.

Converter: A term that applies to several kinds of devices. Among them: power converters, which convert DC power to AC; and code converters, which convert digital codes to binary codes, enabling analogue computers to interface with digital computers.

Cybernetics: Term coined by Norbert Wiener from the Greek word for "steersman." It is the comparative study of automatic control systems, especially of computers. A central component of cybernetics is information theory, (See also *Bit* and *Information Theory.*)

Data: Numeric and alphabetic quantities that are created or processed by digital computers.

Decoder: Generally, a mechanical or electronic device that separates a code into its recognizable component parts.

Diffraction: Interference patterns in a light wave that occur when electromagnetic waves encounter sharp edges or narrow apertures. It is characterized by bright and dark bands.

Digital Circuits: Circuits limited to a specific num-

ber of stable states of being, unlike the analogue circuit. A common light switch is an example of a digital device, having two states, on and off; the more flexible "dimmer" light switch is an analogue device.

Digital Computer: An electronic machine able to ingest and process quantities that are numerical in nature; furthermore, it is able to perform mathematical operations on these quantities. (See also *Analogue Computer* and *Data*.)

Eccentric: Refers to a moving piece of machinery (or mechanical cam) that rotates around an axis that is off-center. If a shaft is placed against the cam, rotary motion can be changed to linear motion.

Electric Microfilm Recorder: A valuable component of the early computer film and graphic systems. Normally consists of a CRT display tube and camera. The Recorder receives instructions from a computer, plots lines on its own display tube with great speed, and records its own product.

Electroencephalogram: A time graph showing the amplitude and duration of electrical impulses detected from various points in the brain.

Electromagnet: A magnet with properties controllable by an electric current.

Electron Micrograph: A photograph of the image seen through an electron microscope.

Electronic Mixing: Generally, the manipulation of various electronic-video devices (like *Chroma-Key*) by the artist-operator–TV producer to create visually imaginative TV pictures, most of them nonrepresentational in nature and artificial (or feedback) in source.

Electronics: Engineering technology using devices that depend upon the emission, behavior, and effect of electrons moving in a vacuum, gas, or semiconductor. Beginning with the invention of the electron tube, nearly all electrical devices not built specifically for the purpose of creating or controlling electrical power are called electronic.

Encoder: A device that changes data or visual material into different forms. (See also *Converter*.)

Facsimile: Copies of text or photographic material transmitted from afar by radio or telephone electrical signals. The copy is then reconstructed from the signals.

False-Color: A technique used extensively in photographic mapping, in which varying infrared or radar signals are artificially assigned to contrasting colors in a photographic process.

Feedback: Literally, this term means the process by which initial information or electronic signals can be corrected with a portion of the result. Generally, it has come to refer to synthetic audio or visual imagery produced within the equipment used, without any dependence upon "external," "live" sound or activity at all.

Fluorescent Tube: An electric lamp coated on its inner surface with a fluorescent phosphor. When bombarded by electrons from within, the tube produces light very close to daylight color. (See also *Phosphor*.)

Fortran: Contraction of the words "formula translation." A computer programming language based on verbal statements and simple mathematical expressions; it is accessible to diligent laymen without detailed knowledge of computer technology.

Gain: Amplification.

Glitch: Slang for an unforeseen technical event causing noticeable—and objectionable—phenomena in the midst of an otherwise satisfactory process.

Hardware: Physical equipment that implements programming or other instruction. In relation to the digital computer, the cabinet and enclosed equipment is the hardware, the programs fed into it, the software.

Head: An electromagnet used to record audio, video, or other electrical signals on tapes coated with magnetic material. (See also *Electromagnet*.)

Hologram: A visually "true" three-dimensional image recorded on a two-dimensional emulsion. The image is formed in the emulsion by interference between laser light reflected from the scene to be recorded and a laser reference light. The hologram can be reconstructed later by passing laser or strong white light through the emulsified plate. (See also *Laser* and a further discussion on pages 82—83.

Hypercube: A form having more than three dimensions in a (mathematical) space of more than three dimensions.

Illiac Computer: An early form of the digital computer. (See also *Digital Computer*.)

Information Theory: A mathematical theory studying the efficiency of the communication of intelligence from source to source. (See also *Bit*.)

Infrared: Electromagnetic waves—often referred to as "heat waves"—that adjoin the red end of the visible light spectrum. They are invisible to the human eye. The Nimbus satellite photographs the earth in the infrared band, for example, to detect and predict weather patterns.

Input/Output (I/O): Devices that either supply or receive computer data instructions. Examples include magnetic tape decks and print-out machines.

Large-Scale Integration (LSI): These are integrated circuit chips holding thousands of circuits.

Laser: Acronym for "light amplification by stimulated emission of radiation," a device that generates a powerful, coherent beam of light. The beam is monochromatic in color and travels vast distances without losing its coherence, or "diverging." (See also *Hologram* and a further discussion on page 81).

Loop Tape: A cartridge containing a closed loop of tape, which can be played back continuously, playing the same information over and over, without rewinding.

Machine: Formerly this term referred to mechanical

devices containing at least two or more interlocking and frequently moving parts that translated its motion into work. Now it has come to mean more complicated assemblages of primarily mechanical devices. Where it is used to refer to assemblages based on electronic energy, the term is misleading. (See also *Electronics.*)

Magnetic Tape: Generally, tape coated with iron oxide, which can then be magnetized by electromagnetic heads. (See also *Mylar* and *Head.*)

Matrix: An array of numbered columns and rows (a chess board is a simple matrix). Generally, it means a complex field of literary, visual, or audio information in which each part nonetheless relates to every other part.

Microwave: A high range of radio frequencies (above c. 1,000 megacycles) where wavelengths are small and special design practices must be used. Microwaves are used to relay voice, data, and television between points on the earth and distant spacecraft.

Moiré Patterns: Wavelike forms created by superimposing linear patterns over one another.

Monitor: In television, a set that displays camera video directly without intermediate modulation or broadcast transmission.

Moog Synthesizer: An electronic clavier console in which sound can be electronically synthesized to create tonal qualities completely different from those normally obtained with clavier instruments.

Multiplex: To alternately insert data from different sources, in a computer program or on a videotape.

Mylar: Trademark name for a pliable, transparent film, with many uses, from packaging to photographic film.

Nanosecond: One billionth of a second. A unit normally used to describe phenomena in rapid transit: the switching speed of electronic devices, for example. In a vacuum, light travels about one foot in one nanosecond.

Oscillator: Any device that varies periodically with time. In a grandfather clock, the pendulum is a mechanical oscillator; in an electric organ, the pitch generators are electronic oscillators.

Oscilloscope: A versatile electronic test instrument, incorporating a CRT and video intensity modulation circuits. The light line on the face of the oscilloscope responds to electrical currents, displaying waveforms and currents, among other patterns. (See also *Cathode-Ray Tube.*)

Phosphor: Chemical compounds that emit "visible" light when stimulated by ultraviolet light or electron impact. (See also *Fluorescent Tube.*)

Photocell: An electronic device that is sensitive to light. When a light beam connecting two photocells is broken by a person nearing a door, for example, the cell can respond with an electrical signal that opens the door.

Photosensitive: Materials that respond to light by surface changes, mostly relating to color.

Plexiglas: An acrylic plastic.

Plotter: An automatic graphic device that can be controlled by computers or magnetic tape units. (See also *Electric Microfilm Recorder.*)

Polyethylene: A light, durable plastic, used industrially in the manufacture of bags, among other things.

Preamplifier: An electronic circuit designed specifically to amplify weak signals while minimizing all competing "noise."

Print-out: Specifically, this term refers to the printed record by digital computers to document the programming transaction and its results. Generally, the term means both visual and written records produced by electronic devices, from computers to television sets. Photographs of a TV image are sometimes called print-outs.

Program: A set of operator instructions—numerical or verbal—that control the sequence of operations in a machine, e.g., computer code. (See also *Fortran.*)

Punched-Tape Programmer: A device which reads a punched paper pattern, controlling the sequence of events related to it—the order of slides in a projector, for example. (See also *Program.*)

Radiograph: A print produced by the following process: the subject of the print is placed on a film, which is exposed by passing rays through the subject onto the film. X-ray photographs are radiographs.

Random Access: The ability to obtain information from a file independent of the information or records surrounding it. Taking a book from a library is "random access." Snipping a bit of audio tape—thus damaging or altering surrounding information—is not.

Real Time: The actual length of time in which a computer program is run.

Sine Tones/Waves/Images: Sinusoidal or oscillating electrical waves produced by a signal generator and monitored either as audio sound, on an amplifier, or as video imagery, on an oscilloscope or TV monitor.

Sinusoid Wave: A sine wave. An oscillating line, the amplitude of which smoothly and periodically changes. The time between adjacent crests or valleys is called the "period."

Software: Specifically, computer programs. Generally, activity that is essentially cerebral in nature, rather than physical. (See also *Hardware.*)

Spherical Mirror: A highly reflective smooth surface, the shape of which is spherical. It can be either concave or convex.

Synergy: A collaboration between or combination of forces that creates a result greater than the sums of the separate, individual contributions. In medicine, for example, a combination of drugs often is more potent than the "paper" total of each added to the other. Also, a group of subsystems functionally integrated to perform a defined system. For example, the television "system" is composed of a picture-producing sub-

system (the program), a transmitting subsystem, an antenna subsystem, and so on.

Telecopier: A long-distance copying system. The document to be transmitted is inserted in the sending unit and a copy appears immediately in the receiver.

Telex: A system of teletypewriters used to transmit messages long-distance.

Timer: An electromechanical device that measures time and closes or opens switch contacts at specific intervals, cutting off or turning on electricity fed to a system of lights, for example.

Transistor: A solid-state electronic device that controls electrical current. It has virtually replaced the vacuum tube in most low-power applications —in portable radios, for example, because of its longer life, higher reliability, and smaller size.

Verifax Copier: Trademark for a photocopying machine.

Videotape: Magnetic tape used to record video signals.

VTR: Abbreviation for videotape recorder.

Notes

Part I

1. "Any tool or method, any concept or idea, which extends human capability," *Technology and Change: The New Heraclitus* (New York, 1967), p. 1.

2. After a meeting that year with Helen Frankenthaler, who had already experimented with "staining." See Gerald Nordland, *The Washington Color Painters* (Washington, D.C., 1965), p. 12.

3. There is, in fact, some question—thanks to the Madrid notebooks—as to whether Leonardo was known first in his own time as artist or engineer. His official burial certificate reads, in French: "Lionard de Vincy, noble millanois, premier peincture, et *ingenieur* et architecte du Roy, mescanichien d'Estat, et ancien directeur du peincture du Roy du Milan" (italics mine). Ladislao Reti, "Leonardo on Bearings and Gears," *Scientific American,* February, 1971, p. 101.

4. Kate T. Steinitz, "A Reconstruction of Leonardo da Vinci's Revolving Stage," *Art Quarterly,* Autumn, 1949.

5. Art Nouveau declined largely because it never found adequate forms for machine mass production, giving way to the simpler, more geometric style now known as Art Deco, which was officially christened at the Paris Exposition of Decorative and Industrial Arts in 1925. The emphasis was put on objects that reflected "contemporary life and feeling." From that time on, plastic, glass, and the new metals became popular materials in furniture and accessory design.

6. The Futurists issued manifestos with continuing gusto, but one of Severini's, written in 1913–14 and unpublished until the 1950's, is the most remarkable of all. "I . . . predict the *end of the picture and the statue,*" he wrote. "These art forms, even employed in the most genuine innovating spirit, limit the creative freedom of the artist. They have within themselves their own destinies: museums and collectors' galleries, in other words, cemeteries." This idea anticipates both kinetic art and the direction of most post–World War II avant-garde art. The entire text of the document is printed in Michel Seuphor's *Dictionary of Abstract Painting* (New York, 1957).

7. The Surrealist André Breton later defined the "readymades" thus: "Manufactured objects promoted to the dignity of art through the choice of the artist."

8. A detailed account of Duchamp's machine-Eros allegory, drawn largely from the artist's own notes and drawings, appears in Marcel Jean's *History of Surrealist Painting,* trans. Simon Watson Taylor (New York, 1967), pp. 94–112. It also quotes Duchamp on *The Bride* as a "hilarious picture."

9. Man Ray's "discovery" had precedents. The Frenchman J. N. Niepce, a collaborator of Daguerre's, conducted similar experiments in 1822. So did El Lissitsky, the German Dadaist Raoul Haussmann, and László Moholy-Nagy, who called his works "photograms."

10. "The Dada Spirit in Painting," in *The Dada Poets and Painters,* ed. Robert Motherwell (New York, 1951), pp. 123–96.

11. Alison Hilton, "When the Renaissance Came to Russia," *Art News* (December, 1971), p. 34.

12. *Proun* is an acronym (in Russia) for "Project for the Development of a New Art." Lissitsky often used it as a descriptive adjective for his work, in all media.

13. *The Realistic Manifesto* is translated and reprinted in *Gabo,* by Herbert Read and Leslie Martin (Cambridge, Mass., 1957), pp. 151–52.

14. In this context, the curious critical reassessment of Constructivism that appeared here and there in the United States during the early 1970's seems, at the least, cruelly mistaken. I have already referred to one example of this in my Introduction. Carter Ratcliff further indicts the Constructivists for "a failed attempt to compromise artistic individuality with a political development that made no allowance for individuality." He also expresses considerable irritation with a movement that preferred public forms of art to painting and sculpture (in "New York Letter," *Art International,* November 20, 1971, pp. 50–53). These are serious misjudgments both of historical fact (the vast difference between the Lenin and Stalin eras) and of interpretation (the philosophical impatience with painting was and is widespread, beyond Constructivism alone). They point to the need for further information about a movement that seems to me the equal of Cubism, both in intellectual content and pictorial invention.

15. See Walter Gropius, *New Architecture and the Bauhaus* (Cambridge, Mass., 1965).

16. *Programs and Manifestos on 20th-Century Architecture,* ed. Ulrich Conrads (Cambridge, Mass., 1971), p. 39.

17. Quoted in Hans Jaffe, "The De Stijl Concept of Space," *The Structurist* 8 (1968), 11.

18. Frank Popper, *Origins and Development of Kinetic Art,* trans. Stephen Bann (New York, 1968), p. 142.

19. A model of the *Piano Opto-Phonic* was reconstructed in 1971 for an exhibition entitled the *Russian Avant-Garde 1908–1922* at the Leonard Hutton Galleries in New York.

20. Reprinted by Experiments in Art and Technology, Inc., in *Techne* 1. no. 1 (April 14, 1969).

21. Alfred Speer, *Inside the Third Reich,* trans. Richard and Clara Winston (New York, 1970), p. 59.

22. These details and many others concerning the construction of the work may be found in Nan R. Piene's essay-catalogue, *László Moholy-Nagy's Light-Space Modulator* (New York: Howard Wise Gallery, 1970), written to accompany an exhibit at the Howard Wise Gallery of one of two replicas constructed by MIT engineer Woodie Flowers. The other replica was shown at the Venice Biennale in the summer of 1970.

23. *David Smith by David Smith,* ed. Cleve Gray (New York, 1968), p. 52.

24. Repetition is a fundamental theme in painting, music, and theater during this period, too. Cf. my "The Dimensions of the Miniarts," *Art in America,* November–December, 1967. It was a major tactic of the artists associated with the *Nouvelle Tendence* in Europe during the late 1950's and 1960's; see George Rickey, *Constructivism: Origins and Evolution* (New York, 1967), pp. 167–78.

25. *EAT News* 1, no. 2 (June, 1967), 2.

26. *Constructivism: Origins and Evolution* (New York, 1967).

27. "The New Sculpture and Technology," *American Sculpture of the Sixties* (Los Angeles: Los Angeles County Museum, 1967).

28. In an early proposal for this work, dated 1967, Benton envisioned that changes in light, barometer, and temperature would cause the wall to divide into "various and separate sculptural forms."

29. They were increasingly incorporated as subject matter, too. Walter Murch had begun to paint time pieces and other industrial parts in the 1940's. His example was further extended by a variety of artists in the 1950's and 1960's. Jim Dine's 1960 Happening was devoted to its title, *Car Crash.* James Rosenquist dealt with the same theme in *I Love You in My Ford.* Lowell Nesbitt launched a series of "computer" paintings in 1965, and Kienholz constructed in 1965 *The Friendly Gray Computer,* which rocks, lights up, and furnishes non-sequitur answers on printed cards.

30. Another logical extension of Vasarely's ideas was the *Musée Didactique Vasarely,* which he opened at the little French town of Gordes in 1970. The nucleus of the collection was Vasarely's own work, of course, but the museum's major purpose, the artist said, was to establish interdisciplinary colloquies among artists, architects, engineers, and scientists.

31. One of the most important American "literal-ists," Ellsworth Kelly, lived and worked in Paris between 1948 and 1954, where he met both Arp and Vantongerloo.

32. Like the Futurist Severini, Vasarely anticipated a point beyond painting, sculpture, and the unique, precious gallery-museum object, too: "The art of tomorrow will be a common treasure, or it will not be." *Le Mouvement* (Paris: Galerie Denise René, 1955).

33. *Art and Industry: The Principles of Industrial Design* (Bloomington, Ind., 1957), p. 38. László Moholy-Nagy took a similar position late in life. He wrote: "I could not find any argument against the wide distribution of works of art, even if turned out by mass production. The collector's naïve desire for the unique can hardly be justified. It hampers the cultural potential of mass production." Quoted in Nan Rosenthal, "The Six-Day Bicycle Wheel Race," *Art in America* (October–November 1965), p. 104.

34. A great many other artists were involved with ZERO either through close, personal contact (such as Fontana and Klein) or through participation in various projects and exhibitions (among them, Hans Haacke, Gerhard von Gravenitz, Munari, David Boriani, and Gianni Colombo).

35. *Pioneers of Modern Design* (New York, 1949), p. 12. It ought to be added that the British changed gears to some extent in architecture during the 1950's, pioneering in imaginative urban housing projects for lower and middle-income groups.

36. Even Wyndham Lewis, by his own admission, traded Vorticism for bucolic relief: "I fled . . . to the repose that lay in unalloyed naturalism." *British Art 1890–1920* (Columbus, Ohio: Columbus Gallery of Fine Arts, 1971), p. 12; text by Denys Sutton.

37. *Art in America* (April, 1965).

38. (Chicago, 1969).

39. Two of the most important surveys of new British art—*The New Generation* at the Whitechapel Gallery in London in 1964 and *London: The New Scene,* which traveled to the United States the following year, beginning at the Walker Art Center in Minneapolis—contained no artists seriously involved with new media. This would have been inconceivable on the Continent, or even in the United States.

40. (London, 1970).

41. Douglas Davis, "Art & Technology: The New Combine," *Art in America* (January–February, 1968), p. 41. More of Klüver's remarks appear on pages 136—40 of this book.

42. Engineers Jim McGee and Larry Heilos made the discovery.

43. By 1971, however, EAT had discarded chapters for a smaller number of regional offices, a few directly subsidized by the parent organization. The chapters abroad had become national in nature, particularly those in Japan and India.

44. One of the exhibition's advisers, Dr. Richard Feyman, a professor at the California Institute of Technology, stated that artists and companies had been forced together in an "unnatural" way, thus aborting the possibility of interaction. In defense of the museum, it must be noted that its original estimate—that twenty of the eighty "invited" artists would find a willing collaborator—proved correct.

45. Manzoni also drew lines on endless rolls of newsprint, reaching hundreds of miles in length.

An early proponent of pure scale, he contributed to *ZERO 3.*

46. Needless to say, technology grew more and more adept at making the other, the tiny end of nature, available, too. The Museum of Modern Art's *Once Invisible,* an exhibition organized in 1967, proved how abundant is the visual knowledge provided by the photomicrograph, which can expose a world of abstract imagery in a drop of water.

47. RCA announced a variation of this device in 1970, which it believed to be the first movielike TV projector. It employed an electron beam, a 500-watt light bulb, and a special mirror to project TV programs directly on a three-by-four-foot movie screen for general viewing. The projector was marketed first among industrial firms and educational institutions.

48. "Frank Gillette and Ira Schneider," a two-part interview by Jud Yalkut, *Radical Software: The Alternative Television Movement* (Summer, 1970), p. 10. Schneider's theory was hardly new, of course. McLuhan and many others had concluded that the electronic media were slowly building an environment that recorded and communicated man's activities as he performed them.

The Argentine intermedia artist Marta Minujin staged a Happening based on this principle in Buenos Aires in 1966. Sixty well-known celebrities were invited to a theater, filmed, and asked to return one week later, where they were barraged with playback information about themselves on sixty television sets and sixty radios. Miss Minujin called the event *Simultaneity in Simultaneity.* By 1970, the technological proof of this theme was abundant. The Picturephone was operating in Pittsburgh, for example, and both long-distance xerography and telephone-telex service made it possible to transmit records and drawings instantly across space. Rudimentary "video braille" systems guaranteed that the blind would have access to the visual information environment.

49. A more extensive discussion of the inherent intimacy of television can be found in my essay, "Video Obscura," *Artforum* (April, 1972), pp. 65–71.

50. The laser beam had implications for the developing TV structure, too, since it could transmit bits of electronic information more cheaply and compactly than either radio waves or cable: thousands of TV signals, for example, permitting manifold expansion of the available broadcast channels, as well as telephone calls. Bell Laboratories announced in 1970 the perfection of a low-cost, pocket-sized laser that could be operated continuously at room temperature with flashlight batteries.

51. One of Pulsa's organizers explained the motive behind teamwork and anonymity in art in terms reminiscent of USCO and GRAV: "Modern society is too complex for one man to understand. A community of artists working together is the only possible way to meet such complexity." David L. Shirey, "Pulsa: Speed, Light, and Seven Young Artists," *New York Times* December 24, 1970.

52. In a lecture at the California Institute of Technology in 1970, John Whitney provided further proof of the creative role played by the environment in stimulating the art-technology interface. He began by "prowling around" Los Angeles war-surplus junkyards, he said, gradually learning how analogue computing devices could be converted into electro-optical graphic-design machines. It was only later, according to Whitney, that he realized the significance of the tool. "I could reason . . . that just as the computer holds much promise in many scientific fields, it must also represent the ultimate weapon—or less dramatically —the ultimate instrumentation for new dynamic graphic arts as well as music." "John Whitney at Cal Tech," *E.A.T./L.A. Survey,* Summer, 1970, p. 8.

53. *The Architecture Machine: Toward a More Human Environment* (Cambridge, Mass., 1970), p. 5.

54. "Computer Displays," *Scientific American* (June, 1970), p. 57.

55. *I.E.E.E. Spectrum* (October, 1967), p. 94.

56. *Artforum* (May, 1969), pp. 29–35.

57. Robert Reinhold, "Chimp's Brain Signals Itself by Computer," *New York Times* (September 15, 1970).

58. Jud Yalkut, "Electronic Zen: The Underground TV Generation," *West Side News* (August 10, 1967).

59. Thomas Hess, "Gerbils ex Machina," *Art News* (December, 1970), p. 23.

60. Quoted in William Canfield, *Francis Picabia* (New York, 1970), p. 12.

61. *Manifestoes of Surrealism* (Ann Arbor, Mich., 1970), p. 26.

62. "Art ex Machina," *I.E.E.E. Student Journal* (September, 1970), p. 11.

63. Kate T. Steinitz and Kurt Schwitters, *Kurt Schwitters: A Portrait from Life* (Berkeley, Calif., 1968).

Part II

1. *Techne* 1, no. 2 (1970), 1.
2. *Ibid.*

Part III

1. *The Necessity of Art: A Marxist Approach,* trans. Anna Bostock (Baltimore, Md., 1963), pp. 1–2.

2. Needless to say, my discussion here draws its examples entirely from Western art. Were I to go further afield, into the uses and definition of art in Eastern, African, and other societies, my point (that "art" is an activity infinitely broader than the formalist, decorative definition allows) would find even stronger support.

3. Fischer, by contrast, glorifies "labor" and declares early *(Necessity of Art, op. cit.,* p. 15) that man and tool are one.

4. *Illuminations,* ed. Hannah Arendt, trans. Harry Zohn (New York, 1969), p. 221.

5. Willoughby Sharp, "An Interview with Joseph Beuys," *Artforum* (December, 1969), pp. 45–46.

6. "Art After Philosophy," in *Conceptual Art and Conceptual Aspects* (New York City Cultural Center, 1970), p. 7.

7. I am indebted for the outline of this progression to William Zuk and Roger H. Clark, in *Kinetic Architecture* (New York, 1970), pp. 21–27.

8. *The World, the Flesh, and the Devil* (New York, 1929), p. 57.

9. "Computer Sculpture," *Artforum* (May, 1969), p. 35.

10. *Literature and Technology: The Alien Vision* (New York, 1968), p. 184.

11. *The Myth of the Machine: Technics and Human Development* (New York, 1967), p. 10.

Bibliography

Books, Pamphlets, and Manifestos

ASHTON, DORE. *Modern American Sculpture.* New York: Abrams, 1969.

BANN, STEPHEN, REG GADNEY, FRANK POPPER, and PHILIP STEDMAN. *Four Essays on Kinetic Art.* London: Motion Books, 1966.

BATTCOCK, GREGORY, ed. *Minimal Art: A Critical Anthology.* New York: Dutton, 1968.

—————, ed. *The New Art: A Critical Anthology.* New York: Dutton, 1966.

BAYER, HERBERT, WALTER GROPIUS, and ISE GROPIUS. *Bauhaus 1919–1928.* Newton, Mass.: Charles T. Branford, 1959.

BENJAMIN, WALTER. *Illuminations.* Ed. Hannah Arendt. Trans. Harry Zohn. New York: Harcourt, 1968.

BENTHALL, JONATHAN. *Science and Technology in Art.* New York: Praeger, 1972.

BERNAL, J. D. *The World, The Flesh, and The Devil.* New York: Dutton, 1929.

BOVA, BEN. *In Quest of Quasars.* London: Crowell-Collier Press, 1969.

BRECHT, GEORGE. *Chance-Imagery.* New York: Something Else Press, 1966.

BRETON, ANDRÉ. *Manifestoes of Surrealism.* Trans. Richard Seaver and Helen Lane. Ann Arbor: University of Michigan Press, 1969.

BRETT, GUY. *Kinetic Art: The Language of Movement.* New York: Van Nostrand-Reinhold, 1968.

BURNHAM, JACK. *Beyond Modern Sculpture: The Effects of Science and Technology on the Sculpture of this Century.* New York: Braziller, 1968.

—————. *The Structure of Art.* New York: Braziller, 1970.

CAGE, JOHN. *Diary: How to Improve the World (You Will Only Make Matters Worse), Continued, Part III.* New York: Something Else Press, 1969.

—————. *Notations.* New York: Something Else Press, 1969.

—————. *Silence.* Middletown, Conn.: Wesleyan University Press, 1961.

—————. *A Year from Monday.* Middletown, Conn.: Wesleyan University Press, 1967.

CELANT, GERMANO. *Piero Manzoni.* New York: Sonnabend Press, 1972.

CHANIN, ABRAHAM, and RUTH OLSON. *Naum Gabo—Antoine Pevsner.* New York: Museum of Modern Art, 1948.

CHIPP, HERSCHEL B., ed. *Theories of Modern Art.* Berkeley: University of California Press, 1969.

CLARKE, ARTHUR. *Profiles of the Future.* New York: Harper & Row, 1963.

COE, RALPH. *The Magic Theater.* Kansas City, Mo.: Circle Press, 1970.

COHEN, JOHN. *Human Robots in Myth and Science.* New York: A. S. Barnes, 1967.

CONRADS, ULRICH, ed. *Programs and Manifestoes on 20th Century Architecture.* Cambridge, Mass.: M.I.T. Press, 1964.

COPLANS, JOHN. *Andy Warhol.* Greenwich, Conn.: New York Graphic Society, 1970. (Includes essays by Jonas Mekas and Calvin Tompkins.)

—————. *Serial Imagery.* Greenwich, Conn.: New York Graphic Society, 1968.

DIJKSTERHUIS, E. J. *The Mechanization of the World Picture.* London: Oxford University Press, 1961.

Electronic Art. Düsseldorf: Verlag Kalender, 1969.

ELGAR, FRANK. *Mondrian.* New York: Praeger, 1968.

ELLUL, JACQUES. *The Technological Society.* Trans. John Wilkinson. New York: Knopf, 1964.

FERKISS, VICTOR C. *Technological Man: The Myth and the Reality.* New York: Braziller, 1969.

Fontana. New York: Abrams, 1962. (Introduction by Michael Tapie; includes *The White Manifesto.*)

FORGE, ANDREW. *Robert Rauschenberg.* New York: Abrams, 1969.

FRANCASTEL, PIERRE. *Art et Technique aux XIX* et XX*.* Paris: Denoël (Bibliothèque Mediations), 1956.

—————. *La Réalité figurative.* Paris: Gonthier, 1965.

FRANCKE, H. W. *Computer Graphics / Computer Art.* Trans. Gustav Metzger. London: Phaidon, 1971.

FRY, EDWARD F. *Cubism.* New York: McGraw-Hill, 1966.

FULLER, R. BUCKMINSTER. *Nine Chains to the Moon.* Philadelphia and New York: Lippincott, 1938.

—————. *Operating Manual for Spaceship Earth.* Carbondale: Southern Illinois University Press, 1969.

GEIST, SIDNEY. *Brancusi: A Study of the Sculpture.* New York: Grossman, 1968.

GIEDION, SIGFRIED. *Space, Time and Architecture: The Growth of a New Tradition.* 3d ed. Cambridge, Mass.: Harvard University Press, 1954.

GOMBRICH, E. H. *Art and Illusion.* 2d ed. Princeton, N.J.: Princeton University Press, 1961.

GRAY, CAMILLA. *The Great Experiment: Russian Art 1863–1922.* New York: Abrams, 1962.

GRAY, CLEVE, ed. *David Smith by David Smith.* New York: Holt, Rinehart & Winston, 1968.

GREENBERG, CLEMENT. *Art and Culture: Critical Essays.* Boston: Beacon Press, 1961.

GROHMANN, WILL, ed. *New Art Around the World: Painting and Sculpture.* New York: Abrams, 1966.

GROPIUS, WALTER. *The New Architecture and the Bauhaus.* Trans. F. Morton Shand. London: Faber & Faber, 1935.

—————, ed. *The Theater of the Bauhaus.* Trans. Arthur Wensinger. Middletown, Conn.: Wesleyan University Press, 1961.

HAMILTON, EDWARD A. *Graphic Design for the*

Computer Age. New York: Van Nostrand-Reinhold, 1970.

HANSEN, AL. *A Primer of Happenings and Time/Space Art.* New York: Something Else Press, 1965.

HEISENBERG, WERNER. *Encounters and Conversations.* Trans. Arnold Pomerans. New York: Harper & Row, 1971.

HIGGINS, DICK. *The Computer and the Arts.* New York: Abyss Publications, 1970.

_____. *The Four Suits.* New York: Something Else Press, 1965.

HILLIER, BEVIS. *Art Deco.* New York: Dutton, 1968.

HOYLE, FRED. *Encounter with the Future.* New York: Trident Press, 1965.

IVINS, WILLIAM M. *Prints and Visual Communication.* Cambridge Mass.: Harvard University Press, 1953.

JAFFE, H. L. C. *De Stijl: 1917–1931.* Amsterdam: J. M. Meulenhoff, 1956.

JASTROW, ROBERT. *Red Giants and White Dwarfs: The Evolution of Stars, Planets, and Life.* New York: Harper & Row, 1967.

JEAN, MARCEL. *The History of Surrealist Painting.* Trans. Simon Watson Taylor. New York: Grove Press, 1960.

JEWELL, DEREK, ed. *Man and Motor: The Twentieth Century Love Affair.* New York: Walker, 1967.

KAHN, HERMAN, and ANTHONY J. WIENER. *The Year 2000.* New York: Macmillan, 1967.

KAPROW ALLAN. *Assemblage, Environments and Happenings.* New York: Abrams, 1966.

_____. *Some Recent Happenings.* New York: Something Else Press, 1966.

_____. *Untitled Essays and Other Pieces.* New York: Something Else Press, 1966.

KEPES, GYORGY. *The Language of Vision.* Chicago: Paul Theobald, 1944.

_____. *The New Landscape in Art and Science.* Chicago: Paul Theobald, 1956.

_____, ed. *Module, Proportion, Symmetry, Rhythm.* Vision and Value Series. New York: Braziller, 1965.

_____, ed. *The Nature and Art of Motion.* Vision and Value Series. New York: Braziller, 1966.

_____, ed. *Structure in Art and in Science.* Vision and Value Series. New York: Braziller, 1965.

KIRBY, MICHAEL. *The Art of Time: Essays on the Avant-Garde.* New York: Dutton, 1969.

_____. *Futurist Performance.* New York: Dutton, 1972.

_____. *Happenings: An Illustrated Anthology.* New York: Dutton, 1965.

KOESTLER, ARTHUR. *The Lotus and the Robot.* New York: Macmillan, 1961.

KOSTELANETZ, RICHARD, ed. *John Cage.* New York: Praeger, 1970.

_____. ed. *Moholy-Nagy.* New York: Praeger, 1970.

_____. *The Theatre of Mixed Means.* New York: Dial Press, 1968.

KRANZBERG, MELVIN, and CAROLL W. PURSELL, JR. *Technology in the Western World.* New York: Oxford University Press, 1967.

KULTERMANN, UDO. *The New Sculpture: Environments and Assemblages.* New York: Praeger, 1968.

LEBEL, ROBERT. *Marcel Duchamp.* Trans. George Hamilton. New York: Grove Press, 1959. (Includes chapters by Marcel Duchamp, André Breton, and H. P. Roche.)

LIPPARD, LUCY R. *Pop Art.* New York: Praeger, 1966. (Includes chapters by Lawrence Alloway, Nancy Marmer, and Nicolas Calas.)

McHALE, JOHN. *The Future of the Future.* New York: Braziller, 1969.

McLUHAN, MARSHALL. *The Gutenberg Galaxy.* Toronto: University of Toronto Press, 1967.

_____. *The Mechanical Bride.* Boston: Beacon, 1967.

_____. *Understanding Media: The Extensions of Man.* New York: McGraw-Hill, 1964.

McLUHAN, MARSHALL, and HARLEY PARKER. *Through the Vanishing Point: Space in Poetry and Painting.* New York: Harper & Row, 1968.

Manifestoes. New York: Something Else Press, 1966. (Includes Ay-o, Al Hansen, Dick Higgins, Allan Kaprow, Alison Knowles, Nam June Paik, Diter Rot, Wolf Vostell, Emmet Williams.)

MARKS, ROBERT, W. *The Dymaxion World of Buckminster Fuller.* New York: Von Nostrand-Reinhold, 1960.

MARTIN, J. L., BEN NICHOLSON, and NAUM GABO, eds. *Circle: International Survey of Constructive Art.* 2d ed. New York: Praeger, 1971.

MARTIN, MARIANNE W. *Futurist Art and Theory 1909–1915.* Oxford: Clarendon Press, 1968.

METZGER, GUSTAV. *Auto-Destructive Art.* London: Architectural Art Association, 1965.

MOHOLY-NAGY, LÁSZLÓ. *The New Vision.* New York: Brewer, Warren, and Putnam, 1932.

_____. *Vision in Motion.* Chicago: Paul Theobald, 1947.

MOHOLY-NAGY, SIBYL. *Moholy-Nagy: Experiment in Totality.* 2d ed. Cambridge, Mass.: M.I.T. Press, 1969.

MOTHERWELL, ROBERT, ed. *The Dada Painters and Poets.* New York: Wittenborn, Schultz, 1951.

MUMFORD, LEWIS. *Art and Technics.* New York: Columbia University Press, 1952.

_____. *The Myth of the Machine: The Pentagon of Power.* New York: Harcourt, 1970.

NEGROPONTE, NICHOLAS. *The Architecture Machine: Toward a More Human Environment.* Cambridge, Mass.: M.I.T. Press, 1970.

NUTTALL, JEFF. *Bomb Culture.* London: Granada Publishing, 1970.

OLDENBURG, CLAES. *Store Days.* New York: Something Else Press, 1967.

OWINGS, NATHANIEL ALEXANDER. *The American Aesthetic.* New York: Harper & Row, 1969.

PECKHAM, MORSE. *Man's Rage for Chaos: Biology, Behavior, and the Arts.* Philadelphia: Chilton Books, 1965.

PELLEGRINI, ALDO. *New Tendencies in Art.* Trans. Robin Carson. New York: Crown, 1966.

PEVSNER, NIKOLAUS. *Pioneers of Modern Design, from William Morris to Walter Gropius.* Rev. ed. New York: Museum of Modern Art, 1949.

PIERCE, JOHN. *Science, Art and Communication.* New York: Clarkson N. Potter, 1968.

_____. *Symbols, Signals and Noise: The Nature of Communication.* New York: Harper & Row, 1961.

_____. *Waves and Messages.* New York: Doubleday and Company, 1967.

POPPER, FRANK. *Origins and Development of Kinetic Art.* Trans. Stephen Bann. Greenwich, Conn.: New York Graphic Society, 1968.

RAY, MAN. *Self-Portrait.* Boston: Little, Brown, 1963.

READ, HERBERT. *Art and Alienation: The Role of the Artist in Society.* New York: Horizon Press, 1967.

_____. *Art and Industry: The Principles of Industrial Design.* New York: Harcourt Brace & Co., 1935.

_____. *Contemporary British Art.* Middlesex, Eng.: Penguin, 1951.

_____. *The Philosophy of Modern Art.* London: Faber and Faber, 1952.

READ, HERBERT, and LESLIE MARTIN. *Gabo.* Cambridge, Mass.: Harvard University Press, 1957.

REICHARDT, JASIA, ed. *Cybernetic Serendipity: The Computer and the Arts.* New York: Praeger, 1968.

REUTERSWÄRD, CARL FREDERICK. *Laser.* Stockholm: Wahlstrom and Windstrond, 1969.

RICHTER, HANS. *Dada: Art and Anti-Art.* New York: McGraw-Hill, 1966.

RICKEY, GEORGE. *Constructivism: Origins and Evolution.* New York: Braziller, 1967.

ROSE, BARBARA. *American Art Since 1900: A Critical History.* New York: Praeger, 1967.

_____. *Claes Oldenburg.* New York: Museum of Modern Art, 1970.

_____. *Readings in American Art Since 1900: A Documentary Survey.* New York: Praeger, 1968.

ROSENBERG, HAROLD. *The Anxious Object: Art Today and Its Audience.* New York: Horizon Press, 1964.

RUSSOLO, LUIGI. *The Art of Noise (Futurist Manifesto: 1913).* New York: Something Else Press, 1967.

SCHÖFFER, NICOLAS. *La Ville cybernetique.* Paris: Tchou, 1969.

_____. *Le Nouvel esprit artistique.* Paris: Gonthier, 1970.

SCHON, DONALD A. *Technology and Change, the New Heraclitus.* New York: Delacorte Press, 1967.

SCHRÖDINGER, ERWIN. *What is Life? The Physical Aspect of the Living Cell.* Cambridge, Mass.: Harvard University Press, 1951.

SCHWARZ, ARTURO. *The Complete Works of Marcel Duchamp.* New York: Abrams, 1969.

SEITZ, WILLIAM. *The Art of Assemblage.* New York: Museum of Modern Art, 1961.

SELZ, JEAN. *Modern Sculpture: Origins and Evolution.* New York: Braziller, 1963.

SEUPHOR, MICHEL. *Dictionary of Abstract Painting.* New York: Tudor, 1960. (First published as *Dictionnaire de la peinture abstraite,* Paris, 1957.)

SHARP, WILLOUGHBY. *Gunther Uecker: Ten Years of a Kineticist's Work.* New York: Kineticism Press, 1966.

_____. *Uecker, ZERO and the Kinetic Spirit.* New York: Kineticism Press, 1966.

_____, ed. *Kineticism.* New York: Kineticism Press, 1968.

SHKLOVSKII, L. S., and CARL SAGAN. *Intelligent Life in the Universe.* Trans. Paula Fern. San Francisco: Holden-Day, 1966.

SNOW, C. P. *The Two Cultures and the Scientific Revolution.* Cambridge, Eng.: Cambridge University Press, 1959.

SONTAG, SUSAN. *Against Interpretation.* New York: Farrar, Straus & Giroux, 1966.

STEINBERG, LEO. *Jasper Johns.* New York: Wittenborn, 1963.

STEINITZ, KATE TRUMAN, and KURT SCHWITTERS. *Kurt Schwitters: A Portrait from Life.* Berkeley: University of California Press, 1968.

STOCKHAUSEN, KARLHEINZ. *Texte zu Eigenen Werken zur Kunst Anderer Aktuelles, Band II.* Cologne: Verlag M. Dumont Schauberg, 1964.

SYPHER, WYLIE. *Literature and Technology: The Alien Vision.* New York: Random House, 1968.

_____. *Loss of the Self in Modern Literature and Art.* New York: Random House, 1962.

TAYLOR, JOSHUA C. *Futurism.* New York: Museum of Modern Art, 1961.

TOMPKINS, CALVIN. *The Bride and the Bachelors: The Heretical Courtship in Modern Art.* New York: Viking Press, 1965.

VAN DOESBURG, THEO. *Principles of Neoplastic Art.* Trans. Janet Seligman. Greenwich, Conn.: New York Graphic Society, 1968.

VOSTELL, WOLF. *Happening und Leben.* Berlin: Werk, 1970.

WADDINGTON, C. H. *Behind Appearance: A Study of the Relations Between Painting and the Natural Sciences in This Century.* Cambridge, Mass.: M.I.T. Press, 1970.

WEISS, PAUL. *Nine Basic Arts.* Carbondale: Southern Illinois University Press, 1961.

WIENER, NORBERT. *Cybernetics, or Control and Communication in the Animal and the Machine.* New York: John Wiley and Sons, 1948.

_____. *God and Golem, Inc.* Cambridge, Mass.: MIT Press, 1964.

_____. *The Human Use of Human Beings.* Boston: Houghton Mifflin, 1950.

WINGLER, HANS MARIA. *Bauhaus: Weimar, Dessau, Berlin, Chicago.* Trans. Wolfgang Jabs and Basil Gilbert. Cambridge, Mass.: MIT Press, 1969.

YOUNGBLOOD, GENE. *Expanded Cinema.* New York: Dutton, 1970.

Articles

AARON, CHLOE. "The Alternate-Media Guerrillas." *New York*, October 19, 1970.

ABEEL, ERICA. "Armory '66." *Arts Magazine*, December, 1966.

ACKERMAN, JAMES. "The Shape of Things to Come." *New York Times Book Review*, August 21, 1969. (Review-article.)

ALLOWAY, LAWRENCE. "Interfaces and Options: Participatory Art in Milwaukee and Chicago." *Arts Magazine* September, 1968.

ANTIN, DAVID. "Art and the Corporations." *Art News*, September, 1971.

————. "Jean Tinguely's New Machine." *Art News*, December, 1968.

ARGAN, GUILIO CARLO. "Un 'Futuro Techno-logical' per l'Arte." *Metro*, March–April, 1965.

ASHTON, DORE. "End and Beginning of an Age." *Arts Magazine*, December, 1968.

————. "Exercises in Anti-Style: Six Ways of Regarding Un-, In-, and Anti-form." *Arts Magazine*, April, 1964.

BAKER, ELIZABETH C. "The Light Brigade." *Art News*, March, 1967.

BAKER, KENNETH. "Keith Sonnier at the Modern." *Artforum*, October, 1971.

BANHAM, REYNER. "A House Is Not a Home." *Art in America*, April, 1965.

————. "The Future of Art from the Other Side." *Studio International*, June, 1967.

BANNARD, WALTER DARBY. "Beyond Modern Sculpture." *Artforum*, May, 1969. (Review-article.)

BELL, DANIEL. "Quo Warranto?—Notes on the Governance of Universities in the 1970's." *Public Interest*, Spring, 1970.

BELZ, CARL I. "The Kinetic Constructions of John Goodyear." *Art and Architecture*, October, 1964.

BENTHALL, JONATHAN. "Cybernetic Congress." *Studio International*, October, 1969.

————. "The Cybernetic Sculpture of Tsai Wen Ying." *Studio International*, March, 1969.

————. "Haacke, Sonfist and Nature." *Studio International*, March, 1971.

————. "The Sociology of Knowledge." *Studio International*, February, 1971.

BLEE, MICHAEL. "Cybernetic Serendipity: The Computer and the Arts at the Institute of Contemporary Arts." *Studio International*, September, 1968. (Review-article.)

BONGARD, WILLI. "When Rauschenberg Won the Biennale." *Studio International*, June, 1968.

BROWNING, JON. "Engineer-Artist Teams Shape New Art Forms." *Chemical Engineering*, February 26, 1968.

BURNHAM, JACK. "Corporate Art." *Artforum*, October, 1971.

————. "A Dan Flavin Retrospective in Ottawa." *Artforum*, December, 1969.

————. "Problems in Criticism IX: Art and Technology." *Artforum*, January, 1971.

Business Week, October 21, 1967. "Science for Art's Sake."

CALAS, NICOLAS. "Takis." *XX^e Siècle*, December, 1964.

CAMPBELL, LAWRENCE. "The Great-Circle Route." *Art News*, April, 1970.

CHANDLER, JOHN. "Art and Automata." *Arts Magazine*, December, 1968.

————. "Art in the Electric Age." *Art International*, February, 1969.

CHASE, GILBERT. "In Between the Arts." *Arts in Society*, Spring–Summer, 1968.

COE, RALPH T. "Post-Pop Possibilities: Howard Jones." *Art International*, January, 1966.

COHEN, MILTON J. "Film in Space Theatre." *Tulane Drama Review*, Fall, 1966.

CONE, JANE HARRISON. "David Smith." *Artforum*, Summer, 1967.

COPLANS, JOHN. "James Turrell: Projected Light Images." *Artforum*, Summer, 1968.

DANIELI, FIDELIO A. "Larry Bell." *Artforum*, Summer, 1967.

DAVIS, DOUGLAS. "Art and Technology: The New Combine." *Art in America*, January–February, 1968.

————. "Art as Act." *Art in America*, March–April, 1970.

————. "The Critic Now." *Arts in Society*, Vol. 5, No. 2, 1968.

————. "The Dimensions of the Miniarts." *Art in America*, November–December, 1967.

————. "For a New Aesthetic." *The American Scholar*, Winter, 1968–69. (Review-article.)

————. "Let Us Not Question." *The American Scholar*, Winter, 1966–67. (Review-article.)

————. "Media/Art/Media." *Arts Magazine*, September, 1971.

————. "Rauschenberg's Recent Graphics." *Art in America*, July–August, 1969

————. "Television Is." *Radical Software*, No. 2, 1970.

————. *Video Obscura. Artforum*, April, 1972.

Design Quarterly, 1966–1967. "Design and the Computer."

E.A.T./L.A. Survey, Summer, 1970. "John Whitney at Caltech."

FENTON, TERRY. "On Art and Technology." *Studio International*, January, 1969.

FORGE, ANDREW. "Anthony Caro Interviewed." *Studio International*, January, 1966.

FRAZIER, CHARLES. "From a Work Journal of Flying Sculpture." *Artforum*, Summer, 1967.

FRIED, MICHAEL. "Art and Objecthood." *Artforum*, Summer, 1967.

GABLIK, SUZI. "Light Conversation: Rauschenberg's Environment." *Art News*, November, 1968.

GELDZAHLER, HENRY. "Interview with Ellsworth Kelly." *Art International*, February, 1964.

GLUECK, GRACE. "Disharmony at the Armory." *New York Times*, October 30, 1966.

GRAY, CAMILLA. "A New Translation of the Realistic Manifesto." *The Structurist* 8 (1968).

GREENBERG, CLEMENT. "The Recentness of Sculpture." *Art International,* April, 1967.

GROSS, ALEX. "Who is Being Eaten?" *East Village Other,* March 3, 1970.

GUBER, PETER. "The New Ballgame: The Cartridge Revolution." *Cinema* 6, no. 1 (1970).

HEALEY, JOHN. "Luminous Pictures." *Studio International,* June, 1968.

HEIZER, MICHAEL. "The Art of Michael Heizer." *Artforum,* December, 1969.

HESS, THOMAS B. "Gerbil ex Machina." *Art News,* December, 1970.

HILL, ANTHONY. "Constructivism—The European Phenomenon." *Studio International,* April, 1970.

HILTON, ALISON. "When the Renaissance Came to Russia." *Art News,* December, 1971.

HOBSBAUM, E. J. "Is Science Evil?" *New York Review of Books,* November 19, 1970. (Review-article.)

HOENICK, P. K. "Robot Art: Using the Rays of the Sun." *Studio International,* June, 1968.

HOFFMAN, ABBIE. "Media Freaking." *Tulane Drama Review,* Summer, 1969.

HUTCHINSON, PETER. "Earth in Upheaval: Earthworks and Landscapes." *Arts Magazine,* November, 1968.

Industrial Design, January, 1969. "Mechanics Illustrated, or the Machine Seen as Art."

JAFFE, HANS. "The De Stijl Concept of Space." *The Structurist* 8 (1968).

JOHNSON, NICHOLAS. "TV—What Do We Do About It?" *Saturday Review,* July 11, 1970.

JUDD, DONALD. "Complaints: About Attempts to Close the Fairly Open Situation of Contemporary Art." *Studio International,* April, 1969.

————. "Groupe de Recherche d'Art Visuel." *Arts Magazine,* February, 1963.

JULEZ, BELA. "Computers, Patterns and Depth Perception." *Bell Laboratories Record,* September, 1966.

KAPROW, ALLAN. "The Education of an Un-Artist." *Art News,* February, 1971.

————. "Happenings in the New York Scene." *Art News,* May, 1961.

————. "The Legacy of Jackson Pollock." *Art News,* October, 1958.

KEPES, GYORGY. "Creating with Light." *Art in America,* Winter, 1960.

KING, M. C., A. MICHAEL NOLL, and D. H. BERRY. "A New Approach to Computer-Generated Holography." *Applied Optics,* February 6, 1970.

KIRBY, KENT. "Art, Technology and the Liberal Arts College." *Art Journal,* Spring, 1970.

KIRBY, MICHAEL. "Films in the New Theatre." *Tulane Drama Review,* Fall, 1966.

KLEIN, STANLEY. "Technology Invades the Arts." *Machine Design,* February 29, 1968.

KLÜVER, BILLY. "E.A.T.: Experiments in Art and Technology." *Paletten* (Sweden). February, 1968.

————. "The Pavilion." *Techne,* November 6, 1970.

KNOWLTON, KENNETH. "Computer-Produced Movies." *Science,* November 26, 1965.

KOESTLER, ARTHUR. "Literature and the Law of Diminishing Returns." *Encounter,* May, 1970.

KOSTELANETZ, RICHARD. "The American Avant-Garde II: John Cage." *Stereo Review,* May, 1969.

————. "A Conversation with Robert Rauschenberg." *Partisan Review,* Winter, 1968.

KOZLOFF, MAX. "Art and the New York Avant-Garde." *Partisan Review,* Fall, 1964.

————. "A Confusion in Buffalo." *Artforum,* May, 1968.

————. "Men and Machines." *Artforum,* February, 1969.

————. "The Multimillion Dollar Art Boondoggle." *Artforum,* October, 1971.

KRAGEN, ROBERT. "Art and TV." *Radical Software,* Summer, 1970.

KRAUSS, ROSALIND. "Allusion and Illusion in Donald Judd." *Artforum,* May, 1966.

LE PARC, JULIO. "Démystifier l'art." *Opus International,* no. 8 (1968).

LÉGER, FERDINAND. "Aesthetics of the Machine: The Manufactured Object, the Artisan and the Artist." *Art and Literature,* Winter, 1967.

LEWITT, SOL. "Paragraphs on Conceptual Art." *Artforum,* Summer, 1967.

LIEDER, PHILIP. "American Sculpture at the Los Angeles County Museum of Art." *Artforum,* Summer, 1967.

————. "The Cool School." *Artforum,* Summer, 1964.

LINDGREN, NILO. "Art and Technology I: Steps Toward a New Synergism." *IEEE Spectrum,* April, 1969.

————. "Art and Technology II: A Call for Collaboration." *IEEE Spectrum,* November, 1969.

LIPPARD, LUCY. "PULSA." *Arts Canada,* December, 1968.

————. "Tony Smith: Talk About Sculpture." *Art News,* April, 1971.

————. "Total Theatre?" *Art International,* January, 1967.

LIPPARD, LUCY, and JOHN CHANDLER. "The Dematerialization of Art." *Art International,* February, 1968.

LLOYD-MORGAN, CONWAY. "Multiples in France." *Art and Artists,* November, 1970.

LYE, LEN. "Is Film Art?" *Film Culture,* Summer, 1963.

McDERMOTT, JOHN. "Technology: The Opiate of the Intellectuals." *New York Review of Books,* July 31, 1970. (Review-article.)

MACKINTOSH, ALASTAIR. "Beuys in Edinburgh." *Art and Artists,* November, 1970.

McNAMEE, DONALD. "Van Doesburg's Cow: A Crucial Transition in the Structure and Reality of Art." *The Structurist* 8 (1968).

MALANGA, GERALD. "A Conversation with Andy Warhol." *Print Collector's Newsletter,* January–February, 1971.

MALINA, FRANK J. "Kinetic Painting: The Lumidyne System." *Leonardo,* Volume 1, 1968.

MALLARY, ROBERT. "Computer Sculpture: Six Levels of Cybernetics." *Artforum,* May, 1969.

MARCUS, AARON. "The Computer and the Artist." *Eye: Magazine of the Yale Arts Association,* no. 2 (1968).

MARGOLIES, JOHN. "TV—The Next Medium." *Art in America,* September–October, 1969.

MATHEWS, MAX. "Computer Composers: Comments and Case Histories." *Techne,* November 6, 1970.

Mechanical Engineering, February, 1968. "Merging Engineers and Art."

METZGER, GUSTAV. "A Critical Look at the Artist Placement Group," *Studio International,* January, 1972.

————. "Kinetics." *Art and Artists,* September, 1970.

MEZEY, LESLIE. "Science in Art, in Science, in Art In Science, In Art." *Arts Canada,* Spring, 1969.

MIECZKOWSKI, EDWIN. "Painting and Prediction." *In Out* (Magazine of the Anomina Group), November, 1963.

MILLER, DONALD. "Vasarely's Dream." *Art International,* May 20, 1970.

MOHOLY-NAGY, LÁSZLÓ. "Light: A New Medium of Expression." *Architectural Forum,* May, 1939.

MOHOLY-NAGY, SIBYL. "Changing Concepts in Architectural Space." *The Structurist* 8 (1968).

MORRIS, ROBERT. "Notes on Sculpture III." *Artforum,* Summer, 1967.

MOVSHON, GEORGE. "The Video Revolution." *Saturday Review,* August 8, 1970.

NOLL, A. MICHAEL. "Art Ex Machina." *IEEE Student Journal,* September, 1970.

————. "Choreography and Computers." *Dance Magazine,* January, 1967.

————. "Computer-Generated 3-Dimensional Movies." *Computers and Automation,* November, 1965.

————. "The Digital Computer as a Creative Medium." *IEEE Spectrum,* October, 1967.

NUSBERG, LEV. "Das 'Kiber' Theater." *Kunstwerk,* October, 1969.

O'CONNOR, JOHN J. "Art Meets Science." *Wall Street Journal,* October 21, 1966.

OVERY, PAUL. "Mary Martin and Kenneth Martin." *Art and Artists,* November, 1970.

PAIK, NAM JUNE. "Expanded Education for the Paperless Society." *Radical Software,* Summer, 1970.

————. "Stimulation of Human Eyes by Four-Channel Stereo Video-taping." *E.A.T./L.A. Survey,* Fall, 1970.

PAQUETTE, RUSSELL. "Cybernetic Art: The Computer as Renaissance Man." *SDC* (*Systems Development Corporation Magazine*), April, 1969.

PICARD, L. I. "Minujin and Lye." *East Village Other,* July 15, 1967.

PIENE, NAN R. "Light Art." *Art in America,* May–June, 1967.

————. "Sculpture and Light: Toronto and Montreal." *Arts Canada,* December, 1968.

PIENE, OTTO. "The Development of Group Zero."
The Times (London) *Literary Supplement,* September 3, 1964.

PINCUS-WITTEN, ROBERT. "Sound, Light and Silence in Kansas City." *Artforum,* January, 1967.

POPPER, FRANK. "Le Parc and the Group Problem." *Form,* September, 1966.

————. "The Luminous Trend in Kinetic Art." *Studio International,* February, 1967.

————. "Movement and Light in Today's Art," *Art and Architecture.* April, 1964.

RAINDANCE CORPORATION. "R. Buckminster Fuller." *Radical Software,* Summer, 1970. (Interview.)

RATCLIFF, CARTER. "New York Letter." *Art International.* November 20, 1971.

RATHKE, EWALD, and ECKHARD NEUMANN. "Constructivism 1914–1922." *Art and Artists,* July, 1970.

REICHARDT, JASIA. "Art and Usefulness." *Studio International,* June, 1968.

RETI, LADISLAO. "E.A.T. and After." *Studio International,* May, 1968.

————. "Leonardo on Bearings and Gears." *Scientific American,* February, 1971.

RICKEY, GEORGE. "Kinesis Continued." *Art in America,* December, 1965.

————. "The Kinetic International." *Arts Magazine,* September, 1961.

————. "Origins of Kinetic Art." *Studio International,* February, 1967.

ROSE, BARBARA. "Getting It Together." *E.A.T./L.A. Survey,* October, 1970. (The Pepsi-Cola Pavilion in Osaka, Japan.)

————. "Looking at American Sculpture." *Artforum,* February, 1965.

————. "The Politics of Art, Part II." *Artforum,* January, 1969.

————. "The Politics of Art, Part III." *Artforum,* May, 1969.

————. "Sensibility of the Sixties." *Art in America,* January, 1967.

————. "Shall We Have a Renaissance?" *Art in America,* March–April, 1967.

ROSENBERG, JAMES L. "A Funny Thing Happened on the Way to the Millennium, or Happenings Revisited." *Arts in Society,* Spring–Summer, 1968.

ROSENTHAL, NAN. "The Six-Day Bicycle Wheel Race." *Art in America,* October–November, 1965.

SALVADORI, MARCELLO. "Fundamental Research at the Centre for the Advanced Study of Science in Art." *Studio International,* June, 1967.

SCHMIDT, DORIS. "L'Hommage au Bauhaus." *XXᵉ Siècle,* June, 1969.

SECKLER, DOROTHY GEES. "The Artist Speaks: Robert Rauschenberg." *Art in America,* May, 1966.

SELZ, PETER. "Arte Programmata." *Arts Magazine,* March, 1965.

SHARP, WILLOUGHBY. "Air Art." *Studio International,* May, 1968.

_____. "Interview with Jack Burnham." *Arts Magazine,* November, 1970.

_____. "An Interview with Joseph Beuys." *Artforum,* December, 1969.

SHIREY, DAVID. L. "Impossible Art: What It Is." *Art in America,* May–June, 1969.

_____. "PULSA: Sound, Light, and Seven Young Artists." *New York Times,* December 24, 1970.

Signals: News Bulletin of the London Centre for Advanced Creative Study, August, 1964.

SKLOVER, THEA. "CATV." *Radical Software,* Summer, 1970.

SLOTNICK, D. L. "The Fastest Computer." *Scientific American,* February, 1971.

SMITH, DAVID. "Sculpture and Architecture." *Arts Magazine,* May, 1957.

_____. "Second Thoughts on Sculpture." *College Art Journal,* Summer, 1954.

_____. "Second Thoughts on Sculpture." *College Art Journal,* Winter, 1954.

SMITHSON, ROBERT. "Aerial Art: Proposals for the Dallas–Fort Worth Regional Airport." *Studio International,* April, 1969.

SPURCH, GRACE MARMOR. "Report on a Symposium on Art and Science Held at the Massachusetts Institute of Technology, March 20–22, 1968." *Artforum,* January, 1969.

STEGEMAN, BEATRICE. "The Art of Science." *Journal of Aesthetics,* Fall, 1968.

STEINITZ, KATE TRUMAN. "A Reconstruction of Leonardo da Vinci's Revolving Stage." *Art Quarterly,* Autumn, 1949.

SDC (Systems Development Corporation Magazine), April, 1969. "An Interview with Dr. Gerard Strang."

TAMBELLINI, ALDO. "Simultaneous Video Statements." *Radical Software,* Summer, 1970.

THWAITES, JOHN ANTHONY. "The Story of Zero." *Studio International,* July, 1965.

TILLIM, SIDNEY. "The New Avant-Garde." *Arts Magazine,* February, 1964.

TOMPKINS, CALVIN. "Onward and Upward with the Arts: E.A.T." *New Yorker,* October 3, 1970.

VANDERBEEK, STAN. "Culture, Intercom and Expanded Cinema: A Proposal and Manifesto." *Tulane Drama Review,* Fall, 1966.

_____. "New Talent—The Computer." *Art in America,* January, 1970.

WASSERMAN, EMILY. "Robert Irwin, Gene Davis, Richard Smith." *Artforum,* May, 1968. (Review-article.)

WHITMAN, SIMONE, and BILLY KLÜVER. "Theatre and Engineering. Notes by a Participant: Notes by an Engineer." *Artforum,* February, 1967.

YALKUT, JUD. "Electronic Zen: The Underground TV Generation." *West Side News* (New York), August 10, 1967.

_____. "Frank Gillette and Ira Schneider, Parts I and II of an Interview." *Radical Software,* Summer, 1970.

YOUNGBLOOD, GENE. "Buckminster Fuller's World Game." *Whole Earth Catalog,* March, 1970.

Catalogues

Against Order: Chance and Art. Text by Robert Pincus-Witten. Philadelphia: Institute of Contemporary Art, 1970.

Air Art. Text by Willoughby Sharp. New York: Kineticism Press, 1968.

Josef Albers: The American Years. Text by Gerald Nordland. Washington, D.C.: Gallery of Modern Art, 1966.

American Sculpture of the Sixties. Essays by Lawrence Alloway, John Coplans, Clement Greenberg, Max Kozloff, Lucy R. Lippard, James Monte, Barbara Rose, and others. Los Angeles: Los Angeles County Museum, 1967.

Les Années "25": Art Deco/Bauhaus/De Stijl/Esprit Nouveau. Paris: Musée des Arts Décoratifs, 1966.

Art in Revolution. Essays by Camilla Gray-Prokofieva and O. A. Schvidkovsky. London: Hayward Gallery, 1971.

The Art of the Real. Text by Eugene C. Goosen. New York: Museum of Modern Art, 1968.

Fletcher Benton: Kinetic Sculpture. New York: Galeria Bonino, 1968.

Wallace Berman: Verifax Collages. Text by James Monte. New York: Jewish Museum, 1968.

Joseph Beuys. Foreword by Franz Meyer. Essays by Troels Andersen, Per Kirkeby, et al. Basel: Kunstmuseum, 1969.

Bewogen Beweging. Text by K. G. Pontus Hulten. Amsterdam: Stedelijk Museum, 1961.

Robert Breer: Floats. New York: Galeria Bonino, 1966.

British Art: 1890–1928. Text by Denys Sutton. Columbus, Ohio: Columbus Gallery of Fine Arts, 1971.

The British Avant-Garde. Essays by Donald Karshan and Charles Harrison. New York: The New York Cultural Center, 1971.

Pol Bury. Essay by Roger Bordier. New York: Lefebre Gallery, 1964.

Alexander Calder. Text by Thomas M. Messer. New York: Solomon R. Guggenheim Museum, 1964.

A Salute to Alexander Calder. New York: Museum of Modern Art, 1969.

John Chamberlain. Text by Diane Waldman. New York: Solomon R. Guggenheim Museum, 1971.

Christo. Text by Lawrence Alloway. Eindhoven: Stedelijk van Abbe Museum, 1966.

Chryssa: Selected Works 1955–1967. Text by Diane Waldman. New York: Pace Gallery, 1968.

Conceptual Art and Conceptual Aspects. Essays and statements by Donald Karshan, Joseph Kosuth, Terry Atkinson, *et al.* New York: The New York Cultural Center, 1970.

Dada, Surrealism and Their Heritage. Text by William S. Rubin. New York: Museum of Modern Art, 1968.

Gene Davis. Text by Gene Baro. New York: Jewish Museum, 1968.

Destruction Art: Destroy to Create. New York:

Finch College Museum of Art, 1968.

Dine/Oldenburg/Segal. Essays by Alan Solomon, Ellen H. Johnson, and Robert Pincus-Witten. Toronto: Art Gallery of Ontario, 1967.

Jim Dine. Text by John Gordon. New York: Whitney Museum, 1970.

Directions in Kinetic Sculpture. Text by Peter Selz. Introduction by George Rickey. Berkeley: University of California Art Museum, 1966.

Essays on Movement: Reliefs by Mary Martin. Mobiles by Kenneth Martin. London: Institute of Contemporary Art, 1960.

Explorations. Text by Gyorgy Kepes. Washington, D.C.: National Collection of Fine Arts, 1970.

Dan Flavin. Essays by Dan Flavin, Donald Judd, Mel Bochner, and Brydon Smith. Ottawa: National Gallery of Canada, 1969.

Focus on Light. Text by Lucy R. Lippard. Trenton, N.J.: New Jersey State Museum, 1967.

Forty-ninth Parallels: New Canadian Art. Text by Dennis Young. Sarasota, Fla.: John and Mable Ringling Museum of Art, 1971.

Naum Gabo. Text by Heinz Fuchs. Includes "The Concepts of Russian Art" by Naum Gabo. Zurich: Kunsthaus, 1965.

Guggenheim International Exhibition 1967. New York: Solomon R. Guggenheim Museum, 1967.

Interactive Sound and Visual Systems. Columbus, Ohio: College of the Arts, Ohio State University, 1970.

Robert Irwin. Text by John Coplans. New York: Jewish Museum, 1968.

Robert Irwin, Kenneth Price. Essays by Philip Lieder and Lucy R. Lippard. Los Angeles: Los Angeles County Museum, 1966.

Jasper Johns. Text by Alan Solomon. New York: Jewish Museum, 1964.

Journey to the Surface of the Earth: Mark Boyle's Atlas and Manual. The Hague: Gemeentemuseum, 1970.

Donald Judd. Text by William C. Agee. New York: Whitney Museum, 1968.

Kaprow. Text by Alan Kaprow. Pasadena, Calif.: Pasadena Art Museum, 1967.

Edward Kienholz. Text by Maurice Tuchman. Los Angeles: Los Angeles County Museum, 1966.

Kinetische Kunst. Zurich: Kunstgewerbemuseum, 1970.

Yves Klein. Text by Kynaston McShine. Essays by Pierre Descargues and Pierre Restany. New York: Jewish Museum, 1967.

Kunst Licht Kunst. Text by Frank Popper. Eindhoven: Stedelijk van Abbe-Museum, 1966.

Fernand Léger: The Figure. New York: Gallery Chalette, 1965.

Leonardo da Vinci: Models Based on the Madrid Manuscript. Text by Richard McLanathan. New York: IBM Gallery, 1968.

Julio Le Parc: Recherches, 1959-1971. Düsseldorf: Städtische Kunsthalle, 1972.

Licht und Bewegung: Kinetische Kunst. Düsseldorf: Kunsthalle Grabbeplatz, 1966.

Light as a Creative Medium. Text by Gyorgy Kepes. Cambridge, Mass.: Fogg Art Museum, Harvard University, 1965.

Light, Motion, Space. Text by Willoughby Sharp. Minneapolis: Walker Art Center, 1967.

London: The New Scene. Text by Martin Friedmann. Minneapolis: Walker Art Center, 1965.

Len Lye's Bounding Steel Sculpture. New York: Howard Wise Gallery, 1965.

The Art of Stanton MacDonald-Wright. Washington, D.C.: National Collection of Fine Arts, 1967.

The Machine as Seen at the End of the Mechanical Age. Text by K. G. Pontus Hulten. New York: Museum of Modern Art, 1968.

Mack: Piene: Uecker. Hannover, W. Germany: Kestner-Gesellschaft, 1965.

Malevich. Text by Troels Andersen. Amsterdam: Stedelijk Museum, 1970.

Man, Machine and Motion. Text by Lawrence Gowing and Richard Hamilton. London: Institute of Contemporary Art, 1955.

Masters of Early Constructive Abstract Art. Text by Margit Staber. New York: Galerie Denise René, 1971.

Mies van der Rohe. Text by James A. Speyer. Chicago: Chicago Art Institute, 1968.

Moholy-Nagy. London: Marlborough Fine Art, Ltd., 1968.

László Moholy-Nagy. Text by Vories Fisher. New York: Solomon R. Guggenheim Museum, 1969.

László Moholy-Nagy's Light-Space Modulator. Text by Nan R. Piene. New York: Howard Wise Gallery, 1970.

Mondrian, De Stijl, and Their Impact. Introduction by A. M. Hammacher. London: Marlborough-Gerson Gallery, 1964.

Robert Morris. Eindhoven: Stedelijk van Abbe-Museum, 1968.

Le Mouvement. Essays and statements by K. G. Pontus Hulten, Roger Bordier, Victor Vasarely. Paris: Galerie Denise René, 1955.

Walter Murch. Providence: Rhode Island Museum of Art, 1966.

A New Aesthetic. Text by Barbara Rose. Washington, D.C.: Gallery of Modern Art, 1967.

New Forms–New Media. New York: Martha Jackson Gallery, 1960.

The New Generation: 1964. London: Whitechapel Gallery, 1964.

Nine Evenings: Theatre and Engineering. Text by Billy Klüver. Statements by John Cage, Öyvind Fåhlström, Alex Hay, Robert Rauschenberg, David Tudor, and others. New York: Foundation for the Performing Arts, 1966.

Options 1968. Text by Lawrence Alloway. Milwaukee: Milwaukee Art Center, 1968.

Nam June Paik: Electronic Art. New York: Galeria Bonino, 1965.

Francis Picabia. Text by William Canfield. New York: Solomon R. Guggenheim Museum, 1970.

Piene: Elements. New York: Howard Wise Gallery, 1969.

Piene: Light Ballet. New York: Howard Wise Gallery, 1965.

Post-Painterly Abstraction. Text by Clement Greenberg. Los Angeles: Los Angeles County Museum, 1964.

Primary Structures. Text by Kynaston McShine. New York: Jewish Museum, 1966.

Robert Rauschenberg. Text by Andrew Forge. Eindhoven: Stedelijk van Abbe-Museum, 1968.

Robert Rauschenberg. Text by Alan Solomon. New York: Jewish Museum, 1963.

Robert Rauschenberg. Essays by Willoughby Sharp, William S. Lieberman, Manfred de la Motte, Lucy R. Lippard, Lawrence Alloway, Douglas Davis. Hannover, W. Germany: Kunstverein, 1970.

Man Ray. Text by Jules Langsner. Los Angeles: Los Angeles County Museum, 1966.

Martial Raysse. Text by Otto Hahn. Los Angeles: Dwan Gallery, 1967.

Recorded Activities. Philadelphia: Moore College of Art, 1970.

Relief/Construction/Relief. Text by Jan van der Marck. Chicago: Museum of Contemporary Art, 1968.

The Responsive Eye. Text by William D. Seitz. New York: Museum of Modern Art, 1965.

Hans Richter. Text by Brian O'Doherty. New York: Finch College Museum of Art, 1968.

Alexander Rodchenko. Text by Jennifer Licht. New York: Museum of Modern Art, 1971.

Russian Avant-Garde 1908-1922. Essays by John E. Bolt and S. Frederick Starr. New York: Leonard Hutton Galleries, 1971.

Scale as Content. Washington, D.C.: Corcoran Gallery of Art, 1967.

Sixteen Americans. New York: Museum of Modern Art, 1959.

David Smith. Text by Edward F. Fry. New York: Solomon R. Guggenheim Museum, 1969.

David Smith: A Memorial Exhibition. Text by Hilton Kramer. Los Angeles: Los Angeles County Museum, 1965.

Richard Smith. Text by Barbara Rose. New York: Jewish Museum, 1968.

Software. Essays by Jack Burnham, Theodore Nelson. Introduction by Karl Katz. New York: Jewish Museum, 1970.

Some More Beginnings. New York: Experiments in Art and Technology Inc., 1968.

Sound, Light and Silence: Works by Landsman, Mefferd and Ross. Text by Ralph T. Coe. Kansas City, Mo.: William Rockhill Nelson Art Gallery, 1967.

Spaces. Text by Jennifer Licht. New York: Museum of Modern Art, 1970.

Systemic Painting. Text by Lawrence Alloway. New York: Solomon R. Guggenheim Museum, 1966.

Takis: Evidence of the Unseen. Text by Wayne Anderson. Cambridge, Mass.: M.I.T. Press, 1968.

Takis: Magnetic Fields. New York: Howard Wise Gallery, 1970.

Takis: Magnetic Sculpture. New York: Howard Wise Gallery, 1967.

Vladimir Tatlin. Text by Troels Anderson. Stockholm: Moderna Museet, 1968.

Technics and Creativity. Essay by Riva Castleman. New York: Museum of Modern Art, 1971.

Jim Turrell. Text by John Coplans. Pasadena, Calif.: Pasadena Art Museum, 1967.

Two Kinetic Sculptors: Nicholas Schöffer and Jean Tinguely. New York: Jewish Museum, 1965.

Gunther Uecker. New York: Howard Wise Gallery, 1966.

Utopie och Visioner: 1871–1971. Stockholm: Moderna Museet, 1971.

Vision and Television. Foreword by Russell Connor. Waltham, Mass.: Rose Art Museum, Brandeis University, 1970.

Wolf Vostell Elektronisch. Aachen, Germany: Neue Galerie, 1970.

Andy Warhol. Stockholm: Moderna Museet, 1968.

The Washington Color Painters. Text by Gerald Nordland. Washington, D.C.: Gallery of Modern Art, 1965.

Thomas Wilfred: Lumia. Text by Donna M. Stein. Washington, D.C.: Corcoran Gallery of Art, 1971.

Unpublished Manuscripts and Lectures

COOK, PETER. *Archigram: Eight Alternative Futures.* Paper for the "Environment and Architecture Conference," Camden, England, 1971.

DAVIS, DOUGLAS. *You Are the Artist.* Lecture for the Industrial Designers Society of America, Syracuse, New York, 1968.

Experiments in Art and Technology, Inc. *Lecture Series 1967–1968.* In manuscript and audio tape form. Lecturers include M. V. Mathews, J. Tenney, B. Bruins, M. Turri.

HOWARD, BRICE. *Videospace.* Manuscript, 1969.

JASTROW, ROBERT. *Science, Politics and Art.* Lecture for the Columbia University Alumni, Fort Monmouth, New Jersey, 1966.

KLÜVER, BILLY. *Interface: Artist/Engineer.* Lecture for the Massachusetts Institute of Technology, Cambridge, Mass., 1967.

KRAYNIK, TED. *Synergic Art from Cave to Computer.* Manuscript, 1968.

MUMMA, GORDON. *Technology in the Modern Arts: Music and Theatre.* Manuscript, 1966.

PAIK, NAM JUNE. *A Music History: Critical Bibliography of Avant Garde Movement.* Manuscript, 1968.

TENNEY, JAMES. *Computer Music Experiences, 1961–64.* Manuscript, 1964.

Index

Page numbers of black-and-white illustrations are printed in *italic* type. Numbers of color illustrations, which fall between pp. 48 and 49, and 160 and 161, are printed in **boldface** type.

Abe, Shuya, 90, 149, 152
Abstract Expressionism, 35, 38, 39
Acrylics, 15, 16
Agam, Yaacov, 53, 56
Agis, Maurice, *171*
Albers, Joseph, 26, *26*, 33, 34, 37, 56
Albert, Calvin, 46, 71
Allgemeine Elektrizitäts-Gesellschaft, 31
Alloway, Lawrence, 61
Alviani, Getulio, *57*
Androids, 108, *108*
Anonima Group, 46, 67
Anuszkiewicz, Richard, 46
Apollinaire, Guillaume, 17
Apple, Billy, 64
Archigram Group, 62
Architecture Machine, The, 100, *101, 168,* 182, 185
Architecture Machine Group, 100, 101
Armajani, Siah, *109,* 110
Arman, 53
Arp, Hans, 52
Arp, Jean, 21, 52
Arrowsmith, Sue, 64
Art Deco, 26, n. 5 (I)
Art Institute of Light, 33
Art-Language Press, 64
Art Nouveau, 17, n. 5 (I)
"Art of Noise, The," 31
Artists' Placement Group (APG), 63, 71
Association of Arts and Industries, 33
Atkinson, Terry, 64
Auto-Destructive Art, 64

Babbitt, Milton, 35, *35,* 97, 112, 153
Baldaccini, César, 40, 129; **7**
Baldwin, Michael, 64
Ball, Otto, 31, 72
Balla, Giacomo, 18, 19, 28
Bandoneon! (A Combine), 2, 70, 72, *169,* 175, 182, 185, 187, *187*
Banham, Reyner, 61, 62
Baranoff-Rossiné, Vladimir, 28, n. 19 (I)
Barzyk, Fred, 90, *91*
Bauhaus, 17, 22, 25, 26, 27, 37, 71, 119, 138
Beck, Stephen, 90; **27**
Beiles, Sinclair, 127
Bell, Larry, 42, 44, *44,* 71, 72, 111, *171, 179;* **15**
Bell Laboratories, 97
Benjamin, Walter, 170, 171, 172, 174, 182, 186
Benkert, Ernst, 46
Benton, Fletcher, 44, 45, *45,* 94, n. 28 (I)
Berlin Dada, 21–22
Berman, Wallace, 46
Bermudez, Jose, *98*
Bernal, J. D., 184, 185, 186
Berns, Ben, 59, **22**
Berris, Linda, *175*
Beuys, Joseph, *88, 107,* 148, 176, 177, *177*
Bicycle Wheel, 20, 21, 27–28
Bill, Max, 52, *53*
Bladen, Ronald, *75*
Boccioni, Umberto, 18, *18, 19*
Bonzagni, Aroldo, 18
Boto, Martha, 58, 59
Boulez, Pierre, 53
Boyle, Mark, 65, *65*
Bracelli, Giovanni Battista, 71
Brancusi, Constantin, 108
Braque, Georges, 17
Brecht, George, 38

Breer, Robert, 53, 54, *54,* 72
Breton, André, 21, 27, 108, n. 7 (I)
Brett, Guy, 128
Breuer, Marcel, 26, 29, 33, 60
Bugatti, Ettore, 29, *29,* 31
Burliuk, David, 22
Burnham, Jack, 73, 115, 162, 169, 170, 181
Burroughs, William, 65
Bury, Pol, 53, 54, *54,* 56

Cage, John, 34, 35, 37, 38, 50, 68, 69, *69,* 70, 71, 75, *77,* 97, 121, 136, 140, 142, 146, 147, 149
Calder, Alexander, 11, 28, 29, *29,* 31, 33, 48, 53, 54, 56, 111, 133, 141
Callahan, Michael, 157, 158, 159
Campus, Peter, *85*
Čapek, Karel, 107
Caro, Anthony, 37, 42, *59,* 62
Carrà, Carlo, 18
Center for Advanced Creative Study, 62
Center for Advanced Visual Studies, 71, 73, 115, 117–18
Center for Experiment in Television, 89
Centre for the Studies of Science in Art, 63, *63*
César (*see* Baldaccini, César)
Cézanne, Paul, 21
Chamberlain, John, 40
Chesapeake-Delaware Canal, aerial photograph of, *174*
Childs, Lucinda, 70, *71*
Christensen, Dan, 16
Christo, 53, *74,* 79
Chryssa, *17*
Cityscape, *80,* 81, *168,* 182
Clark, Kenneth, 178
Clarke, Arthur C., 184
Cohen, Milton, 50
Color Painters, 15, n. 2 (I)
Computer-enhanced photograph, *183*
Computers (in the arts), 95, 96–105, *168,* **41**
Conceptual art, 64, *168,* 179
Concrete art, 52, 53
Concrete music, 31, 35
Connor, Russell, 88
Constructivism, 11, 22, 23, 26, 31, 43, 48, 56, 60, 64, 111, n. 14 (I)
Cook, Peter, 62
Coplans, John, 43
Council of Industrial Design, 60
Cross, Lloyd, 83, *83*
Csuri, Charles, *96,* 102, *103;* **32**
Cubism, 17, 18, 19, 21, 22, 36, 60
Cubo-Futurism, 25
Cumming, Robert, *180*
Cunningham, Merce, 50, *50,* 68, 149

Da Vinci, Leonardo, 16, 29, 71, n. 3 (I)
Dacy, Robert, 157, 159
Dadaism, 19–22, 27, 37, 53, 64, 111
Dali, Salvador, *83*
Dallegret, François, *106*
Davis, Douglas, 90, *91, 186;* **29**
Davis, Gene, 15, 43, *85, 181*
Davis, Ron, 42; **13**
De Maria, Walter, *173, 181*
De Stijl Group, 22, 26, 53
Delaunay, Robert, 27, 52
Delaunay, Sonia, 52
Delgado, José, 105
Della Torre, Marc Antonio, 16
Depero, Fortunato, 28
Deutscher Werkbund, 17

Dignac, **23**
Dine, Jim, 38, n. 29 (I)
Dubuffet, Jean, 77
Duchamp, Marcel, 15, *15, 20,* 21, *27, 27,* 28, 53, 56, 107, 130, 138, n. 8 (I)
Dupuy, Jean, 73
Durkee, Steve, 157–60
Dvizdjene Group, 57, 58

Eakins, Thomas, 15
Earth, **43, 44**
Editions M-A-T, 55–56
Education Research Center, MIT, *105*
Eimert, Herbert, 53
Electricity-seeking automaton, *175*
Environments, 38
Equipo 57, 57
Ernst, Max, 21, 27, 61, 107
Events, 38
Experiments in Art and Technology, Inc. (EAT), 67–73, *136, 137,* 138–40, *138, 139, 140,* 141, 142, 143, 144, 145, n. 43 (I)
Expressionism, 26
Exter, Alexandra, 22

Fahlström, Oyvind, 70, 72
Feininger, Lyonel, 27, 33
Feitelson, Lorser, 41
Feldman, Morton, 34
Ferkiss, Victor, 184
"Festival of Technology," Hannover, 112, *112*
Fischer, Ernst, 169, 170, 178, 181, n. 3 (III)
Flavin, Dan, 23, 44, *44,* 54, 160
Fleming, Dean, 79
Flowers, Dean, 79
Flowers, Woodie, *30*
Fontana, Lucio, 52, 71, 111, 126
Forkner, John, 76
Francastel, Pierre, 11
Frankenthaler, Helen, n. 2 (I)
Frazier, Charles, 79, *79, 95,* 115; **18**
Fried, Michael, 169
Fry, Roger, 60
Fuller, R. Buckminster, 11, 29, 49, 67, 111, 184, 185
Functionalism, 29
Futurism, 15, 17, 19, 22, 25, 56, 60, 138

Gabo, Naum, 22–25, *25,* 27, 28, *28,* 33, 37, 59, 60, 91, 95, 111, 112
Gans, Alexei, 24
García-Rossi, Horacio, 57, 132
Gheerbrant, Gilles, *101*
Giacometti, Alberto, 27, 127, 129
Gillette, Frank, 85, 86, 88, 146
Gilliam, Sam, 15
Ginsburg, Allen, 128, 129
Glarner, Fritz, 53
Glaser, Bruce, 43
Global Village, 88
Goldberg, Rube, 21
Gombrich, E. H., 169
Goncharava, Natalia, 22
Gonzáles, Julio, 36
Goodyear, John, 46
Graeser, Camille, 53
GRAV (*see* Groupe de Recherche d'Art Visuel)
Greenberg, Clement, 43, 169
Grooms, Red, 38
Gropius, Walter, 17, 26, 27, 29, 33, 59, 60, 119
Gross, Alex, 137
Grosz, George, 21, 22, *22*
Groupe de Recherche d'Art Visuel (GRAV), 57–59, 121, 131–32, *132, 134,* 135
Gruppo N, 57
Gruppo T, 57

Guimard, Hector, 17

Haacke, Hans, 58, 79, 94, 95, *95,* 168, *169,* 182
Hamilton, Richard, 61, 64, *65,* 71, *84,* 168, *169,* **186, 187**
Hansen, Al, 38
Happening, the, 35, 37, 38, 68
Harmon, Leon, 99, *99*
Harris, Hyman, 73
Harrison, Newton, 95
Hausmann, Raoul, 21, n. 9 (I)
Haviland, Paul, 107
Hay, Alex, 70, *71*
Hay, Deborah, *70*
Hayden, Michael, **30**
Healey, John, 60, *60*
Heartfield, John, 21, 22, *22*
Heisenberg, Werner, 180
Heizer, Michael, *173*
Henderson, Gil, **40**
Henry, Pierre, 120
Hepworth, Barbara, 60
Hess, Thomas, 107
Hewitt, Francis, 46
Higgins, Dick, 38, 101, 148
High-Vacuum Optical Coating Machine, 44, *44*
Hiller, Lejaren, 97
Hockney, David, 61
Hologram, 82, 83
Homage to New York, 54, *55,* 123, 138, *168,* 186
Hopkins, John, 65
Howard, Brice, 89, 90
Huebler, Douglas, *174*
Hugnet, Georges, 22
Hülsenbeck, Richard, 20
Hulten, Pontus, 76, 78, 136
Hunt, Albert, 65
Huszar, Viomos, 26
Hydraulic Circulation System, 94, *95, 169*

IBM System/Model 145, *176*
Impressionism, 17
Independent Group, 61
Indiana, Robert, *83*
Institute of Design, 26
International Style, 26
Intersystems Group, 92; **30**
Irwin, Robert, 46, 161–66, *161, 166,* 168, 182
Isaacson, Leonard, 97
Israel, Robert, 79

Jactrow, Robert, 180
Johns, Jasper, 35, 38, *38,* 68, 136, *183*
Johnson, Mel, 46, 71
Jones, Allen, 61
Jones, Howard, **21**
Jones, Peter, *171*
Judd, Donald, 41, *41, 42,* 43, 44; **10**
Julesz, Bela, 99

Kahn, Herman, 184
Kamiya, Joseph, 104
Kandinsky, Vasili, 26, 27
Kaprow, Allan, 35, 38, *39,* 68, 88, *89,* 90, *170,* 171
Kauffer, McKnight, 60
Kauffman, Craig, 46, 71; **12**
Keeler, Paul, 128
Kelly, Ellsworth, 43, n. 31 (I)
Kemeny, Alfred, 31
Kent State, 64, 65, *169,* 186, 187
Kepes, Gyorgy, 33, 34, 35, 48, 60, 73, 79, 111, 115–19, *115, 117, 118,* 129; **36**
Khlebnikov, Victor, 22, 25
Kienholz, Edward, *16,* 46, n. 29 (I)
Kinetic art, 27–29, 44, 56–60, 62, 112, 120, 123–24, 126
Kinetic Sculpture: Standing Wave, 24, 28, *28*

King, Philip, 42, 62
Klee, Paul, 27
Klein, Yves, 53, 54, 79, 127
Klüver, J. Wilhelm (Billy), 50, *50*, 67, 68, *68*, 69–72, 109, 111, 136–40, *136*, 141, 145, 176
Knowles, Alison, 148
Knowlton, Kenneth, 99, *99*
Kosuth, Joseph, 179, *179*, *182*
Kowalski, Piotr, 46, 47, *47*, 48
Kozloff, Max, 11
Kramer, Hilton, 43, 174–75
Kraynik, Ted, 85, *86*, 94, *94*, 115
Krebs, Rockne, 72, 76, *80*, 81; **17**, **42**
Krody, Barron, 81, *81*
Kusama, Yayoi, 58
Kyger, Joanne, *90*

La Fosse, Roger, 104
Landsman, Stanley, 75, *103*, *185*
Langsner, Jules, 41
Laposky, Ben, 98
Larionov, Mikhail, 22
Laser light, 81–83, 173–74, n. 50 (I)
Latham, Barbara, 63
Latham, John, 63, 109
Le Corbusier, 26, 29
Le Mouvement, 53, 54
Le Parc, Julio, 57, *57*, 58, *58*, 59, 68, 124, 132, *132*, 135
Léger, Fernand, 17, 23, 27, 40
Leonidov, 23
Levine, Les, 85, 86, *87*, 92, *94*
Lewis, Wyndham, 60, n. 36 (I)
Liberman, Alexander, 43, 79
Lichtenstein, Roy, *16*, 40, 76; **9**
Light (in the arts), 28, 31, 56, 58–60, 62, 67, 75–76, 119, 134, 159–60
Light fixture, *179*
Light-Space Modulator, *30*, 31, 59, *168*
Lijn, Liliane, 128
Lissitsky, El, 15, 23, *24*, 29, 111, n. 9 (I)
Literalism, 41, 42
Lohse, Richard, 53
Long, Richard, 64
Loos, Adolf, 17
Los Angeles County Museum, 11, 76, 77, 161–66, n. 44 (I)
Louis, Morris, 15, 16, 43, 71
Lucier, Alvin, 104
Luening, Otto, 35
Luginbühl, Bernard, 124
Lurçat, André, 26
Lye, Len, 28, 48, *48*, 54, 108

MacDermott, David, *138*
McHale, John, 184
McLaughlin, John, 41
McLuhan, Marshall, 67, 89, 149, 150, 158, 184
Mack, Heinz, 56, 131, 133
Malevich, Kasimir, 19, *19*, 20, 22, 23, 24, 26, 27, 29, 37, 42, 43
Malina, Frank, 35, 56, 60, 111; **24**
Mallary, Robert, 104, 184, 185
Manifesto I (De Stijl), 26
Manifesto del Macchinismo, 52
Manzoni, Piero, 78, n. 45 (I)
Marinetti, Filippo Tommaso, 18
Martel, Ralph, 73
Martin, J. L., 60
Martin, Kenneth, 60
Martin, Mary, 60
Mathews, Max, 97, 101
Mayakovsky, Vladimir, 23, 25
Medalla, David, 54, *62*, 63, 128
Mefferd, Boyd, 85, 93
Mehring, Howard, 15, 43

Melnikov, 23
Merzbau, 21
Mestrovic, Matko, 56, 57
Metzger, Gustav, 15, *15*, 63–64, *64*, 65, 71, 109, *110*
Meyer, Hannes, 26
Meyerhold, Vsevolod, 23
Mieczkowski, Edwin, 46, 71
Mies van der Rohe, Ludwig, 29, *32*, 33
Minimalism, 41
Minujin, Marta, n. 48 (I)
Mobile, 28
Moholy-Nagy, László, 26, *26*, 27, *30*, 31, 33, 41, 59, 60, 72, 79, 111, 112, 168, *168*, n. 9 (I), n. 22 (I), n. 33 (I)
Moholy-Nagy, Sibyl, *30*
Mondrian, Piet, 26, *26*, 27, 44, 52, 99
Moore, Henry, 60
Moorman, Charlotte, 149, 150
Morehouse, William, 46, 108; **34**
Morellet, François, 57, 131, *132*
Morris, Robert, 42, *42*, 43, 44, 94
Morris, William, 16, 17, 21, 59, 106
Motherwell, Robert, 34, 111
Movie-Drome, 49, *50*
Mumford, Lewis, 15, 107, 140, 147, 174, 186
Munari, Bruno, 52, 57
Murch, Walter, n. 29 (I)
Music, 28, 34, 35, 53, 65, 75, 97–98, 153
Muthesius, Hermann, 17, 59
Muybridge, Eadweard, 15
Myers, Forrest, *176*

Nake, Frieder, 99; **33**
Nauman, Bruce, 72, 82, *82*, 86, *87*; **25**
Nees, George, 99
Negroponte, Nicholas, 100, *102*, 107, 168, 182
Nesbitt, Lowell, 71, 72, *97*, n. 29 (I)
Neuhaus, Max, *175*
New Realism in Painting, The (1916), 19
New Realists, 53
New Tendency (*Nouvelle Tendence*), 56, 57, 59, 131
Newman, Barnett, 34, 41
Nicholson, Ben, 60
Niepce, J. N., n. 9 (I)
Nikolais, Alwin, 49, *49*, 89, 153
Nitzschke, Hans, *112*
Noland, Jack, 101
Noland, Kenneth, 15, 43; **1**
Noll, A. Michael, *62*, 99, *99*, 103, 104, 109, 110, 185
North American Aviation, 46–47, 48
Nusberg, Lev, 58
Nuttall, Jeff, 65

Oldenburg, Claes, 38, 39, *39*, *40*, 76, 77, **77**, 109
Olson-Belar electronic sound synthesizer, 35
Once Group, 50, 51, *51*
Once Invisible, n. 46 (I)
On the Dynamic-Constructive System of Force, 31
Oppenheim, Dennis, *173*
Owens, Larry, *140*
Ozenfant, Amédée, 60

Paik, Nam June, 67, 84, 85, 86, 90, 91, 106, 108, *108*, 111, 112, 121, 146–52, *146*, *147*, *148*, *149*, *151*, 168, *169*, 186; **26**
Palyka, Duane, *101*
Paolozzi, Eduardo, 61, 108; **16**
Pasmore, Victor, 60
Paxton, Steve, *172*
Peckham, Morse, 169
Perlstein, Henry, 120
Pettet, William, 16; **2**
Pevsner, Antoine, 23, 24
Pevsner, Nikolaus, 59
Photomontage, 21
Picabia, Francis, 21, *21*, 27, 107

Picasso, Pablo, 22, 36
Picture phones, *175*
Piene, Nan, *30*, n. 22 (I)
Piene, Otto, 31, 56, *56, 57,* 58, 73, 79, *79, 80,* 81, 84, *85,* 89, 90, 111, 112, 115, 131, *131,* 133–35, *133, 168, 168,* 182, *184;* **37**
Pierce, John R., 97
Piscator, Erwin, 26
Pollock, Jackson, 34, 37, 38, 68
Poons, Larry, *172*
Pop art, 40, 41, 44, 61, 62
Popova, Liubov, 22; **4**
Popper, Frank, 36
Pousseur, Henri, 79, 120
Productivism, 23, 25
Program of the Productivist Group, 24
Proun, 23, n. 12 (I)
Pulsa Group, 92, *92,* n. 51 (I)
Punin, Nicolai, *22*

Radiograph of lake deposit, *172*
Raindance Corporation, 88
Rainer, Yvonne, *70*
Rauschenberg, Robert, 35, 36, 37, *37, 38,* 67, 68, *68,* 70, 72, 77, 93, *93,* 112, 136, 141–45, *141, 142, 143, 144, 168, 168, 173;* **38**
Rawson, Eric, 92
Ray, Man, 21, 33, 56, 141
Rayonism, 22, 25
Raysse, Martial, 53, 58, 59
Rayonist and Futurist Manifesto, 22
RCA (Radio Corporation of America), 45, n. 47 (I)
Read, Herbert, 55, 60, 111, 172, 176
"Readymade" works of art, 21, n. 7 (I)
Realism, 23, 25, 31
Realist Manifesto, 24, 25
Relback, Earl, 85
Reichardt, Jasia, 101
Reilly, John, *88*
Repetition, 40, 41, n. 24 (I)
Reuterswärd, Carl Frederik, *80,* 81, *81*
Rickey, George, 43, 48, *178*
Riley, Bridget, 46, 62, *62,* 63, 99
Riley, Terry, 75, *76*
Roberts, William, 60
Robots, 61, 107–8, 149
Rodchenko, Alexander, 20, 23, *23;* **3**
Romanticism, 21, 23, 108
Rosati, James, *75*
Rosenberg, Harold, 143, 145
Rosenboom, David, 105, 106
Rosenquist, James, *16,* n. 29 (I); **6**
Ruskin, John, 16, 17
Russolo, Luigi, 18, 31

Sagan, Carl, 186, *186*
Salvadori, Marcello, 62, 63, 128
Saul, Peter, *107*
Schaeffer, Pierre, 34
Scherchen, Hermann, 97
Schlemmer, Oskar, 26
Schneeman, Carolee, 73
Schneider, Ira, 85, *86,* 88, n. 48 (I)
Schöffer, Nicolas, 31, 53, 55, 58, 59, 68, 75, 79, 111, 120–22, *120, 121;* **39**
Schon, Donald, 15, 181, n. 1 (I)
Schrödinger, Erwin, 180
Schum, Gary, 88, *88*
Schwartz, Lillian, *102–3*
Schwitters, Kurt, 21, *21,* 27, *112,* 181
Scriabin, Alexander, 28
Seawright, James, 49, 75, *76,* 90, 111, 147, 153–56, *153, 154, 155, 156;* **28**
Sebök, Istvan, 31, 72
Sedgley, Peter, 63

Segal, George, 38
Seuphor, Michel, 52, n. 6
Severini, Gino, 18, *18,* 19, n. 6 (I)
Sharp, Willoughby, 162
Shklovskii, I. S., 186, *186*
Siegel, Eric, 85
Signals Group, 62–63
Sky art, 79–80
Smith, David, 36, *36, 37,* 41, 62
Smith, Richard, 61, *61*
Smith, Tony, 42
Smithson, Robert, 79, *174*
Snelson, Kenneth, *178*
Snow, C. P., 106, 140
Sobrino, Guy, *132*
Sonfist, Alan, 94, 95, *95;* **35**
Sonin, Ain, 128, 130
Sonnier, Keith, 86, *87,* 93, 94; **20**
Sorenson, Peter, 85
Soto, Jesus-Raphael, 53, 56
Soundings, 93, 142, *168,* 175
SPACE, 63
Speer, Alfred, 31
Spoerri, Daniel, 55
Stanczak, Julian, 46
Stankiewicz, Richard, 40
Stein, Joel, 131, *132*
Steinitz, Kate, 112, *112*
Stella, Frank, 43, *43,* 44
Stella, Joseph, 27
Stern, Gerd, 157–60, *157, 158, 159*
Stern, Rudi, *88*
Stockhausen, Karlheinz, 53
Strang, Gerald, 72, 97
Sullivan, Louis, 17
Suprematism, 19, 20, 23, 24, 25
Surrealism, 21, 27, 108
Sutherland, Ivan, 102, *104*
Sypher, Wylie, 174, 186

Tachism, 52, 54
Tadlock, Thomas, 85, 86, 90
Taeuber-Arp, Sophie, 52
Takis, 54, 55, *55,* 58, 62, 73, 115, 118, 127–30, *127, 128, 129*
Tambellini, Aldo, 84, 85, *85,* 89, 90
Tatlin, Vladimir, *14,* 22, *22,* 23, 24, 25, 27, 37, 44, 111
Television (in the arts), 50, 61, 64–65, 70, 71, 84–91, 95, 146–52, 168
Tenney, James, 72, 97
Theater Pieces, 38
Tilson, Joe, 61, 64
Tinguely, Jean, 29, 52–55, *55,* 56, 58, 61, 63, 67, 75, 112, 123–26, *123, 124, 125,* 136, 138, 139, *168, 168,* 186
Tovish, Harold, *105,* 115
Tsai, Wen-ying, *92,* 93, 111, 115
Tuchman, Maurice, 76, 161
Tucker, William, 62
Tudor, David, *2,* 34, 70, 72, 97, 168, *169,* 175, 182, *187*
Turrell, James, 72, 81, 161–66, *161, 166,* 168, 182
Tzara, Tristan, 20, 21

Uecker, Günther, 56, *56,* 58, 131
Urry, Steven, 46
Us Company (USCO), *66,* 67, 157–60, *159*
Ussachevsky, Vladimir, 35, 97

Van De Bogart, Willard, **19**
Van de Velde, Henry, 17
Van Doesburg, Nelly, *112*
Van Doesburg, Theo, 26, 29, 52, *112*
Van Hoeydonck, Paul, *107*
Vanderbeek, Stan, 49, 50, *50,* 51, 85, 90, 99, 115; **31**
Van't Hoff, Robert, 26

Vantongerloo, Georges, 26, 52–53
Vardenega, Gregorio, 58, *58*
Varèse, Edgard, 31, 97
Vasarely, Victor, 46, 52, 53, 55, 56, 111, 131, 176, n. 30 (I), n. 32 (I); **5**
Vertov, Dziga, 23
Vesnin, Alexander, 23
Video Synthesizer, 90, 150, *151,* 152, *169,* 177–78
Videofreex, 88, *88*
Videotape, 84–91, 148–52, 185
Von Gravenitz, Gerhard, 53, 58
Vordemberge-Gildewart, Friedel, *112*
Vorticism, 60
Vostell, Wolf, 84, *84,* 148

Waldhauer, Fred, 72, *138*
Warhol, Andy, 39, 40, *40,* 68, 85, 136; **11**
Washington Color Painters, 15, 43, n. 2 (I)
Watts, Robert, *111*
We (Vertov), 23

Weimar School of Arts and Crafts, **17**
Weiner, Norbert, 150
Wesselmann, Tom, 40, 41, 84; **8**
WGBH-TV, 89, 90, 177
White Manifesto, The, 52
Whitman, Robert, 38, *69,* 72, 76, 77, 81, 92, *93,* 109
Whitman, Simone, 141
Whitney, John, 98, *98, 99,* 175, 179, 186, n. 52 (I)
Wilfred, Thomas, 33, *34,* 48, 60, 70, 141
Wittnebert, Witt, 28, *138*
Wortz, Edward, 114, 161–66, *161,* 168, 182
Wright, Frank Lloyd, 17

Yalkut, Jud, *109,* 149, 157, 159
Young, Lucy Jackson, 73, *73*
Yvaral, Jean-Pierre, 57, 131, *132*

Zammitt, Norman, 44, 45, *46,* 71, 111, 179; **14**
ZERO, 56–57, 79, 131, 133–35, n. 34 (I)

Douglas Davis, like the subject of this book, is a fusion of many parts. As the art critic of *Newsweek* and former contributing editor of *Art in America,* he has written extensively about the vanguard arts. He has also published essays, articles, and short stories in a wide variety of periodicals, including *The American Scholar, Artforum, Arts Magazine, The New York Times, Holiday,* and *Radical Software.* As an artist, he has worked extensively in events, new graphic techniques, and videotape. In a series of experimental telecasts in the early 1970's, Davis pioneered the use of the medium as a two-way participative instrument, linking artist and viewers together in live time. His videotapes—one of which produced the image used on the jacket of this book—have been shown in galleries and museums around the world. He has received grants and awards for his artistic work, served as artist-in-residence at the Television Laboratory in New York, and taught at several universities and art schools.